MW01069359

ARTISTS' ESTATES

ARTISTS' ESTATES | REPUTATIONS IN TRUST

Edited by
**MAGDA SALVESEN
AND DIANE COUSINEAU**

RUTGERS UNIVERSITY PRESS
New Brunswick, New Jersey, and London

Library of Congress Cataloging-in-Publication Data

Artists' estates : reputations in trust / edited by Magda Salvesen and Diane Cousineau

p. cm

Includes bibliographical references and index.

ISBN 0–8135–3604–9 (hardcover : alk. paper)

1. Artists—United States—Biography. 2. Decedents' estates—United States.

3. Executors and administrators—United States. I. Salvesen, Magda. II. Cousineau, Diane, 1946–

N6505.A85 2005

709'.2'273—dc22

2004021708

A British Cataloguing-in-Publication record for this book is available from the British Library.

BOOK DESIGN AND COMPOSITION BY JENNY DOSSIN.

Manufactured in the United States of America

CONTENTS

INTRODUCTION

In November 1970, the American artist Jon Schueler joined the crew of the *Margaret Ann* for a fishing trip off the coast of Mallaig in the West Highlands of Scotland. Before he left, he typed out a codicil to his will, leaving his money (minimal) to his two daughters and all of his paintings to me. Living in Edinburgh and immersed in my job as exhibitions' officer with the Scottish Arts Council, I was twenty-six to Jon's fifty-four years. Although somewhat astonished that he had chosen me for this responsibility, I regarded it as temporary. In any case, this "well-preserved" American, as my family politely described Jon, was so energetic and focused as he formed his new life in Scotland that death seemed a far-off abstraction.

However, as my relationship with Jon Schueler developed, the centrality of his work in our lives became increasingly evident. He argued persuasively that by living with him and by using my art history and administrative skills in the service of his paintings, I would be doing something vastly more significant than working for an arts organization. I was flabbergasted by his arrogance. Yet, he spoke with such conviction and such a sense of need that in the spring of 1971, I gave up my independence and the job of which I had been so proud, and quickly became enfolded within Jon's life in the Northwest of Scotland.

I recognized my position as privileged. While reading, or cooking, or titling endless slides in the room next to his studio, I could hear the rhythms of the paintings taking form: the movement of the brushes on the canvas, the clomp of Jon's boots on the wooden floor as he moved between the palette table and the painting, and the quiet periods when he sat in his chair looking at what he had done, listening to his jazz tapes. Although we shared household expenses, I never contributed to the enormous studio expenses of paint, canvas, tools, and other materials. However, in those early days I became Jon's most avid collector—waiting, and watching, and choosing—until my apartment in Edinburgh slowly filled with Schuelers that I owned, which replaced paintings that had been loaned. Jon, warming to my greed for his work, would generously add to my collection on birthdays and Christmas.

I also began working out an inventory system. Not having the records of the previous two decades of Jon's work, which were stored in the States, I simply began at number one in 1970, the point when I entered Jon's life. I helped with exhibitions, wrote biographical and bibliographical summaries and press releases, tentatively tried to gain

publicity, listed the new titles of paintings, wrapped paintings, cranked out letters on the manual typewriter, arranged the photographs in albums—as Jon trod a delicate line between asking and expecting me to do these jobs. Various trips to the United States and elsewhere brought me into Jon's world of artist- and writer-friends—older, articulate, difficult, opinionated, and focused. Somehow, the two-year "contract" renewed itself.

I have a deep sense of nostalgia now, remembering the closeness of those early years in the seventies, but I also recall that Anita Marca-Relli inadvertently provided a warning when she and Conrad came to visit us in Mallaig. Jon was in his element, pleased that a New York artist and his wife were venturing into his chosen, northern landscape. He and Conrad talked and laughed with gusto, swapping stories. Anita joined in, repeating the last sentence of everything that Conrad said. I served dinner and listened. Even though Jon was, as usual, so appreciative of the role I played, I felt I was well on the way to losing a chunk of myself.

In 1975, we separated but, after a year apart, I abandoned my resolutions and joined Jon in New York. We married that year. However, I never again made myself quite so available as a helpmate. I thought I was creating my own parallel life: I flung myself into teaching children, running the New York office of Architects/Designers/Planners for Social Responsibility, and later developing college-level courses on art history and on my newly developed passion, garden history. I wore lightly the eventual responsibility of inheriting all of the paintings, meanwhile dealing with paperwork on weekends, remembering to have major shows documented, and accumulating, if not actually organizing, archival records. Jon had a series of part-time assistants who helped with everything in the studio, and even in the office—where all bills, insurance, and other financial matters were handled.

.　　.　　.

Widow

She wove the veil
Of her widowhood
With thread from his shroud
<div style="text-align:right">Samuel Menashe*</div>

After Jon Schueler died in 1992, it took me some time to accept that my role had been redefined. Like others, I was embarrassed when introduced as a widow, especially since I was just forty-eight. Only Suzanne Mallouk, a drug addict and former girlfriend of Jean Basquiat, after his death in 1988, seemed to enjoy having her friends call her "Widow Basquiat" (the subsequent name of the book by Jennifer Clement).*What I somewhat facetiously call my "widow's work" refers to the occasions when, instead of Jon giving a talk at a museum opening, I give it. Or, instead of Jon being photographed in front of his work, I am, self-consciously smiling, trying to feel as though I have a reason for being there. (I was slightly relieved to see that even Dorothy Lichtenstein had posed with a watering can

in front of *House III*, on the roof of the Metropolitan Museum, at the time of Roy's exhibition there in 2003.*) Having resisted writing anything too private in my letters and postcards to Jon, knowing that they would all be kept and deposited with the Archives of American Art, I find myself since his death pulled into "the story" and contributing to it in a way I once would have thought shameless. The satisfaction I get from seeing my own name in print in connection with other professional projects is in sharp contrast to the reflected glory I gain from my association with Jon. The two worlds do, however, overlap in a confusing way: editing Schueler's writings, bringing material together for a monograph, and directing a video on his life and work have given me (as similar tasks have provided others in this book) opportunities to draw upon unsuspected skills.

Increased acceptance of the artist's work validates not only the artist's life but also the lives of the family members. If, as spouses and companions, we accommodated ourselves to the self-absorption and the drive that it took to be an artist, it was because we recognized that despite the exigencies, the endurance of the work was what ultimately mattered. Were we subservient or supportive? In either case, the future had already been factored into our thinking. Therefore, in looking after our artist's estate, whatever the new demands on our time might be, we draw from a set of priorities that have already been established. No doubt we are caught within the cultural context of our period, and future generations of artists' companions will take different approaches. Artist-wife partnerships such as those of Christo with Jeanne-Claude and Claes Oldenburg with Coosje van Bruggen already offer us new models.

Children of artists are in a more difficult position, having been saddled with the artist's imperative through no choice of their own. Musa Mayer, Philip Guston's daughter, in her brave and revealing book *Night Studio*,* recounts the following conversation:

> "How did Philip feel about having me?" My mother paused for what seemed a long time before answering.
> "He didn't want children," she finally said. "His work, well—you know. It was everything."

Paradoxically, the pride in her father's legacy that Musa gained from managing his estate has helped her to come to terms with the emotional neglect she felt as a child. The force the work exerts on future generations appears again in the words of Susanna Heron, the daughter of Patrick Heron. After some fifty of his paintings were lost in the terrible Momart warehouse fire in London in July 2004, she stated: "It's worse than losing a family member, because you don't think of a painting dying."*

For many widows or companions, the emotional attachment is compounded by a physical continuity, for they remain in the same loft/house and summer place, the studio becoming storage or showplace. I can't imagine not living with Jon Schueler's work: waking up to it in the bedroom, seeing it out of the corner of my eye as I sit at the dining

room table, contemplating it when I look up from reading in the living area. However busy I am with non-Schueler work, I still wander around the studio and into the storage area every few days, checking for leaks, filling the humidifiers in the winter, and turning on fans in the heat of the summer. A stickler for recycling and energy control in other areas of my life, I'll use whatever electricity it takes trying to keep the paintings and works on paper at a temperature of 65 to 70 degrees Fahrenheit, and the humidity level between 60 percent and 35 percent—not up to museum standards but perhaps adequate under the circumstances. My insistence on wanting a functioning sprinkler system and working fire bells in my co-op building, where others are notoriously relaxed about such matters, stems from my concern for the Schueler paintings and archives. In the eyes of other people, this is often viewed as an unhealthy obsession with the dead artist—and perhaps this isn't helped by the way we use pronouns. Just as the artist might say, "I'm in an exhibition at . . ." or "I'm in the Whitney, but not in the Met"—merging work with person—I'll catch myself using equivalent terminology, and notice others doing the same: "Herman's got a gallery now," Regina Cherry said recently of her late husband. "He's with David Findlay Jr."

In the same way that artists usually develop a practical streak (ordering supplies, knowing about tools and materials, organizing transportation), so too have I and other caretakers interviewed in this book. The shift to being the primary decision maker pushed me into consulting the Allworth Press list and reading, for example, *Caring for Your Art* by Jill Snyder* ("Preventive care for art, like preventive health measures, needs constant vigilance and continual maintenance") and the very useful little book *A Visual Artist's Guide to Estate Planning*,* published by the Marie Walsh Sharpe Foundation and the Judith Rothschild Foundation. Although I only remember the need for a conservator once during my twenty-one years with Jon, my life now involves an ongoing dialogue with skilled professionals about the preservation of his work. In contrast to the glamorous position of the women Francine Prose writes about in *The Lives of the Muses*,* we were the dutiful (and by implication dull) art wives whom others could "all feel a bit sorry for (and superior to)," and presumably we turn into the even more dutiful art widows. We quickly learn that the more we know about the work and the archives in our care, the more useful we are to researchers, dealers, and journalists. However, through our very earnestness to draw upon our knowledge of what the artist said, wrote, and thought, we are in danger of becoming the parrot, even as we hope to elucidate. When Joanna Steichen, widow of the photographer Edward Steichen, was upset that she hadn't been invited to participate in a symposium on her husband's work at the Whitney Museum of American Art, curator Barbara Haskell explained that she was seeking new voices and that "although Joanna's book is wonderful, the actual description of the work is what her husband would have said."* In addition, through an engrained sense of loyalty (and often good sense), our critical language is usually very discreet and undeveloped. Others may talk of important and less important periods; we, like impartial parents, try to be even-handed in our love and appreciation of the work.

Yet, there are hints that we once occupied less prosaic roles. As Phyllis Diebenkorn, Anne Porter, and Peggy Gillespie mention in the interviews that follow, they served as models for many of their husband's paintings or drawings. The names of others appear in titles or through private associations (Regina Cherry, Dora McNeil). In 1970, when Jon first used my name for a series of canvases to be exhibited the following year in Edinburgh, I regarded it as a very unwelcome intrusion into my image of myself as a career woman, and I worried about what my mother would say! Later on, I hardly noticed; I was merely pleased that titles were being assigned and that index cards could be completed. Today, when I read *Mood with Magda: Blues in Grey* or *Mood with Magda: Afterglow* on the back of a Schueler canvas, I feel overwhelmed by what now seem such beautiful, tender messages. Doubtless, all close relatives or companions of artists have to deal with the shifts of the private into the public realm and the multiplicity of roles that they have been called upon to play.

. . .

While talking to other people who cared for artists' estates was an obvious outcome of my own preoccupations and curiosity, the impetus for the first interviews was actually something quite different. At the Franz Kline show that was held at the Whitney in 1995, the artist Stephen Pace and his wife, Pamela, introduced me to Betsy Ross Zogbaum, Kline's companion from the mid-fifties until he died in 1962. We had all come to pay our respects for the last time before the exhibition closed the following day. After listening to their vivid recollections of Kline, Pamela remarked that it was a pity that I wasn't taping them. An appointment with the three of them in my loft soon followed, and then a further taped session with Betsy Zogbaum in her apartment.

The interview with Betsy was rich in anecdotes but weak on the facts of how she had managed the Kline estate, which had been left to her and to Kline's wife. This spurred me on to talk to other artists' companions and wives, to hear their side of the story. They were able to fill in the kinds of details and insights that Betsy could not.

Without a specific plan, and whenever I had time, I phoned the widows and families of Jon's old friends and asked if I could put their stories on tape. I was aware of how little information existed on these "significant others." Artists' published catalogues usually include, in a chronology, the names of important people in their lives, but seldom give their birth dates or any other background information. *Who's Who in American Art*, while useful for career information on the artist (education, exhibitions, public commissions, awards, and teaching jobs), gives no personal or family information at all. The response from the women to my interest in them was sometimes hesitant. Most were used to talking about their husbands, not themselves. Even putting together their basic biographies was, at times, complicated. Widows who were themselves artists added a further layer of complexity to my project, as their own professional goals and desires had to figure into the equation.

As the amount of the material grew—each story so unique, each approach to the job of handling an estate so nuanced in its reflection of the personality of the speaker—new

questions were raised, and my inquiry broadened to include the next generation (the sons and daughters of artists), and others in the artist's close circle who were entrusted with the legacy. Complementing these "family" inheritors are the appointed directors of artists' foundations. It fascinated me to consider that they could walk away from the job, conveniently retire, and even be fired. These art professionals are paid (sometimes in the region of $110,000 to $160,000 a year) to do the planning, organizing, public relations exercises, and research on an artist that the relatives and companions, through the emotional entanglement of love and duty, feel they should assume. One cannot deny that availability of money and public acclaim often characterize the world of such foundation directors. Another factor is worth considering: most family members subscribe to the artist's belief in the uniqueness of his or her vision and the cultivation of singularity, rarely ever accepting that the work is part of an "ism" or movement; on the other hand, the more detached and measured voices of hired foundation directors show an enviable breadth of view, an embrace of period and context, and a scholarly openness to fresh thinking that must endear them to museum curators who speak a similar language. Rejections, setbacks, and disappointments are presumably sloughed off more readily by foundation directors, and their sense of personal privacy is left intact.

It soon became apparent to me that I could not ignore the vital role of the gallery dealer. Excellent books on the topic already exist, such as *The Art Dealers* (1984) by Laura de Coppet and Alan Jones,* as well as fascinating material on Julien Levy, Pierre Matisse, and earlier giants René Gimpel and D. H. Kahnweiler. However, I decided to include some current interviews that would reveal new aspects of the delicate artist-dealer relationship, so often represented in terms of marriage or divorce. Further questions necessitated interviews with the knowledgeable writer B. H. Friedman, and with lawyers who specialize in artists' estates, who could clarify the triangular relationship formed by the artist's work, market forces, and the tax code. Finally, the views of Stephen Polcari, former director of the Archives of American Art in New York, provide a perspective that contrasts with that of most managers of artists' estates, and even some foundations. Concerned about access to material that he feels should be in the public domain, Polcari encourages us to consider governmental responsibilities to our national cultural heritage.

. . .

As the project continued and I talked to more people who were involved with artists' estates, the difficulties and complications they encountered kept bringing me back to the question of options. Hermine Ford, the daughter of Jack Tworkov, already has the major responsibility for her father's art estate and also those of her uncle and aunt (Janice Biala and Daniel Brustlein). As she and her husband, Robert Moskowitz, are both painters, their son, Erik, also an artist, will be left with five estates. What possibilities are available to these artist families of several generations? No one I spoke to was comfortable with the option of sending the work to auction. When an artist already had a strong auction record, the

representative of the estate was reluctant to let other people make a profit from work sold off cheaply. They also felt an obligation to the galleries to uphold prices. For estates with lesser-known work, a feeling of debasement, even ignominy, was associated with low prices. In addition, the prospect of scattering the work in an anonymous way left them with a sense of impotence.

Even though I, like most heirs, am locked into feelings of responsibility (and hopes for increased attention to the work), I find something wonderfully refreshing, willful, and naughty in the example of Eunice Bain, widow of the Scottish artist Donald Bain and mother of his two sons. Art dealer William Hardie, who assembled the first big show of Bain's work in 1972, wrote to me on June 20, 2000:

> I knew him from 1967 until his death in 1979, and I think I have the biggest collection of his work! I liked him although (perhaps because) he was impossible, and brave, and was still misbehaving gloriously to the end. Good painter too. Very good when he was in the mood. He had no money at all and his long suffering widow was so scunnered with the whole business that she destroyed all his papers and sent all his work in the studio (i.e. the kitchen) to auction. There was never a dull moment in that relationship.

On a more somber note are the many examples of artists whose work may not have the good luck to be collected and promoted by a responsible dealer when the family steps away. This book does not deal with those sad and grim stories, though I heard many of them. Dying intestate, making no plans, and having very limited resources all spell danger. But, what of a well-respected artist who wants to safeguard the work's future but has no appropriate relative or friend to take over the estate? Jon's friend, the painter and collagist Conrad Marca-Relli, left America for Italy shortly before he died in 2000 and donated all of his work to the Galleria d'Arte Niccoli, a commercial gallery in Parma. In return, he asked that his wife, Anita, be looked after until she died. Anne Arnold tells us in her interview that she is selling her husband's work to her dealer, Anita Shapolsky, who has recently started a foundation for just such purposes.

Other artists without immediate heirs might find solutions in group ventures: the Art Connection in Boston, the Senior Artists Initiative in Pennsylvania, and the Estate Project for Artists with AIDS all stress planning, dispersing, and archiving in distinctive ways. Gary Knecht told me about the Artists' Legacy Foundation,* which was recently formed in California to receive the work (upon death) of his wife, Squeak Carnwarth, and their older friend Viola Frey. They envisage including other like-minded artists, whose financial commitment (realized after death from real estate or other assets) would pay for shared storage and office space. One set of professionals would take care of the legal and accounting work, while a curator and assistants would actively promote their legacies through exhibitions, publications, and museum placements.

Storage area of Artists Archives of the Western Reserve, Cleveland, 2003. Photo: Matthias Minnig. Courtesy AAWR.

Another approach is taken by the Artists Archives of the Western Reserve in Cleveland, Ohio, which was set up in 1997 on the initiative of sculptor David E. Davis. Artists in that region can plan for the future by renting space for a representative amount of work, the initial fee providing interest for the annual payment.* I was impressed by the vast warehouse and its adjoining gallery that showcases the artists' work in group and solo shows. Although more dependent on grants than initially envisaged, AAWR does present another model that could be replicated throughout the country.

. . .

In the last chapter, Jack Cowart, director of the Lichtenstein Foundation, mentions that members of the Council of Artist Foundations meet occasionally to exchange news and information, provide advice to each other, and air difficulties. I see this book as offering a similar forum to representatives of estates, who often work in a vacuum and have a strong tendency to feel that others are more competent or are doing more. In fact, the diversity of skills revealed in these interviews is inspiring, and although each estate is idiosyncratic, a certain overlap suggests that there is surely room for much more dialogue.

All who participated in this project, representatives of artists' estates, as well as gallery owners, writers, and lawyers—have given generously of their time, checking their interviews, supplying biographical information, and selecting and advising on photographs. I owe them a great deal and have gained immeasurably from the interchanges and discussion. Diane Cousineau's collaboration—in shaping and editing the material, as well as providing introductions to the chapters—has been invaluable.

If, as Michael Kimmelman says, "An artist's posthumous reputation is the result of endless vagaries and sea changes,"* I see each of us who looks after estates or foundations as the anchor—the one whose belief has to remain steady—and whose life, in the process, is enlarged and deepened through contact with the artist's work.

MAGDA SALVESEN
New York, 2004

† Notes are indicated by an asterisk within the text. A set of key words from the text will help the reader identify the corresponding endnote at the back of the book.

ARTISTS' ESTATES

B. H. Friedman, 1999, with *Night*, 1955, by Jon Schueler.
Courtesy Jon Schueler Estate.

ONE

FORMIDABLE
ANTECEDENTS

The two figures who tower over all others in any current inquiry into the workings of artists' estates are Lee Krasner and Annalee Newman. While Jackson Pollock and Barnett Newman were alive, both women selflessly devoted themselves to their husbands' art and, after their husbands' deaths, they shaped their artistic legacies with unexpected force and intelligence. Annalee Newman, archetype of the dedicated wife, who supported Barnett Newman both economically and emotionally, and Krasner, prototype of the artist-wife who, during her marriage put aside her own career in favor of Jackson Pollock's, thus stand as imposing images before the widows interviewed in the following pages.

B. H. Friedman, author, and biographer of Jackson Pollock, speaks openly about the ways in which Newman and Krasner developed the value of their husbands' estates. While Krasner has been criticized for excessive maneuvering, Friedman insists that "Lee continued to do everything right," and praises her for firmly setting high prices and releasing the work slowly.

Friedman's appreciative remarks about Annalee Newman's accomplishments leave us with a sense of how remarkable a woman she was, diminished in no way by the secondary, often silent presence she assumed during her long married life. Perhaps no anecdote encapsulates the delicate balance she achieved as forcefully as the one recounted by conservator Carol Mancusi-Ungaro at Annalee's memorial service.* Near the end of his life, Barney asked his wife to destroy one of his paintings, which she found impossible to do. After he died, however, she felt differently:

> I had no choice. I had to carry out his request. So I found the work, I took a large scissors, and I began to cut the painted canvas into many pieces. When I was finished, I was satisfied that I had done what Barney wanted. That night I had a horrible dream. I dreamt that with the scissors in hand, instead of cutting up the painting, I was cutting up Barney himself. I was terrified. The next morning I decided there was only one thing to do. I collected the fragments of the painting, took them to a tailor and instructed him to sew them all back together again.

This divided stance characterizes the precarious position of more than one widow as she struggles between her own desires and the imposing shadow of the artist that remains.

Friedman provides a provocative invitation to the interviews that follow, as well as opening up questions that will be pursued in later chapters—the relationship between artists and their children, the roles of galleries and foundations, and the place of critical writing in shaping an artist's reputation.

<div align="right">D.C.</div>

B. H. FRIEDMAN ON
LEE KRASNER
AND
ANNALEE NEWMAN

For an insider's view of artists' estates, I talked to B. H. Friedman in his Manhattan apartment. He and his wife, Abby, have been closely involved with artists of the New York School since the early 1950s, when they started forming a fine collection of paintings and sculpture. In his capacity as trustee of the Whitney Museum of American Art in New York City, he oversaw the construction of the building on Madison Avenue, designed by Marcel Brauer and completed in 1966. In addition to his novels and short stories, Friedman has written numerous catalogue essays and monographs for his friends. He edited *School of New York: Some Younger Artists* (1959), and his biography *Jackson Pollock: Energy Made Visible,* (1972),* was the first on this artist. He recommended that I read "The Art Establishment" in *Esquire* (January 1965) by Harold Rosenberg, and our interview began with this extract:

> Another recently emerged power is the artist's widow. The widow is identified with the painter's person, but she is also an owner of his art properties—in the structure of the Establishment widows stand partway between artists and patron-collectors. Commonly, the widow controls the entirety of her dead husband's unsold productions: this enables her to affect prices by the rate at which she releases his work on the market, to assist or sabotage retrospective exhibitions, to grant or withhold documents or rights of reproduction needed by publishers and authors. (Mrs. Jackson Pollock, besides being a painter in her own right, is often credited with having almost single-handedly forced up prices for contemporary American abstract art after the death of her husband.) She is also in a position to authenticate unsigned paintings or drawings in the hands of others. Finally she is the official source of the artist's life story, as well as of his private interpretations of that story. The result is that she is courted and her views heeded by dealers, collectors, curators, historians, publishers, to say nothing of lawyers and tax specialists. It is hard to think of anyone in the Establishment who exceeds the widow in the number of powers concentrated in the hands of a single person.

.

Would you respond to Rosenberg's comments?

Rosenberg's article is really focused on the power and the politics of the widow in the art establishment. I turned that around in my biography on Jackson Pollock: "Rosenberg

knows what an artist's widow is called upon to do. However, the idea that meetings with dealers, collectors, curators, historians, lawyers, accountants, etc., might involve hundreds of painful impositions seems, for the moment, to have escaped him. So does the idea that the widow's motivation for releasing the work slowly and reluctantly may have something to do with love for the artist and his only living remains." Lee [Krasner] was very appreciative of my saying this in the introduction to her 1965 Whitechapel Art Gallery catalogue.

I think, for this generation of American artists, Lee did set the pattern for widows. Certainly in everything she did, she made very smart moves. For instance, when the Metropolitan Museum offered ten thousand dollars for a huge painting, *Autumn Rhythm*, Lee felt they could go much further. And she was right. I thought she should just release the work on a regular basis, but she was much more right than I was. I worked with her quite a lot on pricing the estate. Bernard Reis was her accountant, the one who later got into a lot of trouble over the Rothko estate. Anyway, the whole problem was juggling the prices when the estate was appraised: not to put the price so high that Lee would be socked with a huge estate tax and, on the other hand, not to put them so low that later, when the prices went up, she would be taxed very heavily on individual sales. In any case, Lee continued to do everything right.

She also, quite early, decided she wanted to have a catalogue raisonné. One of the reasons for this was to prevent fakes from coming on the market. Not every artist is "flattered" by fakes, but there were Pollock fakes even quite early in the fifties. She put together a team of two very thorough scholars, Eugene Thaw and Francis O'Connor, and she got a very scholarly, beautiful catalogue raisonné, published by the Yale University Press in 1978.

Of course, it was my misfortune that after I wrote my biography (originally Lee had asked me to do it, was extremely sympathetic, and when I read it to her, liked it), she gave it to an art writer* who was staying with her overnight in the country. I had left a copy with her—my mistake, but she had asked for it. When the writer finished it, she asked Lee the one question that would destroy me: "Do you think that this will help Jackson's reputation?" Well, everybody knew Jackson drank, and everybody knew he'd been in various kinds of psychotherapy; but that suddenly hit Lee, and she did try to have the book stopped. The new foreword in the 1995 edition describes all that. In any case, I think Lee really set a pattern. The only one who came close to her was Annalee [Newman, wife of Barnett Newman]. Did you ever get to interview Annalee?

Unfortunately, no. After the fire in River House [435 East 52nd St., New York City] in 1997, she never recovered adequately for an interview.

Annalee learned a lot from Lee, and she made very smart moves. I helped her get into River House because she had a broker who never would have gotten her in there. It was a very restricted building.

Why was it important for Annalee to live there?

She wanted to be in an elegant building that was convenient for foreign critics to

Lee Krasner in front of one of her own paintings, 1984. © Bernard Gotfryd.

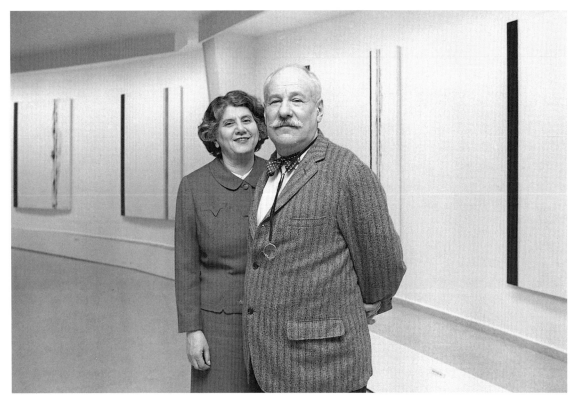

Barnett Newman and his wife, Annalee,
at the Gugggenheim Museum, New York, 1966.
© Bernard Gotfryd.

visit, and purchasers, dealers, and so on. They had lived on West End Avenue in a very humble building, perfectly nice. Lee could be quite vicious, you know. She said to Abby and me, "Annalee must have misunderstood. Barney probably said, 'Why don't you move to Riverside Drive' (which would be a step up from West End Avenue) 'and then you'd have a river view?' And she misunderstood and thought he said, 'Why don't you move to River House?'" But that's Lee. That's totally apocryphal.

Was that a wise move? Does it really matter to curators and others?

Oh, yes. It's more than just convenient. She bought that apartment and knocked out some of the existing walls and reproduced Barney's room on West End Avenue. It was exactly the same size, with his files, coat rack, and his hat— everything was duplicated. It took her about three years to move into that apartment, so she had every detail right, creating some walls where she could always have one very large painting and others with smaller works.

I think it was smart for her to do that, and she began moving in moneyed circles. Sy Newhouse became a big supporter of Newman and bought a major painting and put her

in touch with the right lawyers and professionals. And she did use her apartment very well for parties, some of which we went to. She and Barney had both loved music, and now she became a subscriber to the opera. These were all things that would have been fantasies for Barney. When Annalee was applying for this apartment at River House, I myself was astounded by how big Newman's estate was, even then, about twenty or twenty-five years ago.

The other thing is that Annalee—although I always thought she was a very nice person—hardly spoke when Barney was around. Barney was a very entertaining and compulsive talker. I remember trips to East Hampton, when all she ever said was "hum, eh-huh, er-huh," a repeated sound expressing her approval of him and what he said. Now, suddenly, she had become quite a grande dame. She was doing the talking, and she hired John O'Neill, a good scholar, to handle everything having to do with Barney. She did things that Barney would have done; it was eerie.

Publishing Barney's collected writings in 1990 was a brilliant stroke. I think they found almost every scrap available—letters to the editor, to museum directors, snippets here and there—because Barney never wrote a really sustained piece. To call that book *Selected Writings* is perverse. I don't think they missed much, although he did many drafts of his articles and his letters, so perhaps they are "selected" from those!

And a French scholar, Yve-Alain Bois, now at Harvard, is working on a catalogue raisonné. I don't know if he's going to end up doing it or not, as he's late. But he is so committed to Barney that I think it would be foolish not to keep him. Anyway, Annalee is the best example of someone who learned from Lee, following many of the same steps and inventing a few of her own.

Do you think that she enjoyed playing the role of the widow?

Oh, I think so. Now she was traveling. I think they only made one major trip while Barney was alive, which was in 1971, when Pierre Schneider interviewed him at the Louvre. Most of the places they'd gone to were because of Barney's interests. For example, those monuments in Ohio of the Mound-Builders' culture or the ornithology department at Cornell University because Barney was very interested in birds. Then they made one trip to New England, where Walden Pond was the main destination, if I remember correctly. Her life was pretty much totally focused on Barney. She came into her own when Barney died. I think that's true of Lee too. Lee had very much subordinated her career to Jackson's; after the initial shock of his death, she really opened up in her painting. I happen to like the early work better! However, there's no question that, in a way, not having the responsibility of Jackson was liberating.

Was Annalee good at taking advice and working with the galleries?

I think so. Annalee had John O'Neill as an archivist and registrar, Heidi Colsman-Freyberger, and also a personal secretary. After Barney's death, I think she was in the lucky position of having tremendous support from some very important critics. One of the biggest supporters was a British critic, David Sylvester, who very early on said that Barney

was the most important artist in the second half of the twentieth century. And then, toward the end of Sylvester's life, he decided that Barney was the most important artist born in the twentieth century! Not quite wiping out Picasso, Matisse, Mondrian, and so forth.

So Annalee knew the art world and used it to her advantage? Harriet Vicente, Esteban's widow, said the other day, "Oh, Magda, don't be naïve. It all depends upon money."

Well a lot—and on good advice.

Do you think that money itself meant that much to Annalee and Lee?

When Jackson died, he hadn't yet made that much money—the biggest purchase of his work was Ben Heller's for *One*,* and payment was to be spread over four years. They lived very modestly and with a good deal of hardship. Jackson was the most famous artist of that generation, certainly of the abstract expressionists, so that the potential for real money was there. And Lee knew that. With Annalee, I think it was similar, except that the body of work was so much smaller, which meant that it became increasingly valuable. There are only about 250 works by Barney, including prints. It's amazing how Annalee parlayed that into the kind of estate that I believe it is. For instance, there are only two suites of prints, *The Cantos* and the *Notes*—both fairly large editions—and then some isolated ones. The single prints have smaller editions, and the small ones now go for $20,000 to $60,000. I don't know what the big ones go for—it must be above $100,000. It's a nice position to be in.

Yes. Could we say that the difference between Annalee and Lee was that Annalee's way of living as a widow was an expansion of her former life, while Lee had to almost re-create herself? Everybody knew that Jackson was involved with another woman when he died, so Lee wasn't in the category of the loving wife who naturally looks after her husband's work.

The huge difference was that Lee herself was an artist.

After all the ghastly things that happened, why did she take on the estate? After all, as an artist, she could have taken it as an opportunity to retreat from Jackson and to continue with her own work. Or was the financial gain irresistible?

I don't think Lee's career would have taken off quite the way it did if two things hadn't happened. One was the interest in feminism, the other was that she used the Pollock estate to forward her career. There were many times when the loan of a Jackson Pollock was conditioned on a work of hers being taken for a group show, etcetera. I think, on the one hand, you could say yes, she subordinated her career to Jackson's. On the other hand, there was very little question in my mind that as Jackson's wife, her own reputation was enhanced.

Was there another member of the family or anybody else who could have taken on the estate?

There were others who *might* have—her nephew Ronnie Stein, an artist who almost modeled himself after Jackson. He also was a very heavy drinker. He certainly helped Lee in various ways. On Jackson's side, there was his nephew, Jason McCoy, the gallery dealer.

Lee did give him the estate to handle, but that didn't work out. So she began leaning more and more heavily on Gene Thaw. Do you know who he is?

Yes, he has a wonderful collection of drawings.

He was a private dealer and a trustee of the Morgan Library, to which he gave the Pollock notebooks, maybe all but one. He really took charge. Thus, Lee found a very serious scholar and someone very committed to Jackson. She also was working with Francis O'Connor, who's probably the most knowledgeable Pollock scholar. He's quite amazing. He can look at a signature and say what year it was done, or look at a photograph and from the hairline, say how old Jackson was. He talked to hydraulic engineers because he felt the word "drip" was not accurate. It had to be "spilled." Or rather, I think there was dripping and spilling. Anyhow, Lee got a very good team. The only time Lee and I ever talked again after our severe break was at a party given by a co-trustee of mine at the Whitney when she did make an overture, but it was too late from my point of view. She said to me, "Thank God for Gene Thaw. I couldn't work with Francis O'Connor because he's the most nit-picking scholar." Gene Thaw, being more of a businessman type, did things with a broader brush. Thaw was a big factor for Lee. I really don't know enough about who did that kind of thing for Annalee. There has to be a team of people who decide that the artist's work is worth backing, pushing, selling, and writing about.

Perhaps I should summarize. Probably foremost is the requirement of an important body of work. Nothing can happen without that. Critical support is the next most important thing; in Pollock's case it was really Clem [Greenberg] who put him on the map, even though later he backed off quite a bit. I guess critical support would have to be divided into two parts. It usually starts with good writers but also includes museums and institutional support. Then, having the right gallery would be important. Pollock started with Peggy Guggenheim, a very good place to begin at that time, then went to Betty Parsons, an important gallery with a very good stable, and then to Sidney Janis. After difficulties with Janis, Lee got involved with Frank Lloyd at Marlborough. These were all powerful galleries. Let's not kid ourselves about the art world being lily pure. Along with galleries would be auction prices, which really can be manipulated. For example Leo Castelli did wonderful things for his artists in terms of building up prices at auctions and so forth.

How did he do it? Did he send in people who represented him to bid up the prices or was he there himself?

I imagine that one approach was to tell the right two collectors, "There's a wonderful Jasper Johns coming up; you really ought to get it." All you need are two people who really want something and the prices go way up.

Another smart move was to try to place paintings by new artists in what he considered significant collections. Not that my collection was all that important, but in the early sixties, when the artist was unknown, Castelli offered me a beautiful Roy Lichtenstein— for nothing. He just said, "Bob, I'd like you to have that." An early black-and-white Lichtenstein of a woman's foot pressing a garbage can lever. I didn't accept it because of Jon

[Schueler]. I've never told this to anybody. I refused it because I thought it would upset him to have his paintings hung near a Lichtenstein, whose work he didn't respect, to put it mildly.

What was his reasoning behind this offer?

That I would hang it, and it would be hanging with a Pollock, a Motherwell, a Still, and a Giacometti nearby. Castelli wanted that kind of company for his new protégé. Slightly earlier he had asked me to write on Rauschenberg. Nothing ever came of it, but he wanted a monograph. Anyway, I think there was usually, if not an explicit quid pro quo, an implicit one.

What do you make of the fact that Renate Ponsold [Robert Motherwell's widow] was not given any responsibility for Motherwell's art estate?

She's been rejected and she feels rejected. One night we ran into her at a Village restaurant and went over to say hello. She couldn't have been friendlier, and invited us for a nightcap. We stayed in her apartment from about twelve to three. All she did was pour her heart out about how badly she'd been treated, and I think it's true. I don't know that she would have had the discipline to do what was necessary for Motherwell, but she was excluded from all decisions about his work and doesn't sit on the board of the Dedalus Foundation, which now owns it.

But would Renate really have wanted to manage the estate? She has her own career as a photographer.

I think she would have liked to have been included in the role of custodian. He could have appointed her to the board of the foundation. The other members would have outnumbered her. But then, Motherwell's treatment of his daughters is unbelievable to me as a father: "Jeannie and Lise shall receive a work or two not of museum quality."* That little! I think he also gave each of them $1 million, but that doesn't go so far these days. They'd been pampered, and suddenly they're adrift. Jeannie very much wanted the apartment he had in the building next door to us in Provincetown, and he didn't even leave that to her.

Were both the Greenwich and the Provincetown properties left to fund the Dedalus Foundation?

Renate was allowed to use those houses as long as she wanted, and to keep her apartment in New York. She has a lot of his work that he had given to her previously. She'll not starve. But in financial terms, it's the children whom he really treated shabbily.

I didn't know Motherwell very well, but I never would have thought of him as a mean person.

No, I don't think he was mean. I do think he was overly involved with his reputation, his place in history, all of that. A decent lawyer might have said, "Don't you think that's a little harsh?", but evidently nobody did.

At one point, I thought Motherwell was given too much credit. Today, I think his work is given too little. Art critics can be extremely biased. He was too sympathetic to French

art at a time when the American art world had become so chauvinistic. He was always very bright and articulate, but maybe he wrote too much. His writings have been collected, too, and I think they're pretty good. He was attacked, even more than Alfonso [Ossorio] was, for being rich. His father was at Wells Fargo bank. In France there have been a lot of very fine artists and writers who came from wealthy backgrounds, and it never became an issue. Motherwell was a graduate of Harvard—all kinds of things that rubbed everybody the wrong way. He's the perfect example of the kind of artist Harold Rosenberg would hate the most because he was a well-educated, rich boy. So the Dedalus Foundation can certainly encourage some rethinking and some new writing on Motherwell.

Do the heirs of a writer's estate have similar responsibilities?

A writer's estate is quite different. You just really try to keep the work in print. There's little in terms of manuscripts that has any immediate value, but it has this possibility of recurring value through being kept in print. There are very few writers who make the kind of money that visual artists make today. It's the difference between things and words.

April 2002

TWO

THE WIDOW
IS THE MEMORY

In the course of an informal talk about her husband's life and work, Phyllis Dieben-korn, noting that she possessed all of the artist's papers, remarked, "The widow is the memory." This evocative remark points to the widow's role as the repository of the living presence of the artist, perhaps granting a privileged access to his life and work, but also to the fact that she is in control of the paintings—with all the pleasure, power, burdens, and frustrations that this role entails. "I have total responsibility for the paintings," Die-benkorn says, at the same time affirming that during her husband's life she made no deci-sions in regard to his art. She thus alludes to the situation frequently recounted in these interviews: a wife who once played a secondary role in the artist's career suddenly finds herself propelled toward center stage.

Obviously, the role that these women played during their husbands' lives influences the way they approach the responsibilities of the estates after their deaths. It is not sur-prising that Harriet Vicente, who bluntly announces, "I did everything but paint," and who was instrumental in setting up a museum in her husband's honor in Spain, has taken on the responsibility of representing him there after his death. Yvonne Hagen, with her independent career as an art critic and curator, was especially suited to finding galleries for her husband although, she emphasizes, she is unfit for the tasks of letter writing and accounting. After his death, she found the problems of preserving, storing, and catalogu-ing the remaining artworks to be a strain, but she proved herself more than capable of writing a monograph on him.

Even those more removed from their husbands' careers, however, find unknown resources for dealing with their new responsibilities. Phyllis Diebenkorn contributed impressively to Richard's major retrospective, and she is compiling the records for an eventual catalogue raisonné, all the while insisting that "I just muddle through." Anne Porter, model for her husband, mother of five children, and poet, managed to fulfill Fair-field's wish that a body of his paintings go to one museum, and was able to contribute significantly both to biographies and the catalogue raisonné.

As these women take up their widows' work, they face the mounting pressures of maintaining records and archives; preserving and repairing the art; dealing with account-ants, lawyers, and gallery directors; managing within the constraints of their own finances; and fulfilling the goal of keeping the work in the public eye, which is the crucial

means of keeping the artist alive. How do they do this? Some widows are fortunate to have a museum desirous of the work. Others, steeling themselves, seek out galleries. Some establish relations with scholars and biographers or, like Yvonne Hagen, write an essay for an exhibition and find themselves in that strange position of spending "so much time researching a dead partner's life."

These widows all feel deeply committed to insuring that the artist they knew survives, but are equally insistent that they have no wish to fabricate a myth or to control the artist's reputation. They speak, as Anne Porter explains regarding her decision to cooperate with biographers, because otherwise things would not come out right— "not because people would lie, but because they just wouldn't know." For her, as for many others, it is a matter of accuracy and integrity, as well as the unwillingness to let the artist's vision die with him. How does the widow remain faithful to the artist's being, maintain her own independence, and allow the public a glimpse of the private person without ever, as Vicente says, allowing all of that to become "more important than a single painting"? Such questions haunt these pages.

Some women find that, in performing their widows' work, the meaning of the word "memory" is itself transformed. Vicente, for example, tells us: "Now, as an eighty-year-old person, I feel I'm growing every day, not just dealing with memories, but also figuring things out that he said that puzzled me at the time." Thus, memory, as more than one widow discovers, becomes a vital and generative force.

D.C.

ANNE E. PORTER, WIDOW OF FAIRFIELD PORTER

Fairfield Porter, born on June 10, 1907, painted his wife, family, and friends in quiet domestic surroundings, transforming them into shapes and colors bathed in sunlight. His sitters seem to have slipped into silent reverie, the lack of human interaction leading the viewer to concentrate on the painterly qualities of Porter's work. His still lifes and interiors reflect his deep respect for Édouard Vuillard and Pierre Bonnard, while most of the vigorously painted seascapes stem from summer visits to Great Spruce Head Island in Maine.

Brought up by cultured and well-traveled parents in Winnetka, Illinois, just outside of Chicago, Porter graduated from Harvard in 1928 and moved to New York City where, for two years, he attended the Art Students League. His interest in socialism involved him briefly in mural and pamphlet projects. Porter achieved his mature style in the fifties, after some twenty years of painting. Helped and encouraged by his friends Jane Freilicher, Larry Rivers, Frank O'Hara, John Ashbery, James Schuyler, and Kenneth Koch, he gained recognition after the 1952 exhibition at Tibor de Nagy in New York City, the first of fifteen one-person shows there. Porter died very suddenly of a heart attack on September 18, 1975, while walking the dog near his home in Southampton, New York.

Anne Elizabeth Porter, daughter of the lawyer Henry Morse and Katharine (née Minot) Channing, was born on November 6, 1911. After completing two years at Bryn Mawr and one at Radcliffe, she married Fairfield Porter in 1932 in the garden of her parents' house in Sherborn, Massachusetts. The couple had five children: Johnny (1934–1980); Laurence, born 1936; Jeremy (Jerry), born 1940; Katharine (Katie), born 1949; and Elizabeth (Lizzie), born 1956. In 1949, the Porters bought a large 1840s colonial frame house in Southampton, New York, where the barn became Fairfield's studio. Artist and literary friends constantly wandered in and out of the house, while the poet James Schuyler, as Anne remarked, came for a visit (in 1961) and stayed eleven years. Anne dealt with children and visitors, meals and housework in a famously casual way and, at the same time, pursued her own interest in writing poetry. Her poems reflect a quiet sense of religious awe and a delight in nature. After Fairfield's death, the big house was sold in 1980, and Anne moved into one newly built on the same property, a stone's throw from Fairfield's studio. Since 2002, she has lived with her daughter Lizzie and Lizzie's husband, John Balzer, in nearby Hampton Bays.

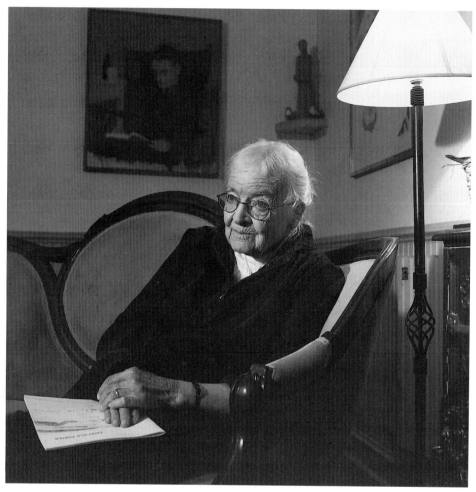

Anne Porter, Southampton, N.Y., 2001. © 2004 William Rivelli.

My visit with Mrs. Porter in Southampton, New York, took place in her kitchen-sitting room, where she sat at a small, round dining room table, bathed in light from two windows. A portrait by Fairfield Porter of their son Johnny hung on one wall, and one of his prints on another. At eighty-nine, Mrs. Porter is small and bent over, with a beautifully weathered face, an alert mind, and a gently quizzical expression. Her voice is almost girlish, hesitant and modest. Little flashes of humor punctuated our talk.

. . .

Your husband wrote to his dealer, Tibor de Nagy, saying, "I am not at all interested in selling pictures to hotels, even less to hotels abroad, and still less in lending paintings to embassies. I don't want to advertise the American government abroad: I get nothing from

such a program except a reputation for passivity and indifference."* **What do you think he did want for his work?**

I think he wanted his work to belong to people who sincerely enjoyed it and who knew what painting was.

The main thing was that they should love the work and not think of it as an investment?

Right. We had a lawyer, Arthur Bullowa, who collected Fairfield's work. I didn't mean to preach to him, but I said, "Arthur, isn't it a shame that so many people have collected the paintings, and no one else will ever see them?" And he said, "Well, some people will leave them to museums." I forgot that he, Arthur, had eight! When he died, I found out that he left his collection to the Metropolitan Museum.

In his will, Fairfield specified that he wanted a body of work to go to a museum. How did you interpret that?

I guess that's why we chose to give a lot of the work to the Parrish Art Museum.* Its very congenial director, Ron Pisano, was eager to accept it, but he didn't remain there very long. There was also the problem of storage. First, I had the paintings in the attic in that big house, and Rackstraw Downes, a friend and advisor, said that they really shouldn't be there. So we built a room in the barn with a lot of insulation and tried to approximate a controlled climate, but that really wasn't adequate either. Having them in the museum seemed like a way to keep the paintings safe. We specified that they should be shown from time to time. I'm not sure that it was the perfect solution. Perhaps there is none.

Are the works shown as often as you would wish?

Of course, I always want his work to be shown more. Fairfield's work can look very conventional to a person who doesn't think in terms of paint and sees only a tennis game or a little girl. I think painters are more apt to appreciate Fairfield's work, though I was told his show in Boston was loved by the museum guards and cleaning people as no other show had been before.

Did the children have ideas about what should happen to their father's work?

No, they weren't very bossy about it. I was the only executor, and I had to decide. I'm not sure what I would do now. Another possibility would have been just to sell them.

You were terribly generous, Mrs. Porter because, although this is thinking in a way that your husband would not have liked, by giving away 186 paintings, you also gave away the children's inheritance.

My children, as our trust officer and financial advisor said, are remarkably ungreedy! I don't think they ever gave a thought to what they could make out of selling their father's paintings. Those who wanted to own some of their father's work have small but choice collections of their own. We still have some in a charitable trust, and they are given away from time to time to museums.

Your decision was really based on what you felt would be best for the paintings?

Yes, it was a cop-out in a way. This must be disappointing for you as a possible solution, to take paintings and bury them in a museum! But Alicia Longwell, who is very

gracious and very good at it, shows the paintings to scholars and people who come to study the collection. I know that the paintings are safe, and they do go out from time to time. I was distressed that the museum was thinking of de-accessioning some of Fairfield's paintings in order to buy others of the same period. I told the board that I thought the integrity of the collection was important, and this should not be done. So, I trust it won't be.

Did you choose the 186 specifically to represent different periods of his career?

It just happened naturally. My daughter Katie took some of the most beautiful paintings, as did my son Laurence, who doesn't like to have any pictures in his house except his father's. Of course, they are sometimes lent to exhibitions, and the gallery Hirschl & Adler Modern has a few.

Did you have any difficulties with the tax situation?

Fairfield's paintings were appraised by the IRS, and we paid taxes on them. It seems funny, doesn't it, to pay taxes on your own husband's paintings, but we did! Then, three years later, they said the paintings had been under-appraised, and so they charged us interest for the previous three years. I thought that was really weird, but I don't think lawsuits are always appropriate because people just get into a lot of anger and lose a lot of money. A class-action case would be different—if all the widows of painters would get together, not just one person. I do admire Kate Rothko, though, for challenging her father's gallery (See Part Nine, "Kate and Christopher Rothko").

Has it been easy to place his work in other museums?

One of the directors of the contemporary department at Hirschl and Adler, Scott Schutz, knew a lot about small museums all over the country. Fairfield loved small museums. Every time we drove near Worcester, Massachusetts, he'd say, "They have such a good museum." So I felt I was doing what he wanted when we gave to small museums. Then we sent paintings out West, where he wasn't that well known. And, one time, a museum in Hawaii was loaned a painting of fall foliage, which is something they don't have there. The first graders all went to see the painting, and they sent me their own pictures of fall foliage from their imaginations. In the end, the museum bought the painting.

John Spike, in his book on Fairfield, warmly acknowledges all the help you gave him.

When you see someone trying to do something to honor your husband, and he asks you to help, you usually try to oblige if the project is valid at all.

Didn't you invite him to write the book?

It's true. That's a wonderful story. Paton [Miller], who worked in Fairfield's studio, sometimes comes over and visits. We were talking, and I said, "Neil Welliver has an art book [by Frank H. Goodyear]"—Neil was a very good friend of Fairfield's, and I also like Neil a lot—"and Fairfield doesn't have an art book, and that's not right." Paton said, "Just a minute." He went over to the little house he lived in, right in back of the studio, and said to his then brother-in-law, John Spike, an art historian, visiting from Italy, "How about doing a book on Fairfield Porter?" John said, "Fine, I love Fairfield Porter's work." So Paton came right back and said, "What else do you want, world peace?"

That's a wonderful story. Did the estate have to put up a certain amount of money for his book? This seems to be the custom nowadays for many art books.

No, although I did for the catalogue raisonné that Hudson Hills published [in 2001]. I think that the Parrish Museum was supposed to help with six thousand dollars [drawing from the thirty thousand dollars given to them for the care of the paintings]. But they used up that allotted sum on another attempted catalogue, so we had to pay something. Bear in mind that there's an eighty-nine-year-old memory at work here!

Did Joan Ludman do the work on the catalogue raisonné as a volunteer, or was she paid by the Parrish Museum?

Nobody paid her. We looked for various people, and some were paid something but didn't work out. My son Laurence suggested Joan, who has been practically miraculous. I did give her and her husband a painting. That was only proper. (I probably should have given them two or three.) She worked all those years, and her husband helped her too. She said it was a labor of love, and she's thrilled now that the book is done.

Did you mind being asked about the details of family life by Justin Spring for his book, *Fairfield Porter: A Life in Art*?

Yes, I do mind; I did mind. But, since he was going to write the biography anyway, if I didn't say anything, a lot of assumptions would be unchallenged—not because people would lie, but because they just wouldn't know. I'm still not sure what I should have done.

It's difficult. How did you make decisions about what letters and papers to destroy, and what to keep?

I don't remember destroying anything. Yes, I destroyed some of Jimmy Schuyler's letters, written to us from the mental hospital, because I felt that he shouldn't be remembered for the things he wrote when he was ill.* I'm not sure if that was right or not. It wasn't that they were incriminating to us, but they showed him in a bad light. I didn't suppress very much.

John Spike expresses his appreciation that the estate of Fairfield Porter donated so much material to the Archives of American Art, now on microfilm: reviews, lectures, poems, statements, gallery contracts, et cetera. Did your sense of privacy control what you didn't want to make public from your own letters?

Oh, the letters to my mother? I had all these letters that were given back when my mother died. I was visiting Katie, and I had some time to spend, so I went through the letters and chose what mostly referred to Fairfield. I thought, what's famous about me is Fairfield! I mean, that's true! There were a lot of other things about babies' first steps and first teeth that I didn't consider of general interest.

Do you think, as widows, we shape, to a certain extent, the myths of our late husbands?

I guess I believe in not trying to control his reputation. I thought his paintings and writings were really where to look for him. Rackstraw Downes and Bill Agee [the art historian], who teaches at Hunter College, have understood him and his way of thinking. Others, too, I'm glad to say, have written with real understanding about him—his friends,

of course. But there's a lot of nonsense, too. I didn't try to make anything look better because I don't think it really helps. Even in the biographies there are details that escaped me, but people can't be 100 percent accurate.

The biographies don't bring out that Fairfield was dealt a very difficult temperament and had to deal with that. He managed to remain with his family, with all of his children, providing for us. He never deserted us for more than a few days. He never deserted us. He made dollhouses for his little girls and a tree house for Johnny, and lots of things like that. I think it was really admirable, the way he took care of us in spite of all the other things he had to contend with in himself. Fairfield spent many patient hours with Johnny in the first nine or ten years of his life. And, though the prognosis was that Johnny "would become a vegetable," he grew up to be a very crazy and eccentric, but a warm and outgoing human being. This must have been partly the fruit of Fairfield's work. When I finally understood this, Fairfield had already died, and I couldn't tell him.

When you were having financial difficulties in the fifties and early sixties, didn't your family feel that they could help?

The times weren't bad enough for that, although having an ill child is very expensive. I don't think that, unless I had left Fairfield, or had been left and was all alone with the children, it would have seemed appropriate. It was better that we were on our own. As I remember, though, my family always provided me with something like $100 monthly. Once my family gave us money to buy a house near them in the country. We had an architect work on it, but Fairfield realized, after plans had been made, that it would not work because my father thought it was selfish for somebody to paint instead of doing "honest work"! And Fairfield understood too—without actually being able to say it—that we would be too dependent if we lived near them. It was hard at the time, but afterwards I realized that he was right. I'm very glad he resisted that plan.

Did these tensions stop you from confiding in your own family?

I instinctively didn't tell my family anything. I think, in this case, that was right. I know, too, that I'm easily influenced. If I had started complaining about Fairfield, it would not only have been disloyal, but pretty soon I would have felt really sorry for myself, and would have started yelling at him.

From the very beginning, you posed for Fairfield. Was this a chore, or did it bring you closer together?

I think I just took it for granted. I wanted to help him, and that was something I could do. Sometimes we had wonderful conversations while I posed.

It seems that long hours were often required?

I remember once having to leave when he was painting my feet, so I slipped out of my shoes and left them there for him to paint while I went away.

Was there ever a time when you didn't pose for him?

No, though I remember one exhibition of Fairfield's at the Tibor de Nagy gallery in

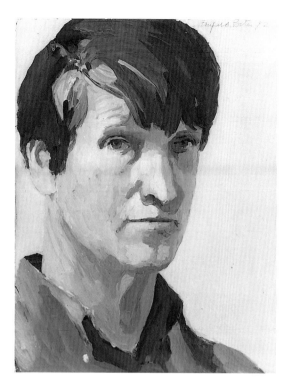

right:

Fairfield Porter, *Self-Portrait,* 1972, oil on masonite, 14" x 10". Parrish Art Museum, Southampton, N.Y., gift of the Estate of Fairfield Porter, 1980. Photo: David Preston. © Fairfield Porter Estate.

below:

Fairfield Porter, *Anne, Lizzie and Katie,* 1958, oil on canvas, 78" x 60". Sheldon Memorial Art Gallery and Sculpture Garden, University of Nebraska-Lincoln, NAA-Thomas C. Woods Memorial. © Fairfield Porter Estate.

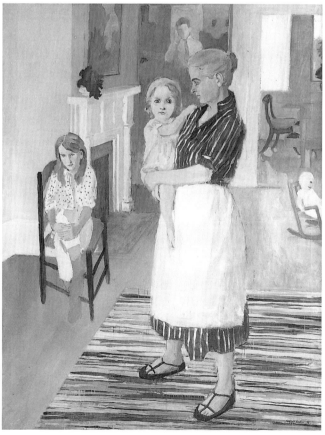

New York, when Tibor remarked that there were no pictures of me that year. I don't remember why. But it seemed a kind of estrangement.

Do you ever mind being put on show in a public way?

Well, I thought of it as a painting—as Fairfield would say, the model was an apple. Cezanne painted apples. So I didn't take it very personally. I was in a painting, but painting was the thing that was important.

Do you object to some of the ways that critics interpret the paintings?

I don't always like other people's theories. I mean, sometimes a critic will mistake Jimmy Schuyler for our son Johnny, picking up a hint of mental illness in the pose, and then make up a whole psychological interpretation about it. There's bound to be some of that.

Since 1975, you have helped John Spike and Justin Spring, and you've worked with Joan Ludman. What other projects have you put a lot of time into?

Sometimes a museum will ask for a loan of a painting, or someone will want a work authenticated. Some five or six years ago, at the request of Hirschl & Adler, I annotated many of the drawings. I recognize the places and can give an approximate date. Then there are always those papers that you sign, which I'm bad at and sometimes forget. Things like that. But not any major projects. The Parrish Art Museum asked me to be interviewed as part of a TV documentary. That's one of the things you do as an artist's wife.

Do you feel that you have lived up to your responsibilities as an advocate for Fairfield's work?

It's always possible to find things one should have done differently. Fairfield has become known, but I don't think I had much to do with it. I think it's because of the quality—not only his ability, but the passion he had for his work gives it a special vitality.

And, what gives you the most satisfaction as time goes by?

The fact that he's appreciated and, of course, the publication [in 1979] of his book of criticism that was edited by Rackstraw Downs. That's a wonderful book.

Your own volume of poetry, *An Altogether Different Language,* came out in 1994. Did you always feel you were going to be a poet?

I think that even when I was a little girl I assumed that was what I was. You know, like somebody is born to be a pig, or an owl, or an ostrich, or something. I just assumed that it would take care of itself, no matter what else I did. And it did, in a way. If I am too busy to write, it doesn't bother me a lot because I feel that some other day I'll have time again.

You never fretted about how your own career was going?

It wasn't a career. It was more like—I don't know—an identity, a calling. If you have a *career* as a poet, you have to go to dinners and get to know editors, and publishers, and stuff like that, which I'm not sure I wanted.

When you had a brood of small children, did you have long periods when you weren't writing?

Once, when my youngest, Lizzie, was a little girl, I was typing a poem. She came into the study and then backed out and said to her sister Katie, "Mom's writing poetry, and

she's as cross as a bear!" So it wasn't always the thing to do, but somehow I wrote anyway.

At times, Fairfield's letters suggest that your work might have had more public exposure. For instance, John Brooks Wheelwright asked you to read your poetry on his Boston radio program in the 1930s.

I didn't feel I was ready for that. It's very helpful not to be involved with a lot of publicity if you are trying to write. You have to listen to what you're thinking and feeling deep inside. I may be very wrong. Laziness is a factor! Other people handle that better.

Feminists could say that your own pursuits had to be put on hold because of your devotion to the children.

Those *were* my own pursuits! I ought to be a very good feminist because my parents would never have met if their mothers hadn't met in the suffragette movement. And one of my grandmothers had a degree from Cornell University. I think feminists are trying to make up for something that really was lop-sided, to correct an injustice. But I think the correction itself is lopsided if it doesn't assume that you can be happy giving time to your husband and children. Sometimes I think that people complaining that they have to wash dishes is a little silly. That's not the real problem, though often there is one.

It seems that you somehow managed to balance things.

I couldn't always balance things. But Fairfield believed that I was a worthwhile person. His mother was very strong, and he was used to a woman being somebody. I knew that he respected my poetry, even if I didn't have a whole lot of time to write. I chose to be an artist's wife, and I chose all that goes with it. More or less.

Was Fairfield supportive of you in other ways, too?

He couldn't be altogether supportive about our having children. And that was something I cared about a lot. You could say I was somewhat selfish about that. I think when the children grew up, he saw that they were very rewarding—as they were very intelligent

Lovers

I can still see
The new weather
Diamond-clear
That flowed down from Canada
That day
When the rain was over

I can still see
The main street two blocks long
The weedy edges of the wilderness
Around that sawmill town

And the towering shadows
Of a virgin forest
Along the log-filled river

We walked around
In a small traveling carnival
I can still hear
Its tinny music
And smell its dusty elephants
I can still feel your hand
Holding my hand
That day

When human, quarrelsome
But stronger
Than death or anger
A love began.

—ANNE PORTER*

and affectionate children. But fatherhood was scary to him because his own father was so aloof. That was hard for both of us. When it came to my poetry and my becoming a Catholic—though at times he teased me about it—he was respectful and even interested.

What strengths do you think you had that were most helpful in your relationship?

I know some things that didn't help! I'm a terrible housekeeper. But I did believe in him. I remember when Fairfield would say, "I'll never be a good painter." He had no recognition and, at the beginning, he didn't even paint all that well. He had a very limited teacher, Thomas Hart Benton. But I was sure that he was going to be a good painter, and I kept telling him that, thinking, I hope it's true, I hope I'm telling the truth. I had that hope, and that was good for him, though it was by no means everything. There was his own courage.

It seems that very often an artist's widow doesn't marry again. Is that because she is surrounded by her late husband's works, and his presence remains very strong?

Well, of course we inherit the paintings, so we have extra responsibility. If a lawyer dies, there isn't quite so much to do. But we have these material objects that are very significant, and we have to look after them. I never married again because it never occurred to me. There wasn't anybody quite like Fairfield! If he had been a truck driver, it would have been the same.

May 2001

UPDATE

The painter Ted Leigh, who was a student of Fairfield Porter's at Amherst College (M.A. 1970), is currently editing Porter's letters for publication.

FOR FURTHER INFORMATION

Downes, Rackstraw, ed. *Fairfield Porter: Art in Its Own Terms, Selected Criticism, 1935–1975.* New York: Taplinger Publishing Company, 1979.

Spike, John T. *Fairfield Porter: An American Classic.* New York: Harry N. Abrams, 1992.

Spring, Justin. *Fairfield Porter: A Life in Art.* New Haven: Yale University Press, 2000.

YVONNE HAGEN,
WIDOW OF
N. H. (TONY) STUBBING

I am a compulsive painter, a constant searcher and explorer of physical space rather than an intellectual space, as though I were swimming through Light.

—N. H. (Tony) Stubbing*

Newton Haydn (Tony) Stubbing, born on February 12, 1921, in London was tall and articulate, and had the wide-ranging interests of a naturalist. He was brought up in England, the son of Haydn and Betty (née Newton) Stubbing. Tony painted and sketched in his spare time during war service (1939–1946), and then attended night classes at Camberwell Art School in London. Eight months later, in 1947, he left his father's catering supply business and set off for Spain. Between 1948 and 1953, he held various jobs to support his painting, sculpture, pottery, poetry, and travels. From 1950 to 1957, he was married to Rosa Marie Garcia Diaz.

His distinctive hand painting, inspired by cave drawings and paintings, evolved between 1951 and 1954. Based in Paris from 1955 to 1958, and in New York on and off from 1958 to 1963, he developed and exhibited his hand paintings, one series of which was called "Rituals." In 1963, he married the dancer and choreographer Ana Ricarda, and moved to London. Unable to paint with his hands after 1968 because of worrying allergies, he turned once more to using paintbrushes. His light-suffused abstracted landscapes stem from this period. He died of lung cancer on October 6, 1983, shortly after his marriage to Yvonne Hagen, with whom he had lived since 1973.

Yvonne Hagen was born on August 14, 1920, in France, where her father, Wilbur Studley Forrest, was chief correspondent for the *New York Tribune*. The family moved to Washington, D.C., in 1930, then to Manhasset, New York, where he became executive editor for the *Tribune*. After high school, Yvonne attended the Art Students League and Columbia University Extension in New York City for several years before marrying, in 1940, Karl Victor Hagen. Hagen was an immigrant from a prominent German Jewish family, who served in the OSS (Office of Strategic Services) during World War II. In 1946, Yvonne and Karl, along with their two daughters, Nina and Karen, moved to Berlin. Karl was a civilian financial adviser to the American forces, and Yvonne researched German artists who had survived the war for art historian Robert Goldwater.

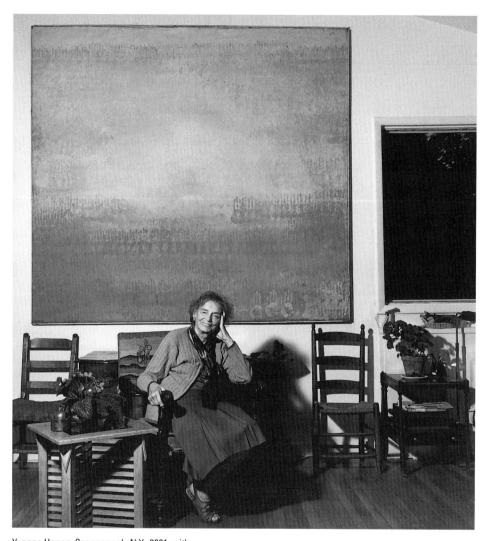

Yvonne Hagen, Sagaponack, N.Y., 2001, with
Sun Ceremonial, 1959, by N. H. (Tony) Stubbing.
© 2004 William Rivelli.

In 1948, Karl was killed when a military plane in which he was a passenger crashed into a mountain. Yvonne, after giving birth to their son, Tony, in Frankfurt, moved back to the United States to live with her parents. By 1950, she and the three children had moved to France. She began working for the *International Herald Tribune* in 1954, and she met Tony Stubbing for the first time the following year.

After returning to the United States in the early sixties, Yvonne worked as an art consultant for a number of galleries and helped to place artists' work. In 1967, she went to Munich, where for three-and-a-half years she served as curator of a new museum of con-

temporary art. She and Tony Stubbing renewed their relationship and, beginning in 1970, divided each year between Tony's house and studio in London and Yvonne's Long Island home. Tony, and Yvonne's son, Tony, improved the barn at her home and added a larger studio, which is now the Stubbing Archive.

I spoke to Yvonne Hagen both on the phone and at her small cluster of houses and workshops at the edge of the saltwater wetlands of Sagaponack, New York. We looked at Tony's paintings and, inevitably, discussed our common concerns: filing and storage systems, record keeping and conservation expenses. We also chatted about our hopes for future exhibitions of the work we cared for, compared notes about humidity and temperature control, and referred to our writing projects, which, not surprisingly, were rooted in those artists whose lives in some way now defined us.

.　　.　　.

As I mentioned, Yvonne, I'm asking people who look after artists' estates about their responsibilities.

Oh, I think you've been the best widow of an artist, Magda. But Nina Kandinsky is the queen of us all! It was too much. She wouldn't allow people to talk about anything except her husband.

Do you try to stop yourself from talking about Tony?

Well, I do try to control myself. But, if I'm with people and I think talking about him is a good idea, I do. Some people are not very receptive. Then I stop. Wouldn't you do that, too?

Yes, I know what you mean. Can you tell me what you have been doing since Tony's death in 1983?

Well, I wrote a twenty-eight-page monograph on Tony. I methodically traced the development of his work, his influences, and his relationship to what was going on around him. I included Sir Herbert Read's piece on him from 1965, and the 1985 essay on his Altamira period by the American art historian Robert Hobbs. I also referred to Alfred Barr, the director of MoMA, and his conversations with Tony in 1959. In a letter written later that year, Barr stated that Tony was the first contemporary artist who painted his canvases with his hands. Then, I brought in the two prominent impresarios in Paris, Julien Avard and Michel Tapié de Celeran, who had written about his work and included it in exhibitions of avant-garde art.

I also described Tony's background. He had a real, formal English upbringing, learning to ride, going to boarding school. But Tony was able and determined to get over the conventional landscape painting that his background implied, although he never lost a love of and feeling for nature.

That was a major undertaking, Yvonne. How long did you spend delving into the past?

It took about a year. I did it in bits and pieces. I sent it off to the Tate in London, which has three of Tony's paintings. They must have liked it, as some of the text was used for their biographical write-up about him. Finally, the Stubbing monograph was incorporated into

the catalogue for the 2000 retrospective of his work at England & Co. gallery in London. Actually, Jane England cut some of the personal material to make it seem more art-historical.

It must have been very satisfying to see it in print.

Of course, it's strange to spend so much time researching a dead partner's life. You want to suggest his inner life, but then there are all the facts to do with his travels and the anecdotes that personalize his biography. Tony had so many interests. After he had been through the whole war, he decided he wanted to be a painter. His parents didn't like the idea too much, as they wanted him to be a broker [laughter], or to go into his father's entrepreneurship. He had twenty-five cafés, and he supplied them with what they needed. Tony was so bored with it, but he survived by taking night courses at Camberwell Art School. Then in 1947, with the fifty pounds that you were allowed to take out of the country, he went off to Spain with his bicycle. He had connections in Madrid through his family, and he got a job as a copyist at the Prado Museum, gave English lessons, and worked as a night watchman for the British Embassy. He loved that. He made clay pots there, which he fired in their furnace. When he was young, he had enormous energy. I bet Jon was that way, too?

Yes, he was full of energy and optimism when I met him in 1970. Was that part of Tony's attraction to you?

Oh, yes. He was also mysteriously glamorous to me. And I was fascinated by what he was making. He was painting with his hands at that time and using his fingers, suggesting primitive rituals.

In 1955, I moved from the country into a big apartment in Paris—a gray, high-ceilinged, dusty kind of place. Joan Mitchell and Paul Jenkins, both American painters, told me, as we sat in a café, about an Englishman who was painting walls and doing carpentry in order to pay his rent and put on a show. Then he came to the door. And I thought, well? We got to know each other, and he also painted my apartment!

I was very young, a widow with small children. He was so jealous of them. It was impossible! He would want to see me on Sunday, and I would say, "Well, I'm taking the children to the Bois de Boulogne." He would come but then be critical of their demands on me, so we'd have a terrible argument. He'd make bitter statements about how women had all the money—sixty-five percent of the world's wealth—as widows, or through inheritances. And I'd say, "Isn't that wonderful!"

I've forgotten why you were in Paris?

I was writing an art column once a week for the *International Herald Tribune*. By the way, the first year I wasn't allowed to use my name, and I could only write two sentences for each show. The editor wanted me to review every show in town. It was great training in concentration and concision.

So it was partly because of the children that there was this gap in your relationship with Tony?

My youngest, also called Tony, was six in 1955, and Nina about ten, and Karen in

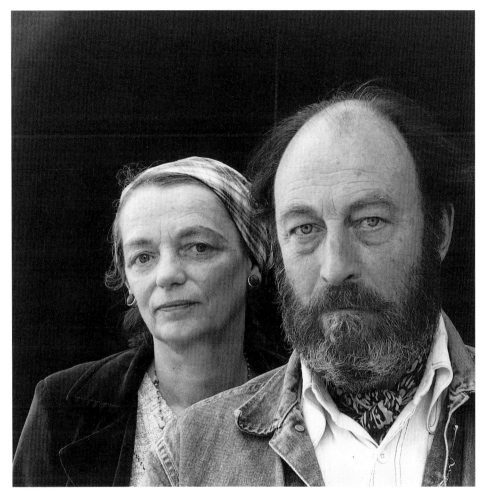

Yvonne Hagen and N. H. (Tony) Stubbing, 1971.
© Hans Namuth Estate.

between—demanding ages. For brief moments in between arguments, Tony and I played with the idea of staying together. But then there was Ana Ricarda, who was utterly impossible for him. In London, she asked him to paint her bathroom wall with pastoral scenes, and her bedroom too, which led to his staying overnight.

Of course, being old-fashioned and liking her, Tony thought it was unfair to live with her without marrying her. But he said he knew on his wedding day, in 1963, that he had done the wrong thing. Ana Ricarda was a little older than Tony. She was a professional ballet choreographer and dancer, of a very conventional sort, which the English love; so his mother was pleased with this, but he was soon miserable. She viewed all men as objects to choreograph. "Step over here, make cocktails for our company." He virtually played the role of decorator, house painter, and chauffeur.

Didn't Tony design costumes and sets for Ana Ricarda's ballets?

Yes, I am being somewhat unfair; that's true. Most of the drawings and designs Tony did for her ballets are in the collection of the Theatre Museum in London.

What happened to you during this time?

I went home to America in 1961. I was supposed to write about art for a couple of magazines— *Art Aujour'hui*, and a Norwegian art magazine, *Kusten Idag*—but it wasn't easy to get into New York to do it. And, as I had overspent when building the house out here at Sagaponack, I was in sort of a scrape. I didn't see Tony for about five years.

How did you make the relationship work only five years later?

It was longer than that. I saw him occasionally when he was in New York for an exhibition, or he would come out to the country to see me. I was trying to dismiss him from my life, as I had to bring the children up, and then he married. When I saw him again, in 1967 in London, on my way to Munich, I thought, "I can't interfere with his marriage," but then I realized that he was truly miserable. I thought, what a waste of talent. He often didn't have enough money to paint because when they traveled, Ana would stay in the most expensive hotels. She thought of him in terms of painting sales. It wasn't right. Finally, we did get together. And I'm so happy we did. I was never bored.

How did you adapt yourself to his life?

Well, I had a streak of adventurousness in my soul, which any woman who gets together with an artist has. We would mostly spend winters on Long Island and summers in London, in his studio, while my house was rented out. Tony painted in both places, and I did things for his career. You see, we were both in love with his art.

That's a lovely way of putting it!

And, weren't you with Jon's?

Yes, absolutely.

I did help him find galleries. You see, I started a thing in 1971 called New Art Liaison, which was supposed to put artists together with galleries sympathetic to their styles. I had good international connections in the art world, and I thought I could be of use to emerging artists. For a while it worked well, but I didn't know how to structure my fees, and some artists didn't have any money. Finally, Tony became dissatisfied that I wasn't working exclusively for him, and I quit. I continued as an art consultant, with most of my activity concentrated on his career, and I occasionally wrote freelance articles, which I still do. Tony and I lived happily together for thirteen years.

Can we backtrack to your earlier years in Germany?

I was in Munich from 1967 to 1971, working for their Modern Art Museum, which was backed by a group of publishers, bankers, architects, a prominent lawyer, a prince, and a well-known playboy. They planned to construct or renovate a building.

Meanwhile, I would visit various towns in Germany, finding out about new artists, visiting artists' studios, and the galleries that showed their work, and deciding on exhibitions for our temporary space. I had the art transported, wrote the essays, chose the repro-

ductions, selected the printer for the poster and catalogue, et cetera. I was ambitious and staged various events during the show. It was hard work, but I felt I was doing a positive job and functioning at full steam. Eventually, I realized that the committee would never come to an agreement. We lost some important funders, too.

I know that Tony has shown in Paris, Munich, London, and New York over the years; but could you remind me what the gallery situation was when he died?

A few months before we knew he was ill, he had had an exhibition in New York at the Maxwell Davidson Gallery, and one in San Francisco at the Paule Anglim Gallery. In England, the Jose Mugga Gallery, a small, new gallery run by a young Portuguese man, had shown him the previous fall. Mugga had a good eye, but then there was a revolution in Portugal, and Mugga's father wanted him to come back. So I lost that gallery. And I could never get Gimpel or any of those other galleries to take on Tony's work, although Arthur Tooth and Son, a prominent Brooke Street gallery, had included his work in several theme shows. Who took care of Jon's work in London?

He never had a dealer there, except in the seventies, when a gallery called House took on Jon, gave him a beautiful one-man show, and included his work in group exhibitions. Then, suddenly, two years later, the director, Jenny Stein, closed the gallery and moved on to other things.

Well, this happens a lot in London. Earlier, in l964, 1967, and 1968, Tony was included in group shows at the McRoberts and Tunnard gallery, also on Brooke Street. Unhappily, the following year McRoberts died in a horseback riding accident.

Is it hard for you to handle the paintings since Tony's death?

It's hard because keeping them in good shape is difficult for someone like myself, who is not very orderly! There are too many of them. I haven't totally finished his archives either. But I make struggling attempts all the time. I find that kind of work distressing. In the past, I relied on a secretary. But, even if I could afford a good one, familiarizing her with all the material is a career in itself. I have filed a lot of material, but then it gets mussed up constantly with somebody coming to see his work or looking through things. So it's an ongoing task. My son Tony, who is a cabinetmaker, has made a beautiful wall of drawers in different sizes for the drawings and small paintings, boxes, tools of all shapes, photographs, slides, postcards, catalogues, unfinished projects, and files. You know what? Louise Bourgeois is the cleverest woman in the world.

Why?

Because she has hired a very nice fellow, Jerry Gorovoy, to be with her half the day as a sort of man Friday. When anyone comes, Jerry is there. He knows where everything is. She does, too, most of the time, but he is quick, and he can help look after visitors and drive her around. She is now in her nineties and has earned an important place in the art world.

So, you don't have any secretarial help?

I've temporarily had people to help. Now I let the galleries take care of much of it, the Nabi Gallery here in Sag Harbor and the one in Britain.

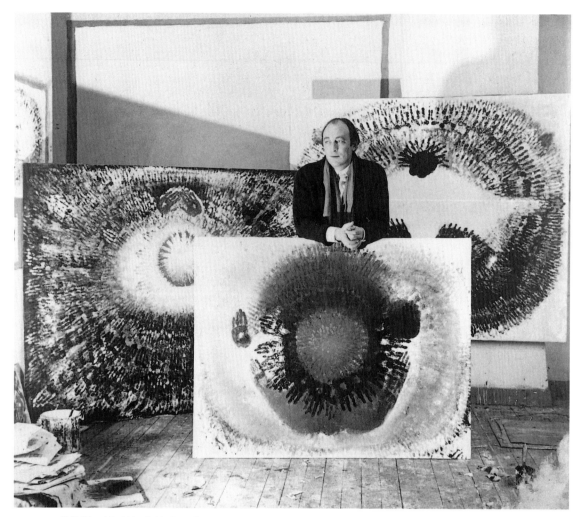

N. H. (Tony) Stubbing in his Paris Studio, c. 1960.
Courtesy Yvonne Hagen.

Two galleries represent Tony's work at the moment?

Yes. England and Co. in London is run by an Australian woman who has a remarkably active gallery where she shows current artists and rediscovers earlier ones. Jane England and I worked on the last exhibition together. She's good at it, so I don't mind her taking over. She has connections with the British Museum and the Tate. The Tate's first acquisition of Tony's work was *First Ritual "Christian"* (1958), which I donated in 1987. They then bought a larger one, *Coral Variations* (1954) in the early nineties, after hovering over it for some months. Having two galleries representing him helps a great deal and makes me feel more secure, and the Nabi Gallery plans to move into New York soon. Val and Min-Myn Schaffner are interested in Tony's later paintings, where he returned to using brushes following fifteen years of

only using his hands, while England & Co. in London shows the earlier ones exclusively. I want his work to be alive, circulating and outside the closet all the time, not in storage.

Tony used to have a gallery in San Francisco that I found for him—a very good one called the Paule Anglim Gallery—but she gave up handling Tony's work after he died because he didn't have enough work over here at the time. She gave me records of the paintings she had sold and returned all of the slides and printed matter. If she is going to put energy into making the paintings well known, she wants to know that there is a continuum. A lot of galleries feel that way. There are only about fifty big paintings, although lots of little ones, and I've got them pretty well organized in periods. Many are works on paper, and some are oils. How do you handle things?

I have some of Jon's paintings in storage in Edinburgh that the Ingleby Gallery draws upon, and the others are in the loft in New York, and at the ACA Galleries and Katharina Rich Perlow Gallery. Where do you have Tony's work?

Before he died, he was painting out here [Long Island] from fall to spring. When he made some money in Germany, at his exhibition in 1978, he designed and built a studio onto a small garage. I keep the paintings here. I have four little buildings. Jane has the others; she took back a lot rolled up and had them stretched in London. Some needed retouching, so she had a restorer do that. But she does it responsibly, so I feel comfortable. She also has quite a number of works on paper in her gallery.

What is your long-term goal, Yvonne?

I want to sell them and use the money to repair the ones that have been damaged. Initially, I wasn't very careful about all that, nor was Tony. He moved too often. I also need time and energy to show them to people. In other words, I want to keep his name to the fore. You did a good job by editing Jon's writings for *The Sound of Sleat*.*

Thank you. And have you got future plans to do more writing?

Yes. A while ago I began my own memoirs, which I've called *From Art to Life and Back*, but I'm not working very hard on them. I get distracted, and then I lost my brother recently. He was a big figure in my life and was always the person I'd call when I was feeling out of sorts and didn't know what to do.

Do you have other advisors, or a lawyer, to help you?

Oh, no. I'm bad about lawyers. I have to remake my will. I've got to get going.

Who has been the most helpful in giving you advice about the estate?

Jane [England] knows the commercial end of things well, and she's very good at keeping in touch. I'm not very good at prices. I just simply say, "They were sold last year for such and such, so perhaps now they should be a little more because of inflation." How do you price things?

The galleries like to increase the price so it looks as though there's movement. If Jeffrey at the ACA Galleries says we should put the prices up 10 percent for the next exhibition, then I usually take his advice.

That's more or less what I do.

When you redo your will, will you hand on the responsibility for Tony's work to your three children?

When Tony made his will, he decreed that I would be an executor along with my son Tony because the lawyer said we needed two generations. Nina, my oldest child, was in San Francisco at that time, so he chose Tony. I think he has to share the work with his sisters.

So, you are not going to set up a trust or a foundation?

I should, but I haven't yet. I have such a small income. I live a beautiful life on what would be considered poverty level here in the Hamptons. I like it that way. Isn't it wonderful to live nicely without having to take care of money and worry about stock markets and things? I'm a state department widow by my first husband. When I told them I wanted to marry Tony but that I couldn't afford to without their income, they replied that I could get married and continue having my pension when I reached the age of sixty. So, that's why we married very late—not until 1983.

That's wonderful!

I could keep my independence—although it isn't that much.

Yes, that's very important. Do you ever feel resentful about the responsibility of Tony's paintings?

Of course, one gets fed up sometimes. But, actually, I've organized it well enough so that I don't suffer too much about it. Min-Myn and Val Schaffner of the Nabi Gallery have been very admiring of Tony's work. They've bought paintings by Tony for themselves and have many reproductions and texts about him on their website. I just saw it today, and I was amazed. I do distribute the paintings, too. I've given each of my children a painting. Tony has one nephew who has many paintings that his mother and grandmother collected, and I gave him more. Do you loan yours out?

Occasionally, but I'm going to think twice about it. I loaned some paintings to the Port Washington Library last year, and unfortunately one of the paintings got damaged, probably in transit. Dealing with the claim by myself took over a year. It's wiser for me to work through the ACA Galleries, as it has an all-inclusive insurance policy.

Yes, that's what I do, and I think it's best.

When you and Tony were together, did you help him with a lot of everyday things to do with his paintings?

No, he did most things himself. But he could be self-destructive, and I had to do the soothing, diplomatic work for him with the galleries—with Paule Anglim especially. She didn't like some of their contretemps!

Yes, that seems to be the artist's companion's job! Otherwise, did he do his own letters, and so forth?

Yes, until he could find somebody at the gallery, or occasionally me, to do it. I did a bit, but I didn't do what Edie, George Rickey's wife, did—she did everything for him. He demanded it, and she did it! Tony wanted me to do it but, as I said, I'm not a very orderly person. So, without a secretary, I couldn't take care of the details. I could find galleries and

get people interested in him, but I couldn't do the writing and accounting very well, although I tried.

During the time you were together, did you miss not working for a publication or a museum?

I still had the family to think about, and I cooked and cleaned the house, more or less, or found somebody to clean it once a week. Then I went on walks with Tony because we both enjoyed being out in the country. We had people in for dinner. Tony was very good at cooking fish; he loved cooking, so we enjoyed doing that together.

And fishing. I liked fishing, although I never took it up as a constant thing, the way Tony did. He made the flies himself. And, when we were in Scotland every summer, he and James Stuart, a Scottish fishing friend, would start fishing at around 5:00 A.M. We went to the Findhorn Community* for five years. Tony was working on the two twelve-by-thirty-six-foot murals. At first, I did some upholstery for the community gathering center, and then after that I worked in the pottery building, where I did some little figurines. It was sort of an idealistic, spiritual crowd that did meditation and people cures. Findhorn was connected with the Lindisfarne Foundation in New York, which was in the deconsecrated church that became Limelight, the nightclub on Sixth Avenue. Starting in 1977, and for a number of years, Tony was a fellow at Lindisfarne, until it moved to Colorado. Have you heard of Findhorn or the Lindisfarne Foundation?

Jon and I went to Findhorn, especially to see Tony's paintings there. They looked very beautiful in the Universal Hall. Because of Tony's interest in Findhorn and its philosophy, did he have strong views about where he would like his paintings to be hung?

He liked having them in a spiritual setting, where the mundane was filtered away. In the galleries he stepped aside except for suggesting the best lighting, which he felt was crucially important. He preferred light flowing evenly over the canvas. He would sometimes take over, which was not always appreciated by the gallery.

What sort of qualities do you think it takes to live with an artist?

Quite apart from having human warmth and attractiveness [laughter], I think that the spouse must admire what her husband is doing and feel that it is something absolutely worthwhile. It isn't just a way to earn a living. Tony yearned for acceptance and perhaps even glory, and he could be jealous of those whom he considered undeserving. I used to tell him such emotions were a waste of time.

Since Tony's death, do you think handling his paintings gets between you and getting on with life?

Oh, no. I love gardening. I love my children, and all of their lives keep me entertained, concerned, and involved. I have seven grandchildren and one great-grandchild. Traveling with someone is the only thing I miss very much. Tony's little house and studio in Brendon Street in London had to be sold, and I find I miss him when I'm over there more than I do here.

October 2000

UPDATE

The Nabi Gallery moved from Sag Harbor to Chelsea in New York City in January 2004. The opening exhibition showed the work of N. H. (Tony) Stubbing and Elwood Howell, and a one-person show of Stubbing's work is planned for the fall of 2005. Its pure, clear-cut space, Yvonne reports, made a stunning background for Tony's paintings—well lit and glowing on the seventeen-foot-long walls.

FOR FURTHER INFORMATION

N. H. (Tony) Stubbing: Retrospective, exhibition catalogue, with an essay by Yvonne Hagen. London: England & Co., 2000.

HARRIET VICENTE, WIDOW OF ESTEBAN VICENTE

Harriet, his [Esteban Vicente] wife of forty years, as well as his caregiver, manager, and consigliore—the wife every artist, male and female, wishes he had one of.

—JULES FEIFFER*

Esteban Vicente was born on January 20, 1903, in Turégano, Spain, the third of six children. He spent his childhood and early maturity in Madrid, where his father was a building administrator at the Banco de España. He studied sculpture at the Academia de Bellas Artes de San Fernando from 1921 to1924, but soon turned to painting.

Vicente lived in Paris, London, Barcelona, and Ibiza (1929–1936) before leaving, with Estelle Charney, his wife since 1935, for New York, taking United States citizenship in 1940. Their six-year-old daughter, born with a heart defect, died in 1943, and the marriage ended that year. He then married Maria Teresa Babin, whom he divorced in 1961.

Vicente joined the avant-garde when, at the age of forty-seven, his work was included in the *Talent 1950* exhibition in New York. Henceforth, he was considered a member of the first generation New York School. Few paintings from previous periods survive because of the artist's dissatisfaction with his earlier landscapes and portraits, and his abstractions of the late 1940s. The paintings of the early fifties, with their interlocking shapes and proliferation of incident give way in the late fifties to larger rectangles of pure color, often arranged centrifugally. Over the succeeding years, with brushwork or spray gun, Vicente produced paintings and collages, in which floating forms or their traces emerge from the saturated glow of color, or from a delicate luminosity of layers of paint.

In 1961, he married Harriet Godfrey Peters and, in 1964, they purchased a house in Bridgehampton, New York. From that point on, they divided the year between the country and Manhattan. In both places Vicente worked by natural light. He was visiting artist at many institutions and was a founding member of the New York Studio School. Before his death at ninety-seven on January 10, 2001, the Spanish government honored him with a museum in Segovia, the Museo de Arte Contemporaneo Esteban Vicente.

Born on April 6, 1921, in the Crown Heights section of Brooklyn, New York, Harriet Godfrey was the eldest of the two daughters of Philip and Eva (neé Goell) Godfrey. Her father, until the Depression, ran the Gottfried Baking Company, which had been built

from scratch by his parents, Jewish immigrants from Middle Europe. At the age of nineteen, Harriet married Donald Peters, a union promoted by both families. She says of those times, "For twenty years, I had the usual life of a New York housewife, mother, and semisocialite of the middle class." Their daughter, Alison, was born in 1942. The family lived in Brooklyn until 1946, when they moved to East 66th Street in Manhattan. They traveled regularly to Europe. In the early fifties, Harriet began visiting galleries and later, with her husband, began collecting contemporary work. They met artists such as William Baziotes, Barnett Newman, Mark Rothko, and Robert Motherwell.

Harriet met Esteban Vicente in 1958 and married him in 1961. Harriet remained an avid traveler, sometimes accompanied by her husband. Both of them received the Spanish Gran Crux de la Orden Civil de Alfonso X el Sabio in 1999 for their contributions to art. Since 1974 and the death of her daughter Alison, who suffered from schizophrenia, Harriet has supported medical research as well as cultural activities.

Ten months after Esteban Vicente died, I visited Harriet Vicente in the Hotel des Artistes in New York. We sat in her twenty-five-foot-high living room, surrounded by Esteban's paintings, which are also hung in the adjoining studio and other rooms. Upstairs are the administrative offices and the Esteban Vicente archives.

. . — .

Can we discuss the ways in which you were involved in Esteban's career?

I did everything but paint. For instance, when a studio wasn't suitably located, I simply got him another one. When he was too old and 42nd Street was too far for him, I bought the apartment right next to us [in 1996], and it worked out just marvelously. He didn't have to go out any longer. I also took care of all the money matters. He once said to me, "I guess you have all the money?" I said, "Well, don't worry about it. It's all yours; but yes, I do have all your money." One day he remarked, "I guess I have some money in the stock market; you know I don't like the stock market." I said, "Who likes the stock market? Yeah, you've got a little money in the stock market."

What was his early life in Spain like?

Esteban, as a young artist in Madrid, was friendly with a group of poets—some, like Garcia Lorca and Jorge Guillén, later became very famous. It was called the Generation of 1927. So, when he was about twenty-three and he had his first show in Spain at the Ateneo de Madrid, those were his pals. There were no painters whom he cared to be with. The painting was still Victorian traditionalism. No one had ever seen a Cézanne; no one had ever seen anything, and whoever was of any interest was in Paris by then. The following year, he said to his father, "I'm going to Paris: I have to learn." His father said, "You're going to suffer some more." He went to Paris, wearing his one suit, and met all the Spaniards there, including Picasso. He had visited the Prado Museum previously, but it has tremendous gaps. In Paris, he started to flower.

In what way?

It loosened the hold of Spain on him. He'd been utterly formed in the Spanish way, and he never rejected his formation. He remained austere and whatever it is that Spaniards are. They're very, very proud, and they're strict, and they love their families, and they love to laugh and dance. But he rejected any form of religion that is oppressive. He believed in pure religion, which has nothing to do with organized religion and people in positions of authority. He was not a Communist; he was an anarchist, which means having no affiliations.

Did you become an anarchist?

No. Now that I'm a widow and don't have him here to listen to, I remember some of the things he said and realize that I learned a hell of a lot, and I now articulate those things. I was growing to be a

Harriet and Esteban Vicente with Renate Motherwell (left), at the Century Association, October 1997. Courtesy Esteban Vicente Archives.

whole person, but I never allowed that to happen when he was alive because he was so fascinating that I preferred to put my energies into him. But he gave back. Now, as an eighty-year-old person, I feel I'm growing every day, not just dealing with memories but also figuring things out that he said that puzzled me at the time. So, aren't I lucky?

Yes, indeed. Could you talk about Esteban's relationship with Spain that led to the opening of his museum in 1998, the Museo de Arte Contemporaneo Esteban Vicente in Segovia?

Since Franco died, Esteban has had many retrospectives and shows there, and this wonderful dealer in Madrid [Elvira González] began handling his work. He had a street named after him in his hometown of Turégano [1991], and a big festival, and God knows what. Then one day we got a phone call from some people in Segovia. A delegation arrived and wanted to know if we would cooperate in forming a museum for Esteban in his home state—a small royal palace would be transformed into a museum. I spoke to Esteban, and he said, "What do you mean, museum? Sure, if they want to give me a museum, why not?" But he said he didn't want to talk any more about it. I went ahead and said yes. We agreed to certain terms. I didn't push too hard or get the answer to every question. I just had faith in those people. And my lawyer figured out how it could be used in a positive way financially for us. All the major decisions about the museum were made by the town council of Segovia and other groups. It was all political, as is true in all of Europe. When Esteban went to see it and had some suggestions, they were prepared to redesign some things that weren't right. He finally fell in love with his museum; he really did.

The first year the museum opened [April 28, 1998] was the year the Guggenheim in Bilbao opened. Nevertheless, Esteban's museum got the first award in architecture for the most creative use of museum space. It's very beautiful, and half of his work is on display

at all times. The other half of the space is used for temporary exhibitions. For instance, now there's a Dalí show because he was a classmate of Esteban's at art school; in the months before, there was a show of wooden sculptures that included work by Juan Gris and Picasso. In January, there will be a show of Esteban's toys. It's a living, growing museum, and it has a wonderful auditorium where concerts and other events are held. Esteban's first memorial was there. When Esteban had a show in Segovia right after Franco's death, they did everything but throw apples at him. The people were utterly provincial and anti-art. But they're not anymore. Obviously, Franco's been dead for a long time, and now they're very open, very receptive.

Did you donate the collages and paintings by Esteban?

We gave 150 pieces, among the very best pieces, and all in very good condition. Now I'm sending his library to them, whatever books he read, from Faulkner to Unamuno to Jesus Christ. He read interchangeably in three languages, French, Spanish, and English. And he read all the classics. I don't remember him reading a modern novel.

Do you speak Spanish?

Not really.

How do you manage?

I always have an interpreter if I'm doing a speech, et cetera. I'll never learn it properly. So I kiss, and I hug, and I show my appreciation. I always have to be very well dressed in Spain. None of these baggy outfits left over from Bridgehampton!

Do you mind being the interpreter for Esteban now that he has died?

I only do it when I want to and I trust the people I'm speaking to. I'm not trying to do a public relations exercise, but I think it's good to have a record from the artist's wife. I think that artist's wives are not very understood—not necessarily misunderstood, but their opinion is hardly ever asked.

Remember when Elizabeth Frank, at the Southampton memorial that was held at the Parrish Museum [November 17, 2001], said something like "Goddamn it, ask the artist's wife, not the critics" for insights on the artist's life!

Nothing has ever been written about artists' wives unless they knew how to make the money, or how to be greedy, or how to be a pain in the neck.

When our husbands die, we suddenly step forward in a rather different way.

I think we step forward because in many instances we have been prepared by these wonderful people to comprehend what they stand for.

It sounds as though you were also skilled in business matters?

I had to be a businesswoman because, when I married Esteban, all of my money had vanished for reasons that I won't go into. And we had to have money. I was a rich girl; I had to have money. So I learned how and, beginning with a little money, through people whom I trusted and with professional advice, I did very well. Esteban always made enough money to pay for his studio, his canvases, his paints, and a couple of suits now and then in London—made to measure, I may add! I made money to pay for everything else.

Esteban and Harriet in Bridgehampton, N.Y., 1980s.
Photo: Rita K. Katz. Courtesy Esteban Vicente Archives.

Esteban always taught. He adored teaching—he really did—and he was very good. He was a founder and faculty member of the New York Studio School in 1964, and he taught there for thirty-six years. He also taught at Yale one semester, and in Hawaii. Then he was at Princeton as artist-in-residence, but he quit—going back after a few years, when they gave him a better studio. Esteban didn't drive, but I started again after I met him so that he could take these out-of-town jobs and have summers in Bridgehampton.

I never made a sale. Well, there was just one. Someone, whom Esteban liked very much, came to this house wanting a drawing. "Let him have a drawing," Esteban said. Then, when this person was leaving, he asked if there were any collages. I said, "Yes, but they're not for sale; they're mine." He said, "Let me see them," and I showed him some. He said, "Oh, I like this one. How much is this?" I said, "It's not for sale." He said, "If it were, how much would it be?" As a joke, I said twenty-five thousand dollars, which in those days was astronomical. He said, "Okay," and he wrote out the check. I couldn't renege. I made that sale, but I was very, very upset. I never sold anything else. I gave his paintings away, but I didn't make sales.

But didn't you help with all the business arrangements at the gallery?

Of course. But I was not a genius at handling the money at the galleries, believe me.

I don't like to do it; it's not my job. I mean, Esteban had a very bad experience at the Gruenebaum Gallery. That guy made himself bankrupt in the eighties, owing Esteban the first big money he had made since 1950. Everything was all right with André [Emmerich] because André is a very decent man, and we had a very good relationship with him. He couldn't sell the work, but that's a different story.

Did Esteban always have a gallery?

He always had a gallery, but not always a suitable one, considering he's such a significant artist. It was great when he was with Leo Castelli. That's how we met. Castelli was one of his best friends.

That was a second marriage for both of you?

We were both married at that moment. It was one of those great things, and that's why I had to learn to make money.

What is there to do now?

There is a body of work—in all media—that I own. There is a catalogue raisonné to be made. That's a long, costly job. There is a museum in Segovia to be nurtured. I just helped them to do a website. They only have three major people working in that museum. In the beginning, all of the signs and information were done in Spanish. I insisted that they do everything in English as well. That costs money, you know. I'm very anxious to bring a group of Americans there because it seems crazy to have this museum in Spain, and no one has seen it.

What are the ways of getting the word out?

I think the Internet is one. Participating in shared shows is another possibility. But it's very complicated to send things back and forth over the ocean. I think that, slowly, people will write on Esteban. There are books being written in Spain that will be translated. Barbara Rose wrote a fabulous introduction to his first retrospective at the Reina Sophia, Madrid, in 1998. I'm really very interested now in having the work put into museums. He's in practically every museum in America, but in the basement! If I say that to any artist or artist's wife, she understands what I mean. That is a political thing. So, just as his reputation in Spain has grown since Franco's death, I think his reputation here will grow.

When we talked last week, you said you were quite drained by the memorials for Esteban?

I was. The memorial at the Parrish Museum was the fourth organized by others for him. The week before, the American Academy of Arts and Letters had a memorial gathering for the six members who died during the year, and Esteban was one of them. There were two citations, one by Jules Feiffer, which is just a gem, and the other one written by Chuck Close, who was a student of his at Yale. Very loving, wonderful. Kurt Vonnegut, who read them, said, "You know, I never met Esteban Vicente. After reading these tributes, I'm so sorry that I didn't." It was very moving. Then there was one this week, and I had had it, you know. I just didn't want to think about it. This year I've also been having all of these operations—I've had one open-heart surgery and six other procedures. Every day I have

estate matters to deal with, as there are many shows going on now. I'm having a good time, but I get tired.

Yes, and the more exhibitions there are, the more time the administration of the estate requires.

Well, I don't think of giving my life over to it. I am not subservient to Esteban and have never been. Instinctively, people recognize that I'm Harriet Vicente; I'm not Harriet Vicente, wife of Esteban Vicente. There would be nothing wrong with that; I just don't happen to be perceived in that way. Anyone who knows me knows that I didn't run his painting life. Thank God. I liked his work; I loved his work; I love his work.

Do you think that any of us could live with artists if we didn't?

I don't see how. It's not easy. If you ask me, Magda, what was difficult about living with him, I truly couldn't answer you. But at a certain moment, every day, there was always some difficult thing. And I just think if you want that life, and if you want to be successful as the wife of an artist, you either tone down potential aggravations or you are more careful about timing. I think you learn a hell of a lot about how to be with someone in a loving way and get your own way. Through their way, you get your own. He was the conductor.

But, Magda, I went on a trip every year without him—either with a group or with friends. And he encouraged me. I have letters, and always he would say, "I hope that you are seeing the things that interest you, and I miss you all the time." I'm not going to say he let me go on the trips; there was never an argument. That helped make me very independent. He went with me the first time I went to India. My daughter had just died [1974], and I was in very bad shape. He was so wonderful because he couldn't stand India. Women's libbers may have great contempt for the artist's wife, who really can be conceived of as sort of a schleppy person who just goes along with the artist. But they don't know.

You feel that you had a rich, full life?

Oh, and how. A very rich, full life. Yes, yes. And it's possible to have a rich, full life with a person in the money business, but I have seldom seen that. Even with artists and their wives who are notoriously incompatible—there's a certain thing between them that I find really terrific.

What is that?

It's an indication that they're both on the same crazy wavelength. I think that artists are a little nutty, and I think their wives are a little nutty.

Could you tell me more about the Harriet G. & Esteban Vicente Charitable Trust?

About fifteen years ago I sold my little Miró, and I started the trust with it. Esteban didn't really know what that was all about. He said, "If you want to, do it." It was nothing big, but it got started and then got bigger. I did my medical research funding with it after my daughter died, when she was thirty-four. I'm on the board of this group called NARSAD [National Alliance for Research on Schizophrenia and Depression] that backs research.

Esteban Vicente in his studio, c. 1968.
Courtesy Esteban Vicente Archives.

I'm very interested in a young researcher who is now at Rockefeller University. I gave the first grant to her when she was just a novice doing amazing work in the genetic field on the cause of schizophrenia and depression. Esteban did these things with me. He also believed in backing the Arabs and the Jews together. I think we both were a little off base on that because I don't think we really understood that that wasn't possible.

Could you go over what you were doing in Jerusalem?

About twenty-five years ago my daughter was crazy about the Palestinians. I didn't know if she was saying that just to annoy me! When she died, Esteban and I went to Israel, and we helped create the first playground in an Arab village where there were also Sephardic Jews. The playground was in East Talpiot, Jerusalem, but it turned out that the children never played there together. Now we have a project through the Jerusalem Foundation to fund programs for predelinquent Arab girls. Without this help, their future is prostitution.

Are the paintings part of the charitable trust?

Some are. I don't know how many. Anyhow, I made up my mind I'm never going to give figures, and I tell all artists' wives, don't mention how many, how few, what period, how much.

Why not, Harriet?

The future can sometimes depend on which are available, which are not, which you have a lot of, and which you don't. Those are business secrets.

But, when the catalogue raisonné comes out?

By then, I imagine some of the work will be sold. I'm going to keep a certain number of paintings for myself, but a larger amount is going into a foundation. Believe me, I have enough paintings to last me for a couple of lifetimes. Then I will see what I'm going to sell and what the foundation will. That's a very technical decision sometimes. It depends on what the tax laws are. My ambition is not to accumulate more Vicente paintings, but I bought one a few months ago. I just couldn't believe I had ever sold that beautiful painting.

Is there any specific advice you would give to other widows running estates?

Many of them make very big mistakes in the beginning because they are rather paranoid and fear that people are going to do them in. They become very secretive and not as trusting as they might be. Now maybe they're right; maybe most of the people you get to help you are crooks—the accountants, the lawyers—but I haven't had that experience. I've had my lawyer for forty years and my accountant for thirty-five, and they're terrific. Often women who run their husbands' estates are very timid, but it's their obligation to get the information. I have told artists' wives what to do after they have asked, and they absolutely disregard it and do some crazy thing or say how they've been done in. They've done themselves in. I find there's a pattern, that artists' wives are not as informed as they should be about the technical aspects of an estate. It's too late after the artist is dead. Relations of artists tend to completely overestimate the value of an estate. One said to me, well, so-and-so told my brother the estate is worth millions. I said, "It's not worth millions; it's worth thousands of pennies." She did all the wrong things.

Like what?

She used the wrong people. She threw out things from the studio because they were dirty. That man will never be heard of again. He's a perfectly wonderful artist, but he was never on the road to being really well known. He was an artist's artist. Of course, it costs money to look after an artist's estate properly. You have to have a very good record of everything, slides, et cetera. I was told that if I hadn't had the archival work in such good shape, it would have been very difficult for Ameringer & Yohe Fine Art to take on Esteban.

Steve Schlesinger, who handles Fritz Bultman's work, said that he depended upon Jeanne to be very organized.

I've had Ellen Russotto, the archivist, for twenty-five years. In the beginning, a couple of hours a week, and now she's four full days a week and has two assistants.

I think artists' wives should have an association. They should educate themselves about different methods of preserving and keeping the work, et cetera. They should think about what will happen when they die. Is there a child who will take over? If there is no one who can, what then? In my own case, what the devil am I going to do with the foun-

dation when I'm dead? It does require a little planning although, I'll tell you, you have to be very fluid in your planning because a good plan can turn out to be a lemon.

Do you think that we could be accused of myth-making?

I think some people could be accused of myth-making. I'm not making up any myths. I don't know about you.

I'm not sure if we can help it because if we're asked to talk about our late husbands . . .

Well, of course that's the problem about being asked to talk—you say too much. You say things that they want to hear because they're used to reading *People* magazine. And that is not what I want to do. I hold my husband with great respect, and I know he never demeaned himself in that way. After all, let's face it, Esteban was one of the most charismatic and handsome artists of his generation. He could have gotten very far on that simple thing if he had chosen to, but he never did. The way Esteban was is the way I want him to be presented. I don't want any myth of what I think. I don't want to tell any kind of story that will be misinterpreted. I don't want people to have too intimate a glimpse of our life. A little, but not much. I don't want any of that ever to be more important than a single painting.

I was fascinated by the slides Emily Goldstein showed at the Parrish Museum memorial gathering—of the garden and the inside of your house with some of the toys Esteban made. Was that getting too much into your personal life?

I think there's a very strong connection between Esteban's late work and the garden. I know it nurtured him when he was really an invalid. Going back to my house in the country when it's winter and the garden isn't blooming is very difficult for me now.

But you said in your talk that, despite not having a green thumb, you would keep up the garden because of him?

I can't let it go. It has me in its clutches. I mean, the paintings have me in their clutches, too, but you can't pull the paintings out all the time and look at them. When I'm in the country, the minute I first open my eyes, I look out of the window and down on the garden.

How do you feel about the connection between art and money?

I don't really have anything to say about that. I really have worked very hard the last forty years to make a life, and taking care of the paintings was part of making a life. I'm very grateful that Esteban did what he wanted to do because he always said that if the artist devotes too much time to the outside and what other people want, the work suffers. He really felt that not being better known pushed him on to do better work.

I sat next to someone after the memorial at the Parrish Museum in Southampton recently, and he said, "Do you remember me? I came to your house in the country and Esteban said, 'Who are you?' I said, 'I would like to buy a painting.' He looked at me, and he said, 'Artists are supposed to paint, and dealers are supposed to sell. Good afternoon.'" And that's the way it was. There was no selling from our place.

It sounds as though, from what you've said, that Esteban never discussed the future and what he wanted done with his paintings?

Nothing. He said several times in the last months, "Oh, poor Harriet, you'll have to take care of all those paintings. What will you do?" I said, "Don't worry about that." But he had no idea of what had to be done to maintain this little establishment that he's the core of.

Can you avoid thinking of this responsibility as a chore?

Of course I don't think of it as a chore—or at least not generally. We are very lucky because we have something that carries on. The paintings carry on, and so does our work—our job, if you want to call it that.

Is "work" a better word than "business"?

Business is incidental. However, if a painting sells, it's because there's business involved. If there's no business and no sales, there's no reputation. The three things go

Esteban Vicente Museum, Segovia, Spain, with installation of Vicente paintings, 2003. Courtesy Museo de Arte Contemporaneo Esteban Vicente.

together. The prices have to get big. It's unfortunate, but that's the way it goes. You can't really separate the three things—money, fame, and business.

November 2001

UPDATE, DECEMBER 2003

In 2002, the Harriet G. & Esteban Vicente Charitable Trust became the Harriet & Esteban Vicente Foundation. All of the paintings by Esteban Vicente are now in this foundation. The foundation funds medical research and human-service organizations of interest to both Vicentes, along with providing for the ongoing conservation, publications, and the archival and curatorial requirements of Esteban Vicente's work. The close relationship with the Museo de Arte Contemporaneo Esteban Vicente in Segovia, Spain, for its preservation and expansion, continues. An annual fellowship that will allow a Spanish artist in mid-career to live at the artists' community of Yaddo in Saratoga Springs, New York, is being set up, and there are plans to enable an American student to spend time in Spain. In February 2004, Harriet Vicente agreed to be interviewed weekly by Elizabeth Frank, who is preparing material for a memoir.

FOR FURTHER INFORMATION

Frank, Elizabeth. *Esteban Vicente*. Chronology and appendices by Ellen Russotto. New York: Hudson Hills Press, 1995.

PHYLLIS DIEBENKORN, WIDOW OF RICHARD DIEBENKORN

[Richard Diebenkorn] was drawn to the practice of art against parental advice, and for him success was not to be measured by property, physical comfort, or financial security, but by the freedom to spend his days in the studio, working to find transcendence within a tradition that he was attempting to understand, validate, and reinvigorate.

—GERALD NORDLAND*

Richard Diebenkorn, only child of Richard Clifford Diebenkorn, a sales executive, and Dorothy Stephens, was born on April 22, 1922, in Portland, Oregon, and grew up in San Francisco. He attended Stanford University from 1940 to 1943, married Phyllis Gilman in 1943, and served in the Marine Corps through 1945.

Early in 1946, on the GI Bill, Diebenkorn entered the California School of Fine Arts in San Francisco (CSFA). In the spring of 1947, he began teaching at the CSFA but, in late 1949, he decided to move the family to Albuquerque, New Mexico, where he gained an M.F.A. in 1951 from the University of New Mexico. His abstract paintings were becoming newly energized by directional brushstrokes, expansive forms, and bright colors. After teaching in Urbana, Illinois, for the academic year and spending a summer in New York (1953), he returned to California, the family's home state. He taught at the California College of Arts and Crafts from 1955 to 1959, and then at the CSFA until 1963. Toward the end of 1955, he turned to a gestural realism, which he explored for some twelve years, becoming known, along with David Park and Elmer Bischoff, as a member of the Bay Area Figurative School.

In 1966, the Diebenkorns moved to Los Angeles, where Richard had been offered a professorship at the University of California, which he kept until retiring in 1973. Here, in 1967, Diebenkorn turned once again to nonreferential painting. Vertical and diagonal elements provide an abstract scaffold for nuanced areas of color—often pink, gray, green, and yellow. His studio was in the Ocean Park area—hence the title of 140 of his paintings from 1967 to 1989. In 1988, the Diebenkorns settled in Healdsburg, California. The following year, he underwent aortic valve replacement, which was repeated a year later. He died on March 30, 1993, at the age of seventy.

Phyllis Gilman, the only child of Harold and Nellie (née Gleason) Gilman, was born on September 2, 1921, in Los Angeles. Her father, a prominent lawyer, died during the Depression, when she was eight, and her mother, through necessity, found a job as a receptionist in a doctor's office. Phyllis married Richard Diebenkorn in 1943 when they were both students at Stanford University, and accompanied him during most of his military service within the United States. Their children, Gretchen and Christopher, were born in 1945 and 1947.

While in Albuquerque, she completed her degree (1952), with a major in psychology. She pursued graduate studies at the University of California at Berkeley from 1954 to 1960, as well as part-time teaching, and then worked as a research assistant. From 1956 to 1961, she worked on a program at the Institute of Personality Assessment, Berkeley, studying creativity, and she taught for one year at San Francisco State University. She was a frequent model for her husband during his figurative period (1955 to 1966) and assumed responsibility for the practical side of their life together. Art commentator Dan Hofstadter remarks, "She was diplomatic, tactful, understanding, and I had the feeling that it was largely she who kept the Diebenkorn family chugging forward."*

In February 2000, my "widow's work" brought me to California, where I attended the opening of Jon Schueler's retrospective at the Wiegand Gallery in Belmont.* I had contacted Phyllis Diebenkorn and Adelie Bischoff, hoping to interview them about how, as

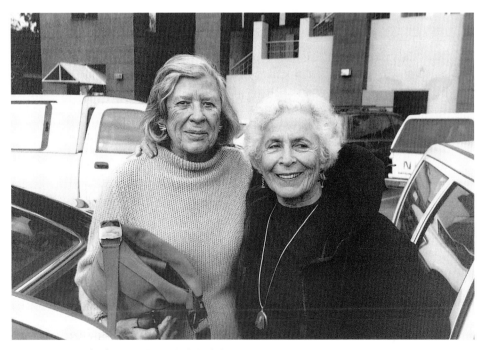

Phyllis Diebenkorn (left) and Adelie Bischoff, Berkeley, CA, February 2000. Photo: Magda Salvesen.

more experienced artists' widows, they were managing their husbands' estates. I had met neither of them previously, but their husbands' names came up frequently in Jon's discussions of the California School of Fine Arts. He had taken courses with both artists (1949–1951) and, in the summer of 1953, the Diebenkorns had rented his studio at 68 East 12th Street in New York City. Because Mrs. Diebenkorn preferred that I not record our conversation, I have summarized her remarks on that day, as well as during a later phone conversation.

· · ·

Phyllis Diebenkorn's words are consistently characterized by discretion, modesty, and an insistence on the limitations of her own efforts. Others, however, whether scholars or friends, speak unhesitatingly about the immensity of her task and the talent and energy she has brought to whatever demands have been made of her. In their catalogues and books, scholars have acknowledged her deep involvement and the inspiration she has given them. In her preface to the 1997 Whitney catalogue, Jane Livingston writes, "Phyllis has given wise and honest counsel and has helped locate and evaluate hundreds of works that I considered for inclusion here. All of [the family] have not only assisted unsparingly in my research, but have lent a significant number of works to the exhibition, many never seen before publicly. It would have been impossible to attempt the project without them."*

When Mrs. Diebenkorn married, she understood that she would share her husband's priorities, and she unreservedly accepted this condition. They had met when they were both students at Stanford University. She knew that he had wanted to be an artist since he was ten years old, and that he had pursued that course despite his parents' initial disapproval. "It would be life without a ceiling, without a limit," she says. "In those days, no one expected to sell paintings. The artist's life was pretty exciting."

As she speaks, she seems to recover the thrill of those earlier times, the feeling that "there isn't anyone else that this could happen with." Whether recalling the peripatetic nature of their lives during the early years of their marriage—from California and New York City to Albuquerque and Illinois, and then back home—or the long hours of uninterrupted seclusion in the studio that Dick's painting required, she shows no evidence of struggle or regret. It was all interesting, she reiterates, and adds: "I was blessed, as he only worked while there was sunlight. Except on drawing nights, he would always be home for dinner."*

Undoubtedly, the family's life totally revolved around the artist's work. Mrs. Diebenkorn alludes to the dining room at the center of their railroad flat in Berkeley (1953–1954), which Dick took over as a studio. Since he was not teaching that year and was at home most of the time, the family had to go down and around to get from one end of the apartment to the other. And, later, when the studio was situated in the backyard (1956–1958), one only knocked if there were an emergency. Feeling that she could only

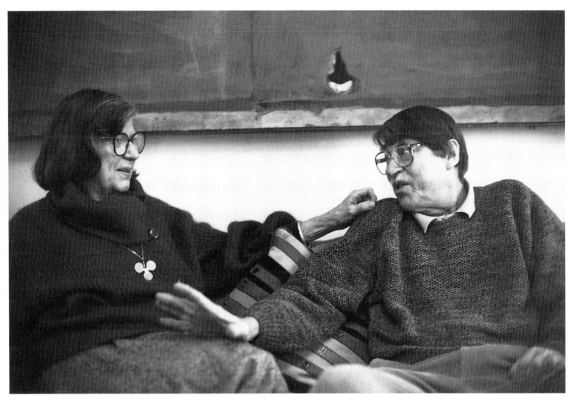

Phyllis and Richard Diebenkorn, Healdsburg, CA,
December 1992. © Sidney B. Felsen, Los Angeles, 1992.
Courtesy Sidney B. Felsen.

disturb him if something happened to his mother, Mrs. Diebenkorn also remembers that she had to shield her husband from outside telephone calls. "I had a hard time saying he wasn't there when he was right beside me making signs to say he was out. We fought about that a bit."

Other memories of her husband followed: his wonderful speaking voice, and his marvelous sense of humor (which few knew about); the way he thought a long time before writing anything down; the inordinate amount of time he gave to composing recommendations for his students; the evenings spent reading and listening to classical music, which he loved and knew a lot about; and the movies he enjoyed going to. Recalling the late forties, when Dick taught at the California School of Fine Arts in San Francisco, Mrs. Diebenkorn remarked that, as he was never much of a partygoer and did not like to dance, they weren't often at the hops there. "Dick wasn't nearly as gregarious as Jon [Schueler]," she said, and, unlike his friend Elmer Bischoff, and Jon, wasn't in the Studio 13 Jazz Band. He took up the trombone for a short time, "but was so bad that he gave it up." He didn't often go to exhibition openings, except for those of his friends.

Mrs. Diebenkorn herself speaks of merely responding to situations as they arise, both in earlier times and now, remarking, "I just muddle through," and she makes light of her contributions. Similarly, she minimizes the intense effort it must have taken to pursue a graduate degree when she had young children. She simply says, "Well, I was young! I don't know how well I did either of them. It was interesting and fun." Only later does she recall that during the six years she spent as a graduate student at Berkeley, she also worked as a research and teaching assistant, which led to further jobs in psychology. When she gave up her career in 1963, she seemingly accepted the change with the same equanimity.

By the time they moved to Los Angeles in 1966, life was easier. "We were fortunate by that time. Dick taught at UCLA, but not for very long. His work was selling, so we didn't need to worry about how we were going to pay next month's rent. I didn't work at all down there." They were able to travel, although only once did they go off simply for a relaxing vacation.* "Dick didn't want to waste the time! Artists don't ever turn off. Every second." Their travels, therefore, were linked to museum going. "Dick would say, 'I want to go to the Prado' or 'I want to go to the Louvre,' and that would be a focus of the trip." Although she admits that originally she had not had the same interests as her husband, she emphasizes that she was more than pleased to adopt them. "I loved it that way."

Recalling the days when she posed for the artist, she emphasizes the spontaneity of these moments: "I just was home doing stuff, and he would say, 'Hold it!' And I would. I posed for him all the time after he started doing figurative work—any old time of the day or night." Sometimes more planning was involved, but unlike the professional models, she did not go into the studio. As always, Mrs. Diebenkorn underplays her own importance: "That's how it happened. I was available. I was there." When I mentioned the wonderful hat she is wearing in *Seated Figure with Hat*, 1967, her response reflected the same casual attitude: "It was just what I happened to be wearing." She also remarked that, although he did draw formal portraits of both children—which she still has—he otherwise didn't call upon them to pose.

Mrs. Diebenkorn speaks with understanding of her husband's tolerance of chaos and his refusal to let anyone touch or clean his studio. Instinctively, he knew where everything was, although "he had no filing system, and I didn't either, so we were a swell pair!" She took care of all practical matters, from house insurance to income tax. "Dick never paid a bill, never knew anything about money." She didn't type, however, and he wrote all his own letters and copies in longhand and took care of all arrangements for exhibitions.

In the late eighties, Richard Diebenkorn's severe medical problems began. "We did the trust together. He was already sick, but not on his deathbed. He didn't want to think about it but wanted it to be done. We had a lawyer come to the house." According to the will, his entire estate was left to Mrs. Diebenkorn in trust, and afterwards would pass to their children. "I have total responsibility for the paintings," she comments. In addition, she has begun a trust for her grandchildren, thus following Dick's desire that both his wife

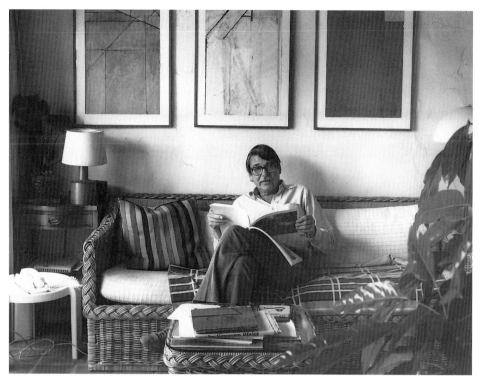

Richard Diebenkorn, Santa Monica, CA, 1984.
© Leo Holub. Courtesy Leo Holub.

and children would be taken care of for another generation. Asked whether she was think-
ing of setting up a foundation for the paintings, she replies, "No. My goal is to leave as lit-
tle as possible, as the children don't want to spend their lives doing 'Daddy's work.'"

Nonetheless, the family has helped her greatly. Her daughter Gretchen has worked on
the archives, and her son-in-law, Richard Grant, has also played a major role. His firm had
worked out the programs for documenting and digitizing the collections of the Getty and
the Smithsonian, and in 1997 he started doing similar work for the Diebenkorn inven-
tory. Mrs. Diebenkorn had been compiling it, along with Linda Birke, from 1985–1986,
until the onset of Richard's illness. Now, Grant is in charge of the team working on the
catalogue raisonné. Three young women help with the computer tasks, and Jane Liv-
ingston is authenticating work and doing the writing. Originally conceived when Mrs.
Diebenkorn was with the Acquavella Gallery, the project was put on hold when she left
the gallery (which had been funding it). Now it is being sponsored by the San Francisco
Fine Arts Museums, and interested parties may contribute in return for a tax deduction.
The University of California Press will publish the Richard Diebenkorn catalogue raisonné
in 2007–2008.

Behind Mrs. Diebenkorn's decision to take matters, at times, into her own hands lay

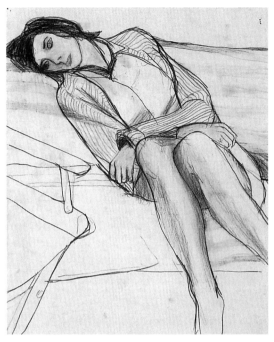

Richard Diebenkorn, *Untitled* (drawing of Phyllis Diebenkorn),
charcoal on paper, 17" x 14", RD 928.
Courtesy Phyllis Diebenkorn.

her frustration at relying on lawyers and deal-ers, whose knowledge and advice she found insufficient, and who "treated the paintings like money." Whether it was a matter of resisting the pressure of a gallery to sell to a private person rather than placing Dieben-korns in museums, or trying to deflect its insistence on choosing ornate frames rather than the plain stripping her husband favored, Mrs. Diebenkorn felt that her own values were at odds with these professionals. She increasingly resented the attitude epitomized by the words of one such representative: "Don't you worry your pretty little head about anything. I'll take care of everything." As for the lawyers, although they were effi-cient in other matters, they were simply not interested, when she tried to designate par-ticular paintings for her two children, in personalizing the endeavor. "The children choose on the basis of their memories and individual responses rather than according to paper worth," she explained.

Undoubtedly, Mrs. Diebenkorn had also been strongly affected by the Rothko scan-dal at the Marlborough gallery. Beginning in 1970, the gallery had brought her husband strong representation in New York and London but, in 1975, uncomfortable with the gallery's involvement with the Rothko estate, Richard moved to M. Knoedler & Company. In this context, one understands Mrs. Diebenkorn's loyalty to the gallery dealer who, she believes, warrants her trust. Like her husband, who said, "I only want one dealer," she has given, whenever possible, a total exclusive to Lawrence Rubin. Diebenkorn had started with him in 1976 at Knoedler. When Rubin left to open a gallery in Zurich in 1995, Mrs. Diebenkorn, too, left Knoedler. Although Rubin then represented her husband's work in Europe, she had no American gallery. This led to the decision to join Acquavella Contem-porary Art—where she remained for only two years. When Rubin returned to New York in 1999 as a partner of Lawrence Rubin–Greenberg Van Doren Fine Art, Mrs. Diebenkorn once again arranged a total exclusive with him. "He's my friend. I like him. Perhaps not the smartest move, but I don't care." Although Rubin is in his early seventies and lives out-side of Milan, he comes to New York City two or three times a year and remains the rep-resentative of the estate, orchestrating museum shows and organizing gallery exhibitions at Artemis Greenberg Van Doren in New York and at John Berggruen in San Francisco.

Because Dick did not keep back paintings, the estate does not have an even represen-tation. "I've finished with them now. Let them go," he'd say. But, finally, she told him, "I want one painting out of every show." Recent gallery exhibitions such as *Richard Diebenkorn: Early Abstractions 1949–1955*; *Richard Diebenkorn: Figurative Drawings, Gouaches and Oil Paintings*; and *Richard Diebenkorn: Figurative Works on Paper*** have explored periods less well known than the *Ocean Park* series. As Jane Livingston explains in the catalogue of this last show, "For reasons more accidental than deliberate, certain of Diebenkorn's drawings have remained out of circulation, possibly unseen by even the artist's closest dealers, curators, and friends. . . . Long before his death and, until recently, they were carefully stored in drawers, not got-ten round to . . . simply because others were more to hand."* Mrs. Diebenkorn also speaks of "a lovely show at the Legion of Honor of the 1980s *Clubs and Spades* series done from their own holdings. I didn't have anything to do with it except I lent them three works on paper."* In 2005, there will be a show of his Albuquerque works (1950–1952).

The sense of loyalty that the artist felt and Mrs. Diebenkorn now feels toward gallery representation extends to institutions with which Dick was affiliated as well as to local museums. Mrs. Diebenkorn, following her husband's wishes, has donated a painting to Stanford University, and she has also endowed a Richard Diebenkorn Fellowship for teaching at the Art Institute of San Francisco which, earlier known as the California School of Fine Arts, had supported him when "he was very young and inexperienced." In this way she hopes that his name will remain present there. In addition, she has carried out the artist's wishes to donate two works to the Phillips Collection in Washington, D.C.

As for the artist's archives, which are kept in the little guesthouse on the property in Healdsburg, Mrs. Diebenkorn says that they will remain in place as long as the catalogue raisonné is in process. Although the Archives of American Art have been requesting them for thirty-five years, she is pleased that her husband postponed this transaction because they are an invaluable resource for this project. Having shared Richard Diebenkorn's life for fifty years, Mrs. Diebenkorn is in a position to interpret and provide the context for these records. "The widow is the memory."

February 2000 and December 2003

FOR FURTHER INFORMATION

Elderfield, John. *The Drawings of Richard Diebenkorn*. New York: Museum of Modern Art; Houston: Houston Fine Art Press, 1988.

Nordland, Gerald. *Richard Diebenkorn*. New York: Rizzoli, 1987; revised 2001.

The Art of Richard Diebenkorn. Essays by Jane Livingston, Ruth Fine, and John Elderfield. New York: Whitney Museum of American Art; Berkeley: University of California Press, 1997.

THREE

THE UNCERTAIN DIVIDE:
Artist/Wife/Widow

As we have seen in the previous section, the widow assumes a necessarily divided role. At times, she occupies the place of the artist, attesting to and perpetuating his vision and integrity, and duplicating the care and attention he gave to his art. On other occasions, she must take on the role of the promoter and seller, becoming an intermediary between the artist and the museum or collector. She does not have the luxury of the artist, who might, like Esteban Vicente, proclaim, "Artists are supposed to paint, and dealers are supposed to sell," and blithely send away a potential client who shows up at his door.

Such divisions are compounded when the wife is herself an artist, as Adelie Landis Bischoff emphasizes at a public lecture when she finds herself speaking "in the dual position of two painters." This double role inevitably leads to further complications and contradictions with respect to the artist-widow's identity. Often temperamentally more suited to the privacy of the studio, she now finds herself immersed in the many tedious details and promotional activities that become the backbone of the widow's work. The women in this chapter offer us striking examples of how such divisions work themselves out when wives who are artists become widows.

Adelie Bischoff recounts how, like Phyllis Diebenkorn, she hardly dared disturb her husband in his studio—even when a fire was raging nearby—while her own painting was continually disturbed by the demands of the household and child-raising. "He was very much the painter. I was the wife," she says matter-of-factly. Bischoff's willingness to let Elmer's career take precedence over her own, and her love and admiration for her husband as both a painter and a teacher, continually inform her words. Nonetheless, she refused to give up her own priorities completely, and she is obviously pleased with the way her own work has blossomed after his death.

Charlotte Park similarly assumed that James Brooks's work was the more important and took up the tasks of shopping, laundry, and paying bills without question. She expresses no resentment or competitiveness, and we don't even feel the tension generated by the fight for time that Bischoff mentions. Emphasizing her husband's gentleness and the mutual support and encouragement they offered each other, Park insists that her belief in her husband's work made her participation in his career a pleasure rather than a burden. Having broken her artistic rhythm for seven years, due both to his need for her during his last years and to her own inability to return to work after his

death, she now finds that advancing age and tasks related to his career interfere with her desire to paint.

Although Regina Cherry's husband was known for being opinionated and difficult, this widow never doubts his integrity as a person or a painter and expresses the same sense of belief in the work as Charlotte Park does. Having married Herman when he was already sixty-seven and she around thirty, Regina Cherry had no illusions that her own career as a painter would be anything but secondary, and she still feels that she can't concentrate on her own work until she has found a gallery for his. Although she regrets the time lost from her studio, she is thoroughly committed to enlarging his reputation by bringing attention to the totality of his work. Speaking of the need to restore some kind of balance to her fractured life, she concedes that her widow's work—inventory, photography, gallery negotiations, exhibitions—is simply an extension of what she was already doing, and then rather wistfully reminds herself, "I'm supposed to be a painter."

May Stevens is akin to the other women in this section in voicing her antipathy toward promoting either the work of her husband or herself; but there the similarity ends, for this staunch feminist and political activist never even considered sacrificing her own career for her husband's. "I would have been miserable," she unabashedly tells us. Luckily, her husband, Rudolf Baranik, felt unthreatened by either this attitude or her fame, and himself became a vocal proponent of both her art and her cause. They taught, shared an enthusiasm for political activism, argued ardently about ideas, and divided responsibilities at home. After his death, she did everything that, as she puts it, "Rudolf would have done for me": having the estate photographed and assessed and bringing the two exhibitions already underway to fruition. Her talks and writings on her husband and his art—her own style echoing his ability to make "words perform with elegance"—offer a moving vision of the artist-activist-teacher for whom there was no difference between art and the deepest moral and political concerns.

Despite certain tensions more or less evident in these couples' relationships, they are all defined by what Adelie Bischoff calls "a deep respect for each other's commitment to art as well as a love for what art could give." She describes this element as the "cement of our lives, the glue between us, and that never left at any time." In each case, this seems to be the crucial aspect of the legacy that these women will pass on.

D.C.

ADELIE LANDIS BISCHOFF, WIDOW OF ELMER BISCHOFF

Elmer Bischoff, born on July 9, 1916, grew up in Berkeley, California, where he received both a B.A. (1938) and an M.A. (1939) from the University of California. His father, a successful, self-made building contractor, of German immigrant parents, was bitterly disappointed when Elmer switched from the architectural program to one of the most progressive art departments in the country. After the war years (1941–1945), when he served in Air Force intelligence, Bischoff almost always supported his painting and his families by teaching, first in high school and later at the California School of Fine Arts, San Francisco (1945–1952 and 1956–1963), and the University of California at Berkeley (1963–1985), where he became a tenured professor. In 1936, while still a student, he secretly married Jean Corse (now Tickle). After their divorce in 1951, he lived with Pat Baskett (now Beer) for six years. He had four children from the first relationship and one from the second. In 1962, he married his former student Adelie Landis.

Bischoff's early abstractions (1937–1941) reflect his interest in the School of Paris, particularly Picasso. After the war, excited by the work of Roberto Matta and others, he turned toward a fluid, indeterminate form of surrealism. This period morphs into the energetic abstractions of 1948–1952, with their broad, flattened forms and gestural, calligraphic marks, influenced perhaps by the jazz improvisations he played on his trumpet. In 1952, he explored a form of representation without obvious narrative intent and became, with David Park and Richard Diebenkorn, one of the main Bay Area Figurative painters. In 1972, Bischoff reverted to a form of abstraction, leaving a hundred and twenty paintings (in acrylic) that often depict parts of recognizable items among abstract forms floating in a layered but shallow space. Bischoff died of cancer on March 2, 1991, at the age of seventy-four.

Adelie Landis Bischoff, born in Brooklyn on February 12, 1926, was the younger child of Eva (née Paris) and Alexander Landis, an insurance agent who lost his job in the Depression and began selling and repairing cars. Although she was admitted to Brooklyn College, her father's illness and financial circumstances necessitated her working as a file clerk. She then entered Mount Sinai Nursing School (1944–1947), and afterwards specialized in psychiatric nursing at McLean Hospital, Cambridge, Massachusetts, from 1947 to 1948. She began working at the Psychiatric Institute of Columbia Presbyterian Hospital, New York but, feeling that "this wasn't my identity," she began night classes at the Art

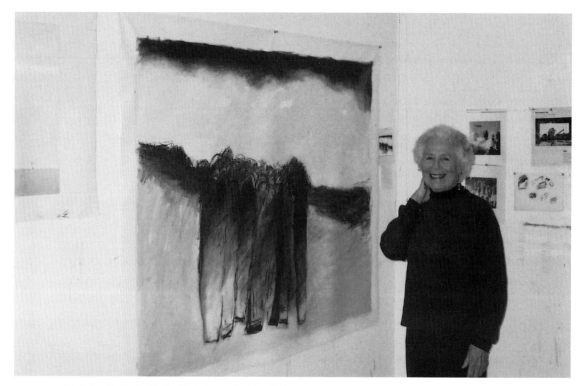

Adelie Landis Bischoff in her Berkeley studio, May 2004.
Photo: June Fetter. Courtesy Adelie Landis Bischoff.

Students League and found her vocation. After two and a half years, she left New York for the California School of Fine Arts, where she studied with Elmer Bischoff for six months. In 1955, she transferred to the University of California in Berkeley, where she obtained a B.A. in art practice and painting (1958) and an M.A. in painting (1959). In 1962, she married Elmer Bischoff, and they adopted three-day-old Mark in 1971. She has exhibited her paintings in the Bay Area and, recently, in New York.

My first meeting with Adelie Landis Bischoff took place in 2000 in a restaurant in Berkeley, California, where I had lunch with her and Mrs. Diebenkorn. The summary that follows is drawn from my interview on that day and a lecture that she gave at the New York Studio School on March 12, 2002. Between the two events, the monograph *Elmer Bischoff: The Ethics of Paint* was published (2001) and the accompanying exhibition had opened at the Oakland Museum of Art. In the spring of 2002, Mrs. Bischoff had her first New York solo exhibition at the Salander-O'Reilly Galleries. Now it was her turn.

. . .

This is a maiden voyage, so be patient. But you can ask as many questions as you choose to ask, and I'll decide whether I answer them or not! I'm not here as a critic,

nor an art historian, nor a colleague (of Elmer's, that is). I'm here in the dual posi-
tion of two painters, Bischoff and Landis, involved in the complex relationship of
husband and wife.

With these words, Adelie Landis Bischoff begins her lecture. Her stature small behind
the lectern—the reading light illuminating her soft, wavy gray hair and her warm smile—
she at times turns gleeful as she purposefully sets limits on how much to divulge. Aware
of the twist in circumstances—the artist's widow now speaking as an artist—she shows
slides first of her own and then of her late husband's paintings.

Again and again, however, Adelie reveals how her own career was inextricably inter-
twined with Elmer's. She recalls how she was his student for six months in 1951 at the
California School of Fine Arts. "He was the greatest teacher I ever had. He didn't preach
but seemed to understand each student's direction very quickly." Bischoff and most of the
other artists teaching at the school were doing huge, abstract expressionist paintings,
while her own, she admits, were perhaps less muscular: "I never got into the drip and
blob. I think it took more nerve than I had at the time."

She met Elmer again in 1957, and their friendship grew into a relationship that led
to marriage in 1962. Adelie was drawn to Elmer's work, which had by now left abstrac-
tion behind. "I tried essentially to emulate the figurative paintings of Elmer. I liked them
enormously." She also speaks of her love for "the quiet, luminous light and feeling of sus-
pended time" in Vermeer, and then goes on to voice reservations about her own figure
paintings, landscapes, and interiors: "I don't think I ever got where I wanted to."

By the 1980s, her path sharply diverged from her husband's. Whereas he returned to
abstraction in 1972, she was driven by social concerns. Her shoe series, paintings of bare
feet in high heels, and the *Beautiful People* series—"the people who don't have to worry
about upkeep"—emerged from the outrage Adelie felt when she saw an ad in the *New York
Times* for a pair of shoes costing four hundred dollars. "I wanted to make some kind of
comment. I don't think I ever succeeded. . . . I didn't have enough cartoon quality that
made biting, figurative painting, but I tried."

Her lecture then turns to the most dramatic event of her widowed life, the terrible
October 1991 Oakland-Berkeley fire, and we are given a glimpse of how, only seven
months after Elmer's death, both her role as an artist's widow and her life as an artist were
dramatically transformed. "Everything was destroyed. I barely got out with my life. I saved
some drawings of Elmer's that happened to be in view. I went around the house choos-
ing—saying yes, no, yes, no—to the drawings and paintings on the wall. As I was leaving
the house, I took one last look and said to myself, "Leave it. Just leave it." Then I drove away.
Her words take an unexpected turn: "It was a kind of epiphany. I felt a surge of freedom
to just leave it, to walk out and leave everything."

Nevertheless, the loss was irredeemable. Much of Adelie's own work was destroyed,
and some 2,000 drawings of Elmer's were burned, as were slides, photographs, and

records—along with boxes of letters, notebooks, and his dream diaries. The consequences, as Susan Landauer remarks in the preface (p. xvi) of her book on Elmer Bischoff, were far-reaching: "Without these materials, I have had to reconstruct his life and ideas through extensive interviews with surviving family, friends, and colleagues." Luckily, the majority of Elmer's oils and acrylics in the estate survived. They were in storage.*

The effects of the fire were undoubtedly explored in Adelie's *Running Series*, which was begun as she started putting her life together and organizing the rebuilding of the house, although the context of these paintings is both larger and more intimate. "I guess it had something to do with the fire and my leaving, and Bosnia was going on at the time, war issues in the newspapers." Later, she wryly adds, the painting *Legs* (circa 1993) contained "a personal reference, but I'm not going to tell you what!" Then calamity struck again; while Adelie was on a site visit to the new house in 1994, she took a nasty fall, which prevented her from walking for a number of weeks. Work on the series was interrupted. Misfortune proved to be a source of artistic inspiration, however: "I started the pen and ink drawings. I don't know where they came from. I'm still doing them. . . . For the first time I was working from imagination. It was a great source of freedom. I have a couple of hundred of these, and I still do them."

The note of reticence and dissatisfaction that characterizes her attitude toward her early work completely disappears as she describes the new direction her work took in 1999, after another epiphany in the studio. "I suddenly wanted to revisit Goya's black paintings in the Prado, so I did. I went for two weeks and was immersed in Goya." She looked at both his paintings and etchings in various museums. When a Spanish printmaker gently questioned her involvement, declaring, "That was another time, Adelie: we're in new times now with new tools," her reply was, "Okay, but say I try for his intensity and specificity?" This goal, she explains, was behind her new charcoal and pastel work—the subject of her 2002 exhibition—with their velvety blacks and the suggestion of looming forms. Unquestionably, she is pleased with the result. "It's been a fertile period during the last few years. I'm drawn to the quirky, dark side, and that's why I'm drawn not only to the skill of Goya, but to the darkness. And the contemporary artists who mean a great deal to me are Francis Bacon and Anselm Kiefer. They are not exactly lighthearted spirits!"

The appeal of darkness to Adelie Landis Bischoff dates from her early figurative paintings, when she was especially drawn to Édouard Manet's work. "I was attracted to his use of black," she tells us, and singles out *The Execution of Maximilian* (1867) as having made a deep impression on her. Her words connect to other remarks she made about her husband's dark paintings of the early seventies, and set up provocative questions about the relation of the two artists' work. She tells us that she has "always had an affinity for these paintings," but she underlines that they had brought Bischoff to an impasse: "He was immersed in listening to Wagner during that period and reading German legends. The paintings became heavy, dark, more subjective. Nowhere to go." This sense that he had

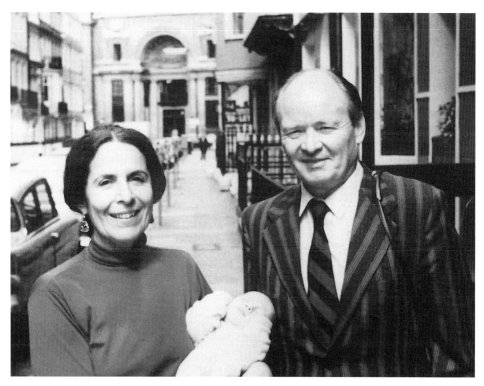

Elmer and Adelie Bischoff with Mark (two months old)
in London, 1971. Photo: Allan Landis. Courtesy Adelie
Landis Bischoff.

reached a "dead end" in fact became the driving force that impelled him toward abstraction again. In 1972, "he said it was as if he didn't want to go to church anymore, but went off to the gym instead." This shift allowed him to express the humorous rather than the oppressive part of his personality, as he took up everything from Krazy Kat to Arabic script to Egyptian hieroglyphics. "He reinvented himself," she marvels, obviously impressed by his enormous energy and imaginative capacity, although she herself is unwilling to interpret any of his disparate styles. "There's a tendency [in the 1960s] to have lone boats and figures not relating to each other . . . people make all kinds of psychological implications, but I'm not going to get into that."

She is willing, however, to evoke the man himself, the painter and husband whom she so admires, and to discuss honestly some of the difficulties that evolved in this marriage of two artists. Without any hesitancy she states, "Elmer was a great painter and a great person. He was an introspective kind of guy but did very well in communicating with people, especially one on one. He had a marvelous sense of humor and was a man of great integrity and gentleness, and he knew exactly what he wanted." At the same time, she freely admits his prejudices when it comes to women painters, recalling the traditional

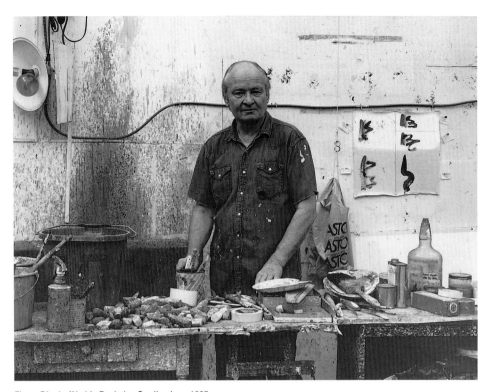

Elmer Bischoff in his Berkeley Studio, June 1985.
Photo: M. Lee Fatherree. Courtesy Adelie Landis
Bischoff.

male attitude that dominated when he was with friends: "Oh, she's really good. She paints just like a man." That this was not easy for Adelie is apparent—"I never said anything, but it all had an effect, one way or another"—and in part explains their "mutually sensed need to keep our work separate." She did occasionally visit his studio (their young son coming along as well), and she would comment on his work, as "that arena was more open than he making comments on mine." Recognizing that her principal role was that of wife rather than artist, she calmly says, "I just bided my time. He was very much the painter. I was the wife. I painted, yes. But it wasn't the primary focus in our lives that his painting was. The major conflict was fighting for time. We were able to work it out one way or another—in between the quarrels, I may say!"

Comprehending her husband's needs—that he was a man of routine and demanded that "his time was primary, whether painting or reading"—she nevertheless admits that adopting a child was of paramount importance to her. This would become "a source of conflict" and, despite the fact that Elmer was "warm and loving" and would read stories to their adopted child, she was the one left to bring him up, "for better or worse." She seems also to have acted as liaison between the five children from Elmer's previous rela-

tionships and their father. Yet, Elmer did not leave all the domestic chores to her. They shared the housework, she organized the household, and he paid the gas and electric bills and did the income tax and all the typing. In fact, the bookkeeper whom Adelie hired for a few days after Elmer died, commented, "If you were audited tomorrow, you would have no trouble," since everything was filed and in order, and studio and business expenses were all recorded in a booklet.

There was no question, however, that when Elmer was in the studio, he was not to be disturbed. Adelie affectionately recounts how she even hesitated to call him when the first fire was raging in circa 1970. The habit was so ingrained that "you don't dare interrupt," she tells us, even when it is 9:30 a.m., you hear the fire engines, and the neighbors are calling." Finally, apologetic but worried about her mother (who was living with them after suffering a stroke), she called, "Sorry to interrupt. Maybe you should think about coming home."*

When asked if she fully shared Elmer's priorities, she replied, "I did, in my own way, but only partly." Nevertheless, her deep respect for her husband and their shared values prevail: "I have to say in defense of Elmer, and in defense of myself—two people who had serious commitments to art—that it was another time. It's very different now for younger people. We talked a lot about art, and we had a deep respect for each other's commitment to art, as well as a love for what art could give. It was the cement of our lives, the glue between us, and that never left at any time."

During the question period at the New York Studio School, a member of the audience asked Adelie how she felt about painting after Elmer died, adding, "I think your work got a lot better. The last works really feel like *your* poetry." Adelie replied, "I do, too. I guess there was a certain release from some kind of pressure."

The mention of pressure reminded me of what Adelie Landis Bischoff and Phyllis Diebenkorn had told me in 2000. The last years of life for both of their husbands had been taken up by illness and hospital visits, surgery, and medical errors. Adelie, like Phyllis Diebenkorn, was grateful that there had been enough time to put their legal affairs in order, as previously "Elmer had never discussed a will. He wouldn't face it until after he was sick. Luckily, there was a window of time after his surgery." He specified that nine selected paintings be sold, the proceeds to go to his six children. The remaining paintings went to Adelie as part of a living trust, and a residual trust held other assets.

Left to handle the estate, Adelie did have the help of her late husband's San Francisco dealer John Berggruen, who was anxious to formalize his position under the new circumstances. Adelie, her attorney, and a longtime stockbroker friend met with Berggruen and his attorney. A new contract was formed, giving the gallery an exclusive for the Bay area. It left Adelie the freedom to make her own arrangements in New York, which she visits at least twice a year, and elsewhere.*

Like Phyllis Diebenkorn, Adelie Landis Bischoff recognizes that galleries often have different priorities from the estate, a sale to a private collector being more important than

working with museums. Although she says, "I don't have a long-range plan," she is holding some works back. She also would like to see more attention given to "the later abstractions [1972–1989] which, unfortunately, have received only nodding acknowledgement. Most of the attention has been given to the figurative works." However, she admits, "I really haven't moved very fast on these estate matters, as I'm trying to get on with my own work."

Adelie Landis Bischoff leaves one with the impression of a perceptive woman who was able to negotiate the deep pleasures and the stresses of a marriage of painters by discerning which battles were worth fighting. Her account of the circumstances surrounding Elmer's proposal gives us added insight into the way these two strong-minded people were able to work out their abiding relationship. In 1961, Elmer was to go east to spend the summer at the Skowhegan School of Painting and Sculpture in Maine. Since they had been together for some four years, Adelie assumed that she was going with him and gave notice that she was leaving her part-time job. This was met with some hemming and hawing and the comment, "It won't look good, not being married." Finally, he announced that he was going alone. Feeling very wounded, Adelie packed up all his belongings and left them outside her door. He could live in his studio for a month before leaving for Maine.

From Maine, Elmer kept writing and telephoning. At the end of the summer, he showed up at Adelie's apartment and moved in as though everything was back to normal. Adelie thought, "When I'm ready, it will end." Months went by. One day, out of the blue, Elmer asked Adelie if she would support him in the event that he lost his job, so that he could continue to paint. "I thought, whoa! If I say no, we won't be married. If I say yes, we will get married." She replied, "Why not both?" meaning she would support him if he would support her. He said, "Just say yes or no," to which she responded, "I'm sorry, no, I won't." Elmer burst out laughing. "That's the answer I want." Two days later, he proposed.

For Further Information
Landauer, Susan. *Elmer Bischoff: The Ethics of Paint*. Berkeley and Los Angeles: University of California Press, 2001.

CHARLOTTE PARK,
WIDOW OF
JAMES BROOKS

I think my whole tendency has been away from a fast-moving line either violent or lyrical into something that is slower and denser or more wandering and unknowing.
—JAMES BROOKS*

James Brooks was born on October 18, 1906, in St. Louis, Missouri, the son of William Rodolphus Brooks and Abigail Franklin Williamson. Because his father was a traveling salesman, the family moved often until settling in Dallas in 1916. Brooks studied at Southern Methodist University in Dallas from 1923 to 1925. Arriving in New York City the following year, he attended the Art Students League from 1927 to 1930. He supported himself by lettering, a skill he had learned previously. During the early thirties, he took long road trips every summer to the west and southwest, painting and drawing in the prevailing social realist style.

He was married to Mary MacDonald from 1938 to 1942 and, during that time, worked on the mural "Flight" for the Works Progress Administration (WPA) at La Guardia Airport. From 1942 to 1945, he served in the United States Army, based in Cairo as an art correspondent. Two years later he married Charlotte Park, and they lived in New York City, spending summers in Montauk, Long Island (after 1949), until a hurricane destroyed their studio in 1954. They bought land in Springs, New York, in 1956, gradually spending more time in the country, while keeping a small apartment in New York. By 1948, Brooks's interest in synthetic cubism had evolved into a lyrical abstraction of stains, drips, and interpenetrating platelets of color. During the following decades, the color forms grew larger and more monumental, but a delicacy of gesture and a concern with both slow and fast rhythms remained. Brooks died on March 9, 1992, at the age of eighty-five.

Charlotte Park was born on August 13, 1918, in Concord, Massachusetts, the daughter of banker George Coolidge Park, Sr., who died earlier that year of pneumonia at age thirty-two. Her mother, (Harriet) Maybel (née Hawkes) married Harold Shepard in 1925, and Charlotte and her older brother, George, moved with them to Oregon, where their stepfather worked for the Forestry Service. Charlotte graduated from Yale School of Fine Arts in 1939, and then worked for the Office of Strategic Services (OSS) in Washington, D.C., during the war. In 1945, she moved to New York City, where she taught children,

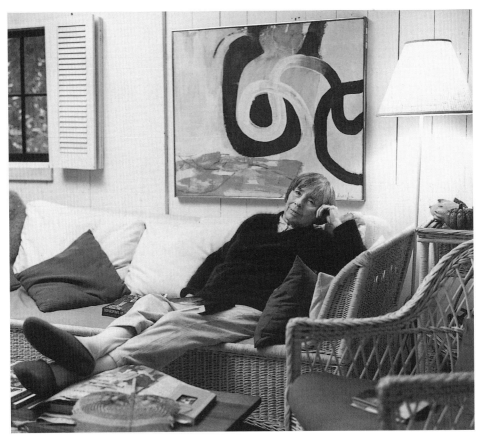

Charlotte Park, Springs, N.Y., 2001, with *Untitled 6,* 1966,
by James Brooks. © 2004 William Rivelli.

first in private schools and, beginning in 1955, at the Museum of Modern Art. Like her
husband, James Brooks, she was caught up in the excitement of the burgeoning abstract
expressionist movement in New York in the late forties. She continued to explore abstrac-
tion with a rich, lighter palette and clearer, stronger vertical and horizontal forms imbued
with a delicacy all her own.

Sitting with Charlotte Park on the porch of her one-story wooden house in Springs,
New York, I could just make out the studios of husband and wife beyond the grass clear-
ing, where the woods began. My last visit to the house had been with Jon Schueler, whose
acquaintance with Charlotte and Jim stemmed from the heady days of the fifties in New
York City.

. . . .

Charlotte, can we begin with when you and Jim first met?
I met Jim in Washington [D.C.] when he came back from an interesting Army mis-

sion in the Middle East in 1945. He had been sent, along with other artists, photographers, and painters, to various battle zones where they were to record their reactions to war. He had decided to go to Cairo because there was no war going on there! When he returned, he came through Washington. We met through a friend of his, Eric Mose, who had been on a WPA program with him before the war, and who was working with me at the OSS. Jim soon went up to New York, and I followed and got a job and an apartment on Gramercy Park. Two years later we got married. And that's how it all started.

You hadn't thought of becoming an artist at that point?

I had gone to art school at Yale, graduating in 1939, but I hadn't done very much—except for some portraits during the war—because I was working. While I was teaching full time at two private schools in New York, I went to Wallace Harrison's classes at night. He was a cubist with extremely rigid ideas, but I found him very interesting. I had started out as an academic painter, but very soon I was caught up in this thing that was going on in the city with abstract expressionism.

Did you have separate studios?

We had one little room that we shared in the loft at 500 West Broadway; Jim worked on one wall, and I on the other. It was only on weekends that we were both there, so it worked out. Both of us were willing to give up a little something. After he found a studio at 540 West Broadway, I had the whole front room of the loft to myself.

What was Jim doing during the week?

We were both teaching. We decided that would be our way of making a living. Jim made more money than I did because he was a man and a more mature artist. That wasn't an issue. I didn't feel at all competitive. He taught at Columbia [1947–1949], Pratt [1947–1959], and Yale [1955–1960], as well as at Queens College [1966–1967, 1968–1969].

I taught children's classes at the Museum of Modern Art for about eleven years. I loved that and was able to add my little contribution. I got so involved in teaching that I even thought I might do that instead of painting. But I'm glad I didn't. I had more patience in those days than the other teachers, so I got the two- or three-year-olds. I would take fifty dollars out of the bank every week, which took care of laundry and food, and we would go to little Italian restaurants and have wonderful meals that didn't cost anything. We didn't feel deprived at all. It was a great time because there was something in the air. The Club was going on, and we'd go there Friday nights and listen to the different speakers and participate.*

When did you start spending summers on Long Island?

We rented a place in Montauk [from 1949], but the 1954 hurricane knocked down our working space and destroyed our paintings. We bought the ten acres in Springs in 1956, and we moved the house here by truck in 1957. We paid three hundred dollars an acre, and it took us a long time to pay back the mortgage. But Jim went to Kootz Gallery in the early sixties, and the paintings were selling well. That was a golden period. Then he had his retrospective at the Whitney in 1963, and right after that we went to Rome. Jim

was invited to the American Academy there as artist-in-residence. I learned then that an artist doesn't want to go places for very long; he only wants to paint! He could have stayed a year or two, but we were there for less than six months. It was great, though. We had a lovely little place that they gave us, and we went tooling all over Italy and Greece in a little Fiat 500. When we got back, I decided I no longer had the patience for teaching, and I didn't need to do that kind of work. We went back and forth from New York to Springs for a while, as Jim taught graduate students for quite a few years.

Did you initially come out to Long Island because other artists were here?

The Pollocks were here. Jim had become acquainted with Jackson before the war because he had worked on WPA murals with his brother, Sandy McCoy. When Jim arrived back in New York in 1945, he rented rooms in various artists' places, including Jackson and Lee's loft on 8th Street. When Peggy Guggenheim bought the house out here in Springs for them that year, Jackson let his brother have the loft, but he stipulated that Jim could have the front room until he found a place to live. And it was a long time!

Was it still important to keep in touch with the New York art world after you moved here?

Not as much. We'd always go in for the openings of friends or older artists, or for a show at the Met or the Modern, and for interesting parties. Jim really wanted to be in New York more than I did. I guess I've always been a country person. Except for the war years, he had been in New York since 1926. He never used to go away in the summer. This was New York, and this was where it was, and this was where he worked. I wooed him into the country. At first he wanted to get back into the city, so we would go in for the winter but, gradually, he got worn down—I guess, by me! He was a city person for many years, but he really liked it a lot here, too.

Did you have a kind of routine to your days?

Yes. Jim would get hungry, and he'd wander in about lunchtime, hang around a little, and then go back to his studio. In the morning, I usually did all the things like shopping, laundry, and paying bills—he never paid bills. I innocently took that over, and it became my life's work! It still is. After lunch, I was out to my studio. We would both end at about 5:30 p.m. In the wintertime, we had to traipse through the snow to get to our studios but, when we did, it was wonderful to be out there, away from everything, even the house. Now it's a little more of a chore.

I found that I was in and out of Jon's studio all the time, but I didn't talk about the work with him very much. I didn't want to impose upon his world unless we were doing things together in the studio: choosing paintings for an exhibition, or selecting paintings to photograph, and so forth. Did you visit each other's studios and comment on each other's work?

Jim was very encouraging about mine. I think I probably visited his studio more than he did mine. I just loved to look at his work, and we would discuss it. The one thing I did learn was not to ever say I recognized an object. Once I found a duck in one of his paint-

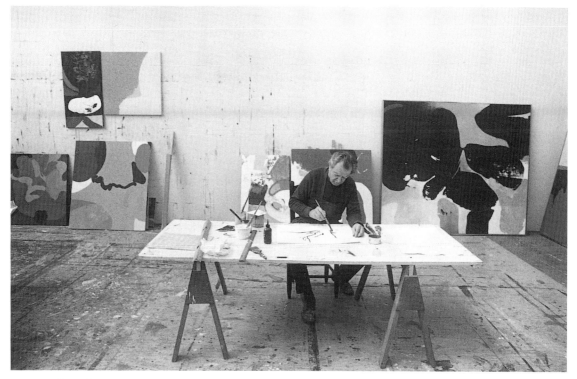

James Brooks in his studio, 1975. © Hans Namuth Estate.

ings. He said, "Well, let's not have that happen again because once it's there, you'll always see it!" Oh, it was terrible!

If Jim had a gallery, he never particularly tried to bring you into its stable, or vice versa?

No, no. Neither of us liked that idea. I would never ask to be shown in Jim's gallery, and I don't think he thought that was such a good idea. I started painting much later than Jim, of course.

Did you help much with his career?

I did a lot of things and was happy to. In those days we didn't have a copying machine, so I would make copies in longhand of letters I thought important. I really believed in him and his work. It wasn't a burden, and it didn't take up that much of my time.

Jim liked you to be involved?

Oh, yes. We really were very close that way. He was a very gentle person, so he was a very easy guy to live with compared to many other artists.

Was he quite good administratively?

He was unusually organized and, unlike most artists, always listed his paintings. Although he painted in an intuitive, spontaneous way, another part of him required this order. This helped an awful lot in later years. You can see that quality in the work he did as a lettering man. He was very good. In fact, he never had any problem in New York with

money during the Depression because he was paid well for magazine ads. Jim also designed two alphabets for something called photo lettering, which was the beginning of the end of hand lettering. The firm is still in business, and I was able to use one of his alphabets for Jim's name when I was planning the stone for his grave.

Was it a decision on both of your parts not to have children?

Yes. He said it would be all right with him, but I thought it was tough for artists to have children. Also, I was twenty-nine and he was forty-one when we got married. Had I been married earlier, I probably would have had children. But it just seemed—well, it wasn't a driving force.

Do you think artists of your generation didn't have children because of their financial insecurity?

Right. New York was surfeited with artists who could teach, which was often the only job available. They would leave New York with their children and their wives and would teach around the country. So they weren't in New York when all this excitement happened, and they never did catch up. In fact, two friends of ours did that. In New York, you could bump into somebody on the street, and you might be included in an exhibition. If you were out in Wyoming, or Chapel Hill, or wherever, it wouldn't happen.

Charlotte, can we turn to the will now?

Our lawyer advised us to figure out what we wanted to do with our property and possessions. We decided which nieces and nephews should have what, and whom we would give paintings to. Otherwise, Jim left everything to me, so it was a very uncomplicated will.

And, if something had happened to you both, what would have become of the paintings?

Everything would have been turned over to my executor, my niece Julie Cochran [born 1941], who lives in Texas. The emphasis is doing whatever is possible to promote Jim's reputation: finding galleries and putting on shows, giving paintings to museums, and finding a place to store things. Taking care of my work, too.

Had you or Jim discussed with Julie the role she might play?

Yes, but I'm afraid not very conscientiously. We had total confidence that Julie would do the right thing. Jim didn't want to be involved, and neither did I, which was pretty stupid—but that's the way it was.

How did Julie become involved?

When Julie got a Woodrow Wilson scholarship to go to Columbia University in 1963, she lived in our loft down on West Broadway for a year, and she spent time with us in Montauk during the summer. Later, after she and her first husband separated, she moved back into our loft. She was always with us—it was like having a daughter. So, it was just natural to have Julie take over, and she was very willing to. She just adored Jim, who was her mother's brother.

When Jim died in 1992, was he associated with a gallery in New York?

Yes, he had been at Berry-Hill since 1989. He had a super opening that year. They went all out to make a beautiful presentation. That was the height of the art market—right afterwards it went kaboom. They sold quite a number of Jim's paintings and raised the prices enormously. That helped us very much through Jim's illness.

Did Berry-Hill help you plan future projects?

Well, I hesitate to say this, but there were some difficulties, so I left the gallery.

What did you do then?

It worked out nicely. My friend, Meg Perlman,* who loves Jim's paintings and knows a lot about the art world, approached Joan Washburn about taking Jim on, and I've been with her ever since. As soon as Joan took him on, she had a show—in 1993. She's very honest, and I respect her. At that time, I was a little disillusioned about the art world and the auctions, so it was very lucky for me to find her.

Has the Joan T. Washburn Gallery relieved you of the major responsibility?

Oh, I think it's still up to me, but I'm not very good at it. Neither was Jim. We weren't aggressive enough to do very much ourselves. But I trust Joan completely. I make suggestions, and she does, too. It's kind of an even thing.

How often are you in touch with her?

We usually talk at least once a week, but it depends on what's going on. I never do anything without her—and, finally, things are moving.

Do you get involved in choosing what goes into all of the exhibitions?

Oh, yes, although I trust Joan a lot about what to send.

What haven't you done that you possibly should have?

I haven't given away a painting each year. However, I have done one gift recently. I had a whole lot of drawings on newsprint that Jim made for the mural at La Guardia Airport, and some maquettes and painted sketches of heads. I decided that I would give them to the Brooklyn Museum of Art, which Joan suggested, because it has other WPA artists' work. I had thought about the Archives of American Art in Washington, D.C., but Joan thought that if someone were writing about Jim's mural, the Brooklyn Museum would be more convenient because it was closer to La Guardia. I'm very happy about the decision. I gave them the material after having it appraised, and this year I didn't have to pay my income tax or my estimated taxes for next year. So I should have been doing more of this. In the will, we had a list of the museums where we would like to have Jim's paintings. But, when Jim and I did this, we were both very innocent—we just did things because we were told to. We listed museums like the Yale University Art Gallery and the Museum of Fine Arts in Boston, places that meant something to us. Jim taught at Yale [1955–1956], so that seemed a logical place.

After making an inventory of Jim's work for estate taxes, did you hire a curator to work on a catalogue raisonné, or something similar?

I had Mike Solomon, who was here when Jim was ill. He catalogued everything. The works on paper, which had been in portfolios, are now in five museum cases. Each has a

number, as does the file card, so we know exactly where it is. He also built racks on wheels for these cases so they can be moved around, and, oh, he did everything. He just adored Jim. He was here when Jim came back from the hospital in about 1989, and he helped me arrange furniture.* He's one of those wonderful, dear people. He runs the foundation for Ossorio now [see Part Six].

For the last two years, I've had a marvelous young woman working with me once a week, Siobhán Conaty, who is now going on to get her Ph.D. in art history. It was Mike who found Siobhán for me. We have been updating, on the computer, the list of Jim's talks and the material he wrote for catalogues. I've also done a tremendous amount of organizing file cabinets and slides—and we've taken pictures of things that had never been photographed, for our card file. We've always had file cards with photographs of the paintings and, on the back, their provenance, which is mighty handy. Now, we have slides as well.

What more is there to do?

I need somebody to do some research for me, and to help with things, because I'm getting very forgetful, and things keep coming up. A young man, David Goldstein, who is working for Mike at the Ossorio Foundation, will take over after Siobhán shows him what to do.

Do you type or use the computer?

No, and I'm not going to. I'm way back in the Dark Ages. And I've never typed. With Siobhán—I wrote the letters, and she put them on her computer and sent them out. She also did the ordering of conservation materials, like the wrapping and archival paper. It's wonderful to be able to leave things for someone else who can do them so capably! I have done one thing to get into this day and age, and that is to get a copier. I could have bought one years ago and not spent twenty-five cents each time I had to go into the village!

You mentioned that you stopped working during the last few years of Jim's life because he needed a lot of attention. After he died, how long was it before you were able to get back to your studio?

I could have gotten back much sooner, but I just kept procrastinating. It was about seven years. He was ill for two to three years, and the rest of the time was just not getting to it. Now I've established a fairly good habit of getting out to my studio. I had never stopped working for any length of time before, and I thought that when I started working again, I could just pick up and continue. But there was no way. I had to think about how I made the lines and how I got this brushed look, which before had just been evolving out of my life of painting. It was a great shock. I'm finally getting into something that speaks to me. For almost a whole winter, nothing happened. Things have started, and I've even shown one or two of them in local shows.

Ideally, how would you like to balance your own work and your responsibility for Jim's?

Well, as much as I can, I want to work in my studio. But, if there's something going on, I spend more time on Jim's work. When that lets up, I'll be free. I don't know whether

Joan's planning a show for Jim this year or not. She has a big painting of his up now for her summer show. There's no great rush, but I would like to have as many shows in the city as possible. She's concentrated on the fifties, which is what is hot now, and has had several shows—one of paintings and several of the works on paper [1993, 1994, 1995, 1998]. I haven't anything in particular in mind. I would like to have a show of his work this year because there wasn't anything last year.

I wanted to get Jim's work organized while I was still able to, so I could feel I left it in the best condition I could. I have been concentrating once a week, and I think things are pretty well under control now. Suddenly, there's a woman doing her Ph.D. dissertation on Jim—a delightful woman, Anne Abeles, who teaches art history at C. W. Post Campus of Long Island University.*

When is her thesis going to be completed?

Oh, I don't know. She's written the introduction, and she's working on the first chapter. She's so thorough—she goes to the public library and looks through old telephone books to find the names in Jim's letters. She went out to Dallas, where Jim lived during his teenage years—his family was there—and went to the library and the museum. She also visited Julie, who has lots of Jim's paintings.

Do you hope her thesis will be turned into a book? Are other people working on such projects?

Siobhán is very bright, and she and Anne have talked about doing a catalogue raisonné together. Whether that will ever happen, I don't know. Siobhán worked at Peggy Guggenheim's museum in Venice, and then the next year she worked at the Venice Biennale in the summer. She teaches and has curated a show for the Pollock-Krasner House this year [*Art of This Century: The Women*], which includes many people whom Peggy Guggenheim had in her women's shows way back in the forties.

What plans do you have for the foundation you mentioned?

My own private lawyer said he didn't think there was enough money, but everybody says he's being extra conservative. This foundation is going to be set up by Julie's husband, who is a corporate lawyer. There's a specialist in his firm who will work out the structure. Julie will be the executor, and we'll have three trustees. I've asked Meg Perlman, and she said she would be delighted, and two others have been suggested. But it hasn't been formalized yet. Julie's gotten the idea that I would like it after I go, but I told her, "I would like to know what's going to be happening while I'm still able to think and talk about it." It would give us the opportunity to figure out how best to take care of Jim's work. Mike [Solomon] would like this studio to be the headquarters for the foundation. People could visit the studio—they are already making tours here—and see all his writings and books. But it seems impractical, and I think forming a foundation simply to look after the work would be better.

Are you setting up the foundation for tax reasons, or to give Julie support and direction?

Charlotte Park and James Brooks with Jackson Pollock
(right), Montauk, N.Y., 1953. On wall, Brooks's painting
Number 41-1949, oil on canvas, 37" x 96". © Hans Namuth
Estate.

Well, it's partially for tax reasons. Julie will inherit the property, but not the paintings. She is very imaginative, so I think she will probably do more than I've done. But I also think we need an organization with trustees who are involved in the art world and can contribute ideas.

And how would that tie in with your work?

I haven't thought about that. Maybe they will be incorporated. You know, Edward Albee lives out here. He saw a painting at a show that I was in. He called and wanted me to sell it. This was while Jim was sick, and I said, "I don't want to let it go." He replied, "Well, think about it." Elise Asher said, "You know what's going to happen to our work?

It's going to be down in some moldy basement. Why don't you just let it out to be seen?" So, I sold it to him.

Have you not thought about your own work because your time is taken up by organizing Jim's?

I just haven't. I think Jim's is really worth doing something with. I don't feel that confident about what I've been doing. But I think Julie will do something with it—pack it away somewhere, or whatever. I haven't even talked to her about that.

Are there any artists' wives or widows whom you would not like to be compared with?

Well, Lee Krasner did wonderfully well for her husband, but I think it killed him eventually. She would be an example of the ideal artist's wife, one who didn't do much about her own work until he died, but had this ability to promote his. She would have cocktail parties and get him into shows in the city, and he became famous. But he had a problem with drinking, and he was very shy and quiet when he wasn't drunk; it was painful for him to be in this position. Eventually *Life* magazine said he was the greatest painter in America [August 8, 1949]. Imagine going into your studio with that behind you! I think it was good for his notoriety, but I don't think it was so good for Jackson.

Are there other wives or widows whom you feel have managed better?

[Pause] I don't think very many. I can't think of anybody. Esther Gottlieb taught to support Adolph, although he did inherit a little money from an uncle at one point. After Adolph's death, she set up a foundation right away, with a young man working there. The Gottlieb Foundation helps artists who are in need (see Part Six).

Would Jim's do that?

If there were enough money, yes. Even without much money, it could do some things. I thought I would eventually give Jim's books to the Pollock-Krasner House. It would be nice if we could be like the Judith Rothschild Foundation, which helped us in 1997.* But there will probably only be enough to promote Jim—which is a lot in itself!

Soon after John Constable died, his widow simply had a sale of many of the paintings, so they got out into the world and were spread far and wide. Before you decided to set up the foundation, did you ever think about sending the work to Christie's or Sotheby's?

No, that's what I worry about. I don't like the idea of selling like that.

Why not?

Well, why not give? The idea of selling his work off doesn't appeal to me at all. And, in private houses, they would be seen by so few people. The only problem about giving paintings to the museums is that they show them when they get them, and then they get stored. The Met has three of Jim's, but they've only been seen once, when they put up the new wing. No, I don't like that idea, although what you say about them being seen by an enormous range of new owners is true.

Do you think that Jim and other artists of that generation have a secure place in history?

This isn't a high time for abstract expressionism. So there aren't that many calls or

shows. There was the important museum exhibition in Japan of the abstract expression-
ists [*Founders and Heirs, 1997*], curated by Dore Ashton. Irving Sandler organized a show in
Mexico City and wrote a fat, enormously heavy softcover catalogue for it [*Pintura Esta-
dounidense Expresionismo Abstracto, 1996–1997*]. Things go along slowly. When I gave this work
for the mural to the Brooklyn Museum, I stipulated that I would like to have a show, a small
show of it. They did, so that was nice. A show is being organized out here for September,
at Glen Horowitz Booksellers, which is on Newtown Lane in East Hampton. It's all works
on paper but, out here, where it's damp, there's a lot of foxing on the paper. Every single
thing in the show had to be conserved, which took time and is taking a considerable
amount of money. Conservators, as you know, are very expensive!

Do you want to stay out here in Springs?

I love it here. I'm very happy. I can't imagine ever going anywhere else to stay. I really
think it's wonderful. I like the country. I always have. And, finally, Jim got to really love it
here, too.

July 1997

UPDATE

In October 2000, the James Brooks and Charlotte Park Brooks Foundation was
formed. The trustees are Julie Cochran (president), Meg Perlman (director and curator),
Dwight Emanuelson, and Charlotte Park. The ten-year association with the Joan T. Wash-
burn gallery came to an end in 2002, and the Artemis Greenberg Van Doren Gallery inau-
gurated its representation of the work of James Brooks in October 2003. In Los Angeles,
the foundation is now working with the Manny Silverman Gallery, which held its first
James Brooks show in 2004.

FOR FURTHER INFORMATION

Herskovic, Marika, ed. *New York School Abstract Expressionists: Artists Choice by Artists*. Franklin Lakes, N.J.: New York
School Press, 2000.

James Brooks: Selected Works 1960–1985. Essay by Sarah K. Rich. Artemis Greenberg Van Doren Gallery, New
York, 2003.

Sandler, Irving. *The Triumph of American Painting: A History of Abstract Expressionism*. New York: Praeger Publishers,
1970.

REGINA CHERRY, WIDOW OF HERMAN CHERRY

Herman Cherry was born on April 10, 1909, in Atlantic City, New Jersey, the son of Israel and Rose (née Rothowitz) Cherry (Cherkovsky). He was brought up in Philadelphia until 1924, when the family moved to Los Angeles in search of a better life. He studied at the Otis Art Institute in Los Angeles (circa 1927); at the Art Students League in Los Angeles (under the synchromist Stanton Macdonald-Wright, circa 1927, 1928), and in New York under Thomas Hart Benton (circa 1931). Continually on the move during the thirties and early forties, Cherry was involved in artists' union work, briefly ran a gallery, and assisted on murals for the WPA project in Los Angeles and New York.

His early work reflects his interest in American Regionalism, Mexican mural painting, and Chinese art. In 1945, he went to New York and, by the early fifties, his work had become abstract—jostling patches of centrifugal color. A heady involvement with the New York art world of the fifties was followed, from 1961, by some twenty years when he only exhibited out of town. In addition, he wrote and taught at various colleges and universities as a visiting artist. Beginning in 1964, he spent summers in East Hampton. In 1984, he started once again to show his work in New York City—at the Luise Ross Gallery and in a retrospective at Baruch College in 1989. A full-scale retrospective followed at the Ball State University Art Gallery, Muncie, Indiana, in 1990. His concern with the nuance of edges and the pulse of color are evident in the radiant tones of his late work. He died on April 10, 1992.

Regina Cherry was born in Ranis, Germany, in 1946, one of three children. In 1949, the family moved to West Berlin, where she attended grammar school, gymnasium (1952–1964), and studied basic Bauhaus design, drawing, and sculpture at the Staatliche Werkkunstschule (1964–1967). She then worked independently in sculpture and painting, took up photography and, for the next ten years—between periods of formal study at the Hochschule der Bildenden Künste (1970–1976)—she traveled extensively throughout Europe and studied murals in Mexico (1973). Based mostly in West Berlin, she worked as a photographer for artists and musicians, as a letterer in graphic design (1974), and as a stagehand (1975). In 1976, she moved to New York City to live with Herman Cherry, whom she married that year. Since then she has worked in New York as a freelance photographer of art, an editorial assistant/secretary for two medical magazines (1978–1980), and an assistant at art galleries (1981–1998). Helping Herman Cherry in his studio until his death in 1992, she herself continued painting during the summers on Long Island.

I spoke with Regina Cherry in her loft on Mercer Street in New York City. The long, rectangular eighteen-hundred-square-foot space, with windows at each end, holds Herman Cherry's work in the middle section, with his studio (now hers) at the east end and the living area in the west end.

. . .

Before Herman died in 1992, did he talk to you about what he wanted you to do?

No. He always said, "I've known too many professional widows with a millstone around their necks. Make a big bonfire. Give it away, or burn it." But he didn't really mean that. Herman was very social and wrote other artists' catalogue essays, so people knew his name from the past, even though they didn't really know his work. There were some wonderful shows shortly before Herman died, and he had a beautiful retrospective at Ball State University Museum of Art at Muncie, Indiana, in 1989. It never traveled, unfortunately.

What was left of the estate?

The estate is quite large—about 450 paintings and about 1,300 works on paper. Most of the paintings were stored in the basement of this building, though not the works on paper. Shortly after Herman's death, I built these huge racks and brought all the paintings up because it wasn't safe down there. We even had a flood once. Then I had to list and photograph them, which took a long time. I still have to transfer the inventory numbers onto the actual paintings. I do this every time I take one out. The works on paper are already labeled on the back.

I've created inventory catalogues of both the paintings and the works on paper. I found a place that made contact sheets from thirty-five-millimeter slides. Then I just cut out the images and glued them into the two books, four to a page, with all the information about each painting. They're arranged chronologically. That was a lot of work! It would have been very expensive if someone else had done it on the computer. It's been very helpful to dealers; they can take a look at these images before they come to the loft. Unless the paintings are pre-chosen, it's difficult to find them quickly, as everything is stacked by size (rather than chronology) to take up the least amount of space. I wish I had a bigger loft just for the storage.

That's superb. And the visual inventory is a combination of work you have and work that has already sold?

It's predominantly what's here in the loft. Herman didn't sell that much until the eighties. When I met him, he had almost no slides of his work, even though he had worked with Kyle Morris in Contemporary Slides from 1954 to 1959. He took installation shots of museum and gallery shows and photographed individual paintings that were sold to places like MoMA, universities, and art colleges. He didn't have any written records of the paintings either.

How long did it take you to get the paintings up from the basement and photograph them all?

Regina Cherry in her New York City loft, 2001.
©2004 William Rivelli.

I couldn't do it all in one fell swoop because I still had to make a living. First, we built the racks. [The artist] Rufus Zogbaum helped me. We ordered heavy-duty metal industrial shelves, four-by-eight-by-ten feet, and joined the units together after I figured out the different levels for groups of paintings of certain sizes. It was useful for Rufus, too. When we finished, he took pictures of them and passed the idea on to other estates he was working with.

I did the photography of the paintings and works on paper myself at night, so it took a couple of years. I got a little grant from the Rothschild Foundation,* which was really helpful. But the money ran out, and I burned out, and I stopped. I practically finished it two years ago. Then I just couldn't deal with it anymore.

Did you have a gallery to help you after Herman died?

Luise Ross had been representing Herman. There was a memorial show in 1993. Then Luise moved into Outsider Art, and Herman didn't belong there any longer. She did nothing for him, and finally she returned all the work. So I had to go out peddling, and that's not something I like to do. I'm not good at that.

How do you go about it?

First, I write a letter. I have to really push myself to do that. I hate it. I'm still too much involved, too close to the work. But these inventory books helped me get a dealer for Herman. I showed them to Gary Snyder, and that led to a studio visit. There'll be a show of works on paper at his gallery in the fall. It's a beginning. Meantime, I arranged for a show at the Pollock-Krasner House next summer. You know, I take the books, and they take a pick, and that's it. It's fantastic! We've applied to the Rothschild Foundation again for a grant because we're trying to get a catalogue together.*

Do you think that there are enough foundations that can help?

I don't know. The Rothschild Foundation is tailor-made for estates because others are mostly for live artists or institutions. I haven't really gone into this thoroughly. Herman never applied for any grants.

It must be a relief that you now have a gallery?

Yes. I would also say to myself, "Unless I have Herman somewhere in a home, I can't focus on my own painting." There is still a lot of work: showing the dealers all the paintings, giving them slides, cataloguing, and so on. But Gary Snyder is a passionate, young, energetic dealer, and he has a beautiful space. He used to focus on the thirties and forties; now he's moving to the fifties and sixties. I hope he'll move on further than that with Herman's work.

What do you think sustained Herman over all the years when he wasn't showing?

That's a good question. He didn't show for twenty years in New York. In 1961, his gallery dealer Ellie Poindexter said, "You know, things have changed. Pop's in, and goodbye." Actually, Herman gave up painting. When I met him in 1975, he said he wasn't going to paint again. But between me being around, maybe pushing him a little (!), and the CETA project. . . . In 1975, the government, because of the big recession, created a program called CETA [Comprehensive Educational Training Act], which was designed for postal workers, ditch diggers, policemen and, in New York, for artists. It was terrific—like a small WPA—and it lasted until about 1982. It created a whole new community—writers, poets, painters, sculptors, and actors. So Herman was on the dole from 1978 to 1981. That forced him back to painting because he had to do murals for places, and some easel projects.* He didn't go around looking for a new gallery—it was too humiliating—but Luise Ross invited him to show with her in 1984.

Starting in 1957, he taught all around the country, but he never took tenure. He didn't like the idea of being tied up in academia and dealing with all those problems. He was offered tenure twice at SUNY, New Paltz, New York, but refused. It was a tougher life, but that was his choice. Since there were periods when he didn't work, or only in spurts, there

isn't a lot of continuity in his paintings. When you jet around the country teaching, it disrupts your studio life. But he would always take a lot of paper along and create wonderful series of works on paper. That's why there is so much.

He was also writing poetry. He had a little book published in 1976 [*Poems of Pain & Other Matters*]. An old friend, Alcopley, published it and did the illustrations.* I still have boxes full of his poetry. And I haven't touched the papers. That's something that estates have to deal with—the archives. Eventually, I'll have to go through them, but I'm not an art historian. God forbid! No insult here! I guess I have a mind that can work that way when it's pushed, but I've got to make a living, too. So my life is really fractured. The Archives of American Art wanted Herman's writings and the letters, but I understand that there's a backlog at the moment. Sometime, I'll deal with that.

Herman died almost ten years ago. What are your plans for the next ten years?

I can't think in those terms. I can't think further than, maybe, a year ahead. I'd like to get Herman's work in museums if I could. But, of course, you can't do it alone. You need a dealer. Museums don't like to deal with widows. They want to deal with dealers. I never understood that. They would have a much easier time, and probably get a better break, from me.

Do you think collectors also feel more secure going through a dealer?

Yes. You know what it is? It's the stamp of approval. Even collectors are somewhat insecure unless they are buying something that's established, blue chip, and has auction records.

Nowadays, many of the galleries expect the estate to go halves on catalogues and to help in other ways.

It's unbelievable. I'm prepared to do something regarding catalogues, but I think ads and mailing costs should come out of the dealers' pockets. An ad is some two thousand dollars, and they want you to share it. I think, for a fifty percent commission, they can do that themselves. There's something else dealers do: let's say you have a show in another town with another dealer, who gets thirty percent, or even forty percent; the New York dealer takes twenty percent, and you end up with forty percent. I heard that from two different dealers. That is pretty awful. Why can't they both take twenty-five, or twenty to thirty percent? I'm going to push for that. I'm not difficult, but I'm not a pushover!

Do you feel that you are doing much more for Herman's work than he himself did?

Yes. Even while he was alive, I did a lot. I took the slides, wrote letters, helped him put his shows together, and so on. I was also his studio assistant. What I'm doing now is simply an extension of that.

Is it actually easier now to do that work by yourself than it was being the second-in-command?

We did actually work together quite well. We even titled together. I don't know. It's maybe a little easier.

Do you think that we have the right to ever throw anything out?

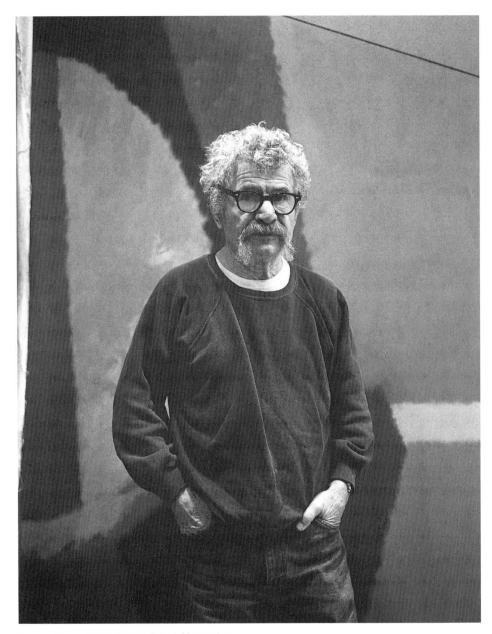

Herman Cherry, 1984, in front of *Elaine's Masterpiece*.
© Regina Cherry 1984–2004. Courtesy Regina Cherry.

Very important question. I don't think we have the right. Artists should do it themselves. The problem is that they forget. Or, perhaps they make the wrong decisions. Each time Herman moved, he'd throw out stuff, destroy canvases. Years ago, I came across some slides of

REGINA CHERRY | **87**

a group of paintings. "These are nice paintings from what looks like the early sixties. Where are they now?" I asked. He said, "Oh, I destroyed those." He was working in that vein again in the eighties. If he'd only kept them, it would have been a fantastic continuation.

In his last year, when he couldn't really conceive any new work, Herman went through some canvases and tore some up. I'm sorry, very sorry about one of them. But I didn't let him throw them away. I said, "Listen, these are beautiful segments," so I got stretchers, and we stretched them up. He made a bunch of smaller paintings out of two canvases and, actually, some of them he worked on again. They are titled *Regina's Choices, I, II, III, IV, V, VI, VII*. But me throwing out things? Never, unless it's a canvas that is completely unfinished, has one stroke on it, not even an idea. Then, I'll use it myself and paint over it. I would feel terrible throwing out things.

Do you hold back certain paintings?

I said to Gary Snyder, "I don't want you to just pick the cream." He said, "Don't worry, you can always tell me if you want to hold something back." He's very amenable there. I pulled one out even after he made the selections. He wouldn't remember; he picked so many. He was like a kid in a candy store. But you have to make sure that you are not naive about it, and some widows might be. I keep some back because they are personal favorites. Then there are a group of black and whites from the early sixties, and I know there weren't so many of that particular group. Others that I think are especially good, I would like the dealer to place in a museum.

Do you mind being introduced as the widow of Herman Cherry?

Well, they don't say it that way. They always say, "Oh, this is Mrs. Cherry. She was married to Herman Cherry." Of course, you are always the appendage. In spite of feminism, I don't think it has changed that much. But the word "widow" definitely has a negative ring to it.

To what extent has looking after Herman's work invaded your own life and career?

It takes a lot of focus. I don't quite know how other widows have dealt with that. I feel responsible, and I also think the work is deserving, so somebody has to do it. I'm supposed to be a painter, but I haven't been in the studio in a while. I hope to get back. I spoke to Charlotte Park a few days ago when I was out in East Hampton. Her husband, James Brooks, died the same year as Herman. I said, "Are you in the studio?" And she said, "No, are you?" I said, "No, not yet!" She said, "Let's push each other a little bit."

Before Herman died and, before you had this responsibility, was your own work the most motivating force in your life?

It was also a bit on the back burner. I mean, I was married to an artist who was a lot older and whose work I appreciated. Then he wasn't well, so I had to put a lot of energy into that. But I knew when I moved in with Herman that he was a very forceful person. Neither of us had any money. I was working and taking care of Herman, and whatever time was left was for myself— that wasn't a lot.

Where did you spend your early years, and how did you meet Herman?

I was born in the eastern part of Germany and was raised in West Berlin. I went to some art schools there. We met in Berlin in 1975 through artist-friends, Shinkichi Tajiri and Martin Engelman. Herman had been fired in 1974 from Kingsborough College in Brooklyn because he was sixty-five and had to retire. So he was down and out, had no money, and was ill. He said, "I'll take one last trip to Europe, and that's my swan song, and that's that." It turned out differently!

How old were you, and what were you doing at that point?

Twenty-nine or so. I was divorced by that time. I had a studio and was painting and working at various jobs—in the theater, et cetera, and doing some photography, too, though not particularly focused on art reproduction because I didn't have the equipment to do four-by-five-inch transparencies. I did things like photograph avant-garde musicians.

So Herman arrives in Berlin. Go on.

Well, that has nothing to do with the estate, does it? [Laughter]

Yes, because the way the Cherry estate is handled depends to a certain extent on the personality of the widow.

Okay. So, we met and, I guess, fell in love. We spent some weeks together. Then, in May, he went off to Paris and Spain. He phoned from Holland to say that he might come through Berlin again. He did, and he stayed for four weeks with me. The rest is history.

Is it history?

Well, then I came to visit him in the winter of 1975—not my first time in New York, but the first with him. I returned the next summer. I knew he was going to have major heart surgery, and I stayed to take care of him. After that, going back and forth was complicated because of immigration, so we decided to marry. We were living with a time bomb. Actually, we had to get separate mattresses because I couldn't sleep: I was listening to that ticking valve! I guess he had much longer than he expected. He had a second heart surgery in 1986 to renew the worn-out valve. That gave him a few more years.

Once you were in the States, what kind of work did you do?

First, I worked for two years as editorial assistant to Alcopley for two medical research publications. Then I worked part time in galleries for close to twenty years, and I did freelance photography and was the in-house photographer for Herman. I first worked for the Carus Gallery, from 1981 to 1987, and then at Saidenberg Gallery, from 1988 to when they closed two years ago. In the first gallery, I did everything: matting, framing, hanging shows—you know, you get overworked—but I drew the line at photography because they weren't prepared to pay me extra for that. Right now, I'm freelancing a lot, doing art photography, specializing in transparencies and slides. That's enough!

And how do you feel about the interruption to your work?

Oh, my painting! I'm supposed to be a painter. [Laughter] I'm not much of a careerist, but I haven't been idle. When I can't get to the studio, or even to do smaller works like watercolors, I write a lot of poetry.

Have you had a gallery while you've been living in the States?

No. I'm not much of a pusher. I've been in group shows here and there, and another one is coming up at Studio 18 Gallery this year. In fact, I picked out some paintings for it today and said, "Gee whiz, I've got to get back to work." But, as I said, only now that I have Herman in a gallery, do I feel that I can focus.

Some people have mentioned that the museum in the town where the artist came from or summered sometimes becomes relevant for exhibitions or placing paintings.

Yes, to some extent. Herman wasn't born in California, but his family moved there in 1924, when he was thirteen. He later wrote some articles on the scene there, and I guess was a little blackballed until recently. But, Marian Yoshi-Kozinick, with Julia Armstrong-Totten of the Getty Museum, is organizing a show of the Art Students League in Los Angeles, where Herman went. So there's some interest in that early social realist work of Herman's from the thirties, but the problem is that there isn't much of it. He left it behind when he came back East in 1945, or some of the family has it.

Of course, Herman had the Long Island connection for many years. Actually, that retrospective at Muncie, Indiana, was supposed to come to Guild Hall, East Hampton, in a smaller version, but it didn't work out. People always say, "Well, Herman was so difficult." He shot himself in the foot in many ways. He was very outspoken: he didn't ass kiss; he didn't play a lot of social games. That puts you into oblivion. There's a funny story. Guild Hall is supposed to collect regional artists. They wanted one of Herman's paintings for a long time, and asked him many times. He said, "You're so rich here. I mean, I haven't got a penny, hardly a pot to piss in, and you want me to give you a painting?" He always said no, but then, at some point, they decided they wanted to buy one. The director, Inez Whipple, and Eloise Spaeth, a trustee, came here and chose a painting. They must have been so embarrassed at how inexpensive it was that they didn't even take off the twenty-five percent that Guild Hall could have claimed. They paid him the full price. He said, "Hey, that was victory!" He always stood up for those things. Don't forget, he was involved with founding the artists' union in California way back in the thirties.

By the way, Jerry Nordland is proposing a show, to the Jewish Museum, of five artists who were friends, four of them in New York. It would be Richards Ruben, Reuben Kadish, Herman Cherry, Sy Boardman and, from Chicago, Seymour Rosofsky. So, hopefully. . . .*

What are some of the things that others might have thought self-destructive?

I hear this from people who knew him in the sixties. I didn't see it that much when we were together, but I knew that he was very outspoken. People would say, "Oh, he's nasty." He wasn't nasty, just very direct. Knowing that about him, I think people just didn't want to deal with him.

Do you think that he acted on principle and with integrity?

He was a moral person and had lots of integrity. That was a big attraction when I met him. Very outspoken. Herman wouldn't have shown at Marlborough if they had asked him, and I wouldn't approach them either because of the Rothko scandal and now the

Francis Bacon case.* A lot of artists don't have much spine, you know. Somebody comes and says, "Oh, come on, show with me," and they go. Herman was different. You have to really be a little courageous in your work and life.

If you sell more of Herman's works, and there is an increase of recognition, what would you like to see done?

Well, it would be lovely to get a monograph published. Obviously, it is important to build up catalogues and publications through exhibitions. Basically, Herman has one poor little catalogue of recent times and a not very impressive retrospective catalogue.* Young people have such fancy catalogues. I guess Herman's generation was not into that self-promotional mode. He always admired Adolph Gottlieb. He said Gottlieb was terrific in the studio and, when he left the studio, he was a very good businessman.

With more money, I would definitely have a few paintings restored professionally. Some I've restored myself, especially when they come back from the galleries and all the edges are rubbed off. I know what paints he used. I'm always upset when dealers don't take more care. I told Luise Ross, "Listen, these were new paintings. You were the first person to have them. I had to spend hours restoring them."

Publications or lectures would be great, but I can't speak and I can't lecture, so someone else has to do that. I haven't really looked much at what other estates have done. Actually, I work in the dark and by myself. People ask me what I've done. They get ideas from me!

Is there anyone else, other than you, who could handle Herman's estate?

Herman was not exactly a family man. He got away from it as far as he could. But suppose I gave the estate to Herman's family. What would they do with it? He has a brother who's eighty-eight, and a sister who is ninety-four. Then there's a niece, a nephew, a grandnephew—and three grandnieces whom I don't know. I met them once or twice. The nephew is a poet in San Francisco, but I don't think he could be burdened with this, and he doesn't know enough. Ten years ago, Herman's grandnephew, Dani Tull, was too young, but now I'm going to make him the executor of the estate. He's a painter, himself, and a wonderful young man, and he admires Herman and his work—so that's perfect.

I'm lucky. I have a friend, Una Dora Copley, who has two estates to deal with, no children, and nobody to leave them to; when she goes, what do you do?* There's the Artists Welfare Fund, run by Artists Equity, but I don't think they are doing anything with the stuff they are getting. There should be a foundation that houses and manages estates when the artist's widow goes and there are no children, so that the art doesn't just get put on the auction block and disappear. It's a real issue.

Would that be such a terrible thing? In the past, artists' families have taken what they wanted and sold everything else.

No, it's not terrible. But what happens is that you sell it for ten cents to a dollar. Dealers buy it up, and I kind of resent that. I was approached by a dealer and given that option. "I have someone who is interested," this dealer said. I guess he must back him to some

extent; I don't know how it works. For one lump sum they get the whole estate, and then this dealer and this person split the profits as they sell the work. I don't consider $300,000 to be a fair price for a fairly large estate.

What did you say?

I said no because I don't need much money to live. I've lived simply all my life; I'm not going to change now. If I get half a million, or whatever they're going to offer, no, that's not going to make me happier. If I were really in straits, I might. It all depends on the circumstances. Herman wasn't well known, so I would rather take what's left and build up a visual reputation so that people get an understanding. Because he didn't show for twenty years, a lot of people don't know his work of the fifties and sixties. I need to keep it together for the moment to build a picture of who that artist was, what his work was. I'm not greedy. When I go, if there's any money or seed money, one could build a foundation, or give the paintings back to the family.

It takes time for interest to be shown again in an artist who has died. Some people say to me, "So, what are you doing with Herman's work? Are you doing anything?" I find that very offensive, especially knowing what I have accomplished. I have to work, and I have my own life. One has to find a balance. Then, a year later, the same question. I don't think they have a concept of how difficult it is to find a dealer who wants to really work with you, especially if it's an artist who didn't have a big sales record and, for that matter, has no auction record. They tried to make me feel guilty, and I resented that. I've worked most of my life for Herman.

Do you have any family members in Germany who could help?

No.

At the moment, in your will. . . .

I haven't got one! Once a year my accountant asks, "Well, have you made your will yet?" Maybe tomorrow. I'll have to do a quickie before I go on a trip to Europe. You know how artists are about making wills. Herman didn't make a proper will until about two months before he died; his previous one was made in 1975 before we were married. I happened to come across a publication at work saying that the laws had been changed; noncitizen spouses did not have the same rights and inheritance benefits as citizen spouses. I wasn't a citizen. My jaw dropped. So we got cracking because, otherwise, to satisfy the IRS, I would have had to sell all Herman's work. Horrible.

Is there anything you would advise artist-widows not to do?

Artists' widows who are artists themselves try to make, if their husband had a reputation, conditional deals, saying, "You want his work, you'd better show me, too." I think that's a no-no. It has been done a lot. Don't kid yourself. I think Lee Krasner did that plenty, and Sally Avery probably did, too. Also, and I agreed with Herman on this, if somebody curates a show, that person should not include him or herself in a show. But a lot of artists do.

Has Herman's work influenced your own?

I would say that Herman definitely had an influence on me, especially as far as color

is concerned, but I always felt that it was a good influence. I still have a different emotional color, space, et cetera. It's visibly influenced, but it's not as closely related as I've seen in the Avery family.

A final question: When Herman started to show again in the eighties, were things smoother between him and the galleries?

I'm to blame! When people said, "Oh, you've gotten so mellow," he would bristle up—he couldn't stand hearing that. But he was less abrasive, I guess. Maybe his personality had changed a little. When I met him, he had been a bachelor for about twenty-seven years, and a depressive. But a lively bachelor, too! I just ran across a wonderful little misprint. Lawrence Campbell did a beautiful profile on Herman for *Art in America* in December 1990.* There was a description of Herman being this forever-running person who was taking part in a multitude of art-related activities in the fifties. It reminded Campbell of a clock with spinning legs. Gary Snyder had it typed out for his website, but it came out as sinning legs! I said, "This is very appropriate; he would have loved it." But I e-mailed the gallery, "You've got to change that!"

October 2001

UPDATE

The day before the November 2002 opening of Herman Cherry's paintings at Gary Snyder Fine Art, Gary told Regina that he would be closing his gallery and returning to dealing privately. Herman's work once again had "no home." However, since March 2004, David Findlay, Jr. Fine Art has represented the Herman Cherry estate, mounting a one-person show in 2005.

FOR FURTHER INFORMATION

Herskovic, Marika, ed. *New York School Abstract Expressionists: Artists Choice by Artists*. Franklin Lakes: N.J.: New York School Press, 2000.

MAY STEVENS,
WIDOW OF
RUDOLF BARANIK

I want to paint a world of stillness but on the verge of turbulence, motionless yet almost falling apart, a sleep-death landscape yet full of pulsating tension and flux. I want no images which can be described, but I seek an imagery which invades my own consciousness in a disturbing way—white cloth fluttering in the dark, like banners from which the night drained the red.

— RUDOLF BARANIK*

Rudolf Baranik was born on September 10, 1920, into a Jewish family in Lithuania. In 1938, he was sent to stay with an uncle in Chicago because of the escalating political tensions. As a result, he escaped the fate of his parents and sister, who were killed when Germany invaded Lithuania two years later. These experiences would shape his later political convictions and would strongly influence his art. He served in the United States Army from 1942 to 1946, attended the Art Institute of Chicago—supporting himself by working for a Lithuanian newspaper—and began studying at the Art Students League in New York in 1947. Taking advantage of the GI Bill, he lived in Paris from 1948 to 1951 with May Stevens and their son, and studied painting with Fernand Léger. In 1951, they returned to New York. Throughout that decade, Baranik's paintings reflect an interest in the plastic values of the School of Paris, fused with a deep social consciousness.

Subsequently, in developing his socialist-formalist aesthetic, he veered more toward abstraction, while still incorporating semi-figuration and references to geologically exhausted substances. In the *Napalm Elegies* (1967–1974), created during the Vietnam War, shrouded shapes emerge incandescently from the darkness on a textured surface of blacks and suffused light. In the early eighties, he began using words in his paintings—line after line of indecipherable poetry or letters on canvases of a cool night light—which he described as incantations to his son, Steven, who died in 1981. Baranik's experience as an activist and innovative artist were applied to a long teaching career at the Art Students League (1947–1996) and at Pratt Institute (1968–1996). In 1997, he and May Stevens moved to Santa Fe, New Mexico. He died there on March 6, 1998, at the age of seventy-seven.

May Stevens, born in Boston on June 9, 1924, grew up on a tidal inlet of the Atlantic in Quincy, Massachusetts, the daughter of pipe fitter Ralph Stanley and Alice Margaret (née

Dick) Stevens. Graduating in 1946, with a B.F.A., from the Massachusetts College of Art in Boston, she went on to study at the Art Students League in New York City, where she met Rudolf Baranik. After marrying in 1948 and moving to Paris, she briefly attended the Académie Julian, and then painted at home after their son, Steven, was born. In 1951, she completed her first political painting and, since then, she has been committed to socially engaged art. The *Freedom Riders* series was first exhibited in 1964 at the Roko Gallery, New York City, with a catalogue introduction by Martin Luther King, Jr. Her *Big Daddy* series (1967–1976), started during the Vietnam War, explored the ambivalence she felt toward her father, who was pro-war and pro-establishment. This was followed by the *Ordinary/ Extraordinary* series (1977–1984), which juxtaposed images and words of her mother, Alice, with those of the communist heroine Rosa Luxemburg. In 1981, her son, Steven, suffering from borderline schizophrenia, committed suicide by jumping off the George Washington Bridge. Since 1990, beginning with the *Sea of Words* series, her work has become increasingly lyrical, addressing themes of loss and absence through the imagery of rivers, other bodies of water, and boats.

The psychoanalyst and artist James W. Hamilton, who writes on creativity,* hearing of my project, introduced me to May Stevens, who had recently been widowed. A painter herself, she was now in the position of looking after the estate of Rudolf Baranik, as well as planning for her own legacy. We talked on the phone and met at exhibitions of her work at the Mary Ryan Gallery in New York City, and at the Jersey City Museum, where, in tight black leggings, loose tunic, and high-heeled boots, she gave a gallery talk (2003) on Rudolf Baranik's *Napalm Elegies*.

· · · ·

When we first talked, you mentioned the possibility of a foundation for Rudolf's work and yours. How have those thoughts developed?

I've hardly done anything on it. I have been approached by people connected with some institutions for my archives—especially those related to feminism. But I have said no because it would be more creative and useful to find a college or university interested in taking both my work and papers and Rudolf's.

Rudolf and I were extremely active in the political artists' movements during the sixties, seventies, and eighties in New York. In fact, Rudolf was responsible for getting artists such as Leon Golub, Jack Sonnenberg, Phoebe Helman, Nancy Spero, Irving Petlin, and me involved in Artists and Writers Protest Against the War in Vietnam. On July 27, 1965, we bought a full-page ad in the *New York Times*, which said, "END YOUR SILENCE"; six hundred people gave ten dollars each. We went on to organize many exhibitions, and such things as "The Angry Arts Week" in 1967. It was a full week of activities, with street theater; an exhibition at New York University's Loeb Center, which Max Kozloff, former editor of *Artforum*, called "A Wailing Wall"; a leaderless concert at Town Hall at midnight; and flat-bed trucks that brought poetry readings around the city.

Since we were so active, we have many papers, publications, and posters. Rudolf designed several famous posters that are reproduced in poster anthologies. In our two lofts at 97 Wooster Street in Soho, we were constantly at our painting, but also having meetings—my feminist meetings on the seventh floor, and Rudolf's political meetings against the war on the sixth. I was one of the twenty women who founded *Heresies: A Feminist Journal on Art and Politics* in 1977; my art and writings appeared in it often, and my ideas helped shape the magazine for a dozen years or so. So, I'm looking for the perfect place, and someone who could be trusted to put this project into being.

That's a magnificent plan.

Yes. But it would take a lot of time to set up the trust and to find funding. The trouble is that most of my friends are of a similar age, and one needs representatives from the younger generation. I'm trying to do my own work—painting and printmaking and writing—and I'm often asked to do special projects, to teach, and to do speaking gigs.

But, since Rudolf died, you have also had to put in a good deal of time on his estate.

Yes. I probated his will. With the appraiser, I went over every painting, both in the Santa Fe and New York studio—some one hundred paintings, and works on paper. When the curator from Tucson came to plan the 2000 exhibition at the University of Arizona Museum, I had to take all the paintings out, unwrap and show them, and then they had to be rewrapped. That exhibition and the one at the Jersey City Museum were planned prior to his death. I spoke on Rudolf's work in Tucson, as did David Craven, Rudolf's biographer, and Donald Kuspit, a critic who supported his work long before his death and has continued to do so ever since. There have been other group exhibitions that he has been part of, that I have also worked on. And, of course, I worked on the catalogue for the Jersey City show. I thought I would do the design myself, but I was very, very busy with my own work. I gathered the essays, wrote mine, and edited the others when necessary. The museum sent me the design for approval, and I made changes. There was also all the phoning and faxing before the shows opened, and all those things that Rudolf would have done for me.

Would he have?

Of course. We always did these things for each other. He was *extremely* supportive of my work, and talked about it all the time. It was easier for him to talk about mine than about his because he didn't like to push himself forward. He believed that I was very talented. If he were writing an article on some aspect of art and politics, which he did a lot, he would always include me. The longer piece he wrote on me was published in David Craven's book.

Your own exhibition at the Boston Museum of Fine Arts in 1999 was dedicated to him: "For Rudolf Baranik, who went with me every step of the way." Did you always find ways of acknowledging him?

Of course, but I was, and am, a very strong feminist, and I realized that if Rudolf's career had become a lot more important than mine, I would have been miserable. Luck-

ily, he never felt threatened by my fame because of his own self-confidence. Actually, I got more notice than he did, largely because of feminism.

So, you now have two impulses: to keep the archives as well as your work and his together, and to get his work out through galleries and sales?

The two ideas support each other. The better known his work, and the more its reputation grows, the more desirable some kind of center would be.

Are you actively looking for a gallery for him?

I am always looking.

You weren't able to use the exhibition at the University of Arizona as a springboard for finding a gallery in New York?

New York isn't much impressed by what goes on in Tucson! Nor was it that easy to persuade people to go to Jersey City. But I'm working on both our careers as much as possible. I got, for example, a call from a curator of the Barcelona Museum of Contemporary Art, who is setting up a citywide antinuclear set of exhibitions in May 2004 and wants to include a wonderful work of Rudolf's that she has seen in a catalogue. So this kind of thing happens. Just this morning I received a paper by David Craven, based on the talk he gave at the symposium we had in New Jersey [2003]. It's really extremely interesting, a new interpretation of Rudolf's work.

Yes, many people stress how important it is to have scholarly support in promoting an artist's reputation. You certainly speak as though you can count on that.

Yes, Lucy Lippard, Donald Kuspit, and David Craven have often written on Rudolf, and the Jersey City Museum catalogue will spread the critical opinion further. There was a huge mailing of that catalogue, and I'm still getting responses to it. You know Rudolf's expression "socialist formalism"? He stands out as someone who was unwilling to sacrifice either the formal qualities or the import they carried. I feel that Rudolf's work is alive and especially relevant today, where we're back at war, back to bombing and killing people.

Could you talk more about your own political involvement?

There were lots of shows and articles about women's work. We went on lecture tours and traveled this country and abroad, talking about our work and also the work of other women artists. We didn't fit into a stylistic group, but our political involvement, which showed up in our work, made a community for us. Throughout the antiwar movement, we created our own venues, our own publicity and magazines. Guerrilla Girls were constantly putting up posters all over SoHo. The first posters said, "These artists"—they listed all these male artists who were well known—"are in galleries which show no—or less than 10 percent of—women artists in their galleries." It had tremendous shock value! We were willing to put all our time and energy into furthering a cause and coming up with outrageous ideas. You know, Guerrilla Girls wore gorilla masks.

Were you a Guerrilla Girl?

We were all Guerrilla Girls.

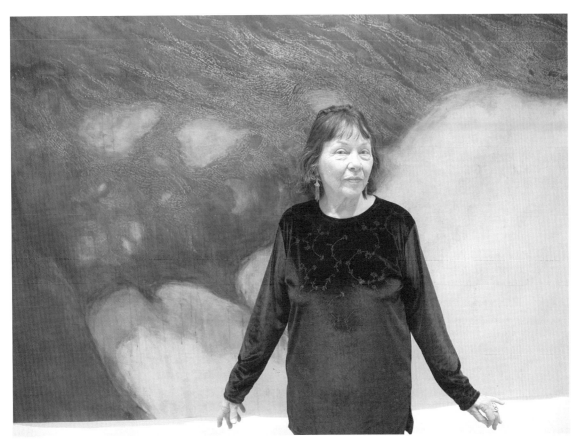

May Stevens at an exhibition of her work, Mary Ryan
Gallery, 2003. Courtesy Mary Ryan Gallery.

Was it mainly the universities that responded to the social-political implications of your work and Rudolf's?

They have the greater freedom and are not about selling. We never intended to make our living by selling art because, if that's your goal, then you tailor your art and make it saleable. We supported ourselves through teaching. We had to love and value our art, and we didn't expect Rockefeller, head of the Museum of Modern Art, to buy our art, with its political position.

What other political issues did your group take on in the sixties, seventies, and eighties?

Rudolf was very passionate about Civil Rights. He did a piece on Emmett Till, who was accused of whistling at a white woman in 1955 and murdered. Rudolf also did work on Attica. He and the black artist Benny Andrews did a book in 1972 on the prison rebellion, and Rudolf got many artists to contribute work to commemorate the slaughter of these mainly black prisoners.

Rudolf seems to have had a wonderful ability to bring artists and people together?

"Rudolf and May Square Off in Conversation," November 1997. Photo: Patricia Hills. Courtesy Patricia Hills.

Absolutely. People trusted him. There was nothing flamboyant about him, just as in his paintings there is nothing flamboyant. He was very gentle, kind, and humorous—and very, very smart. The basic thing about him, Magda, is that he trusted his own instincts; he didn't care what other people thought. You couldn't put him down because he knew he was right—which, in a way, is an obnoxious quality—but he knew he was right, and he was!

It also seems that he loved a good discussion.

He loved arguing! To live with him I had to learn how to argue. He was always arguing pro-Marx, and I was arguing pro-Freud. We had a wonderful relationship.

How did he deal with your passion for feminism?

He made it possible for me because it really, in a way, took over my life. He would stay home and take care of things there, and I would go out to meetings. We always shared the responsibilities, not in a programmed way, but just according to what needed to be done. We would often have these dinner parties for artists and, as I became more and more of a feminist, my conversation totally revolved around preaching feminism. The way Rudolf handled it is that he adopted feminism, and he spoke more about that than I did. He didn't give me a chance. It was infuriating, and so smart! He was fascinated by feminism and read all the literature. Some of my friends thought that he was too patriarchal, too opinionated, too arrogant. He would simply reply that those were his opinions, and anyone else was welcome to hold other views and to voice their opinions. As the movement became stronger and all of Rudolf's friends had to deal with their wives and girlfriends, most of them became very supportive.

When I read that you had become pregnant so quickly, I thought that surely you would have had to step back from painting. Then I noticed that you had your first one-person exhibition during the time that you had a baby.

Yes. Even when I stayed home with our son in Paris, I knew I had to paint, and I could

MAY STEVENS | 99

because Rudolf always helped with our child. Here are two stories from those early days. When I was in Paris, Rudolf brought his professor over. I cooked dinner. He looked at my work, and he said, "This work is not honest." I said, "What do you mean?" He answered, "It's too strong for a woman." You know, the Guerrilla Girls have a poster that says, "It's even worse in Europe." And, do I know it!

Then I came back to New York. I approached a gallery there. The director took me into his office, and I put my two little paintings against the wall. He seemed to be very interested as I talked about them. At the end of the interview, he said, "Why does a girl as pretty as you are want to paint?" I had been thinking, "Oh, I'm going to have a show!" So, I was confirmed in my belief that I would have to really fight to get somewhere

I'm amazed that you found the time to pursue art and to engage in political activities.

I have always thought that people have "enough time." I always had enough time and enough space because I made sure I had a big studio—that was essential. As far as time goes, we always simplified our lives. I didn't have anything in the house that I didn't need. I didn't want fancy furniture because I didn't want to take care of it. Our circle consisted of artists, family, dear friends—we didn't have to build an elaborate social life.

I know that you both taught for many years. Were you lone voices at Pratt and at Visual Arts?

Not at all. Others were as politically engaged. Those were the people we sought out as friends.

Your husband is quoted in David Craven's book as saying, in 1976, "But the fact is that my work, like the work of a handful of other American artists who have responded in moral outrage to the war in Vietnam, has been largely ignored by the museums." Has the situation changed significantly since then?

Somewhat. This kind of an approach does not leave you out. It just means that it's harder. But, if you're good, determined, and you are totally honest, you stand out.

Then you feel that your efforts, on behalf of ethnic minorities and women, to be represented in the Whitney and other institutions have borne fruit?

Absolutely! Look at the women artists that are known now. Louise Bourgeois, Elizabeth Murray, Barbara Kruger, and Sherry Levine have represented the United States at the Venice Biennale. Women are all over the place. Compare the income that women make from sales with what men make—it's outrageous—but it has improved, and it only improves when you make a fuss about it.

Ultimately, despite your reservations about the policies of some major museums, you would like Rudolf's work and yours to be shown there?

The Whitney, the Modern, the Brooklyn Museum, and so many others here and abroad own work by both of us. Rudolf is represented in the Hirshhorn, the Modern Museum in Sweden, and the Museum of Contemporary Art in Vilnius, the capital of Lithuania, where he had a major retrospective. I have work in the permanent collections of the San Francisco Museum of Modern Art, MOCA [Museum of Contemporary Art] in

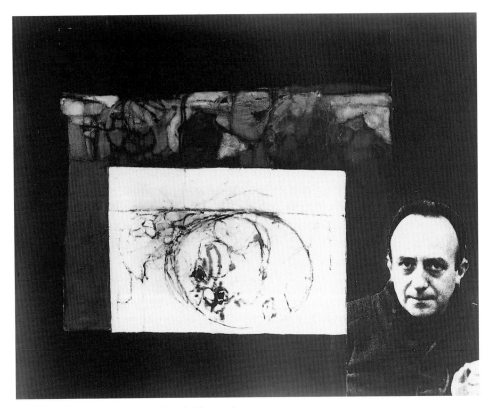

Rudolf Baranik with a painting from *Napalm Elegy* series,
made during the Vietnam War, early 1970s.
Courtesy May Stevens.

Los Angeles, the National Museum of Women in the Arts in Washington, D.C., the Joslyn
Museum in Omaha, Nebraska, and others.

**Does the fact that Rudolf was Jewish help in showing or selling his work? There is, for
example, the Jewish Museum in New York.**

He was not very religious, but there was a show called *Jewish Artists on the Edge* at Yeshiva
University Museum, New York City, which I put his work into, although I wasn't sure he
would have liked that.

**I noticed that you had donated a very beautiful painting of his to the Jersey City
Museum [*Napalm Elegy 21*, 1972, 72" x 48"].**

Yes. It's a small museum, and they don't have money, but they have taste and do a good
job. Alejandro Anreus, the curator of Rudolf's show, is a committed person whose star is
rising. It was hung in the room adjacent to Rudolf's show last year, and you had a very
long vista for it. The wall was gray, and the lighting was perfect.

Do you have a policy of donations?

Well, I gave a painting of mine to them as well, since they asked me for it and were

working on Rudolf's show. Alejandro, who is no longer curator at the museum, was try-
ing to build a politically conscious collection for the museum. That's just what Rudolf and
I would support. You probably noticed that everything in that adjoining gallery reflected
political, ethnic, or gender concerns. There are well-known names—Lorna Simpson, for
instance, who, in her very subtle, minimalist, and conceptual way, is asking for recogni-
tion of the way black people have been treated. There are a lot of Latin Americans who are
very conscious of discrimination, which shows up in their work. There are some gay peo-
ple—like Lyle Ashton Harris, who is a young black man who loves to go around in ballet
costumes. He's a photographer, and he makes giant photographs of himself all decked out
in various ways. Glenn Ligon is another black man whose work is very important, and he's
had shows all over. Accepting the moral responsibility for an art of social significance does
not leave you out. It puts you in a different category. These are the things that matter to
me, and these are the things that mattered to Rudolf.

In 1986, Rudolf took a show of artists' work to Cuba. He invited feminists and anti-
war protesters, including the sculptor Mark di Suvero, Joyce Kozlof, Miriam Schapiro, and
Michelle Stuart, et cetera. We sent fifty works, and then, instead of bringing them back,
we all agreed to donate them. It's in Rudolf's article in *Art in America* [March 1987].* In
fact, there's a show in the National Museum for Fine Arts in Havana right now [2004]
called *From Picasso to Keith Haring*. It includes works that Cuba acquired from Picasso, Keith
Haring, and others, plus the fifty works that Rudolf oversaw the donation of. David Craven
has taken his students there for two weeks. A friend of mine, Jaune Quick-to-See Smith, a
Native American, also went with a group from the Massachusetts College of Art. This is
not what reaches the top of the news about who's "in" in the art world. I mean, Robert
Motherwell is an interesting artist, but why the hell does he get so many museum shows?
The answer is purely money. The trustees of the Museum of Modern Art in New York con-
tribute to the museum, and they buy paintings from the curators' A-list. They don't want
these paintings to go down in price, so those artists are constantly paid attention to.

Have you stepped back from political activism now that you are living in Santa Fe?

I would not say so. I am, at the moment, engaged in making an artwork for an exhi-
bition that is going to be called *The Damaged Book*. An individual, who is anti-gay and against
discussions about sex of any kind, went into the San Francisco Public Library and
destroyed a large number of books. So someone has decided to do an exhibition about
that, and forty-four artists have each been given one of the damaged books and asked to
create a piece of art. I am one of four artists who will be videotaped in the process of mak-
ing the work. The tape will be shown here in June, along with a huge show with a cata-
logue—everything will be illustrated—at the Center for Contemporary Arts of Santa Fe.

Have you been involved in other similar ventures recently?

In 1999, I had the exhibition you mentioned at the Boston Museum of Fine Arts, with
a fine catalogue and a videotape of me talking. The museum acquired a major work, *Go
Gentle*; another major painting, *Fear and Desire*, was sold to a couple who had their architect

redesign the house they were building to accommodate the twelve-foot painting, which they will donate to the museum in ten years.

There was a traveling show here called H_2O, which I was in, organized by Jo Anna Isaak, a well-known curator. She used that very simple and noncommittal title because she wanted different kinds of responses. Out here in the Southwest, it's a very ecological issue, and some of the works dealt with that—the scarcity of water.

I am also in the traveling exhibition called In the Spirit of Martin, about the legacy of Dr. Martin Luther King, Jr., with artists such as Andy Warhol, Robert Rauschenberg, Jasper Johns, Romare Bearden, and Martin Puryear.

Could we now touch on a more personal matter? Rudolf has written very movingly about the death of your son:

> As the '80s rolled around, all the elegies—napalm, earth, stars, sky—were things of the past. I did a painting now called Words I. It had a subtle, holistic pulsation, writing which remained enigmatic, a discontinuous text of poetry, letters. But to me it was also an incantation, a plea. Our son, Steven, was struggling to maintain a balance, to hold on, and we tried many ways, without knowing which was the right one, to help him to life. In 1981 he left, having written to us an elegant farewell note which ended with "thanks Earth, Namaste."*

Could you comment on the way this loss has figured in your paintings?

When I was at the Bunting Institute at Radcliffe [1988–1989], I met a woman, Civia Rosenberg, who did an exhibition based on her son's death. We were in a loss group together. After I left, I asked Civia if she would like to do a joint exhibition with me that we would call Crossings, using images of our sons. It was shown at the DeCordova Museum and Sculpture Park in Lincoln, just outside of Boston. These were the specific things we did, but I think there may have been other ways in which we responded to our loss.

Was there an ongoing dialogue between your paintings on the top floor and Rudolf's paintings one floor below?

It's hard to pinpoint, but there's no question there was a constant interchange. We always looked at each other's work. When I started Big Daddy, which was my political work during the anti–Vietnam War protest, Rudolf came into my studio, saw this cartoony image that I was working on—this big, fat, naked pink guy with a bulldog in his lap— and said, "Are you crazy?" I said, "Leave my studio, and don't come back until you're invited!" We were very honest with each other. We talked and worked together constantly, which didn't mean that I always liked what he did, and he didn't always like what I did.

I note that you both use words in your paintings.

In Heresies, each issue had a theme, and we found that, in the visual images, many women used words. I remember thinking that, when it mattered to you so much to get your idea across, you often wrote about it, in it, around it; you were so desperate to push

it out there, to get it to come off the wall, to get people to listen, pay attention, and change.

I used a quotation from Pablo Neruda and made a work with nothing else but this, written in capital letters in English and in Spanish. I used graphite on a panel six feet tall and three feet wide. It says, "The blood of the children in the streets is like the blood of the children in the streets." There is nothing that you can say to make it worse. You can't take it further.

Do you feel you have gotten somewhere?

There's always further to go, more work to do. I have a New York gallery. I live in Santa Fe. I'm respected here. There are two books being written on me.

Can you tell me about them?

Well, I can't talk too much about them because I don't know when they are coming out. They're impressive. One of them is by a feminist theoretician, and the other is based on interviews. They will hopefully be coordinated with the touring exhibition that is in the works. The first showing is at the Minneapolis Institute of Art in 2005.

Wonderful. One last question: Is there any very personal way that you have chosen to remember Rudolf?

I have his work hanging in the house, and then I've also made a shrine for him—with photos, candles, flowers—in much the same way as the local New Mexicans do. And, finally, my large paintings of water from the last few years are of sites Rudolf and I visited together. They all contain or refer to his ashes, which I scattered there with friends and people who loved him.

October 2000 and January 2004

For Further Information

Rudolf Baranik

Craven, David. *Poetics and Politics in the Art of Rudolf Baranik*. Foreward by Elizabeth Hess. Atlantic Highlands, N.J.: Humanities Press, 1997.

Rudolf Baranik (catalogue). Essay by Lucy Lippard. Tucson: University of Arizona Museum of Art, 2001.

Rudolf Baranik: The Napalm Elegies (catalogue). Essays by May Stevens, Alejandro Anreus, David Craven, Donald Kuspit, et al. Jersey City: Jersey City Museum, 2003.

May Stevens

May Stevens: Images of Women Near and Far, 1983–1997 (catalogue). Boston: Museum of Fine Arts, 1999; published by Mary Ryan Gallery, New York, 1999.

May Stevens: Rosa / Alice, Ordinary, Extraordinary (catalogue). Gambier, Ohio: Kenyon College, 1988.

FOUR

UNFINISHED DIALOGUES:
The Artist and the Gallery

More than once the artist-dealer relationship has been compared to a marriage. Acts of seduction and rituals of courtship may well characterize the exchange, perhaps ushering in an extended honeymoon period. But just as likely, suspected betrayal, open conflict, and eventual separation will follow. Recent scandals and examples of corrupt and irresponsible dealers have created visions of insatiable greed in the public consciousness, while images of temperamental and driven artists have inscribed scenes of explosive encounters in our memories. Thus, it comes as no surprise that alliances between dealers and artists are almost always at risk and are frequently short-lived. The artist—or the heir who stands in the artist's place—desires continual recognition and absolute fidelity, while the gallery, by its very nature, is a place of divided loyalties.

For widows or other heirs, the search for gallery representation is often the most arduous ordeal of their new duties, the fear of rejection or exploitation at times paralyzing them. For their part, dealers are wary of taking on disorganized estates, difficult personalities, or heirs who have not already assumed the responsibilities of maintaining records and caring for the work. To varying degrees, both are aware that the economics governing the gallery make eventual abandonment an unspoken but continual possibility.

Jeanne Bultman and Stephen Schlesinger offer what seems to be an ideal relationship between widow and dealer. A sense of calm and equilibrium issues from their words, and their long partnership is defined by mutual respect and admiration. He appreciates the seriousness and skill with which she performs the demands placed on her, and she is grateful for his devotion to her husband's art. Neither pressures the other, and both are willing to accept somewhat modest goals. Although he doesn't expect a sudden and enormous change in Fritz Bultman's reputation—the work is "much too tough for most people"—he is committed to putting on one "elegant" show each year, confident that recognition of the artist's importance as an Irascible will come at the right historical moment. Schlesinger leaves us, however, with no illusions as to what the stakes are for the widow: without time and money, and energetic efforts to preserve and care for the paintings, "you might as well burn them."

What happens, then, when a widow has neither the stamina nor the skills to take on the huge responsibility that Jeanne Bultman has assumed? For an artist-widow like Anne Arnold, who is completely overwhelmed by such demands, the innovative project of

gallery director Anita Shapolsky is a much-needed lifeline. Anxiety-ridden about her inability either to handle her husband's estate or to concentrate on her own career, Arnold has increasingly relied on this dealer, and is thinking of turning her husband's estate entirely over to her.

Aware that estates often fall between the manipulators and the desperate heirs, Shapolsky envisages her nonprofit educational foundation as the repository of estates of artists who have neither heirs nor sufficient funds to store, preserve, and expose their work. Admitting that she would buy the estate at well below the market value, Shapolsky insists that her mission is, nonetheless, a social-minded one; it offers peace of mind, a possible share in any sales to come, and a commitment to the "intrinsic value" of the legacy, which goes far beyond its dollar worth.

If ever we needed confirmation that the hopes of dealers might unexpectedly be realized, the interview with Jeffrey Bergen, director of the ACA Galleries, provides it. His account of managing the Romare Bearden estate is fascinating in its description of the unusual way the estate was bequeathed; the particular problems this engendered; and the immense increase in value it has gained since 1989, when Bergen staged his first show of this African American artist, whose recognition was delayed until the time was ripe.

D.C.

JEANNE BULTMAN,
WIDOW OF
FRITZ BULTMAN

Fritz Bultman was one of the most complex men I have ever known—at once, generous and acquisitive, calm and temperamental, snobbish and democratic, loyal and vindictive, religious and heretical, slow-spoken and quick-witted.

—B. H. FRIEDMAN*

A. Fred Bultman, born on April 4, 1919, into a prominent New Orleans family, was the second child and only son of A. Fred and Pauline (née Gschwind) Bultman. His father owned the House of Bultman, a Catholic funeral business, and his elegant mother entertained extensively. Fritz went to Munich on a high-school junior year abroad program in 1935 and boarded with artist Hans Hofmann's wife, Maria. He met Hofmann, himself, when he returned to the States, studying with him in New York City and Provincetown, Massachusetts, from 1938 to 1942. With Hofmann, he found "the world I had always wanted to know"* and a more nourishing relationship than he had with his father, who had urged him to become an architect. In 1943, he married Jeanne Lawson. By the late forties, he was participating in exhibitions with other emerging abstract expressionist artists, and was one of the eighteen Irascibles who signed the May 22, 1950, letter of protest to New York's Metropolitan Museum of Art. His early canvases, with their rough, painterly surfaces, suggest a fusion of geometry and mythological symbolism.*

Between 1952 and 1956, suffering from frequent bouts of anxiety and depression, Bultman produced very little work, but resumed painting and sculpting after an intensive period of Freudian analysis. Beginning in 1962, large-scale collages, using previously painted paper that was then torn or cut, became a major preoccupation. These grand abstractions—with their shapes of strong, exuberant color—integrate the long sinuous lines of Bultman's figurative drawing and the symbolic signs he favored (the Y, infinity, and the yin and yang of sexual parts). In 1976, he began making related stained-glass windows, which were soon executed by his wife, Jeanne. He died of cancer on July 20, 1985.

Jeanne Lawson Bultman, the youngest of three daughters, was born on November 7, 1918, and brought up in Hastings, Nebraska. Her father, Gayle Lawson, owned the local hardware store, and the family of her mother, Luella (née Brach), was in the dry goods business there. She spent two years at Hastings College (which was founded by her grand-

father), taking general studies, and then she headed east to New York City in 1939. She studied pattern and dress making for one year, did some fashion modeling, danced in nightclubs, and then took up bookkeeping. She met Fritz Bultman in 1942 while working as a model at the Hofmann summer school in Provincetown. They were married in 1943, and their two sons, Anthony and Johann, were born in 1945 and 1948. They lived in Provincetown year-round from 1945 to 1952. Thereafter, they were based in New York but returned to Provincetown for approximately five months each year, where the sea and the garden provided constant inspiration. Since Fritz's death in 1985, Jeanne has continued this routine, while managing her late husband's estate. Her varied interests include volunteer work in a New York soup kitchen.

On May 31, 2000, I visited Jeanne Bultman in her brownstone on East 95th Street in New York. Tall and stately, with her hair swept up behind her head, she had prepared one of her delicious soup lunches. We sat surrounded by several of her late husband's large, powerful abstract paintings. Generous with her advice to me on previous occasions, she now told me more about her life with Fritz and her work with the estate.

. . . —

Can you tell me how you first met Fritz?

A friend of his drove me to Provincetown in the summer of 1942. He said, "I think you and Fritz will get along very well." Since I had been posing at the Art Students League in New York, he suggested that I work for Hans Hofmann.* And that's the way we met. Fritz had been a student of Hofmann's since 1938. Modeling kept me going all summer. We all went to the beach every afternoon.

Once you met Fritz, were you quite happy to abandon your own career?

Well, I didn't really have a career. I left home when I was twenty and never really went back. I went to a fashion school here in New York for a year. One thing led to another, and I got into modeling on Seventh Avenue because I was so tall. From modeling, I got into show business. It wasn't really dancing. You just paraded around. I did it for three or four years with other friends, and it was great. Then I got involved with bookkeeping at the Plaza and the Sherry Netherlands, which gave me a good salary until we got married.

Did you ever model for Fritz after that first summer?

Oh, yes, early on and a little bit later; but when he began drawing from the model regularly in 1957, he wanted the bodies of girls of about eighteen. In New York, the models from agencies were always kind of stiff and didn't work out too well. The ones he found in Provincetown were usually friends or friends of friends, sometimes girls who waited on tables and needed a little extra money. There was an ease to it. They could sit there, and he'd draw them, and they could talk.

You and Fritz returned to Provincetown to live?

We were married at Christmastime in 1943, and we went back to Provincetown in the spring, borrowing a place up there. Then we found some land with a little shack on it

and, eventually [1945–1952], we lived there year-round for eight years.* Fritz would go down to New York from time to time to get his art business going. He began to show in 1947 at the Hugo Gallery, and had another show there in 1950. I would stay up in Provincetown with the children.

Did you know what you were getting into when you started going out with Fritz?

No, I certainly didn't! I had no idea. Mrs. Hofmann had tried to tell me that you just can't marry an artist and have children. But I really didn't listen to her. I don't think that anyone who marries an artist quite knows what she is getting into, unless she is an artist herself. I didn't. He was one of the first artists I met, so I didn't have much to go on. I was looking for something new, and it certainly fulfilled that desire!

Did Fritz automatically assume that his work would be the main focus of your lives?

I think so. It already was the main focus before we were married.

Did you see yourself as an enabler?

You have to be if you are married to an artist. They're different from other people. They really are. You have to help them a lot at certain times—when they're down and depressed, and work's going wrong. But that's part of being a wife.

When you lived up in Provincetown year-round, was that a good period?

It started well, but we were isolated in the country without a car. It got a little rough, and Fritz's work wasn't going well. He painted the same thing over and over again, scraping off what he had done. We realized we had to do something; the children were getting a little older, and they needed a better school. So we came to New York for a couple of weeks in 1952 and started looking around. We found an apartment through a friend and left the children with their grandparents in New Orleans for six months until we got straightened out in the city. But, even after Fritz had teaching jobs at Pratt and Hunter and various visiting artist positions, we could still go to the Cape for summers, over Christmas, and for other holidays, too. That worked out pretty well.

Every marriage obviously has ups and downs, but what sustained you through the period when Fritz was having intense emotional problems and was in analysis, from 1952 to 1956?

Jeanne and Fritz Bultman with Anthony, Provincetown, N.Y., c.1947. Courtesy Jeanne Bultman.

Fritz Bultman in his Provincetown studio, 1947.

Photo: Maurice Berezov. Courtesy Jeanne Bultman.

I always had things to do and people to see, and I knew other artists' wives who had the same problems. I can't really nail it down any more than that. And we were always building or renovating in Provincetown or in New York, so that all helped to get me through a bad time. Then things got better.

Did Fritz ever talk about his expectations for his work?

He and the other artists in the early fifties and sixties who were just beginning to show didn't expect very much. Prices were very low then. If you had a sale, it was great; it was so unusual. Fritz just wanted to keep on working. He would say to me, "Listen, you can't ever count on living off the sale of art. So it's a good thing you have your rentals." And we did. I have two rentals in Provincetown and one here in New York, and he was right.*

Did you look after the business side for him, too?

Well, not a whole lot. He would keep his own records and write his own letters. After he taught at Hunter [1959–1963], he was invited to lecture at various places around the country, and he would arrange all that himself, too. It wasn't necessary for me to help at that point. He knew I was knowledgeable and could take over when he died.

Jon [Schueler] always used to take me along to galleries for business talks. Did Fritz want you to do the same?

No, that was not part of my role, not at all. He made his own decisions, very definitely, about galleries and whom he wanted to show with.

Robert Motherwell, in his beautiful tribute to Fritz in 1988, describes him as "one of the most splendid, radiant and inspired painters of my generation," but then wonders whether his work has been underrated: "Perhaps, with his explosive temperament, he was not very adept at playing the New York gallery game."*

That's so. He did have an explosive temperament. He blew up quite a lot with dealers and friends. But not with me! We had that figured out early on, I guess.

Did Fritz always have his New York studio in the house so that communication was easy?

No. Before we bought this house in 1956, he had a separate studio across town, but he had so much trouble getting to it and staying in it. Here, with his studio at the top of the house, it was very easy. If he wanted something to eat, he'd come downstairs and get it. And if he woke up at night and wanted to look at something, he could. A lot of fellows don't like that kind of situation at all, but it worked for him.*

Were you totally in charge of the children?

No. We really did things together, and that's what helped our marriage. He did a lot with the children, too, because being an artist, he was home more than other husbands. Other artists' wives would say, "I wish they would go away from nine to five," but we sort of worked things out as we went along. We had a lot of trouble with Johann and Anthony when they were teenagers but, finally, they grew up.

Was it your particular decision to have children?

No, the decision was totally made together. It didn't just happen! After we had two, I

suggested that I'd like to have two more, and that's where we differed. He said, no, two is enough! And that was all right with me.

When the children left home, did your life change in any way?

We were delighted to have more time together without interruptions. Fritz kept right on working just the same.

Did you then become more involved in his work?

Yes, because I started doing stained glass after 1976.* I was good with my hands, you see. So I went to a teacher, and it took me about two years to get good at it. I worked from Fritz's collages, but I still needed his input for the artistic pattern. You have to plan for small enough pieces so that they can be cut and put together. I couldn't have done that by myself. I took over the south part of the top floor, with Fritz in the north. He would keep coming in to see what I was doing and, of course, he picked all the colors. We had a couple of commissions,* and others we just sold. It was a fun time. After he died, I tried with a student of his to do it for a while, but I lost interest. It was doing it together that kept me going.

Could we take up the matter of the Bultman estate? When Fritz died in 1985, had he specified in his will what was to happen to his paintings?

Fritz Bultman in Provincetown, 1980. Photo: Renate Ponsold.
Courtesy Jeanne Bultman.

He left everything to me and to my discretion. He knew that I would take good care of his work, as it was important to both of us. We talked a great deal about it because he was ill with cancer for four years before he died.* He wanted Steve Schlesinger to continue to represent him, which was fine with me.

Do you think that he realized the enormity of the task?

I think he did, as many friends were also in this situation. He had gone through the work, particularly the drawings, and thrown a lot out, which helped a great deal. Every artist should think of that. He eliminated things that he didn't want ever to be shown, mostly student work that he didn't feel was up to his level.

In a general way, what did he want for his work?

Well, he was very realistic. He knew it couldn't fly high. He just wanted it to go along, being shown as much as possible. He didn't have that huge a body of work, which was very fortunate for me. Let's say five hun-

dred pieces all together. That included the sculpture and oil paintings, collages, and about two hundred and fifty drawings. It's possible for one person to keep track of an inventory of that size.

He didn't consider setting up a foundation?

No. He hadn't sold that much. Since not much money was involved, there was no reason for a foundation.

I suppose the job has developed over the last fifteen years since his death?

Not a whole lot, because the number of sales has continued about the same as when he was alive. We sell about twelve a year.

Looking back, what are you particularly proud of?

Mostly keeping the inventory straight because I hadn't done much, and Fritz had done hardly any of it. People put it on computers or disks now, but I just used the old-fashioned index card—it has a little slot to put a slide in. It's really just for identification. I arrange the cards chronologically so you can look up an early work by the year, and you recognize it by the slide. It took me about five years to do this, really working a lot. I went to a photography school here and learned how to make slides. So, I do feel that I have accomplished a lot by organizing the inventory. It comes in *very* handy when a painting turns up that we had no record of—not very often, but it has happened.

First you completed the inventory of what you actually had?

Exactly, but I also had some records of what had been sold by galleries Fritz had been associated with. For instance, he was with the Kootz Gallery in 1952 when there were quite a few sales, and I had those records of names and addresses. I could usually get a date and a price from other galleries, too. I did write to many of the owners to check what they had and to try to get slides, but a lot of people didn't respond. It's possible they've moved or weren't really that inclined to help, or whatever. But I did try to complete the records, and I enjoyed doing it.

Are there other things you've worked on since Fritz died?

Well, having a show every year at the Gallery Schlesinger necessitates pulling things out and looking at them. Very often restoration has to be done, or reframing, or both. You cannot show a painting that's not in good condition. Steve also sends out other shows. Last year we had four exhibitions* around the country—usually galleries, not museums particularly. However, the Staten Island gallery did have a pretty big show last year. That came through Diane Kelder, who was always interested in Fritz's work. She was leaving her job and wanted to give Fritz a big show before she left. She kept it to drawings, about thirty-five to forty, that spanned his whole career. We sometimes get a request like that, which is very nice.

Are there special geographical areas that Fritz was connected with?

Well, I wish I had more. He went to school in Chicago, and we had tried to get a Chicago venue or even a gallery, but were unable to. Of course, a big show in New Orleans* came about because he was born and lived there until he was sixteen, and his father and sister were involved in the museum.* Then, since we had always summered on

Cape Cod, the Provincetown Art Association and Museum also took that traveling show. But it's hard. Fritz never had any connection with California—he never even went there— but I would like a West Coast venue very much. Steve [Schlesinger] has tried but, of course, Fritz's work is totally unknown out there. So, geographically, we haven't been able to spread out nearly as much as I would like. We had a gallery in Paris for many years, and he did sell there. But that was in the sixties, and it's too long ago. In any case, the gallery is half way out of business, so it hasn't had a show of his for a long, long time.

Has Fritz had a scholar or a curator particularly interested in his work?

Maybe. There's an art historian at the University of Georgia right now, Evan Firestone. He and Fritz worked together on some shows in New England some years ago and became friends—even though Evan was a good deal younger. He got interested in Fritz's work and has written a number of articles for art magazines.* He would like to find the time to do a book, but he needs to find a publisher before he spends five years writing one. How- ever, having written about him over the years, he will eventually have enough essays to make a book. He is the one who first comes to mind.

The only other person is Roger Ogden, a collector in New Orleans, who is on the board of Louisiana State University, which has a publishing department. But he and Evan have totally different ideas on the sort of book they would like to do on Fritz. Ogden wants a picture book, a coffee table book, while Evan's would be a scholarly one. I would like to see both of those things happen eventually. Anything is better than nothing!

You mentioned when we were talking before that you didn't want the responsibility to be handed on to the next generation?

But, what are you going to do? I talk about it with my children, and they know exactly what I've been doing. They wouldn't be able to work on it full time, but that won't be nec- essary. I do feel they will take care of things and work with Steve Schlesinger. I have a very good lawyer who will take care of the legalities, although he has no knowledge of art. I also have five grandchildren, and maybe one will be interested.

You've never considered letting the remaining paintings go to auction?

No, they wouldn't do well in auction. It would just be throwing them away, as we haven't built up enough sales, and Fritz's work is not sufficiently well known. I'd rather just give them to friends, which I do, and my children and grandchildren, so they all have some things in their homes. The children may consider the auction possibility, but I won't be around.

Could you talk about the role of the gallery and its importance?

Steve Schlesinger showed Fritz before he died, and they got along well together. That's why I continue with him, even though, after Fritz died, people like Bob Motherwell said, "Oh, you must go to a big, important gallery. I'll get you a Knoedler, a Pace, or some- thing." Well, I did look around, and they weren't interested. Why would they be? He is not a big seller. So, of course, I hung on with Steve.

Do you work easily with him? Does he accept the widow's role?

Jeanne Bultman and Stephen L. Schlesinger in Gallery
Schlesinger, 2004, with *Pendulum,* Fritz Bultman, 1951, oil
on board, 14" x 10". Photo: Nick Knezevich. Courtesy
Magda Salvesen.

Oh, yes, very much so. He also respects the fact that I have made such a good inventory, that I know where everything is. We've always worked easily together. He's very knowledgeable and also has total respect for and total commitment to the work. So we don't have any problems working with each other.

Over the years, some widows have invested money in catalogues. . . .

Well, I've had to at times. And I have to pay for the restoration and the framing. I'm perfectly willing to do that. It's my responsibility to take care of those things.

I've always admired your openness in talking about your role. There are other people who are more secretive, feeling that it's undignified to suggest that they pay for anything.

Oh, I don't know why that would be. When estates can't afford to pay for the restoration or framing, usually the gallery pays; then, when paintings are sold, expenses are deducted. If you restore two or three things at a time, it isn't a huge bill.

Would you wince if I asked you whether you considered that you were running a business?

Well, I am. I run it out of my house. I have a lot of expenses that are totally related to the art. The IRS accepts that—I've been audited twice. A certain percentage comes off of your telephone and your building expenses if you are running an art business. I wish it were bigger, but that's the way it is.

Do you feel a certain amount of satisfaction when you're actually in the black at the end of the year?

Oh, yes, definitely. Sometimes I'm in the red. But that's good tax-wise, too.

What do you think are some of the qualities of the ideal artist's wife?

Stamina, first of all! And patience and the ability to relate to someone else and work with him. Certainly, an artist's wife has to be interested in the art and how it may develop. I think we give so much time and consideration to these men because it's the work itself that interests us. We may not be creative ourselves, but we can watch someone else be.

Have there ever been times when you resented the responsibility of the estate?

Oh, not me. I enjoyed it. Whatever else I was doing, I didn't feel it was that important. No, I never resented it, and I still enjoy the responsibility. I wish it were a little bit more successful so I would be busier, but it's all right.

Have the experiences of other artists' widows influenced you?

Well, Lee [Krasner] came to live with us a while after Jackson died [in 1956]. She blossomed in a way, but it was just so difficult—all the legal problems and the responsibilities. But, in the long run, I realized it's what she wanted to do, and she did a very good job of it. It was painful at first because she wanted to get back to her own work, which she finally did. I guess that's why that expression "artist's widow" always seems to refer to Lee. She was the big one! She was so strong. And, yet, none of us want to be Lee!

Sometimes people refer to Annalee Newman as the classic artist's widow.

She did an awful lot for him. But, you see, Annalee didn't have anything else to do. I mean, she spent her early years supporting Barney, and I think she was very happy doing that and wanted to continue. Too bad you didn't interview her before she died because I'm sure she had some stories. Barney was the first and most important thing in her life, as Fritz was in mine. I could have had other careers, but I didn't really want them. I was in my middle sixties when Fritz died. The children asked, "Well, aren't you going to have another man?" I said, "Well, no. I'm too old to start with someone new." I didn't want to be bothered! You know, you don't want to let anybody else into a long relationship like that.

Do you feel that Fritz would be pleased with what you've accomplished?

I think so. He would know I've done the best I could. I mean, maybe there are other things I could have done that I haven't, but I think he'd be pleased.

Are there ever times when you stop and think, "What would Fritz have wanted?"

I don't stop to think about it very much; I probably just go ahead and do it my own way. No, I'm not basically sentimental in that way. After forty years of marriage, you do know; you know.

May 31, 2000

UPDATE, FEBRUARY 2004

In August 2003, the Ogden Museum of Southern Art, University of New Orleans, opened in Louisiana. A gallery was given over to the paintings, sculpture, and drawings of Fritz Bultman. Since then, a smaller selection of Fritz Bultman's work has been permanently on show in a large survey of art from 1945 to 1975. On the roof, the Bultman sculpture *Opening and Closing*, 1975 (bronze, sixty-seven-by-thirty-six-by-thirty-two inches), has been installed, a recent gift from Jeanne Bultman. Chief curator David Houston reports that the Ogden Museum "will, in the future, mount a large show on Fritz Bultman. He is an important artist from the South who was part of that great moment that changed the American cultural landscape."

FOR FURTHER INFORMATION

Fritz Bultman: Collages, Catalogue of the exhibition at Georgia Museum of Art, University of Georgia, 1997. Essays by Evan R. Firestone and Donald Windham.

Fritz Bultman: Retrospective, Catalogue of the exhibition at the New Orleans Museum of Art, 1993. Essay by April Kingsley.

Herskovic, Marika, ed. *New York School Abstract Expressionists: Artists Choice by Artists*. Franklin Lakes: N.J.: New York School Press, 2000.

Born on January 12, 1941, and brought up in Brooklyn, Stephen L. Schlesinger did not have a background that would especially prepare him for the art world—his father was in the toy business. He remembers as a child being titillated by a reproduction of Thomas Hart Benton's *Persephone* and, also, responding to *Gulf Stream*, Winslow Homer's painting of an African American fisherman, at the Metropolitan Museum of Art. Then, when he was nineteen, he saw the Hans Holbein portrait of Sir Thomas More at the Frick Museum and experienced a kind of epiphany. He developed a passion for aesthetics, which he maintained for the next five years while working on Wall Street. When he was thirty-five, he took two courses with Rosalind Bengelsdorf Browne, a former student of Hans Hofmann and wife of the artist Byron Browne, at the New School for Social Research. He found her enormously knowledgeable—"It was a great gift that she gave me"—and remained closely in touch with her until she died two years later.

In 1977, he quit Wall Street and worked for three years as a private dealer with broad interests (Rembrandt etchings, Renoir, Agam, et cetera), going back and forth between New York and Europe. He also handled the work of Byron Browne and became interested in the art of Indian Space painter Steve Wheeler, as well as other artists who had matured in the thirties and who had been introduced to him by Rosalind Bengelsdorf Browne. In 1980, he opened the Gallery Schlesinger at 822 Madison Avenue, New York, and represented the artists of that period. Two years later, he met Fritz Bultman and began showing his work. In 1990, tired of the world of art trading and speculation, he moved into his present, smaller gallery at 24 East 73rd Street, where, as a one-person business, he can quietly represent fewer artists: Fritz Bultman, Hannelore Baron, Peter Heinemann, Steven Harvey, and Sarah McEneaney. Steve Schlesinger is married and has one daughter. He and Vera, his wife of thirty-four years, are also very involved with their eighty-acre farm in Pennsylvania, where Steve has planted a small orchard and, as stewards of the woods and meadows, they provide a sanctuary for wild animals, birds, and human beings.

Desiring a dealer's perspective, I talked with Stephen Schlesinger, who represents the Fritz Bultman estate, in New York City.

·　　　·　　　·

Steve, what do you expect of Jeanne?

She has to put half of her life into managing the estate. Recently, she hasn't been as active as she had been earlier, but I would say there were many days when Jeanne put in at least four hours: helping the photographer; packing or unpacking something; working on the provenance of a particular piece; keeping records up to date; being interviewed by some writer; showing Fritz's letters to someone from the Archives of American Art; or deciding what she was going to give and where.

I've had a gallery for twenty years and have often given advice. Many people are so naive. They think it is going to happen without them doing anything. At least on ten occasions, I've told people who look after art estates: "If you are not going to work on it—if you are not going to put your time and money and energy into it; if you are not going to get the paintings cleaned, framed, and stored properly; and if you are not going to catalogue them properly—then you might as well burn them, because nothing is going to happen. It's just going to end up being a burden."

Unless the paintings are extremely valuable, you've got to work to *make* it happen. If Fritz Bultman's paintings were like Francis Bacon's paintings, then you wouldn't have to do anything. Otherwise, in order to increase the value, you really have to work at it. The gallery can't afford to take so much time or to put somebody on that job until they reach a certain value, and the dealer has the possibility to make significant sales. Jeanne knew that automatically because she probably had seen what happened with other people. I remember Rosalind Browne telling me, when I was first working with the estate of her late husband, Byron Browne, that Sally Avery was the reason that Milton Avery's estate was so valuable. She was such a good businesswoman. She really knew how to make it happen. Not that Milton wasn't a good painter but, if there hadn't been someone like her, the estate wouldn't have reached what it did in terms of financial success. By the way, one of the things Sally Avery told Rosalind Browne was that whatever gallery wants to show the work, show it. Don't be fussy; the more people see it, the better. She never held back, even if it was not such a good gallery.

Are there any other widows who have been as influential as Sally Avery?

I don't know. Talk to Jeffrey Bergen at ACA Galleries, who handles so many estates. Rita Reinhardt or Annalee Newman, both had very valuable paintings. I knew Harry Holtzman, who inherited Mondrian's estate. He wasn't a widow, but he acted the same way; it was an enormous responsibility. He gave up thirty-five years of his life answering questions, writing books, and keeping records. I would imagine that even Rita Reinhardt, or Annalee Newman, or the wife of Adolph Gottlieb had a big job. I think, also, when things become *so* valuable, it's a very aggravating job, because then it becomes more about money than art. The pleasure has gone. People try to take advantage of you to get the work more cheaply and make you miserable in that way.

When did you become Fritz's dealer?

When I first started, I made a specialty of American abstract paintings of the thirties

and forties—Fritz really wasn't one of that group—but some of them, like Byron Browne, were painting abstract paintings in the fifties, so I was sort of interested in that time. In fact, Mercedes Matter was one of them. I don't know how I met Fritz; maybe he came into the gallery and we started to talk. He and Mercedes were friends, and we did a two-person show around 1982. He was very encouraging and nice to me, which was interesting because Jeanne said that he had a really tough time relating to dealers, fighting with them all the time. Not with me. One thing I do remember was that he called me from Provincetown a day or two before he died in 1985. In a very matter of fact way, he said good-bye.

Do you and Jeanne share a sense of pioneering as you create a stronger market for Fritz's work?

We both realize how difficult that is. We've always had the attitude that we are not in a hurry, and we'll do what we can, what makes economic sense. I'm just a small gallery, and I am not a promoter. From the first time that I saw Fritz's work, I believed in it. It's not pretty. A connoisseur, somebody who really knows, appreciates it. When you know the paintings and drawings as well as Jeanne does, or I do, you realize how good they are. But, at first glance, they are much too tough for most people. You know, we don't expect a lot. If we make a sale, we're really happy. And Jeanne can afford to be patient, so she never puts pressure on me. We do shows that we feel are elegant, and maybe one day somebody will come around and buy one. It doesn't happen often. But it happens.

What have you and Jeanne accomplished that most pleases you?

First of all, we have had a show just about every year, coming up with different aspects of Fritz's work each time, so each show was different. I'm always amazed when I come up with another one because there isn't an enormous amount of work. There was also the retrospective at the New Orleans Museum in 1993, and another one, of the collages, in 1997 at the University of Georgia in Athens. Jeanne is also constantly being interviewed. She was around during a very important time in the history of American art. She still has all her marbles, and her memory is a treasure.

Yes. And these exhibitions keep Fritz's work in the public eye.

There was a time when we did some advertising, but it didn't really help. My experience is that if you have the work of a famous artist, advertising makes sense. If you don't, it's hard to stay in business if you have to spend money on ads in magazines.

What are your long-term goals in terms of Fritz's work?

I don't think there is a lot one can do aside from keeping the work in good condition, maintaining the records, and being patient. If you had $100,000 to spend on advertising, you'd probably sell one or two pictures, but then where would you be? The thing is that Fritz was one of the Irascibles in 1950. He was a kind of prodigy. He's part of history, so at some point people are going to want to make shows of what was going on at that time, and they're going to want to use Fritz's paintings. That's how it will happen. If we are ready, and if we have the paintings in good condition and nicely framed, and they look nice in the show, then someone is going to want to buy one. That's the way the work

gets sold, not from taking ads in magazines, but from one-on-one contact with a museum person, getting it shown, getting it in catalogues.

It's constantly happening. There are ten things that happen every year where Fritz's name is mentioned, or where there's a reproduction, or somebody borrows a piece, or there's a catalogue. I just feel that this will develop. I hang them on the wall. If you want to buy them, you buy them. I really don't believe in selling art in any other way. The problem today is that people buy art by the name, not by the picture. So it's hard. It's hard with someone like Fritz, who never had a big reputation, and we haven't been able to do much about that. When the artist dies, a lot of the momentum dies with him, even though there's a widow who will do the work and a gallery that will mount shows. Without a powerhouse-promoting kind of gallery, there isn't so much you can do. Some day, maybe, somebody will.

Yes, seeing that Fritz is included in shows of his generation and making the works available is terribly important.

We are not always successful. But the Metropolitan Museum has some Bultmans, and we found out that they put together an abstract expressionist show in 2000 for the Juan March Foundation in Spain, with works on paper of all the big guys, and Fritz was included. They produced a really beautiful catalogue, with two full-page reproductions of Fritz's work—one was a collage and one was a gouache, I believe. That happened because they had bought some work ten years earlier—and they had them, and they fit into the show.

I've talked to some artists' widows who feel that it is very important to place paintings in museums. But that undercuts the gallery, although it's prestigious. How do you feel?

Well, Jeanne is pretty generous. Whenever a museum or university gallery went out of its way to put on a Bultman exhibition, Jeanne always donated a painting. And when the Met wanted to buy something, we made the price possible. We got paid well, but it was less than we were originally asking, and Jeanne also gave five or six works on paper at the same time, and it really paid off. It didn't make any difference to us having those five works or not, and we got into an important traveling exhibit with a beautiful catalogue, which will impress somebody.

We've talked about this a lot. When the University of Georgia in Athens made the show, we gave them a work. When Hunter College did something [1987], Jeanne gave them a work. When Miami-Dade Community College made a drawing show [1998 and 1999], we gave them a work. It makes sense. It's a nice thing to do, and certainly it's an easy way to support the institution. Then, of course, it is added to his list of works in public collections, and not everyone knows that you gave it. Not that there is anything wrong with that. Sometimes collectors see that kind of information, and it gives them confidence. Jeanne is eighty-two, and she doesn't want to be burdened with a lot of stuff. We'd love to sell things but, if we can't sell, we'll give them away. Jeanne has always been generous with me, too. She has given me a number of works, compensating me that way if I can't make money by selling to a museum.

October 2000

ANNE ARNOLD, WIDOW OF ERNEST BRIGGS, WITH BOB BROOKS

Ernest Briggs, the only child of Ernest (E. P.) Briggs, Sr., a warrant officer in the U.S. Navy, and Emma (née Docili) Briggs (1905–1952), was born in San Diego, California, on December 24, 1923, and grew up in Los Angeles and San Francisco. From 1943 to 1946, he served with the U.S. Army Signal Corps. He studied at the Schaeffer School of Design for a year, and then, on the GI Bill, at the California School of Fine Arts (1947–1951), both in San Francisco. A student of Clyfford Still, he moved from representational painting to a personal form of abstract expressionism.

When he arrived in New York in 1953, his work was promptly shown at the Stable Gallery, in 1954 and 1955, and was included in *Twelve Americans* at MoMA in 1956. Delicate hatchings of nuanced color in the early fifties gave way to a network of thicker, irregular brushstrokes, sweeping diagonally or vertically across the canvas. He developed a more calligraphic style in the early seventies, while his later work was increasingly linear and geometric, still painterly but with references to architectural structures—what he called "gates" and "castles." Beginning in 1961, Briggs taught at Pratt Institute in Brooklyn. That year he and his wife, Anne Arnold, bought a house and barn in Montville, central Maine, at the foot of Hogback Mountain. They spent summers there, and Ernie built a new studio in 1974, a wooden building, about thirty-by-forty feet, with a row of windows high up on the northeast side. He died of cancer of the esophagus in New York City on June 12, 1984, at the age of sixty-one.

Anne Arnold was born on May 2, 1925, to Edmund Arnold, a civil engineer, and his wife, Fanny (née Doty) Arnold. She and her two brothers were brought up in Melrose, Massachusetts, summering on the coast at Humarock. After studying at the University of New Hampshire (B.A. circa 1946) and Ohio State University (M.A. 1947), she taught drawing, painting, and art history at Geneseo College, New York, for two years. She then moved to New York City to study sculpture at the Art Students League (1949–1953). Around 1960, she married the abstract expressionist painter Ernest Briggs. They lived at 128 West 23rd Street and, later, beginning in 1977, on West 29th Street. Anne taught at Brooklyn College from around 1971 until approximately 1991. In the late fifties and sixties, working in wood and sometimes stone, Anne carved heads of friends and made large figurative sculptures. In the seventies, stretching Dynal (canvas) over wooden armatures, she made big, witty animals that were painted with polyester resins. Since Ernie's death

in 1984, she has continued sketching, outside, in Maine and has been working with watercolor and pencil.

Bob Brooks, a close friend of Ernie and Anne since 1971, was born on December 25, 1938, in the Bronx. He graduated from the School of Visual Arts in Manhattan in 1969 and has taught photography there since 1970, also working freelance. Recently, he has transposed his interest in cityscapes and exotic birds to painting.

There was no conversation about "estate planning" when I was first introduced to Jon Schueler's artist-friends and acquaintances in the New York of the seventies. Thirty years later, partners had died, the physical demands of handling paintings and sculpture had become problematic, and the lack of children, coupled with a lifestyle that often didn't encourage close family relationships, had left an inheritance vacuum. Chatting with Anne Arnold and her companion Bob Brooks, I heard that she was considering an offer for the work of Ernest Briggs from the Anita Shapolsky Foundation.

Anne Arnold in her New York City loft, surrounded by paintings by Ernest Briggs, December 2001. Photo: Philip Vaughan. Courtesy Magda Salvesen.

Could you give me some background information, Anne? Did Ernie have good gallery representation when he died in 1984?

Anne: He had been doing quite well. The last gallery that he showed with was Gruenebaum in New York, but the gallery went out of business a few years later.* Then, somehow, I got involved with Anita Shapolsky. She had a big gallery in SoHo at that time and was showing abstract expressionists of Ernie's generation. In recent years, she gave up that space downtown and moved the gallery into her town house on East 65th Street.

Where were all the paintings when Ernie died?

Anne: A lot of them were rolled up in the studio where I live. When Anita got involved with the work, we took a lot of it out to Jim Thorpe, Pennsylvania, where she has just established an art foundation in a church building she owns. It's a great space, and she has summer exhibitions there.

Bob: Anita's main thrust is what is happening in her gallery here in New York. Whether or not she shows Ernie's paintings in Jim Thorpe is really rather peripheral. What she has now doesn't compare to the real gallery space downtown, where people came in all the time, and she had big openings.

Anne: Yes, what happened was disappointing. At her 65th Street gallery she only has group shows. However, it's a place where a lot of people see Ernie's work because something of his is always on exhibit.

What is Anita recommending that you do about Ernie's paintings?

Anne: She just talked about her foundation at the last meeting—we didn't decide anything. It's named for her and is a nonprofit. We'll talk more about it in January when she comes back from Florida.

How would this benefit Ernie's work?

Anne: My problem is that I keep worrying that I'm not doing anything about his work, and it's distracting. I felt that if I could just donate all of his work someplace, then maybe I could concentrate on my own work a bit. Anita would pay me a little money for Ernie's paintings and place them in this foundation. I think I should donate at least half of them so that I get some tax benefits out of it. That was my idea. She wanted to buy the whole thing.

Bob: I think the crucial question is what Magda asked: How does it benefit Ernie's work, and how does it benefit Anita? Is the foundation supporting itself, or is it giving out grants? We need to make sure before you hand over the paintings! I've just got back from Maine, so I don't know the details.

Anne: She said something about art education. It's a tempting idea, although I wouldn't get the money that I should for it. But at least the work would be cared for and seen.

How many paintings are there?

Anne: Over a hundred at least, and works on paper, and various other things, too.

Bob: Magda, how do you feel about this?

Anne Arnold and her work, with Bob Brooks, New York,
December 2001. Photo: Philip Vaughan.
Courtesy Magda Salvesen.

**Anita is not that young, so I would ask her: Who else is on the board? How will it be
run in the future? How much capital is there? Is the foundation set up to run for a fixed num-
ber of years? If the latter, what would happen to Ernie's paintings at the end of that period?
Would the foundation have enough money to employ a full-time, paid professional direc-
tor? Would it generate exhibitions? Would the paintings always be sold, or would the foun-
dation donate paintings to museums? Institutions are often very wary of dealing directly
with the artist's widow, so that could be a dignified way of presenting Briggs's paintings to
institutions. I would certainly want to see the mission statement.**

Bob: It would be a good solution to the problem of keeping the work intact, and
would free Anne from the worry of what to do with the paintings.

What do you mean by keeping the estate intact?

Anne: What we mean by keeping them intact is not to divide them up in my will
between my niece and nephews, who don't know anything about handling paintings.

Nevertheless, do you feel that you've made some progress with the estate?

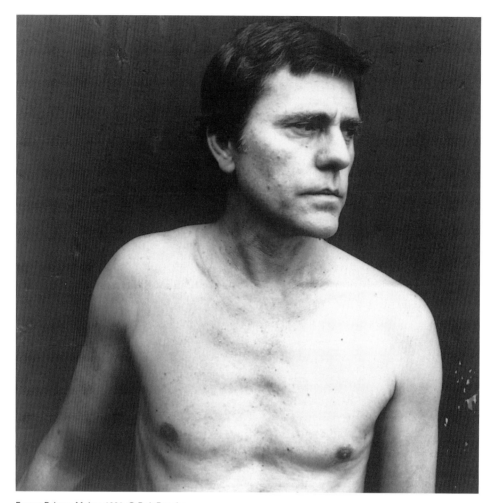

Ernest Briggs, Maine, 1981. © Bob Brooks.
Courtesy Bob Brooks.

Anne: Not really, no. Some things have been sold, and they've been seen. It's better than nothing. I should have done more about pushing for museum exhibitions or donating works, but. . . .

Bob: What Anne is saying probably represents the classic situation of what happens when the widow left with her husband's work is an artist herself. Anne feels this obligation to devote her whole life to seeing that something happens with his work.

Anne: Except that I am not doing it. It's distracting, and I'm feeling guilty.

Bob: The anxiety and guilt that comes along with these hundred or whatever number of paintings is just horrible. It's a real dilemma because Ernie was a wonderful artist but never got the attention that he should have, partially because of his own attitudes—not playing the necessary games. He probably would have been more well known when he

died if he had, although everyone in the art world knew who he was because he was a serious painter.

Anne: Once, he was in an exhibition called *Still Working: Underknown Artists of Age in America* [1994–1996].

Bob: I don't think he would have participated in it in his lifetime but, all of a sudden, there's not much you can do with his work.

What could you have done that you haven't done?

Anne: I don't know. But I wanted to ask you what you're doing about Jon's work. What will you do in your will about his work?

In fact, I've just changed my will. After Jon died in 1992, I wrote a quick codicil that simply said that if I were killed or died, then the paintings stored in Scotland would all go to a Scottish or a London auction house, and the ones in New York would all be sent to Sotheby's, Christie's, or Phillips. I did that knowing that they would realize very little money and that the market for Jon's paintings would be ruined for maybe twenty or forty years. But the Schueler paintings would all be out in the world rather than in storage, and I wouldn't be handing over a terrible burden to my sisters and brother in Scotland. Like you, I don't have children. Jon's two children, and their children, are too far away and have no experience with the art world. Now, as time has gone by, the situation has changed. I've got good galleries for Jon's work in Edinburgh and New York. I have a sense of loyalty and responsibility to those galleries. Publications have come out. Touring exhibitions are being organized. Therefore, I'm now in the process of arranging through the lawyers in Edinburgh and New York for the paintings to be transferred into a foundation at my death. There are, of course, some problems: who are going to be the officers overseeing the management of the paintings? There would have to be an administrator or curator in Britain and one in the United States. The main goal is not to leave a muddle and financial obligations.

Anne: I don't think of myself as an artist's wife because I was an artist myself. So I didn't do for Ernie the things that other artists' wives did, like take care of all their paper work and so forth, and arrange for exhibitions and things. I had to worry about handling my own work, so he didn't have a typical artist's wife. We got along well partially because our work was so different. We both admired each other's work and could talk about it to each other, but it wasn't like some couples who painted—when you can't tell who did which paintings.

Did you have studio spaces in the same loft?

Anne: Ever since the mid-seventies, when we moved into West 29th Street, I've had my studio in the rear of the building, and his was in the front, with a little living space in between.

What are the most helpful things Anita has done?

Anne: A few paintings have been sold to people in Europe. . . .

Bob: Through Anita, there's a collector in Europe who is very interested in Ernie. Everything's happening on a very small scale. I think Ernie deserved better but, through

the Shapolsky Gallery, his work will be included in Marika Herskovic's book [see bibliography]. There are artists who have died whose work is just left in some warehouse. Anne is being very hard on herself when, in fact, she did quite a bit, and the work is alive. The question is how long will it stay alive? Well, nobody knows. And Ernie is part of the reason that he's not famous because he was just ornery about the system.

In what way?

Bob: Ernie had a lot of cynicism about the way the art world operated. Anne knows more about that than I do. Something happened with gallery dealers who wanted him to do certain things when he was becoming a superstar. Maybe they wanted him to paint certain ways, I don't know, but he was very caustic about that system and didn't want to deal with it.

Anne: He didn't want a gallery dealer to say, "Well, this work is going well, so please keep doing more of these." He always wanted to keep experimenting and changing.

Bob: I spent a lot of time with Ernie. He was a serious painter, and that's what he lived for. He was totally unaggressive about his career, one of the least aggressive people whom I ever met. Whatever happened to him probably happened in spite of Ernie. I don't think he ever took his work around or sent out his slides to galleries, at least when I knew him. At the time of his death, he was doing his most beautiful work, I think, and had he not died

Anne Arnold and Dolores the Pig, Maine, 1981.
© Bob Brooks. Courtesy Bob Brooks.

young [sixty-one], he might have become more known in the world. He painted his best show, in my opinion, when he was going through chemo. So things were happening.

Anne: He never pushed himself. He did the opposite, which annoyed dealers and museum people. Of course, Ernie had Clyfford Still as a role model, and Clyfford Still was very ornery and difficult with dealers.

Bob, how are you involved in Ernie's estate?

Bob: I'm not. I'm just here for moral support, and Anne talks to me about things. I'm an executor of her will so that, if anything happened today, I would have to deal with this. I'm sixty-two now, and I don't know if I'd have the energy to do what you are doing for Jon's work. I'm not as personally involved as Anne is with the work, but I would try to do the best I could. Another executor is the artist Lois Dodd. Between the two of us, we might be able to figure something out.

Bob, you're a photographer and painter yourself?

Bob: I'm not worried about my own work because I really don't feel that it's that important. Whatever is in my studio, people will know what to do with it. It's not a big deal. But this is a major deal because these are two wonderful, prolific artists.

Anne, what are you arranging for your work?

Anne: I haven't arranged anything. First, I want to work out what will happen to Ernie's paintings. I made out the will a long time ago, but the decision about Anita's foundation will affect everything.

Bob: I think if Anne would just get her act together and have another show—she's still a Fischbach artist.

Anne: Well, I'm not doing sculpture, at least not at the moment. Any work I'm doing is on paper.

Bob: Anne won't be leaving as much work as Ernie so, luckily or unluckily, it's not as monumental.

Anne: No. I don't have a huge amount. A few have been sold over the years. Some of the sculpture is big and awkward to handle, but it's not that difficult.

Do you have a complete inventory of Ernie's work?

Anne: Pretty much, and Anita has a list, too. Most of the work in the loft in New York has now been photographed.

Bob: I photographed everything that was in Pennsylvania, and the other photographer, sent by the European collector, did close to a hundred. As Anne said, the work is wrapped and a lot of it is on rolls, so it's very hard to get them out.

Anne: I don't want to damage the work, and some are too big to put on the wall in my place.

Bob: We took some of the very long paintings to a building that Anita owned that had an undivided space with a huge wall. They could be unrolled and stretched out and temporarily stapled onto the wall to be photographed. But there are other unphotographed paintings on rolls. I think Anne has an idea of what they are and when they were done.

Would there be any point in getting them stretched so that they were more accessible?

Bob: Well, stretching them would be impossible because there is no place to keep them.

Anne: The other thing is that I wouldn't be able to get them out of the building if we took them off the rolls. The ones that I have on stretchers are of a size, for the most part, that can fit into the freight elevator. It damages paintings if you keep stretching them and unstretching them. Anyway, what's the point of stretching them if they are not going to be shown?

If I donated the work to Anita's foundation, I could then have some space, and maybe get the place painted. My place is a total wreck. It can't be done while I've got Ernie's paintings around and all my sculpture. And then, I go away for five months of the year, and I forget about everything. When I come back, it's hard to remember where I put things. Oh, God. Life is a mess!

But it must be a relief to escape to Maine.

Anne: Yes, in a way it is. But it also lets me put off doing anything about the estate!

December 2000

UPDATE

At the end of 2003, Anne Arnold and the Anita Shapolsky Art Foundation reached an agreement. The foundation bought all but ten paintings by Anne's late husband, Ernest Briggs. The oils and acrylics (exact number unknown, as many were rolled) were picked up from the loft on West 29th Street and transported to the foundation's headquarters in Pennsylvania. The estate will also receive a small commission on work sold for a period of two years. The diaries and correspondence of her late husband remain in Anne's care, as do the works on paper (about a hundred). Talking about these recent developments, Anne said, "Make sure in your book that you remind artists to sign and date their work," as much of what remains will be difficult for her to catalogue.

FOR FURTHER INFORMATION

Ernest Briggs: Artist of the '50s, Catalogue for *The Paintings of Ernest Briggs: Abstract Expressionist of the 1950s,* Mishkin Gallery, Baruch College, New York, November 22–December 18, 2002; published by the Anita Shapolsky Art Gallery and Foundation.

Herskovic, Marika, ed. *American Abstract Expressionism of the 1950s: An Illustrated Survey.* Franklin Lakes, N.J.: New York School Press, 2003.

ANITA SHAPOLSKY
ON HER FOUNDATION
AND GALLERY

Born in New York City, Anita Shapolsky (née Kresofsky) received a B.A. from Hunter College, New York City, and an M.A. from New York University. First doing social work with children, she went on to become a guidance counselor and teacher of nonnative speakers for the board of education in New York. Her work as chapter chairperson for the United Federation of Teachers union won her a Trachtenberg award. She and her husband, realtor Martin (Meyer) Shapolsky, had two children, Lisa and Ian.

Anita Shapolsky's interest in art originated at Hunter College and was developed through museum visits and courses, friendships with artists, and extensive traveling with her husband. She began by collecting ancient art and then, in the seventies, turned to contemporary work, with a special interest in abstract expressionism. In 1982, she decided to leave teaching for the art world and opened the Arbitrage Art Gallery at 99 Spring Street, second floor, in SoHo, New York City. In 1984, she changed the name to Anita Shapolsky Gallery, remaining at that location but moving to the more spacious first floor and basement. In 1997, tired of pristine white walls and feeling that the charm of SoHo had faded, she moved her gallery to the warmer ambience of two floors of her town house at 152 East 65th Street. While specializing in second-generation abstract expressionists, she also represents younger artists and older Latin American abstract artists. During the summer, she exhibits work in the spacious Anita Shapolsky Art Foundation in Jim Thorpe, Pennsylvania, about a two-hour drive from New York.

Anita Shapolsky always made me feel my responsibility as an artist's widow. Sizing up my appearance and energy level whenever I visited her gallery after Jon Schueler's death in 1992, she would ask me what I was doing with the estate. This question was always troubling because the answer was, inevitably, "Not enough." Nevertheless, she was appreciative of my efforts and encouraged my projects. Naturally, when I heard that she had set up the Anita Shapolsky Art Foundation, I wanted to report on her innovative project for this book. We chatted in her New York town house. Later, she took me out to her large summer gallery in Pennsylvania to see her exhibition, *Abstract Expressionists of the Fifties*. Anita talks in a vibrant, husky voice, and dresses with great panache.

· · ·

Anita, could we talk about the new foundation and its connection with your New York gallery?

Anita Shapolsky with conservator Alfred Hujsa, in Anita
Shapolsky Foundation, Jim Thorpe, PA, 2003.
Photo: Magda Salvesen.

The Anita Shapolsky Art Foundation was born in November 1998. It's a not-for-profit 501(c)(3) educational foundation. Exhibitions and activities take place in a former Presbyterian church, built circa 1859, that has eighteen valuable windows by Tiffany and Lafarge. This building, in Jim Thorpe, Pennsylvania, belongs to the foundation, and much of my personal collection will also eventually be gifted to it.

There's also the possibility that the foundation can take on the art from the estates of other artists. The circumstances would vary. It would buy an estate at a reasonable rate—not at fifty percent because the foundation would be taking care of storage, conservation, photography, insurance, promotion, and so on. This would be a great incentive to some heirs because they would be freed from the responsibility. The foundation would try very hard to place some work in museums and institutions. The heirs wouldn't receive any tax advantages, but it would increase the status of works for sale within the foundation. When the foundation sold a work, the spouse or the heirs might get a percentage from the sale for a period of time. The foundation can also sell through my gallery in New York, or through other galleries. There could also be outright purchases of estates.

Many artists' relatives are not interested in the art at all and just give or throw it away.

I'm trying to work with some of the artists, spouses, or other heirs who are getting older now and don't have the finances or storage facilities to keep the work. The church in Jim Thorpe has two floors—altogether, some ten thousand square feet.

I know people whose specialty is to go out and buy artists' estates for very little cash. They'll buy them very, very cheaply and store them, then try to resell individual pieces—fine work, art of the fifties. You never know where that work will go, as they're not willing to share records or put any energy into keeping documentary photographs. Artists are desperate; they don't know what to do with their work if there are no heirs, no relatives, no money.

Some spouses are just not able to handle things. They may be as old as the artists and in poor health, too. If they set up their own trusts, they need people on their boards whom they have to pay, so it becomes expensive. You should check with Artists Equity—I believe they take the estates of artists, but they need an endowment.* Almost any place you go, there is a cost for storing the art.

It's not so easy to donate work directly to a museum, either. One artist I represent told me that some museums would only take his work if he gave them a sum of money for maintenance and insurance. His estate, which is also connected with other galleries, has been donating pieces to places that will take them without all this maintenance. To establish value, it's a very good idea for artists or their heirs to donate to smaller museums that are starting out and need collections. Ironically, museums often accept work from collectors more cordially than from heirs because a collector will donate the work *and* give the money to maintain it. I guess it's a good way for the rich to get a tax write-off, but it's not relevant to impecunious estates.

What are some of the educational programs that the foundation sponsors?

I have lectures in the church, musicales, and poetry readings. Andrew Bolotowsky, who handles his father's [Ilya Bolotowsky's] estate, has been there with a group several times—we had wonderful flute playing and Renaissance dancing. A town like Jim Thorpe, lost in the late 1880s or early 1900s, is very appreciative of the fact that the foundation is there. We sponsor art walks, put on shows and plays, and rent the building out for a minimal amount to other community and cultural groups. It's a very unique town.

Right next door to the foundation is the opera house. Imagine a town like this having an opera house in the 1880s! It had the largest number of millionaires per capita in America—all the coal and steel barons—but it's not a rich town now. We have a Laurel Festival of the Arts in May and June every year at the opera house, and their opening reception is held at my church. I have the largest space in town. The local people find that we're an asset—we cooperate with them, and they work well with us, respecting the art and bringing in their children. We'd love to get some interns from the local universities to work with us, hanging shows and cataloguing work. I need to be in touch with Lehigh University. When I bought the church in 1985, we were a nonprofit Pennsylvania organization called the Josiah White Exhibition Center (named after Josiah White, who

designed the locks for the Lehigh Canal and started Bethlehem Steel). We started putting on summer exhibitions in 1986. But, after my husband died in 1992, it took time to make a decision about creating the foundation.

How many people are on your board?

At this point, the foundation has my own children, Ian and Lisa. I'm in the process of adding others, professionals in the art world.

How involved are your son and daughter?

My daughter, who is a photographer and deals in real estate, is more involved. She has set up our website. I've been teaching Lisa over the years, so she is very knowledgeable. She has been thinking about opening a gallery herself, linked with mine. However, one of the problems for the foundation is that she lives in Florida and has three children. My son is a publisher and probably could help with catalogues. They're both very supportive, but it's a very big undertaking. Besides running the New York gallery, I have other investments to take care of. So I have a very hectic life. If you're a social-minded person, you worry about the artists and the estates, the relatives, the spouses, et cetera, and you try to do the best you can for everybody. Your loyalties, when you have a gallery, are not to one artist. I have a very good group of artists, and I'm proud of every one of them, or they wouldn't be in my gallery. They know that.

Do you expect artists or the estate to contribute to cards, catalogues, and transportation for your New York gallery shows?

It's just too expensive for my gallery to produce the catalogue. There is a fifty-fifty split to print brochures for one-person exhibitions. Usually, the announcement cards are managed by the gallery for group exhibitions. Some galleries charge retroactively. They will produce the catalogues, and then a certain amount is taken out of the sales. One way or the other, the artist does pay something.

Years ago, the operating costs for running a gallery were much lower. You sent an announcement to the *New York Times* and they would review the exhibition. Now you've got hundreds of galleries, and the cost of ads in the art magazines is very high. Instead of charging the artist for his share, some galleries take a piece of work. There are different arrangements. My artists sometimes show elsewhere and have had many negative experiences: art that is not returned, bad bookkeeping, no consignment sheets. There are many galleries called "vanity galleries" where the artists pay for everything, and even give a painting to the dealer. In Japan, artists pay for the wall space, the party, the catalogue, just to get a chance to show. Many American galleries do that now, too.

Is there camaraderie between you and other mainstream art dealers who are interested in the period you specialize in?

Well, we know each other and share information. There's healthy competition because we're all showing fine artists. I don't ask my artists for an exclusive or make them sign a contract. When I have a special show of artists of the fifties, I call different artists and estates, or the other galleries that represent them. I find that people do business together.

Gallery of Anita Shapolsky Foundation, showing (left) a
Richards Ruben and (right) two 1950s paintings by Ernest
Briggs. Photo: Magda Salvesen.

How have you been able to develop a new market for the artists of the fifties?

I still get collectors coming in and saying, "I didn't know these artists, but I've now become very interested in them." The work is so fresh and good that I try to find people who will appreciate it. In today's art market, there are many younger people who have the money but are not very knowledgeable. They just buy names. So I try to develop a different clientele. I have several who buy something new every year or two, so I know that they're developing their own collections. Corporations are not collecting much anymore—they buy posters for their offices nowadays. I know many of the consultants. They could buy inexpensive art for their clients if they trusted their own eye more. The last year or two have been really disastrous for selling good artists' work. In the eighties, I sold to GE, Siemens, to many corporations, but not often since the mid-nineties. Today, professionals, doctors, and legal offices have started collections. You just don't know who is going to be your next collector.

Recently, I talked to a widow of one of your artists who stressed how guilty she felt about what she hadn't done for her late husband's work.

It's very complex. She was never really involved in his work since she was an artist herself, so it's difficult for her now. She was filled with anxiety about the future. The gallery that had the memorial show in 1984 sold some paintings, but half of them disappeared.

So I only have a few of his paintings from the early eighties. There are other problems. When the artist died, most of his work was rolled. When I went down to the loft, the cats were wandering around in the area where the paintings were stored. I also worried about the rest of the paintings in her loft. I took a great deal of that work to Pennsylvania, and the widow had the paintings put on stretchers. I agreed that the expenses would be covered by future sales. His work is wonderful. I didn't know it well until then. A photographer friend of the widow came to the church with us and took photographs, as I must have proper records of everything in my care.

She broached the subject last year. I said, "The foundation will buy the entire estate, paying you over a period of time. We will sell it over the years or give it to museums and, while you are alive, you will get a percentage." She said, "No." I said, "To bring him to fruition, we have to get a catalogue, we have to try to move the paintings into museums. I'm not investing all this time and effort and money without some security. You're not doing anything to promote him, but I'll work with you. I'll do it. We need to place all the work in the foundation." I think she hoped to get much more money than I was able to offer. Now, since the economy has changed for the worse, the situation is different. That's why these things are not set in stone.

Do you think that the foundation could represent as many as ten or twenty artists?

It could handle the work of many artists. My specialty, and my raison d'étre, is to help those artists who have no heirs to handle the work. Since 1982, when I started my gallery in New York, I've tried to exhibit and expose artists who were painting well in the fifties and sixties, and who then, because of the different fads that came in, were forced more or less underground. Some of them continued working and producing art into the 2000s. Seymour Boardman is an excellent example.

I try to help both living artists and estates. I know of one or two artists who died and didn't have anyone to take care of their work. The sculptor George Spaventa [1918–1978] is one of them. His family is up in the Bronx—these people have no idea of the importance of his work. I showed Frederick Kiesler [1890–1965], the great architect and sculptor, when he was underknown, and also Jeanne Reynal (1903–1983). I get many inquires from relatives who have inherited art estates. A few years ago, I couldn't do anything. Now I'm doing it slowly. It's a Herculean task.

Most estates have work from different periods: student and unfinished work, as well as mature and late work, works on paper, and prints. Would you be prepared to take everything?

That's one of the things I'm still working on. Taking works on paper is a big responsibility because they need special storage and handling. You have to have climate control to avoid dampness, and I'm not really set up at this point for that. I'm trying to set up a timetable for more renovations.

You mentioned that you would publish catalogues for the work in the foundation. Would you also generate traveling exhibitions?

Yes. That's what I would like to do—mount exhibitions at the foundation and then send them to other venues.

Do you envisage hiring a curator for the foundation?

Eventually, I'll have to have a person there full time. Right now, I'm working on getting a new heating system. It's been three years. Afterwards, it will be an easier situation. We can set up storage space in the church proper upstairs, which has ceilings that are, maybe, thirty feet high.

Now that many of the artists from that generation—of the fifties, sixties, and seventies—have died, is there an enormous difference dealing with the representatives of the estates, compared with the artists themselves?

I found that the artists of the fifties often became extremely irascible in the eighties and nineties. They were not easy people. They didn't trust anybody. They had been sort of downtrodden for the previous twenty or thirty years because, after the sixties, nobody was interested in them. They came from the days when they had these co-op type galleries, where they took turns sitting at the front desk, and they never paid more than thirty percent commission and resented even that. So, it's easier dealing with the heirs or spouses because they understand that you're trying to do something for them.

I think most gallery dealers act as social workers because they're dealing with human beings. The art has intrinsic value, not dollar value. Every heir thinks that her husband's work or father's work was the best work of that entire time. They look at the other artists' work in the gallery and say, "That's good, but my husband's is better," or, "You have too many people in your show," when I'm just showing five artists. I rarely do one-person exhibitions now because of the economy.

What makes an estate difficult to deal with?

People must cooperate with me if I'm trying to do something to help them. They must catalogue the work. I have to know beforehand what they have and how big the estate is. One person said, "I have twenty or thirty paintings," and then I discovered that there were at least 150 paintings and works on paper. I have to be able to sit down and talk to the family and discuss what we can do. I have to know if there are any other claims on the estate. I need to work with one main person who can make decisions, and who is willing to put time into helping with all the details.

So the representative of the artist's estate should be cooperative, have things organized, and have a complete inventory of the paintings?

Hopefully, but it never really happens. Believe me!

October 2001

For Further Information
www.anitashapolskygallery.com
www.asartfoundation.org

JEFFREY BERGEN
ON THE
ROMARE BEARDEN
ESTATE

It is not my aim to paint about the Negro in America in terms of propaganda. It is precisely my awareness of the distortion required of the polemicist that has caused me to paint the life of my people as I know it—as passionately and as dispassionately as Breughel painted the life of the Flemish people of his day.

—ROMARE BEARDEN*

Romare Bearden was born in Charlotte, North Carolina, on September 2, 1911. Around 1914, his family joined the great migration north, settling in Harlem. New York City remained Bearden's base for the rest of his life. As a boy, he made occasional trips to the South to visit his grandparents, and he spent several school years in Pittsburgh, Pennsylvania, with his maternal grandparents. In 1935, Bearden graduated from New York University with a degree in mathematics. However, his interest in art lured him to the Art Students League. For the next two years, he studied with the German artist George Grosz, who encouraged him to incorporate social and political commentary into his work. After serving in World War II and studying philosophy for six months at the Sorbonne in 1950, Bearden turned to music. He founded the Bluebird Music Company and recorded twenty of his own songs. In 1952, he became an employee of the Department of Social Services in New York. He began painting, again, in his spare time after his marriage to Nanette Rohan in 1954. By 1966, he was making enough money from his work to devote himself full time to his studio. He had turned from abstract painting to collage in 1964, blending magazine clippings, fabrics, and paint. His work in this medium, and in watercolors and prints— richly poetic layers of allusions to both rural and modern urban life—recall his experiences in the South and his love of jazz and literature. He died on March 12, 1988, at the age of seventy-six, much respected and the recipient of many rewards and honors.

Nanette Rohan Bearden (January 20, 1927–August 10, 1996) was the founder and artistic director of the Nanette Bearden Contemporary Dance Theater in New York. In the early seventies, she and Romare Bearden made the Caribbean island of St. Martin their second home. There, in 1985, she founded the Nanette Bearden Fine Arts Gallery to assist the young emerging art community. In 1990, she helped establish the Romare Bearden Foundation in New York.

Born in New York City in 1953, Jeffrey Bergen received a B.A. in 1976 in art history and environmental studies from Antioch College, Ohio. After graduation, he joined his father, Sidney Bergen (1922–2001) at ACA Galleries (American Contemporary Artists). Artists Stuart Davis, Yasuo Kuniyoshi, Adolf Dehn, and the writer Herman Baron, Sidney Bergen's uncle, founded the gallery in 1932. ACA was a pioneer in exhibiting contemporary American art by African Americans, minorities, and women artists. Jeffrey Bergen is now president and owner of ACA Galleries. He is a member of the Art Dealers Association of America and is on the board of the New York Open Center. His wife, Dorian Perchik Bergen, is vice president of ACA. They live on the Upper West Side of Manhattan with their two sons.

In *Art in America's Annual Guide to Galleries and Museums*, 2003, the ACA Galleries listed itself as representing seventeen estates and seventeen living artists. Rather than asking Jeffrey Bergen to discuss his widespread commitments, I thought that, because contemporary African American artists were strongly represented—Benny Andrews, Faith Ringgold, Richard Mayhew, and Barkley Hendricks—I would focus on the gallery's long association with the estate of Romare Bearden.

. . .

Jeffrey, how well did you know Romare Bearden?

I'd met him several times. Meeting him is not exactly knowing him, but he knew who I was, and I certainly knew who he was. He'd visit ACA like clockwork, seeing almost every show.

At the time of his death, his work had been handled by the Cordier & Ekstrom gallery for a long time. How did the switch to the ACA Galleries come about?

When he died in March 1988, he left everything, and I mean everything, in the care of his attorney and good friend Morris Cohen. Morris had helped Romy out of a million different jams, had assisted members of his family as well, and I guess he was just his most trusted friend. Prior to his death, Romy was actually represented by several galleries. Morris said, "I just want to have one dealer who's responsible to me and is responsible for everything. If something goes wrong, I know who to yell at. If something is missing, I know who to talk to. It's their responsibility, and I don't want his work spread out all over the country with bad consignment records." Over a period of four to six months, he talked to numerous galleries. We were all asked to submit formal business proposals concerning what we would do. We must have met with him ten times. For whatever reason, he decided we had the situation he was looking for. It was quite complicated because it wasn't somebody dying and leaving some artwork. Romy had made arrangements to create a foundation that had its own body of work, and then there was a whole group of work that was in Nanette's private collection. ACA was asked to take over everything and to do what we could to promote his work.

How old was Nanette Bearden at the time, and why wasn't she put in charge of the foundation and estate?

Jeffrey Bergen in ACA Galleries with 1969 collage by
Romare Bearden, *Amistad Incident,* May 2004. Photo:
Michael Korol. Courtesy ACA Galleries, N.Y.

Well, we were good friends, but we never talked about her age! Age and money in the
bank are things I never discuss unless there's a really good reason. Of course, when the
will was read, Nanette initially was in shock. She was the main beneficiary of everything,
but she was not put in charge. She had a dance company (which Romy had supported to
the tune of thirty-five thousand dollars a month), so that certainly kept her busy.

Who else was in the family besides his widow?

That was it. Romy did not have kids himself, but he had a big family through Nanette.

She had seven sisters, and all of them were married and had children. Romy sent a whole pile of nephews and nieces through college from the sale of his artwork. He was kind of king of the family, always helping out in one way or another. He was a very generous man in a lot of different ways.

What are the foundation's goals?

The foundation's mission is to perpetuate the legacy of Romare Bearden, and to add to the growing body of knowledge about his life and work. It also provides support for aspiring young artists. He knew how hard it had been for him. It was difficult enough being an artist in the forties, fifties, and sixties, but being an artist of color made it twice as hard, and success only came to him later in life.

He was concerned that other artists of color shouldn't have as difficult a time as he did, and he was also interested in promoting scholarship. With his friend Dr. Harry Henderson, who just passed on, he coauthored a significant book, *A History of African-American Artists: From 1792 to the Present,** a whole area that had been virtually ignored by museums. There were hundreds of good artists whose work never saw the light of day. Most of them worked and died in obscurity. Maybe they had made some inroads into the art culture during their lifetimes but, upon their deaths, often what was left was just scattered to the winds, and no scholarship was done. So, together, they made an important contribution.

The foundation is also interested in making sure that artists are judged by their artistic merit, not the color of their skin. That was very important to Romare Bearden. It's a shame we even have to segue things into these artificial components because he was an American artist, and that's the way we treat him—an American artist who had a distinctly African American perspective.

What have you been able to do with Romare Bearden's work since your first exhibition in 1989?

When we started with the estate, Bearden collages were $35,000. Today they would be worth between $250,000 and $500,000. We thought the work, given its quality, was low in terms of what prices should be. Of course, there were secondary market sales that we and other dealers were involved with, but there was a fairly full estate that we alone controlled. It had some really great pieces in it, and we just systematically started to increase the prices to where they are today. Private clients, museums, and major collectors are buying them. So I think we had quite an impact in terms of being the main cheerleader and getting those numbers up, creating and maintaining a very active market.

That's being very modest, Jeffrey, because it doesn't just happen by putting the collages and paintings on the wall and opening the door.

True. We became very actively involved in museum shows, and in film and book projects. I've always likened an artist's career to a stool that stands on three legs; it must have all three components in place to grow in terms of the market. It's one thing to be selling art for ten thousand dollars or less—anybody can do that—but to make it creep up into

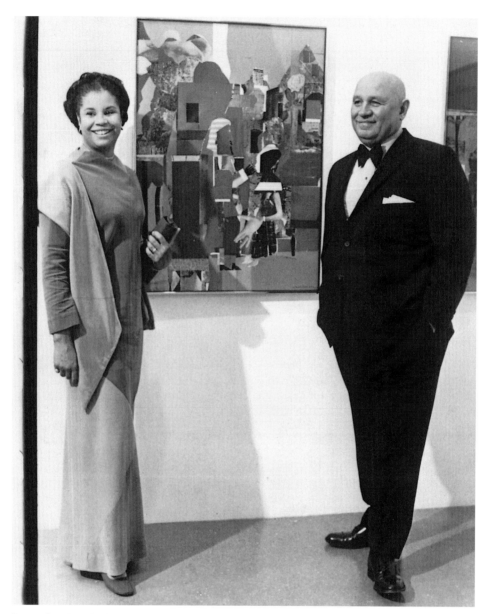

Romare Bearden with his wife, Nanette Rohan Bearden,
at the opening of his exhibition, Museum of Modern Art,
1971. Photo: Sam Shaw. Courtesy Romare Bearden
Foundation.

the higher realms of price points, you really need to have: great critical success; a museum
following, with museums taking an interest and promoting the work; and sales. If you just
have two, it's not going to happen.

Has the change in the political and social climate from 1989 to the present helped your mission?

Absolutely. The Civil Rights Movement made people aware of the significant achievements of African Americans in every course of life—engineering, science, the arts, music, sports. Even as late as 1989, there was a gray wall of prejudice when it came to museums acquiring art by African Americans. For instance, that year a representative of Harvard's museums approached us. "You know," he said, "I am ashamed to tell you that Harvard has been acquiring art for over two hundred years, and we don't have a single black American artist in the collection." I thought it was pathetic. The reality was that it wasn't the only place that was like that. The same problem existed at that time in all the big museums across America.

Two things then happened at once. One, African Americans constituted a significant portion of the tax base of cities. It's still a small proportion of the population, but of the 280 million Americans, about 40 million are African American. Museums slowly became aware of the need to represent the country in a fairer way. As a handful of African Americans became fairly affluent, they started to sit on boards. Romy was right up at the top of the better-known black artists, and museums became interested. Significant museum exhibitions then started to take place, and we were including him in numerous group shows all over the country. Books came out, too. So we slowly raised the public's awareness, and the people who took the time to look felt he was underpriced and under-appreciated.

So we accomplished certain things. We raised the price way beyond anybody's expectations. A thousand percent in fourteen years, and we're riding the crest of it right now. I still think the price points are relatively low when you compare them to the $3 million for work created by some contemporary artists within the last ten years. There certainly is room for growth in terms of his market. Romy made a significant contribution, especially in the realm of collage, which he really took to a whole new place. In that area, he is a singular giant. Also, there are social concerns embedded in his work. He spoke eloquently about the African American experience and his own life, which was quite extraordinary. He was a mathematician, a musician, a composer, and a social worker. He could have played professional baseball. He was just a special human being who had a world of experiences. He was premed at school—his mom wanted him to be a doctor, but it wasn't really his path.

These were the two crucial phenomena: the museums starting to get on board, and the expansion of a more affluent class of African Americans—people who were taking home a six-figure salary. They had raised their kids, taken care of the basics, had savings—and some were becoming interested in art. Often this group wanted to create collections that were Afro-centric. We really hadn't seen this before—except for a handful who were there real early, like Bill Cosby and Danny Glover. Now there are many collectors, especially of Bearden's work, and they are putting upward pressure on the marketplace. The third leg of the stool, if you will, the critical acclaim, has arrived too. All three are now in place with regard to Bearden.

Has representing the Bearden estate also led you to other African American artists, including those who can be rediscovered through Romare Bearden and Harry Henderson's book?

Yes. When the gallery was founded back in the 1930s, part of its vision—which we have tried to maintain—was that all God's children should get a seat at the table. We were showing many significant African American artists in the thirties, forties, and throughout the fifties, so I think that served us well when Morris Cohen was deciding who should handle the Romare Bearden estate. For instance, we gave Charles White [1918–1979] his very first New York solo show in 1946, and represented him between 1946 and 1965. We have been working with Benny Andrews* since the 1960s and Faith Ringgold* since 1995. We are also involved in the resale of African American art on the secondary market. All this helped ACA develop a client base that was desirous of other African American artists. Having Romy, who was like a crown jewel, brought us in touch with people who might not have come to us otherwise.

Was size one of the factors in wanting to take on the estate? How many collages, works on paper, and paintings were there?

That's a good question. When we started, there were hundreds of collages. At the time, our mandate was to sell because we wanted to put money into the foundation for projects. We may have done almost too good a job. They do have a small core of collages left in the estate, but not a whole lot. Certainly, the great ones are all gone.

Are you still working with Morris Cohen?

No. He died in 1989. Nanette, as Romy's widow, then had the legal right to take over the estate. We worked with her and, when she hired an attorney who was a former district attorney, a very sharp guy named Greg Perrin, we dealt with him and Nanette until she died very suddenly in 1996. Nanette couldn't have died at a worse time because we had huge projects about to come to fruition. For instance, there was a collector who was willing to put up $1 million for a catalogue raisonné—and it was desperately needed.

Nanette left everything to her seven sisters and, maybe, fifty or forty-five nieces and nephews. Nobody knew much about art, the museums, or the art world, and so all they could do was say, "Stop everything." That's what they told us to do. The $1 million for the catalogue raisonné, the museum shows, everything. Just stop. So we did. We assisted in hiring an appraiser, after which the IRS brought in their own. It took three years for them to work out tax implications. Of course, during that time—although we were involved in the Bearden business through the secondary market—we couldn't sell a thing for the family or the foundation, and we couldn't help them raise money.

Has the family now delegated one or two people to be their spokespeople?

Well, Tallal El Boushi, a young man who lives in California, has been nominated chairman of the foundation, and his aunt, Marie Rohan, is the cochair of the foundation and executor of the estate. Other sisters also hold key positions, either with the foundation or with the estate, and there's an advisory board for the foundation.

Are they also working with other galleries?

From time to time, they have given a piece or two to other dealers, but they haven't done any solo shows with other galleries. Right now, they're rethinking whether they want to have one gallery representing the estate.

And who has all his papers?

The Archives of American Art has one group. After Romy died, we made arrangements with Morris to donate the contents of his studio to the National Gallery's conservation lab, where they were able to take a look at all the inks, dyes, glues, paper, and tools that Romy had used. They now have an excellent understanding of how he worked.

Did you ever think of encouraging a single museum to have such large holdings that they could establish a room devoted solely to Bearden's work?

Part of what we all wanted to do was to have the works widely spread and appreciated. Not to say there isn't a huge advantage to be able to go to one institution and look at thirty works. But, at the moment, that's not the case.

Have there been museums in certain geographical areas that have been particularly interested in acquiring Beardens?

Certain ones feel almost like he's their native son. The Mint Museum in Charlotte, North Carolina, is one because he was born in that city. Residents there are especially interested and proud. He also had deep ties to Harlem and to Pittsburgh. They have holdings of his work, and a lot of southern museums are attempting to acquire it, too.

Were you at all involved with the current Bearden show at the National Gallery of Art in Washington, *Romare Bearden: Call and Recall?*

We had given Ruth Fine the initial idea for the National Gallery Show and, years ago, we shared with her hundreds of transparencies from our Bearden archives. Later, after she had done a great deal of research, she came back to us for additional assistance. Unfortunately, the timing couldn't have been worse. We were moving the gallery and, literally, all of our records, photo files, and sales receipts were stacked in hundreds of boxes in a warehouse and completely inaccessible. Ruth completed the show without direct access to these. What she put together was a wonderful tribute, and it's been a great success. I think she would agree, though, that it was a show, not the show, and that we have only just begun to discover the breadth of Romy's extraordinary vision.

October 2003

FOR FURTHER INFORMATION

Fine, Ruth; Sarah Kennel; Nnamdi Elleh; Jacqueline Francis; and Abdul Goler. *The Art of Romare Bearden.* Washington, D.C.: National Gallery of Art; in association with New York: H.N. Abrams Inc., 2003.

Schwartzman, Myron. *Romare Bearden: His Life and Art.* Foreword by August Wilson. New York: H. N. Abrams, 1990.

www.beardenfoundation.org

FIVE

THE NEXT GENERATION

This part moves us toward a longer view of the principal figures involved and a somewhat varied perspective on questions pertaining to the estate. Time has intervened with attendant shifts in matters of reputation, the size and shape of the legacy, and the obligations involved. In some cases, foundations and/or trusts are already in place; in others, the work of organization and promotion is still to be done. March Avery, the daughter of Milton Avery, ushers us into this section, conveying a sense of confidence and direction. While other voices do not so readily echo this assurance, they all express an enormous respect for—even awe of—the artistic presence they grew up with, and an intense dedication to the legacy that is theirs.

In these interviews, we approach the artist's household through the vivid memories of childhood, which reveal the particular dynamics of these parent-child relationships. March Avery gives us an immediate sense of what it was like to grow up in an artistic milieu, where it was not unusual for the wife to be the primary means of support, for peanut butter and jelly to be the daily fare, and for artists, like Mark Rothko and Adolph Gottlieb, to be passing in and out of each others' homes. Helen McNeil has equally clear childhood memories of Jackson Pollock and Franz Kline, recalling her surprise at later discovering how famous they were. She also tells us of peering into the studio to see her father, George McNeil, "moving his arms around, coming up to the canvas, stepping back, darting at it."

These daughters emphasize the degree to which their homes revolved around the artist and the mother's unwavering assent to the situation. Understandably, this situation is not always easy for the child. Helen McNeil tells us that she can identify with Musa Guston's feeling that she had been ignored by her father: "I think that children of creative parents pretty uniformly feel neglected . . . you have to reckon that the dedication of an artist-parent is somewhere else." Christopher Schwabacher makes a similar point in a different context: "I think for artists, their works of art are their means of achieving immortality because, in many ways, those are closer to them than their own children."

McNeil speculates that her complex emotional connection to her father necessitated a certain psychological as well as geographical distance before their later "wonderful conversations" about his painting could come about. At the same time, she, like Avery, feels that much of her life had been a preparation for taking up the responsibility of her father's

art. Charmed as we are by Avery's insistence that she—having the example of her mother before her—can handle the artist's estate without agony or fuss, we might suspect that McNeil's occasional feelings of being overburdened by the number and variety of demands on her time are closer to the norm.

Christopher Schwabacher, the first example of a son representing a mother's estate, is also an estates and trusts lawyer who addresses the kinds of issues that many heirs face. Because his mother, Ethel Schwabacher, had not received the recognition she had hoped for, he and his sister have taken on the mission of increasing her visibility through shows, donations to museums, and the publication of her journals. While the autobiographical writings of his sister, Brenda Webster, reflect the painful conflicts that are part of her legacy, Schwabacher's voice is that of a man completely comfortable in the role that he has assumed—"trying to carry out a mandate that [his mother] was unable to in her own life."

Schwabacher leaves us, however, with few illusions regarding the time and energy required for the task. The work must be actively promoted, and networking is essential. Relying on galleries is inadequate. "Ideally, the dealers would do all that, but they don't have time." He also briefs us on some of the issues at stake in setting up trusts and foundations.

Schwabacher's candid appraisal of the facts is complemented by his sensitivity to the psychological dimension of the situation. His recognition that the mission of taking on an estate might contribute significantly to the process of mourning and provide a "solace" of its own—creating "a bond, a link to that person who is no longer here"—strongly resonates with other voices that we hear.

D.C.

MARCH AVERY,
DAUGHTER OF
MILTON AND SALLY AVERY

We were in love with painting and it occupied most of our thoughts. At breakfast Milton was already planning his day's endeavor.

From the breakfast table to the easel was a few short steps. Without much ado, a painting was begun. It might be a landscape, a group of figures, a solitary boat. The subject was not the object.

Though the essence of the subject was always maintained, the object of the painting might vary from a symphony in close color harmonies to an arrangement in interlocking shapes and colors—or endless variations on the theme of diagonal thrust, the exact balancing of light and dark, or the juxtaposition of the bold and the timid. Over all was his continual search for order and harmony. . . .

It is this order and harmony that moves and envelops us.

—Sally Michel Avery*

Milton Avery, born on March 7, 1885, grew up in Hartford, Connecticut, where his father was employed as a tanner. From the age of sixteen, while working at various blue-collar jobs, he took art courses and painted part time. After meeting Sally Michel, he moved to New York City in 1925. His early style, a variant of American impressionism, quickly developed as he responded to paintings by Henri Matisse, Raoul Dufy, and other members of the School of Paris. In 1935, at the age of fifty, he had his first one-person show in New York. In his mature style, Avery simplified the contours, organizing his flattened forms almost abstractly. These joyous color arrangements (not without wit and humor) stem from a wealth of drawings of sea, landscape, animals, and figure groups of his family and friends, usually brought back to New York from summers spent in the country. From 1951 until 1995, the Grace Borgenicht Gallery managed his paintings, steadily increasing their exposure. He died on January 3, 1965.

Sally Michel was born in Brooklyn on July 29, 1902, the second of seven children of Lena Michels and her husband, both immigrants from Eastern Europe. In 1924, she met Milton Avery in Gloucester, Massachusetts, where both were spending the summer painting. Despite the objections of Sally's Orthodox Jewish family, they married in 1926. She worked as a freelance illustrator for *Progressive Grocer* and then for Macy's department store,

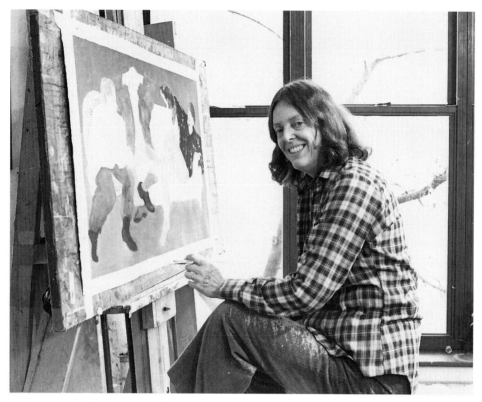

March Avery in her New York City studio, 1993.
© Philip Cavanaugh. Courtesy Philip Cavanaugh.

enabling her husband to paint full time. For some twenty years, beginning in 1940, she was the illustrator for the "Parent and Child" articles in the *New York Times* Sunday magazine section. Sharing her husband's studio for almost forty years, she, along with their daughter March, often worked side by side with him in the country, and a certain affinity can be found in their paintings. Always an important spokesperson for Milton Avery, after his death in 1965, Sally managed his estate effectively—giving interviews, providing information and, particularly in the eighties, writing introductions and essays for many of his catalogues. Sally worked mostly on paper, and on a small scale, and she rarely exhibited during her husband's lifetime. But, after 1965, she painted steadily and had a solo show in New York (1981) as well as two retrospectives in other cities. She died on January 9, 2003, at the age of 100.

March Avery, the daughter of Milton and Sally Avery, was born on October 12, 1932, and grew up in New York, spending summers in the country. As a child, she was the subject of many of her father's drawings and paintings and was the inspiration for his first retrospective, *My Daughter March* at Durand-Ruel Galleries in 1947. In her father's later lounging figures of adolescence and young womanhood, her tall, angular body, long straight hair, and sharply cut bangs are clearly recognizable. In 1954, the year she gradu-

ated from Barnard College, she married Philip Cavanaugh. She supported him until he completed his education, and then returned to her painting full time. Their son, Sean Cavanaugh, was born in 1969. Along with her independent exhibitions, her work is seen in the popular Avery family group shows.

In 1976, Jon Schueler took me to meet Sally Avery, who lived in an apartment overlooking Central Park in New York City. I listened as they talked about the Milton Avery, Mark Rothko, and Jon Schueler exhibition that had recently taken place at the Cleveland Museum of Art,* and marveled at the vivacity and energy of this artist's widow. Twenty-four years later, I talked to March Avery about the role she, herself, had assumed in managing the Milton Avery estate. I appreciated the blunt, matter-of-fact way March approached the subject, as well as her sense of humor and irony.

. . .

Was your father's death in 1965 unexpected?

Oh, no. He had been very sick for some time and spent the last number of months in the hospital. He had suffered a number of heart attacks, and he was not a young man. There was a will in place.

Did he simply leave all his paintings to your mother?

It was set up so that most of the paintings would go into a trust. Of course, my mother was the beneficiary. Actually, there were three trustees: my mother, one of my uncles, and my aunt. In 1965, my mother also set up the Milton and Sally Avery Arts Foundation. That eventually will get everything, which is very good. It's a nice way of handling the problem of what to do with a successful artist's work, particularly if there aren't many children—there is just me. If you had fifteen children, that would be a different matter.

That was very thoughtful of him, to have set up everything carefully before he died. Was he normally well organized?

No, no, no. I think it's probably because we had good lawyers. He wasn't a businessperson at all. It was probably the lawyer saying, "This is what you should do," and everybody saying, "That sounds good, we'll do it!" That's probably the way the foundation came about, too.

Every now and again, I see paintings by Milton Avery loaned to exhibitions from the trust.

The foundation is not legally allowed to hold any paintings. If it did, we would have to pay out five percent annually on their value, which would sap the money in the foundation. So there are no paintings in the foundation. The foundation has money, and it's invested; like any charitable foundation, it has to give at least five percent of its worth away to charity each year. Obviously, we do that. In fact, we give more than that away every year to charities. My mother occasionally transfers stocks and bonds to the foundation. After my mother dies, I am the beneficiary of the trust. After I die, everything in the trust will go to the foundation.

Did your mother gradually shift into gear to manage the estate?

She was an excellent businesswoman. Very, very good. She always handled my father's business matters. My father did not do the business end. She even titled most of his paintings and works on paper.

Your mother was an artist, too. Did her work come first, or did your father's?

My father's. There's no question about it.

After 1965, did your mother immediately devote herself to the estate, or did she return to her own work?

She was still very young [sixty-two], and very vigorous, when my father died. For the first couple of years, she did a great deal of traveling. She traveled all over the world because Milton wasn't interested in that sort of thing. He only went to Europe once, late in life, with my mother and me [1952]. She went to India, China, and Africa, everywhere, to satisfy the desire that she was unable to fulfill when he was alive. Lots of widows do that.

I think that my mother's painting became much more individual, much better, after my father died. She always had a tremendous amount of energy. She had painted a great deal, and she continued doing that. When she traveled around the world, she would draw all the time, and then come home and paint from those sketches. Starting at the end of the sixties, and through the eighties, even up until 1991, she was doing excellent work, big oils, forty-by-fifty inches. I really have tremendous respect for the way her work got better. That's not always true of painters as they get older. But it certainly was true in my mother's case.

When you were a child, did she have much time to paint?

Well, she was the sole supporter of our family when I was a child. She was a commercial artist. She did fashion sketches for Macy's and, for many years, illustrated a column called "Parent and Child," which appeared every Sunday in the magazine section of the *New York Times* under her maiden name, Sally Michel. That was steady income. We knew that was coming in every week.

So she was always the working mother?

Well, I would not call her a working mother. I don't think she would ever think of herself in that way—she supported the family.

I assume, because of the subject matter of your father's paintings, that you left New York during the summers. Did your mother always go, too?

She had an arrangement with the *New York Times*. She would say to Lester Markel, the head of the magazine section, "Well, I'm going away," and he'd say, "Well, I'll see you in the fall, Sally." There was one summer when we stayed in Kent, Connecticut, and she would come in on the train once a week to pick up the stuff for the magazine section. But, usually, we just went away.

So, to a certain extent, she could dictate her own terms?

She had faith in her own ability. When she first went to ask for this job—I hate to say this, but the *Times* is a notoriously poor payer—they offered her an amount that she found

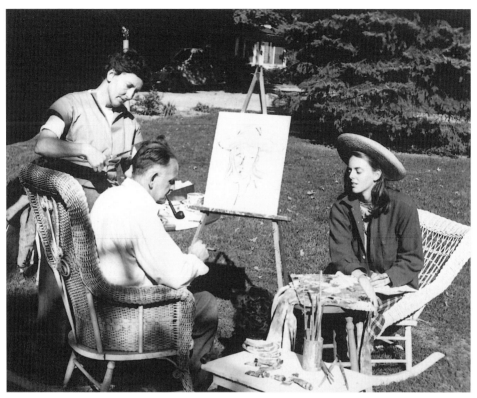

Sally and Milton Avery with their daughter March, Mill-
brook, N.Y., c.1948. Courtesy Milton Avery Trust.

totally unacceptable. We had not a cent, but she said, "I won't do it for that." And—this is unusual—they called her back and said, "All right, we'll raise it." I mean, it was nothing, about forty-five dollars a week, but it was a lot for us.

Did she go to art school?

Back then only the brothers were sent to college, so she was not given that option. She tried different things. She wrote for a while. She wanted to be a commercial artist, so she made a portfolio and took it around. She did some greeting cards and sent them off with little poems and drawings, and they wrote back and said the poems are fine, but we don't like your drawings! But she had a natural talent. She was very determined and would not take no for an answer. If people said, just to get rid of her, "Come back in six months," she would. She was cute, you know. She got a little work.

What was she doing when she met your father?

Her father had given her enough money to go and paint for the summer in Glouces-ter, Massachusetts. Milton was also there, so they met as painters. They got married in 1926. A few years later, I was born.

It was after they got married that she got the *Times* job?

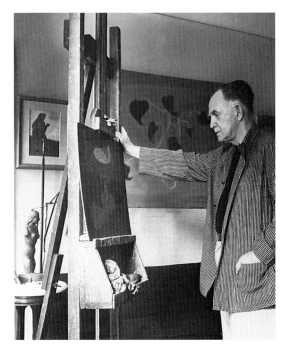

Milton Avery in his New York City studio, 1950. Courtesy Milton Avery Trust.

Oh, yes, quite a bit after. We ate a lot of peanut butter and jelly! You know, it didn't seem terrible. It was the Depression, and nobody had any money. It wasn't a big deal. She had that job at the *Times* for about twenty years, until the fifties, when Milton started making enough money so she could stop. There were a few collectors at that point, like Hirshhorn and Roy Neuberger, who bought his paintings.* We began to eat a slightly more varied diet!

Having stepped back from the *Times,* did she immediately start helping your father?

She always helped him. She always was the practical one in the family. My father was a painter, you know, he wasn't practical. He painted. I mean, he was helpful—he washed the dishes, he swept the floor. But he was not interested in money. He was interested in painting, and that was it. He had worked as a child. Then, after his father died in 1905, he had to support his mother and his cousins, who were all girls. At Hartford he worked very hard, often working at night so he could paint during the day. After he married Sally, essentially, he never had a job again. She thought he was a genius. I think she was right! But it took a lot of courage for a young person like that to act in the way she did. It was also typical of their friends. Rothko and Gottlieb had the same situation. Esther Gottlieb was a schoolteacher, and Rothko's first wife, Edith, made jewelry. Nobody thought it was strange at all.

Do you think your mother had specific goals when she was in charge of the estate?

She thought primarily about the paintings, although she was good at investing money, too. When Milton died, his reputation was already very strong, but she wanted to get the paintings into as many galleries and museums as possible. She wanted to steadily raise their prices, which she did, of course, in the eighties. She was very businesslike about maintaining the same price in every gallery. If sales were good, she would raise all the prices, sometimes every six months. Back in that upsurging market, it was possible to do.

Was she the kind of person who dealt easily with galleries and the art world?

Very well! As they say, she had "people skills."

That's important. Some gallery owners won't touch an estate because of their feelings about the widow or the inheritors.

Sure. Unfortunately, many good artists' paintings aren't seen because the people who handle them don't know how to manage them properly. It's too bad, you know.

Do you think some people hesitate to assume the responsibility to begin with?

I think the widows are less likely to resist than the children are. Sometimes, the children really don't want to be involved. They have their own lives to lead. But I think that most widows at least make an attempt. They may not be successful, but they do try.

It sounds as though your mother rather enjoyed her public role?

My mother was very charming. She was very good-looking, and people liked Sally a lot. She loved going to openings and being admired. Everyone kissed Sally. I'm the exact opposite. Nobody ever kisses me!

She was proud of Milton's paintings. I don't think she ever thought of herself actually as Milton's widow. She was a very vibrant, full-of-life woman, and she just took life by the teeth and shook it. She went out every night. She never walked; she always ran. When the telephone rang, she would run to pick it up, even when she got to be in her seventies and eighties—and it would make us nervous. She had always done it that way, and she saw no reason to change.

Did she also entertain a lot?

No, she wasn't a big entertainer. She preferred going out. She had lots of friends.

Was there anything else that she would have preferred to have done?

Absolutely not. No. She always did *exactly* what she wanted to do.

It's very satisfying to hear that, March.

Well, I don't know if it's so satisfying for the rest of us, who are unable to act that way.

She used to get very irritated when people said, "You've done such a wonderful job with Milton's work." She would reply, "The work is great. The work does it. I don't do it." But the truth is that she was a very good businessperson. Of course, good work surfaces, cream goes to the top. It would have done so without Sally but, certainly, she made the journey a lot easier.

Did other widows or wives ask her for advice?

People asked her opinion all the time. They thought she had some magic, secret formula, but she really didn't.

Do you think she had any model? Lee Krasner or Annalee Newman, for example?

No, she was self-created, very self-created.

Did Sally help with the many books and catalogues that came out on Milton's work?

She didn't do the research. No, she wouldn't do that at all. But, when a gallery was having a show, she would insist on having a catalogue because, after three weeks, the show is over. She wanted nice catalogues. So, the galleries did that. But she didn't try to influence who was invited to write the essays.

Artists' widows often emphasize the hours of time that it took to do the inventory.

She just didn't do it. My mother was very efficient; she wasn't a fusser. I know some artists' widows with much less stuff to work with—and much less talent to work with—who make a big deal over the things that my mother would not pay any attention to.

How did she know what she had?

Most of the time, she didn't.

After you father died, there must have been some sort of inventory?

She hired professionals to do that. You have to. Nobody is going to accept the widow's inventory of what things are worth, because they'll be exaggerated.

Did she always have a secretary or an assistant?

She never had a secretary or assistant.

So when paintings went out to galleries and came back again. . . .

She dealt with that. People make too big a deal out of this. You have a book, you put it in the book, you write out a consignment sheet, and off it goes. What's the big deal? I don't know why people fuss so. You see, I have my mother's attitude.

Did she ever try to keep certain paintings back?

Yes, some paintings she wouldn't sell. But it wasn't a problem. There were always plenty more.

Do you know approximately how many paintings and drawings there were when your father died?

I don't know how many there were when he died, and I don't know how many there are now.

Really?

I really don't. People say to me, "Oh, I assume you inventoried all the drawings for a catalogue raisonné," and I just laugh. If you have five hundred drawings, that's one thing. You can catalogue them. When my father died, I cannot tell you the condition the drawings were in, or how they were kept. It's embarrassing. I've spent literally years just trying to sort them out. As for my mother's work, that's still in a mess.

Did your mother, like Clyfford Still, want a core collection of Milton's work placed in particular museums?

No. She would say something like, "This painting should go to a museum," but there was nothing formal written about it. As things came along, decisions would be made. I think Clyfford Still was much more cerebral. My mother is a very spontaneous person. There was no planning; there were no long-range formal goals. If a museum was interested in a painting, she would entertain that idea. As life came along, she dealt with it.

I assume that the Milton and Sally Avery Museum at Bard College [1981] was one of her projects?

Sally never had any interest in buildings. We don't give any money for buildings. They named one of the buildings after Milton. We give money for professorships and scholarships at Bard.

So the foundation is for art historians?

No. It's essentially to encourage painting. We give a good deal of money to places like Yaddo and the MacDowell Colony, for artists to paint. I tend to try to give large amounts to help young people, even grammar-school kids, because I think that's very important.

But the foundation was set up to give money, not to artists directly, but to nonprofit institutions, and to sponsor people to come and paint in the summer. To me, painting is wonderful. Everybody should do it, whether they are professional or not.

When were you brought in on the boards of the trust and the foundation?

When my maternal Aunt Augusta died, I took her place. Then, when my uncle died, my husband Philip took his place. When my mother became incapacitated, my son joined us. So we are now the three trustees. The foundation has officers. I'm the president, my son is the vice-president, my husband is the treasurer, and Harvey Shipley Miller is the secretary.*

You've had to take on a lot, March. You are a painter yourself; you've got both your parents' work; and you've also got your public duties. Could one describe them as that?

[Laughter] Public duties? Going to openings and being polite to people? I'm not very good at that!

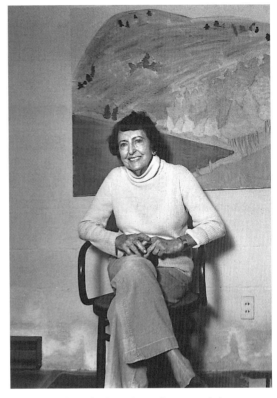

Sally Michel (Avery) in front of one of her own paintings, Bearsville, N.Y., 1982. © 1982 Harriet T. Tannin. Courtesy Milton Avery Trust.

Did you always assume that you would gradually take over from your mother? Did you ever try to wiggle out of the responsibility?

Oh, no. I embraced it. I'm deeply convinced that my father was a great, great painter. And I take great joy in the opportunity of being able to deal with the work. I mean, it's a pleasure. I'm very lucky that my son, who is also a painter, feels exactly the way I do. We go up to my mother's apartment to work on trust affairs one day a week, and we spend a lot of time oohing and ahhing at the paintings. Frankly, I would have a very hard time doing it without Sean. Between the two of us, we keep our heads above water. You could fill up all your time working on it but, since we are both painters, we are not willing to do that. I think we do a pretty good job, though. Obviously, at times it spills over into other days.

Until recently, Philip was teaching full time at Baruch College, so he never spent as much time as we do. But he has an excellent eye, and he's very practical and good about money matters. He gives his expertise, although he doesn't do as much actual hands-on stuff. He doesn't wrap paintings the way we do.

Do you have anyone to help you?

I have a very good bookkeeper, Bali Miller, who has worked a couple of days a week

up at Sally's for many years. She handles all the stuff that I find repellent, like working on the computer and dealing with the accounts. She is also a private art dealer, so she understands art and appreciates Milton's paintings. It works very well.

I know that you've all done a most wonderful job with the estate, but are there projects that you still want to accomplish?

Like everybody else, we want to see Milton's work going into important museums. For instance, there was a painting just recently acquired by the Tate Gallery that my mother never wanted to sell. She had always said, "This painting isn't for sale." But then, the Tate wanted it. I thought that was a very appropriate thing to do.

I would also like a larger exposure of Milton's work in Europe and Asia, and some more books done on Milton. I would like the paintings and drawings to find good homes. I love having them around, but it seems sort of criminal to have them in storage and drawers. It's a gradual, slow process. I don't expect this to be completed in my lifetime. I think it's foolish to push things too hard. They happen as they happen.

Did Milton respond easily to art historians who wanted to write on him and his work?

My father was very nonverbal. He hardly talked at all. I think he would simply have frustrated any writer.

Since 1965, has the family been more closely involved with writers?

No.

Have you got your mother's head for business?

I don't think so. She enjoyed the battle. I really don't. Actually, I think my son is better at it than I am, and he's better with people, too. I'm kind of a grouch, and he's not.

What some artists, and then their descendents, find upsetting is that you have a price list and you think everything is straightforward, but then it never is.

If you think that, you're being naive. I'm not very naive. I've known this business for a long time. I'm very practical. That attitude would be very foolish.

But it does seem that very often one is under pressure from the gallery to. . . .

Well, I do not respond well to pressure, and the galleries know it. They say, "Well, we always take off ten percent," and I say, "Not with me, you don't, so get that," and they listen.

Some of it, as you say, comes from practice.

Absolutely. People come to me and tell me how shocked they are at what happens in the art world. I'm not shocked. I deal with it.

Did your mother talk to you about what she was doing over the years?

I was always there, you know. Even when my mother was able to handle everything, my Aunt Augusta and I would go one day a week to the apartment and work with her. I always knew what was going on, although I didn't control the situation because my mother liked to.

I often helped Jon Schueler negotiate with the galleries and, together, we could keep calm. Since he died, I'm much less certain when put on the spot.

I'm just so grateful to have Sean and my husband. I would think that it would be terribly hard to do it all by yourself. You can't bounce it off anybody.

Someone suggested that the estates of well-known artists are less interesting to handle because of the large money component.

It's a terrible thing to say that money is an irritation, but it is kind of insulting to refer to a painting as a million-dollar painting rather than as a beautiful one. I don't like that. But it doesn't make the work less interesting. The paintings are still beautiful. If you stop to think about how much each one is worth, you would be afraid to handle them as we do. If someone wants to pay a lot of money for them, okay, fine. But that's not the important thing.

Is the price a strange abstraction to you even now?

As I often say, if a painting of Milton's sells for a million dollars, he would just howl if he was around—he would think that was the funniest thing he had ever heard in his life.

Did it give your mother a lot of satisfaction to see the prices rise?

Yes, it did. Absolutely. As I said, she was a very good businessperson, and it gave her a lot of satisfaction.

While you were growing up, did you meet a lot of artists?

Yes, they were always around. I was an only child, so my parents took me everyplace. We spent a good deal of time in each other's houses. I knew Rothko and Gottlieb and their wives very well.

Since your mother hadn't been able to go to art school, when you said you wanted to go. . . .

I never went to art school. My father said, "Don't go to art school." But I did want to go to college, so I went to Barnard and majored in philosophy. I never took an art course. I never even took an art history course. I think it was rather foolish of me, frankly, but that's the way it is.

When did you start painting?

When I was two years old. I always wanted to be a painter.

What did you do after graduating from Barnard?

I got married. Philip went to Columbia University when he returned from the Korean conflict in 1954. He was only a sophomore when I met him, so I took a job to support him while he got his B.A., M.A., and Ph.D. When he finally got his degrees, I quit. I quit fast and said, "Now I'm going to be a full-time painter."

Congratulations. What was your job?

I worked for the New York state employment office, where I got jobs for commercial artists. So it was vaguely related, but I really hated it.

You saw him through all those degrees, and also had a child?

Uncle Sam and I—thank God for the GI Bill of Rights. That really paid for the tuition. I just paid for the hamburgers. Actually, I didn't have Sean until late in life—1969. That

was not from choice, but the way it worked out. By then my husband was teaching, so that was not a problem.

Well, I have to go. I always call my mother's apartment at 5:00 P.M. and talk to the women who take care of her. That usually involves a rather lengthy conversation.

Thanks so much. It sounds as though managing your father's work is as satisfying to you as it was to your mother.

My main pleasure is in dealing with the paintings and the drawings, being able to be in their vicinity. Frankly, I'll be quite honest with you: I think I do a good job. I feel I'm competent. That's satisfying.

October 2000

UPDATE

Sally Michel Avery died on January 9, 2003, at the age of 100.

FOR FURTHER INFORMATION

Haskell, Barbara. *Milton Avery*. New York: Harper & Row, 1982.

Hobbs, Robert. *Milton Avery: The Late Paintings*. New York: H. N. Abrams, 2001.

Kramer, Hilton. *Milton Avery: Paintings*. London and New York: Yosoloff, 1962.

CHRISTOPHER
SCHWABACHER,
SON OF
ETHEL SCHWABACHER

I realize that I had always felt that art was not a question merely of self-expression, the joy of making beautiful colors or the joy of understanding the construction of nature and its realities. But it primarily wishes for the joy of giving joy. That was the necessity, that was the innermost necessity for the artist. If at times the joy of giving was confused with fame, that was rather a verbal mistake. What does fame mean except that one was able thereby to give more to a greater number of people?

—ETHEL SCHWABACHER*

Ethel Schwabacher, born on May 20, 1903, the daughter of wealthy Jewish lawyer Eugene G. Kremer and his wife, Agnes (née Oppenheimer), was raised in Pelham, New York. Her father died in 1920, when she was in her teens, and her only brother, Jimmy, was institutionalized when he was in his twenties. After some ten years of studying sculpture, Ethel turned to painting and, in 1928, left for Europe. She underwent psychoanalysis for two years in Vienna with Helene Deutsch. On her return to New York in 1934, she studied privately with the artist Arshile Gorky and—with Wolfgang S. Schwabacher, a prominent entertainment lawyer whom she married in 1935—formed a collection of his and other artist-friends' work. Daughter Brenda and son Christopher were born in 1936 and 1941.

Ethel's paintings in the late forties, which reflected Gorky's interest in the preconscious and the simultaneity of impressions, blended images of animals and flowers with areas of pure color. The death of her husband from a heart attack in 1951, followed by the rejection of her book* on Gorky (who had committed suicide in 1948 at the age of forty-three), led to severe depression, a series of attempted or threatened suicides, and a life-long commitment to Freudian analysis. From 1953 to 1962 her work was shown, along with other abstract expressionists, at the Betty Parsons gallery in New York. Her bold, colorful, gestural "abstractions" evoke images of women, childbirth, pregnancy, and mythological themes. This period flowed into the joyful color field paintings of the early sixties. The Civil Rights paintings and drawings of 1963–1964 herald a return to figuration, reinterpretation of myth, and an interest in portraiture. Through paintings of Orpheus and Eurydice, Sisyphus, and Prometheus, Ethel explored themes of loss of love, abandonment,

Hannelore and Christopher Schwabacher, August 2003.
Courtesy Christopher and Hannelore Schwabacher.

and search. She rarely painted after 1976 because of severe arthritis, but she wrote or dictated journal entries intended for publication. She died on November 25, 1984, at the age of eighty-one.

Christopher C. Schwabacher, born August 23, 1941, the son of Ethel and Wolfgang Schwabacher, spent his childhood in New York, with vacations at the family's farm in Pennington, New Jersey. After graduating from Harvard College in 1963, like his father and maternal grandfather, he trained as a lawyer. He received his degree from Harvard Law School in 1966, and an LL.M. from New York University School of Law in 1967. A specialist in estates and trusts, he practices with the law firm Brauner Baron Rosenzweig & Klein in New York City, where he represents a number of artists and collectors. He is a member of the Art Law Committee of the Association of the Bar of the City of New York, and also serves as a director or trustee for a number of philanthropies, including Artists Space, the Fine Arts Work Center, and the Betty Parsons Foundation. He is on the finance committee of the Parrish Art Museum, the advisory board of the Pollock-Krasner House and Study Center, and the planned giving advisory committee of the Museum of Modern Art. He and his wife, Hannelore, have two children.

Over the years, paintings with a very individual touch would catch my eye in group exhibitions of American work from the fifties. I would peer at the label: Ethel Schwabacher. At one such show, Anita Shapolsky, who handles Schwabacher's nonfigurative work, introduced me to Christopher Schwabacher, and I later visited him at Brauner

Baron Rosenzweig & Klein, where he sat at a large legal desk in his office, which commands extensive views across Lower Manhattan.

. . .

Could we begin with your personal situation as the son of the artist Ethel Schwabacher? What plans had your mother made for her paintings before she died in 1984?

Since I'm a tax planner, we were obviously concerned that my mother's art works shouldn't become major taxable assets of her estate because they were very illiquid and would have been a considerable burden. So something that was disappointing to her—that she didn't get the recognition she thought she deserved during her lifetime—worked fortunately from a tax perspective. We could take the position that, even though they were very wonderful and beautiful works, they did not have a market value at the time of her death.

Her will was silent as to her art, other than leaving it to her daughter and her son. We started to establish a market for it by working with dealers and arranging for museums to receive donations. Only after her passing did we develop some value to the work, at least from a market perspective.

Did you have the main responsibility?

It was really shared. My sister, Brenda, got her Ph.D. in English and is a very good writer.* My mother had written a journal in the last years of her life. As her hands got more and more arthritic and she was less able to do her art, she started writing about artists she knew, her own work, and her theories about art. Brenda and a professor at SUNY–Albany edited the journal, *Hungry for Light*, which was published some years after my mother's passing.

Brenda also wrote a book called *Paradise Farm*. Although it was a work of fiction, its heroine was really my mother, and it reflected her childhood and upbringing. That also helped establish my mother's persona in the art world. So, while Brenda worked on that side of things, I dealt with dealers and museum placements. There are now twenty-five museums throughout the country that have her paintings in their collections.

Which museums were most relevant for your mother's work?

As she was a New Yorker, we focused on the museums here; there are now Schwabachers in the Whitney, the Guggenheim, the Metropolitan, and the Brooklyn Museum. Her work is also at the Zimmerli Art Museum at Rutgers University in New Jersey because it gave her a retrospective exhibition following her passing in 1987. A catalogue came out at that time, so there was a lot of visibility. We've also organized other museum placements.

Our family situation is somewhat relevant to others with artists in their families. What do you do with the legacy that you have? Clearly, there's a nexus that runs between the scholarly and museum communities and the market. They're intimately related. You need to have museums holding the work to help validate it. But they are not terribly comfortable if there is no market, so it goes back and forth. You definitely have to have sales. In

Ethel and Wolfgang Schwabacher with their children,
Christopher and Brenda, 1942. Courtesy Christopher and
Hannelore Schwabacher.

fact, there are some museums that won't take works unless there is some market interest.
On the other hand, museum exhibitions develop that market interest. That is why we gen-
erally recommend to clients that they give some works to significant museums and then
try to get professors of art history involved in writing about the artist and the work to gain
further validation.

How much work was there at your mother's death?

There were a couple of hundred canvases, and then a lot more works on paper. That's
another issue. It is a problem if there's a rather small group of works in the estate. Dealers
are then less likely to want to promote the artist's work because they don't have enough
inventory to support the investment. Of course, if it's Jackson Pollock and there are just a
few works and they are each worth $2 million, then it may be worth it. But, short of that,
it's a difficult proposition.

In your case, there was a sufficient amount?

A couple of hundred, a hundred and fifty is fine. But that's an important considera-
tion. Often in our planning we try to arrange for a certain number of the works, under
the will, to be given directly to charity or to a foundation that will then donate them to
another charity. Then they are not taxable, and a vehicle is created to get them into muse-
ums. A family foundation should work in conjunction with a dealer so that they are not
competing with each other. Obviously, the museums won't buy any works from the dealer

if they can go to the foundation to get one, so it's a difficult equation—keeping the museums interested in making acquisitions, but making sure that enough museums have the work.

Which dealers do you work with?

We work with different dealers with different estates. It depends really on where that artist has shown. You want a dealer who has clients who relate to the artist's style. Clearly, collectors have different tastes, and they tend to aggregate with those dealers who reflect their interests.

With your mother's work, have you stayed with one dealer?

Well, it's difficult. If you don't sell a lot, sometimes dealers get less enthusiastic, and want you to move on. We've tended to have the same dealer [Anita Shapolsky]. But, again, the market has not been very active. If we sell one or two works a year, we're quite content.

What goals do you and your sister have for your mother's paintings?

Our goal is really her goal. I think any artist wants to be recognized as a great artist. Very few will make art unless they believe they will gain recognition because it's much too painful a process to go through unless you feel you are doing something remarkable. If all my mother's works were in significant museums and private collections, she would, wherever she is, be very happy because that's where she believed they should be. So if, in our lifetime, we can slowly distribute these works, we will have done our task. Then the public will have to decide whether this work is something worth thinking about.

What happens if there are paintings left over when you and your sister die?

That raises a whole other issue. And there is some tension because, in any family, there will be members who really like the works. We have many of the works in our homes, and our children want to have some, too. So there is a bit of a conflict between keeping them within the family and getting them into museums and significant collections. There are works we know we could sell easily, but we don't because they have become part of our lives. Of course, if families don't have the resources or energy or time to promote an artist's work and they enjoy keeping it, that's another way of making it live—giving satisfaction to those who remain. That's a perfectly legitimate approach.

Do you find, in your situation, that it's advantageous to frequent certain places, to be seen at openings?

There's no question that, from the market perspective or that of getting museum shows, you have to be very proactive both during an artist's lifetime and afterwards. In the traditional model, the artist was a male, and his wife was his business manager both during his life and afterwards. Sally Avery, Annalee Newman—those are real lions who go out there and promote their husbands' work. That has been a pattern, and it's true for Richard Pousette-Dart, for Bill Baziotes, and so on.* Of course, the husband of a woman artist could do the same thing. Then, you've got to have a child who steps up to perform that promotional role. You've got to be around; you've got to know people. Ideally, the dealers would do all that, but they don't have the time. Also, you've got to have effective

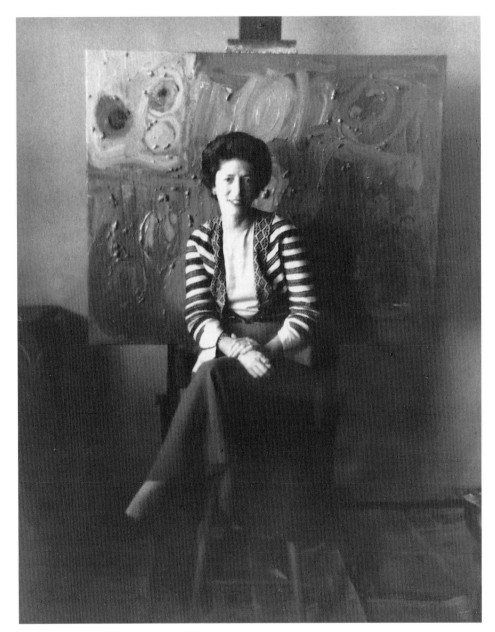

Ethel Schwabacher in the 1950s. Photo: Richard
Pousette-Dart. Courtesy Christopher and Hannelore
Schwabacher.

records. We counsel our clients to have very good inventories, photo inventories of all the
works, provenance histories, and exhibition histories because it's important for the muse-
ums, the buyers, and the art historians. They all want that information, and nobody else

has the time to assemble it. If it's not available, it is much more difficult to promote the work.

In your case, is it you who keeps the inventories?

Actually, my wife, Hannelore, has assumed that responsibility. She's the curator of the Schwabacher works. She has a scientific background, medical science. This has become one of her projects. And, of course, we have an updated biography, bibliography, photo inventory. If art historians want to know about something, we can send them slides or other information.

There are often jokes about the artist's widow, but fewer about the artist's children. Do you ever feel uncomfortable with this responsibility, although it is shared with your sister and your wife?

No.

Not at all?

No. I'm an estates and trusts lawyer, and I advise various families as well as a number of artists and collectors. It seems perfectly natural to carry out my advice in my own situation. I feel entirely comfortable trying to carry out a mandate that my mother was unable to in her own life. I believe in her work and, if you believe in the work, you are more likely to feel a sense of mission. I've often talked to artists' families and realize that this is a considerable solace to them, especially perhaps to the widow. When you lose someone, it is a way of carrying on the artist's life and work. It brings a lot of personal satisfaction and is a bond, a link to that person who is no longer here. I think for artists, their works of art are their means of achieving immortality because, in many ways, those are closer to them than their own children. The work is almost an extension of themselves.

Do you think that it's practical to invest financially in the artist's work? Have you done so?

Well, it's certainly a practical concept. Many artistic families don't think they have very much cash. Artists traditionally like to think of themselves as rather impecunious—having a lot of wonderful art but not much money. In today's world, a successful artist has quite a bit of money. So it really depends on the circumstances of the family. Of course, you can also apply to sources like the Judith Rothschild Foundation, which helps artists' estates do catalogue raisonnés and retrospective exhibitions. I know a number of artists' estates that have been successful in obtaining grants from that foundation for those purposes. Also, if you can get a museum to offer a show, it can apply for grant money to supplement the exhibition budget.

Have you found that artists are willing to plan ahead? What would a sensible will be?

Obviously, each individual is different. But, in my experience, artists are generally concerned about avoiding unreasonable estate taxes imposed on their estates because of the many works on hand at the time of their deaths. That's what we try to focus on. The matter is quite simple if there is a surviving spouse because then there is no estate tax—even if there is $700 million worth of art. But there is a generational transfer tax on prop-

erty passing from one generation to the next. You try to focus an artist client on this issue and structure a plan, for example, a combination of a charitable foundation and gifts of art to children after the surviving spouse has gone. That's what estate lawyers are here for: to minimize transfer taxation, and to create a vehicle for enhancing the value of the art after death.

Often the artist has an interest in some artistic cause so that the foundation is not only a vehicle for placing his or her work in museums but also for carrying out some projects—like a fellowship at an art school, or art classes for children in the public schools. The proceeds from the sale of works in the foundation can be used for these charitable purposes as well as for doing a catalogue raisonné, museum placements, and other promotional efforts.

It's a lot of bother to run a foundation unless there's a certain amount of income or, to begin with, capital. Is there a kind of base line that you recommend?

Well, that's a good question. It's hard to draw that line. Obviously, it's most convenient if there are financial assets in addition to the art to pay for rent, insurance, and such items as a curator. Otherwise, you have to rely on having a certain number of sales on a regular basis. That can be a problem. We often write these things so that it's flexible. If the resources are lacking for a foundation, the executor could place works in museums within the period when the estate is in administration—usually two or three years. With the foundation vehicle, you have a longer period of time, which is more rational because, usually, the absorption rate is relatively low. It would be very difficult to place fifty to eighty works within a period of two or three years.

If you were setting up a foundation, would you think of its lifespan in terms of thirty or forty years?

Yes. It depends, but certainly you need space because just the negotiations and the discussions with the museums, the selection process, and so forth take time.

Could you explain the benefits of a trust for artists' families?

You can set up a trust for the benefit of your family members. You can set up a charitable trust or charitable corporation. There's not much difference from a layperson's perspective. But the trust is also a vehicle for holding the art for family members. We often do that because we don't want to have family members competing with each other. Instead of giving seven paintings to one daughter, seven to another, and twelve to the wife, you put them all into trust (with one trustee), and there is common management and disposition of those works by one person—and that trustee can deal directly with the dealer. As the works are sold, the beneficiaries receive a portion of the proceeds in accordance with their interest in the trust, or they share proportionately in the income earned when the proceeds from sales of art are invested by the trustee. Every family trust beneficiary participates when one painting gets sold, rather than having a lottery or Russian roulette, with one person scoring while the others are sitting on works that don't get sold. You always have issues of valuation. It's so difficult to know the real worth of the art works and

to allocate them fairly among family members. It really does require some consultation so that the legal solutions are structured in such a way that they won't create tension for the family and, instead, will keep everyone together.

What kind of set-up creates clashes of interest?

You don't want different family members going to different dealers with different portions of an art portfolio and competing with each other.* You want to have a coordinated approach, or you are going to be in trouble. And you try to identify personality conflicts between parent and child or between children, and work out structures that will minimize those frictions. If the artist is married for the third time and the children are by a prior spouse, you've got to balance things or have a mediator so that there's not a conflict between people who may not like each other.

In the setting up of a trust or foundation, what sort of role should the gallery that represents the artist play?

It's probably safer to use the gallery as an advisor, just as you use a lawyer or an accountant, rather than in a fiduciary role because then you are locked into the gallery. The gallery could change management or close, or you could become disenchanted because the gallery wasn't promoting the work appropriately. You want to have the flexibility of saying that you are going somewhere else.

What are examples of estates that have floundered, and of others that seem to have been settled positively, going according to the original will of the artist?

From the outside, that's a very difficult question to answer. Certainly, the Rothko will was a disaster. Some people feel that the Pollock-Krasner Foundation is a very successful operation. Judith Rothschild did a wonderful job with regard to her estate planning and the available resources. Much of it has to do with the market, which for some artists has been fabulous. I can think of a lot of bad examples, not many good ones.

What has led to these estates not working well?

I think it's insufficient planning. Traditionally, artists didn't think they needed to plan. Of course, sometimes it's the people involved, who use their positions in a self-serving way.

Do successful artists more frequently make their way to you than those without much money, who may be less inclined to face the situation?

The problem about not wanting to face it can sometimes happen with the artist who is quite successful as well, especially if there is an untimely death. In many ways, the structuring is less significant than the people who are there to implement the structure. The key thing is having people with time and energy and resources to do the heavy lifting. A lot of work has to be done.

So, you're suggesting that the galleries have to have a lot of help?

Absolutely. There is too much competition. People in New York are overwhelmed by the enormous amount of art available in museums and galleries. To really get to the top, to get significant recognition, requires a tremendous effort.

Do you think that kind of dedication can only come from family or very, very close friends?

If there are enough resources, you can certainly pay professionals, perhaps a former dealer, to do that promotional task. But, more typically, somebody not being paid has to do it.

Do you find that most artists just assume that the remaining spouse will take on the responsibility?

That has to be discussed. Sometimes the spouse doesn't have the intellectual and emotional resources to do it. If there are no children, you have to try to find someone else.

Have you ever advised your clients to have everything sent to an auction after they died?

Not unless they are very well known, and then there are certainly enough resources to hire people to manage the work. If there's no real market for the work, an auction is inappropriate. In any case, a reputable auction house wouldn't take it. Unfortunately, I've run out of time. But to sum up: If the artist hasn't created a reputation for his or herself, and if there's no circle of friends, no family that wants it or is capable of handling it after their passing, then the work has to be given to schools or hospitals or something of that sort. Or, it would be better during the artist's lifetime to give it to dear friends, letting them make a selection. They then have these art works as a remembrance and as something that gives them pleasure. But something has to happen, and it's not going to be a museum that takes on a hundred or two hundred works.

September 21, 2000

ADDENDUM

In his remarks, Christopher Schwabacher underscores the contribution that his sister, Brenda Webster, has made to perpetuating their mother's legacy through writing, and how important such publications are. Webster, who has written psychoanalytically informed studies of William Blake and W. B. Yeats, along with fiction and an autobiography, has drawn attention to Ethel Schwabacher and her painting. She has also imaginatively worked out her own ambivalent, often tortuous, feelings toward her mother and her childhood. The publication of her mother's journals, which she and a friend and colleague edited, and her own first autobiographical novel in 2000* reveal the intense division that plagued Webster throughout much of her life: "In one, Mother is the gifted woman who taught me how to love beauty and persevere in trying to create it, and in the other the raving, cruel woman who often hurt me."

Webster, therefore, offers a more intimate portrayal of the artist than does her brother. Impressed by the degree to which "art mattered" in this household, jealous of the attention her mother's paintings and artist-friends received, and frightened by her mother's instability—which seemed inseparable from the art to which she was passionately devoted—Webster learned early that art was a risky enterprise. Registering the impact of the death of Arshile Gorky, a close friend, on the family when she was eleven, she writes:

The salient fact for me was that he was an artist, and it seemed that Art, like Sex, was dangerous. From what I could make out from fragments of conversation, being an artist was like being a high-wire walker in a circus. You exposed yourself to the crowds. You were always in need of money. Unless, like my mother, you had someone strong and capable like my father to take care of you, you might crack.

This intuition was soon to be confirmed when Webster's father died suddenly, and her mother attempted suicide. Only many years later did she begin to reconcile her intensely ambivalent feelings toward her mother. A particularly moving—if not conclusive—passage is her description of the reading she gave in 1993 on the joint publication of her mother's journals, which she had worked on for six years, and her own novel, *Sins of the Mother*:

> When I read from the journal at Cody's bookstore in Berkeley with my commentary and slides of Mother's paintings, people cried—I was almost crying myself. Her paintings were so luminous, her lyricism poignant, marvelous. I admired her spirit, the way she transcended her pain. I believed her when she said art should be gentle, beautiful, like the ancient art of China or Egypt, excluding everything ugly or angry. Yes, I found myself saying, yes.

FOR FURTHER INFORMATION

Berman, Greta, and Mona Hadler. *Ethel Schwabacher: A Retrospective Exhibition*. Catalogue essays. New Brunswick, N.J.: Jane Voorhees Zimmerli Art Museum, Rutgers, The State University of New Jersey, 1987.

Webster, Brenda S., and Judith Emlyn Johnson, eds. *Hungry for Light: The Journal of Ethel Schwabacher*. Bloomington and Indianapolis: Indiana University Press, 1993.

HELEN McNEIL, DAUGHTER OF GEORGE McNEIL

I'm in the painting, I'm overwhelmingly in the painting. My feeling is extremely dominant, it's a very subjective approach. And in that sense I come out of an existential background of the Fifties.

—George McNeil*

George McNeil, the son of Irish Catholic working-class parents James McNeil and Anna Kenny, was born in Brooklyn on February 22, 1908. His father worked as a plasterer's assistant, or lathe-man. McNeil studied at Pratt Institute (1927–1929) and the Art Students League (1930–1933) with Jan Matulka, but found his path as a student (1933–1936) and then monitor and assistant teacher of painting and collage (1936–1938) in the Hans Hofmann School of Fine Arts in New York City. In 1936, he married fellow Pratt and Hofmann art student Dora Tamler (1910–1990) who, until the late 1970s, worked almost continuously in commercial art. Their two children, Helen and James, were born in 1942 and 1948. A founding member of American Abstract Artists in 1936, McNeil participated in the WPA Williamsburg Mural Project (1938) and then gained an Ed.D. from Columbia University in 1943. Following service in the U.S. Navy (1943–1946), his first teaching job was at the University of Wyoming (1946–1948). He then taught painting and art history at Pratt Institute in New York (1948–1981) and at the New York Studio School (1966–1981). His paintings of the thirties, muted in color, are loosely cubist, developing into abstraction. By 1950, they are manifestly expressionist and abstract, with active forms emerging from heavily textured surfaces. In 1959, McNeil turned to figurative abstraction, infusing his bathers, dancers, and other figures with an absurdist vitality. By the 1980s, his vividly colored images, with their floating heads, graffiti and phallic shapes, were influencing a younger generation of neo-expressionists. In these later paintings, his mastery of the manifold techniques of manipulating paint is especially apparent. He died on January 11, 1995, at the age of eighty-six.

Helen McNeil, the daughter of George and Dora McNeil, was born in New York City on October 24, 1942. She has a B.A (1963) from Reed College, Oregon, and an M.A. (1964) and Ph.D. (1970) from Yale University, where her dissertation was entitled "Fiction and Phenomenon in the Later Poetry of Wallace Stevens." After teaching at Hunter College, New

York, from 1968–1971, she became a lecturer in, and then chair (1990–1993) of American Studies in the School of English at East Anglia University, Norwich, England, as well as cofounder of the film studies department. She has written many articles and reviews on such subjects as women's poetry, modernism, and the Beat Generation, and is the author of the critical biography *Emily Dickinson* (1986) and editor of *Selected Poems of Emily Dickinson* (1997). Recently, she has begun writing on her father's art and its era. In 1997, she left UEA and returned to the United States, partly to manage the McNeil estate and partly to pursue her writing. She lives in Truro, Massachusetts, with her second husband, the English artist Graham Ashton (born 1948), and has two adult children from a previous marriage.

At the opening in 2002 of *George McNeil: Bathers, Dancers, Abstracts* at the ACA Galleries, New York City, I sought out Helen McNeil. Having heard that she had returned from England and was taking care of her father's work, I had a hunch her story would be invaluable. Later that year, entering through the dark garage, I followed Helen into a two-storied room, about twenty-five-by-thirty-six-feet long, with light coming through the high northeast-facing clerestory windows and skylights.

. . .

So, this is the George McNeil studio?

Yes, this is the place. In 1971, my parents bought this enormous carriage house in the Clinton Hill section of Brooklyn near Pratt Institute, where George taught for many years. My father referred to this building as his lair, or carapace, because, in addition to my parents' apartment above and a rental apartment, he had this beautiful studio, plus lithography and storage areas, and a basement with a photographic darkroom. He worked mainly with natural light from the two big skylights, but also with artificial light. He painted on the floor—you can see all these paint stains—and on wheeled trestle tables that he would walk around. In between, he leaned the paintings against the wall to confirm the vertical. The convenience of the studio area was a great help in allowing him to keep painting almost to the end. Early on, he established steady—even obsessive—work patterns that enabled him to continue working into old age. Some of his most powerful and complex work was done after the age of seventy-five.

At what point did you begin to prepare yourself for your eventual role in managing your father's estate?

As the child of an artist, it became clear to me at a very young age that someday I would be responsible for this, although I had always assumed—as George did—that my mother would outlive my father. I drew like crazy when I was small but, the moment I reached puberty, I switched over and started to write. In working on twentieth-century modernism, I found that my interest in literature, particularly poetry and literary theory overlapped with art and art history. I also did cultural broadcasting and literary and art reviews, enjoying the feeling that I could write about art when I wanted.

As a young woman, I did need some distance. It's not a coincidence that I went to col-

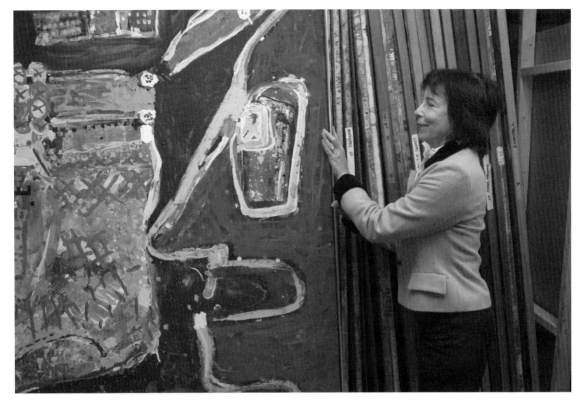

Helen McNeil, Brooklyn, N.Y., 2003, with *Lexington Avenue*, 1987, 78" x 64", by George McNeil.
Photo: Philip Vaughan. Courtesy Magda Salvesen.

lege on the West Coast and then went to live in England. But it's also not a coincidence that I married an artist, Graham. My children, too, have gone into creative areas, but not those taken by previous generations. My son, Gabriel Silver, is a television producer, and my daughter, Liberty Silver, is a photographer. She's also helped me in photographing and databasing George's work—a task I still haven't completed. So they've found their own individual ways to deal with the cultural inheritance.

Do you feel that you have been influenced by the values of your father and his generation?

It's complicated. George was part of the most important twentieth-century American art movement, and I remember people like Jackson Pollock, Lee Krasner, and Franz Kline from my childhood. I do value creativity—maybe too highly—and I do prefer expressive painting above other arts. Other values I disagreed with. In spite of my mother's career, George would say to me depressingly often, "Why don't you forget about all this feminism stuff? It won't get you anywhere." In fact, if I had "forgotten about" feminism, I would have gotten precisely nowhere.

You mentioned the memoir *Night Studio*, published by Musa Mayer, the daughter of Philip and Musa Guston, in your essay for the Provincetown catalogue. What situations in the memoir do you identify with?

How to deal with what one might call the charisma of creativity and still find one's own identity. The artist's child (or, as we used to say, the "art brat") can identify too deeply with the parent's creativity. The Oedipal cliché exists because it happens—especially with fathers and daughters. Fathers and sons, I think, have a harder time—there may be love, but there's also competition. My parents didn't have the dramatic and painful marriage that Philip and Musa did, so I was spared the infidelity and strongly conflicted loyalties, but I recognized Musa's sense of being neglected by her father. I think that children of creative parents pretty uniformly feel neglected. While George was dutiful in his family relations, and my parents were thought by their friends to have a very good marriage, you have to reckon that the dedication of an artist-parent is somewhere else. Children of business executives have to deal with this as well, but they can say, "He's got the wrong values. I'm not going to live like that!" With an artist-parent, it's a lot harder because the parent's values may well be ones you admire yourself.

Was the studio mostly out-of-bounds to you?

I did peer into the studio and see him work from time to time. His painting method was a kind of dance. He'd be moving his arms around, coming up to the canvas, stepping back, squinting, darting at it. Lillian Orlowsky described his work method at the Day's Studios in Provincetown as painting with his whole body.* He always played music when he painted. The studio in our brownstone parlor wasn't a locked door, but it wasn't as if I could come in with a sandwich and tell him about my school day. Then, in 1954 or so, he got a studio at 42 Washington Avenue, near the Navy Yard, and I didn't go there because it was in a rough area. Later, when I would visit from England, I was able to be more forceful because I knew time was short. So I would ask, "Why did you do this?" or "How do you feel about that one?" and he would talk to me—I felt like an equal. He also relished debating with Graham. Those were wonderful conversations, but perhaps it took distance to establish them.

As a child growing up, did his distrust of the art world affect you?

I was aware of it, and it affected me deeply, although it upset my mother more because she saw that the great ocean liner of international fame had set sail and Franz [Kline] was on it, Guston was on it, and George wasn't. At the memorial for my father at the New York Studio School in early 1996, the artist Mercedes Matter, lifelong friend of my father, said that de Kooning once remarked to her that he couldn't understand why McNeil—as good as any of them—hadn't become as famous as some of the others. I think it was what Mercedes termed George's "underdog" personality. A man so irascible that he couldn't be bothered to go over to Manhattan to pose for the photograph of the Irascibles is a man who excludes himself from the social aspect of the art world.*

Do you think there are others in your father's generation who, for some reason, weren't aboard the international liner either?

George and Dora McNeil with their children, Helen and
James, on the beach at Provincetown, MA, c.1950.
Courtesy Helen McNeil.

Yes, some already have reputations but are even better than their reputations might suggest: James Brooks is one, Georgio Cavallon and Irene Rice Periera are others.

Turning to the estate itself now, what particular issues do you think distinguish artists' estates from other kinds?

Many issues are shared by all estates. Where is everything? Did things disappear? Who should have what? Who takes over? When businessmen or businesswomen die, what they accumulated is dispersed or sold, and that's the end of it. But artists don't die in that sense because they are alive in their work. The artist's "body" is real, physical, present in the body of work.

What kind of planning would you recommend?

It may be hard for older artists to look with a gimlet eye at their spouses or friends or offspring, but they do need to think about who is best able to take on long-term administration of the estate. At least one executor should be of the younger generation. Probably the ideal is three executors—two from the family and one friend who is also a professional adviser. But professionals cost money. George had a good estate lawyer, Ralph Lerner, who specializes in art estates [see Part 9] and who continued to be helpful to my brother and me after our father's death. If the artist's estate is under $1 million, or if there isn't a pattern of regular sales, then family or long-term friends should be enough.

Often the wife is left in charge.

The artist's widow can be a formidable and persistent advocate because she cares, as does the child or long-term companion. George told me once that when Fritz Bultman was ill, he purportedly leaned over in his hospital bed and said to his wife, "Jeanne, if it's the last thing I do, I'm not leaving you an art widow!" And he didn't—not then. After fate did make her an artist's widow, Jeanne became a successful, professional advocate for Fritz's work. After Lillian Orlowsky's husband, William Freed, died, the energy Lillian marshaled on his behalf reawakened her own art career, which is now flourishing.

But "art widow" and "art heir" aren't universally appreciated roles. A couple of years ago, a dealer said to me, "It's so great to talk to you because so often I have to deal with frail wives and embittered children—of whom there are many." And there *are* many. If the estate is large enough to pay professional advisers, then advisers should complement family.

When was the George McNeil Charitable Trust set up?

It was all set up in George's will. The trust didn't come into operation until after the estate was settled, when the tax returns had been filed and accepted, because the value of the works depended on the appraisals the IRS accepted. We also had to apply for the 501(c)(3) nonprofit status through the New York State attorney general's office. The artist should set up a will when he or she is healthy, and it appears that any reckoning is at least ten or fifteen years away. It's easier to alter a will than it is to start from scratch. I think George's legal work cost about six thousand dollars altogether. He had a regular will and later decided to form a charitable trust. Doing this is not all dismal: threatening feelings of mortality can be dispersed by planning, contacting museums, and having fun saying, "Oh, I'll give them this one; I won't give them that one."

Did the appraisal for the IRS go smoothly?

We had a member of the Association of American Appraisers come. She wasn't cheap. Seven years ago it was over ten thousand dollars, and that was after we had given her an up-to-date annotated list. The work was valued according to recent auction prices. But Ralph Lerner saw to it that the paintings were divided up using a blockage discount, a method first established with the David Smith estate [see Part 7] and also used by the Warhol estate. What the appraiser reckoned to be my father's better works did get quite high valuations—fifteen to twenty thousand dollars —and I thought, "Oh, my God!" But lesser work was set much lower, and some, with severe conservation problems, were given no sale value. So it worked out.

A couple of artists in their fifties and sixties have told me they were frightened their work would drain all other value from the eventual estate. One wondered whether he should destroy work to avoid this disaster. But, unless it's a big estate, there's absolutely no need to destroy work; it's not appraised according to the highest price received, but valued according to auction prices. If there's no auction record, the appraisal value plummets.

One bit of advice that we received from Ralph was to watch out for the small works. I think a third of all art estates are audited, so you have to assume yours will be. The IRS

inspectors won't necessarily challenge the valuation of a huge abstraction because it's just weird to them (although, beware: if they are suspicious, they can refer the estate to an art panel that has art history professors and gallery owners on it). However, they can value lithographs at five hundred dollars apiece; if there are a thousand lithographs, the value of the estate shoots up, fueled by perhaps less important work. So it may be useful to give away "small" works before that moment.

Did your father reduce the estate by giving his children gifts before he died?

The ten thousand dollar individual annual gift tax exemption—now eleven thousand dollars —does not restrict you from giving away art works priced higher than that, as long as they are not sold within a year of the gift. Over the years, George must have given my brother and me seventy or so gift paintings, though not all of them are immediately saleable. He would write on the back of the painting, "Gift to my daughter, Helen," "Gift to my son, James," and put the year and our birthday. I wouldn't always know what shows "my" paintings were going to be in and, in the eighties, when he had very successful exhibitions, it was quite a delightful surprise having these checks appear. Now and then, as I look at the paintings in the storeroom here, I'll turn one over and, seeing the inscription, I'll have a warm feeling. I think the choice of gift was pretty arbitrary. My brother and I used to joke that our father would give paintings to me that had "charm" titles like *Thin Waist* or *Dancer # 5*, while he received "existential" titles like *Angry Man*. When we checked, though, Jim had received quite a few of the rather sexy and energetic *Dancer and Bather* series from the sixties and seventies, and I had titles like *Cyclops*, *Professor Unrath*, and *Questioning Man*.

Do you think setting up a charitable trust is a good idea?

It depends. In our case it's been a psychological help, an initial financial help, and a long-term financial and administrative burden. There's an immediate benefit in that the artist can specify a desire to place a certain number of paintings in museums or other non-profits. The trust works become a charitable gift whose value is deducted from the estate, so there's a big tax benefit. To maintain charitable status, you have to give away at least five percent of the value of the trust each year, and you must file a separate tax return. If art works are sold, that income will be used to serve the designated charitable purpose. In our case, the George McNeil Charitable Trust has donated money, art supplies, and art works to the New York Studio School, and paintings to museums.

I have doubts about charitable trusts whose sole purpose is to conserve and promote the deceased artist's work. Although legal, they seem rather like self-promotion. And I have practical doubts about charitable trusts in which all or almost all income from works sold goes to administrative and storage costs. These costs can also spiral if nobody is controlling how much time or money is being spent.

How much does it cost to run a charitable trust?

Setting up a charitable trust requires planning and money. Running a charitable trust involves money and long-term commitment. Professional advisers need to be paid pro-

fessional rates—even an ordinary administrator gets fifty dollars an hour—so, unless there is a good income coming in, all the funds of the charitable trust can be absorbed by expenses. This happened to us with horrifying speed. Another way of looking at it is that any trust should have a cash bequest sufficient to run it for three to five years. We didn't have this.

We have trust costs at a minimum of forty-five hundred dollars a year for insurance, accounting, and utilities. I do the administrative work for nothing. I haven't calculated storage costs because we are fortunate to have this great building where we have been able to make a secure storage area for the medium and large paintings. After George's death, we considered selling the studio building and putting the work into storage. Because we had large paintings, we got staggeringly expensive estimates from art storage firms, like twenty-five thousand dollars a year, and that was in 1995. You can use non-art storage, but then there is no climate or humidity control, adequate insurance, or communal viewing area—which you need for paintings.

There's still a lot we have to do with the smaller works, and with conservation. For the 2002 exhibition at ACA Galleries and the Provincetown Art Association and Museum, the conservation, cleaning, relining, and restretching costs were over four thousand dollars, and that was with my husband, Graham Ashton, doing most of the framing. The trust couldn't pay for this—we did.

Do you think, then, it is pointless to set up a charitable trust unless the estate is extremely large and income generating?

If the estate isn't large, there are other ways to reduce tax. Artists can give away everything during their lifetime. There is the possibility of folding the work into a larger, established art trust. I have heard that the Renate, Hans and Maria Hofmann Trust has offered to do this for one or two people. You can establish a trust specifying that it disperse all the work within, say, twenty years. You can donate work to several nonprofits (who have agreed), or leave everything—cushioned by some cash—to a single museum, university, or other nonprofit, in which case you should first establish what the museum will do for the work. It should be a place where the existing collection is sympathetic to your work. You can't rely on the enthusiasm of a curator alone because curators are involved in a nationwide game of musical chairs and may be gone before the ink is dry.

Also—very important—you can leave your papers to the Archives of American Art or a museum. The archives want notes, journals, correspondence, et cetera (and they prefer the originals—please!—which set off a spate of photocopying for us). But they're also really interested in technical information—the kind of paper the artist used, types of paints, unfinished work, images stuck on the studio wall, sales receipts—exactly the sort of stuff that gets thrown out when a studio gets cleared. I sat here in the studio with my trusty Macintosh computer and made lists of George's hundreds of paints, and I kept his two painting tables—one for oil, one for acrylic, with their dozens of tins of his color mixtures—these are the chef's ingredients.

Did your father decide which paintings should go into the trust?

George wanted to include a certain number of paintings that he felt were museum quality. Other large paintings were put in because we figured they would be appraised pretty high, and it would be better to think of these as potential institutional gifts. In the summer of 2002, for example, the trust donated *Beach Scene* (1968), a seventy-two-by-seventy-eight-inch painting with energetic figures in Hofmannesque colors, to the Provincetown Art Association and Museum. Finally, in terms of the trust, we put in paintings that were important but would require conservation.

Was your father good at keeping records?

George kept good records of his paintings and, as a break from painting, he liked to photograph them, initially in black and white and then in color. He developed most of the film himself down in the basement and, in the apartment, he rigged up a little clothesline where he would hang the prints to dry. The fact that he kept a pretty complete photographic record of his work was a great help, not only to him, but also subsequently to the estate. Because George, like so many of the abstract expressionist generation, never thought his work would do very well, he was a lot less conscientious about keeping records of sales. We have had a lot of difficulty figuring out where works that we have photographs of have gone. Also, he repainted and destroyed a certain number of works, which he only occasionally indicated. George's photography habit means we have images of early and late stages of some paintings. He repainted a lot; it's almost as if his artistic practice was not so much painting as repainting. A work that was already multilayered could be completed and signed, but then he would take a look at it, perhaps ten years later, and decide, "Oh, I could do *this* to that," and change it. It's very illuminating to see the different versions, how he would shift from abstract to figurative and vice versa, or charge the emotional impact with a later feeling while keeping some formal elements of the psychic history of the work—what he once called the "psychological underpainting."

How many paintings went into the trust, and what was left?

About a third of the paintings in the estate were selected for the trust. The estate has mainly the medium-sized paintings (forty-eight-by-forty-four inches, fifty-three-by-forty-eight inches, and seventy-eight-by-sixty-four inches), which George favored after 1975. What happened to us followed the pattern, I gather, of many estates, in which the federal and state taxes took away all the cash. We were left with the studio building, my parents' house in the Catskills, the paintings, and not a bean to do anything with! A few works on paper and lithographs are also in the trust, which has made it easier for me to donate them, rather than clinging to them. Others were given to my brother and me during my father's lifetime. Post 1979, when McNeils were selling well, the galleries were interested mainly in large pieces, so works on paper—mysterious heads, studies, abstract landscapes, early figure work—remained in the cabinet.

Do you have any other advice to offer?

Artists should photograph their work and make a list—even the most pixilated digi-

tal image is better than none. If federal estate tax survives, then a bypass trust is useful in any estate because funds can be passed on tax free (up to the individual limit) to the next generation. Meanwhile, the money in the trust is available should the surviving spouse fall on hard times. Both my parents had these. And—advice for anyone—spend your traditional (non-Roth) IRAs before you spend your savings because otherwise they will be taxed twice, as income and as inheritance.

Did you feel well advised by professionals?

We had an excellent estate lawyer, as I said, but we also had one adviser who didn't want the family involved. An artist using a mixture of family, friends, and professionals has to make sure that everyone agrees about goals and that everyone gets along. A professional can be replaced; an executor can't. Somewhat distant people can swim into view in the last years of anyone's life. These new friends may be expecting to be paid in other ways besides friendship, even if this is not spelled out. I have heard of one old artist whose neighbors have recently become so friendly that they have offered works for sale without any control over valuation, commission, et cetera. The person who told me about this apparent exploitation felt anguished, but also felt unable to prevent it.

Despite all the taxes, you do still have the studio building—and the house in the country, which was bought in 1975?

Actually, we had to sell the house in Kerhonksen, New York. It had a triple garage, and George worked on paintings that he pulled out into the sunlight on those wheeled tables he favored. He did seventy-eight-by-sixty-four-inch plein air paintings! But it had to go; at least another artist bought it.

Was the decision to return to the States difficult?

Before we moved to the U.S., we both had been flying back and forth like crazy during George's illness. Graham had a gallery in New York that was doing nicely with his work, and we both knew the estate needed serious attention. I was tired of my university, and the children had grown up. It was a big decision made up of small decisions. We did decide to keep some distance from the estate by living mainly in Truro, on Cape Cod—near my childhood stomping grounds in Provincetown.

How have things worked out with your brother, James?

As the more academic, art-orientated child (and married to an artist), I was always going to be the one dealing with the art. As the one able to be in New York, I also ended up doing the taxes and trust work and, together with Graham, the property management and physical care of the art. The situation was lopsided, with the typical reactions. The one who does the work can resent it: Why me? Don't they understand how hard this is? The one who isn't dealing with the work is tempted to feel, What are they carrying on for—it's just a couple of letters—what's the big deal? It wasn't all that stark for Jim and me, but we learned that if you can't share responsibility equally, then a lot of time needs to be spent talking things through.

After the first couple of years, Jim and I agreed that I would handle all the family art as

well as the trust. Now, if we sell one of his paintings, he gives me a small percentage of his share as an administrative fee. This means he's not having a steady drip of money out of his pocket if work isn't selling, and I have an incentive to sell all the paintings equally—though I certainly hope I would have done so anyway. In terms of property, when Graham and I sold our house in London and my house in Norwich, we were able to buy Jim out of his share of the studio building and then do a desperately needed renovation that Graham supervised. Jim sold me some of his paintings that had condition problems or looked less marketable. But he still has a good collection, some of which are mixed in here with the others. My children own a few paintings each, given to them by George during his lifetime, also mixed in. So if a client picks somebody's painting, well, goody for that person!

Has the estate work become a full-time job?

It hasn't, but I'm not sure I've found the right balance between pursuing my own work, paying enough attention to Graham's career and my children, and responding to what needs to be done for my father. I mean, Graham is alive. George isn't. Why spend time with the dead when the living have needs? Graham has asked this, and so have I. But I have discovered that every step toward improved organization has decreased the perceived burden of having all this left in my lap. So I'm hopeful that eventually the sense of "Why me?" will fade away. I mean, I really know why it's me.

Shall we look at your parents' lives and try to fill in some gaps?

My mother had just begun to study art at Pratt Institute when she met my father, also a student there, in 1926. They had a classically New York Irish-Jewish romance, vehemently opposed by both families, so they knew each other for some time before they actually got married in 1936. Maybe that struggle helped give their relationship its durability. When Dora died, George insisted on a Jewish funeral, even though none of us knew what to do, on the grounds that if she hadn't married him, she would have stayed a Jew. I think he wanted to give her back something he felt he had taken from her. By 1936, both my parents were students of Hans Hofmann, friends with fellow students Mercedes Carles (Matter), Ray Kaiser (Eames), Lee Krasner, John Opper, Giorgio Cavallon (a lifelong friend), and Linda Lindeberg (later Georgio's wife). It was also the era of Lillian Kiesler, Burgoyne Diller, and Irene Rice Periera. George became one of the founding members of the American Abstract Artists in 1936 and then worked for the WPA and exhibited at the 1939 World's Fair in New York. Dora was the one who stepped aside and got the regular salary in the late thirties and forties until my dad started teaching. In one sense, Dora never forgave herself for not continuing as a fine artist. On the other hand, stepping aside and succeeding elsewhere may have helped. After all, they had the Jackson Pollock–Lee Krasner relationship to look at up close—not exactly a recommendation for two-artist marriages.

Can you discuss your mother's career?

Dora worked for *Vogue Pattern Book*, and then *Esquire*, first as a layout artist, then assistant art director. After the war, she moved to an ad agency, earning fifteen thousand dollars a year—huge for those days. Meanwhile, George, who had got an Ed.D. from Columbia

because he felt he should be able to help support a family, was kept in the Navy until 1946. I think his war service affected the development of his career because almost all his friends and fellow artists—Kline, de Kooning, Pollock, Gorky, Rothko—weren't in the armed services, so they could develop their art and be active in the New York scene when he couldn't. When George finally got a job teaching at the University of Wyoming for two years (1946–1948), Dora quit her job and joined him. She didn't work for seven or eight years, then became associate art director at Simplicity Patterns, a job she held until she retired in the late 1970s. That job was the source of hundreds of fabric swatches around the house, some of which ended up in George's paintings. Only years later, in the eighties, when I was teaching women's studies, did I discover how extremely unusual it was that my mother not only had a full-time job when she had two young children but that she had a professional job, not a pin-money job. Both my parents came from poor families. There was no backup; in fact, they helped support their extended families. So, a second income enabled us to go to Provincetown in the summers, George to Europe, children to college—the middle-class thing. Dora was less successful trying to help George's career socially: he adamantly did *not* want people invited over for dinner, drinks, et cetera, and to see the work.

How did your father handle the combination of teaching and his own art?

When my dad got a job teaching at Pratt Institute in 1948, running the evening art school (until 1960), he brought in a lot of his friends, like Kline, Nakian, Guston, et cetera—quite an amazing list. I remember Jacob Lawrence coming to the house once, so he may have been one of the teachers then, too. Between 1960 and 1981, George had a large and influential undergraduate art history class, and he also taught painting in the M.F.A. program. I say "painting" because he felt uncomfortable critiquing the minimalist and conceptualist art that many students were producing then. He also taught at the New York Studio School. The teaching earned him a certain amount of ribbing from his artist-friends. But he enjoyed the teaching experience, and it let him pursue his self-education. When he went to Europe, he photographed like mad and used the slides for art history—but also for himself. There was little he hadn't looked at. I always assume that if a painting of his looks like it's aware of this or that artist—"influence" is too direct a word—then chances are he was aware. Whether consciously or unconsciously, it's all worked into the paint.

Can you talk a little about your father's experiences with galleries?

His career went in an up-down-up trajectory. From 1950 to 1955, he showed at Charles Egan, a pioneering abstract expressionist gallery, where he had solo shows at the same time as his friend Franz Kline. When Egan died, he went to Poindexter (1956–1959), then Howard Wise (1960–1968), after which there was a terrible period from 1968 to the late seventies when he didn't have a New York gallery. Later, he told me that he had despaired, but he kept on. Some of the paintings from that period are actually among my favorites, tremendously poetic, introspective, with figural elements, and that almost throwaway efflorescence of color that he's always been a master of. The turning point was

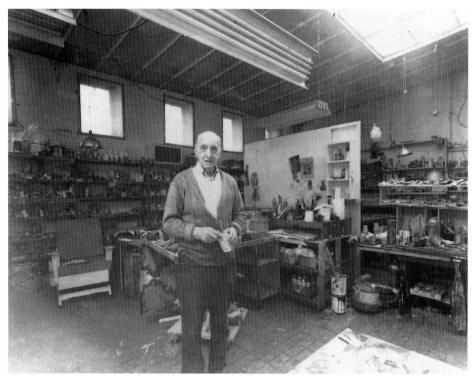

George McNeil in his Brooklyn Studio, 1988. Courtesy
Helen McNeil.

the 1979 landmark show at Terry Dintenfass, after which he was picked up by
Gruenebaum. Julian Weissman, the gallery director, really promoted his work, and when
Gruenebaum was heading toward disaster in the mid-eighties, my father followed Julian
to Knoedler, and then to Hirschl & Adler Modern, having virtually sellout shows through-
out the eighties. Then George wondered if he would live to have another exhibition. He did
and, after the splendid 1993 show at the New York Studio School, George went to ACA,
again with Julian, where we've remained.

Do you feel that it is important to keep having gallery exhibitions?

It's better to have works kept in commerce after the artist's death. We've certainly
done that. If art is exhibited and sold, then the work remains in front of the public—it's
reviewed, it's talked about. If it is dispersed exclusively to museum collections, that's great
in the long term, but it doesn't do anything to keep the work alive in that twenty- to
thirty-year period when the art-historical position of the artist is being reassessed. No
work is quite so uncontemporary as the work of an artist who has just died because there
will be no more new work. There is a period of liminality when it is no longer contem-
porary but it's not yet historic. The art has to find a new position in the changing
panorama of the artist's contemporaries. In my view, this takes a generation.

Are there exhibitions you would like to see that concentrate on different periods or contexts of his work?

We're developing a traveling retrospective for which we have four museum venues so far. Solo shows aren't in vogue right now—the curse of the "great man" theory. George was such a totally New York painter, but the work should get out of New York.

Should we hold back work from galleries?

Mentally, I hold back all the time, but in practice I don't. In a few cases, I've agreed to a sale but said we'd probably want to borrow the work for a future exhibition. We sold one of my father's WPA designs, a small oblong gouache with biomorphic shapes that he did for the Williamsburg Mural project in 1938. Although we still have one more, I felt torn about selling this one. However, the buyer assured us that his collection, which concentrates on the WPA, was already designated to go to a particular museum. That's excellent.

I made a mistake with the 1998 ACA show, where there were a couple of small gouaches of dancers and street scenes that George had done in Cuba in 1940. He lived there for six months and had his first solo show at the Lyceum Gallery in Havana. The gouaches are wonderfully lively, but they're the only ones we have, so I put "Not for Sale" on the price list. Needless to say, someone came into the gallery and said, "Oh, I really want that one!" Jeffrey Bergen phoned me and, after some dithering, I put a high price on it. By the time Jeffrey got back to the client, he had lost interest. This underlined for me the fact that everything you show is really for sale. One should be frank about it.

Despite what I just said, I think if the work is selling, the person in charge of an estate would be well advised to set aside some favorites, maybe even ten percent—just sit on them for ten or twenty years. My favorite paintings overlap with those that galleries have also liked, but it's not as big an overlap as one might think. Everyone likes this painting here on the wall—*Black Sun*, from 1955. It's a strong, mainly orange painting with a black circle that predates similar ones by Gottlieb by several years. In the PAAM catalogue of 2002, Peter Selz came right out and said it was a masterpiece. But I also like paintings in which I can read a personal code, which might not be readily available to others. There are some I like because I enjoy the formal problem they tackle, particularly the complex color layering of the post-1959 work. I also like some of George's psychologically difficult work—"tough" is the euphemism. There can be snarling faces and agonized figures, as well as angels and dancers. Two artists, Robert Henry and Selina Trieff, recently bought a "tough" imaginary head with bared teeth that George did in the seventies. The Boston Museum of Fine Art recently bought a "tough" lithograph, *Alone #2*, an anguished head that was done a month after my mother's death. I thought I'd be dead before anyone else would like this one, but it has a quality of passion that would jump out of a wall in a museum. On the other hand, you'd have to have an aesthetic sensibility that would appreciate hanging Mathis Grünewald's *Crucifixion* in your living room! (George, of course, hugely admired Grünewald.)

In your essay, you link the fishnet stockings, print dresses, high-heeled shoes, bobbed

hair, and Jewish nose of the females in many of the later paintings to your mother. How-
ever, in the 1991 video, *George McNeil: The Painter's Painter*, your father specifically says
he doesn't want the paintings to be seen as narrative in any way, and he doesn't want to
discuss the symbols or the images.

But you noticed the apology I put before that in the essay, the qualification?

**Yes, but at some point this is going to be very important in the interpretation of your
father's work.**

That's why I wrote it down.

Future biographers, future writers are going to come to you. . . .

God, let's hope they do! I want those Ph.D. students. George needs that monograph.

**Are you going to feel comfortable discussing some of the coded or secret meanings of
these images?**

There is no single reading of an art work or work of literature, and any accepted
meaning will alter according to the cultural demands placed on the work. There's no
question but that it would be absurd to try to read even the most figurative McNeil paint-
ing purely symbolically. As someone who's been involved in literature, I'm acutely aware
that I may have a tendency to see coded signs or narratives because that's more like a lit-
erary reading. I try to compensate for that when I'm talking or writing about George's
work.

Many people go for "interpretation" because it appears to be easier: you confine
yourself to the story, to the symbolic image—you can say he was obsessed with breasts
or, in my father's case, shoes. He was highly amused by Donald Kuspit's essay in the 1993
New York Studio School catalogue that offered a full-blown psychoanalytic reading, a fair
amount of which was about foot fetishism. George laughed and said, "Oh well, I guess
I'm a foot fetishist at age eighty-three!" It didn't bother him. He didn't feel it was destroy-
ing the work to bring that out because he knew what else was operating in the work. On
the other hand, leaving out his intense involvement with color, compositional dynamics,
and context would diminish the work. If someone were doing an exhibition of foot
fetishism, I'd want to know more before putting one of my dad's works in it.

Would you dread the idea of someone doing a biography of your father?

I may be foolishly smug on this, but I don't think there are any big skeletons in the
closet. There may be a couple of small ones—everyone has them—so no, I wouldn't mind
at all. George wrote and lectured extensively about art, and I'd be delighted if someone
wanted to use that material. The period from the thirties through the fifties is becoming
historical—the "mid-century moderns"—and it's just begging for reassessment. It can be
done chronologically or, maybe, backwards. For example, Chapter 8 of *Art of the Postmodern
Era* by Irving Sandler (1996) is about Guston and McNeil as the expressionists who were
influencing younger artists in the eighties. I also think that now video and other forms of
time-based art have been around for a number of years, the curatorial turn-away from
painting has lessened.

Just one last question. I think of your father during the difficult period in the sixties and even afterwards as being rather like the lone warrior.

I think perhaps he was. He had a family, he had thousands of students, he had friends who wanted to see more of him—but part of him was always alone. And he was a war-rior—he raged at what he perceived as stupidity—though perhaps he was more a war-rior in the Buddhist sense—almost egoless, focused, free. When nobody wanted to look at expressive art, he kept on working, and that was that. He was solving problems that the work brought up. So his work developed and changed without external support. In the eighties, when I think he felt he had nothing to lose, he just let it all hang out there in the painting, and he moved himself even further forward in art. He had the pleasure—not a term he'd use—of something hard won. Perhaps what he achieved was the *honor* of living a life in art that kept deepening its creativity, right up to the end.

December 2002

UPDATE

Since this interview, the George McNeil estate has signed a contract to be represented by Salander-O'Reilly Galleries, New York.

FOR FURTHER INFORMATION

George McNeil: Bathers, Dancers, Abstracts: A Themed Retrospective, Catalogue for the exhibition curated by Helen McNeil and Graham Ashton, and organized by the Provincetown Art Association and Museum, in cooperation with ACA Galleries, New York, 2002.

Herskovic, Marika, ed. *New York School Abstract Expressionists: Artists Choice by Artists.* Franklin Lakes, N.J.: New York School Press, 2000.

SIX

FOUNDATION SAMPLINGS
SoHo and Southampton

Sanford Hirsch, director of the Gottlieb Foundation, emphasizes that "the artist's foundation is an extension of the artist's personality." The two interviews juxtaposed in this chapter give concrete form to this observation. Both Adolph Gottlieb and Alfonso Ossorio participated in the electrifying current that passed through the mid-century art world; however, the distance between the Adolph and Esther Gottlieb Foundation's SoHo office space in New York City and the Alfonso Ossorio Foundation's large gallery, housed in a warehouse in Southampton, New York, reflects a number of contrasts. Nonetheless, in each case, the artist's spirit of generosity informs the vision of the director guiding the foundation.

Though already well ensconced in the art world, both Sandy Hirsch and Mike Solomon came to their positions as foundation directors largely through fortuitous circumstances, and with a skeptical attitude toward the politics that govern the gallery and museum world. Since both men were present at the inception of the foundation—when its very existence was in question—their perspectives are particularly revelatory.

Having only a slight acquaintance with Adolph Gottlieb during his lifetime, Hirsch joined Esther Gottlieb, his widow, in establishing a foundation to preserve the artist's legacy and fulfill his desire to support mature artists. Twenty-seven years later, Hirsch recalls that they originally hoped the foundation would last ten years, proudly adding that it has served as the model for the Pollock-Krasner Foundation, among others. Careful sales and the widow's bequest of most of her assets have solidified its financial standing.

Unlike the Gottliebs, whose generosity to other artists was initially limited by their own finances, Ossorio had the means to offer substantial support to other painters, most notably Pollock. It is, in fact, ironic, as Solomon points out, that Ossorio's wealth might have detracted from his reputation as an artist, since the art community tended to concentrate on his role as a collector or owner of an enviable property in East Hampton. It is even more ironic that the terms of his will resulted in his foundation being underfunded.

Solomon points out that these factors did not facilitate his efforts to run a foundation in this artist's name and that, at Ossorio's death, his work was far from having the same kind of market that Hirsch could assume for Gottlieb's. Thus, Solomon felt he had to reestablish and reframe Ossorio's reputation, insisting that he was a "major" force in the art world of his time, and one of the few to forge a connection between European and

American artists. Like Hirsch, he believes that the encouragement of scholarship—for which the Ossorio archives are a tremendous resource—is vital for increasing the visibility and the recontextualizing of the work. Just as Hirsch desires to explore Gottlieb's relationship to Rothko and other less-known aspects of his art, Solomon wants to highlight Ossorio's significant relationship to Dubuffet and Pollock.

In Solomon's description of the exhibition space that now showcases Ossorio's work each summer, he affirms Hirsch's vision of a foundation that mirrors the personality of the artist: "I took my cue from Alfonso himself. At the very end of his days at The Creeks, . . . he said he would like it to be back the way it was in the fifties: a gray rug on the floor, white walls, very austere so that you could see his individual pieces."

<div align="right">D.C.</div>

SANFORD HIRSCH
ON THE
ADOLPH AND ESTHER
GOTTLIEB FOUNDATION

The important thing is the immediate impact. . . . My painting just comes out and gives your eye a wallop. . . . I have a certain urge to have something in the painting which is serene or something which is tearing itself apart, and so I just put them in.

—ADOLPH GOTTLIEB*

Adolph Gottlieb was born in New York City on March 14, 1903, the only son of the three children of Emil and Elsie (née Berger) Gottlieb, who both emigrated as children from Bohemia, now part of the Czech Republic. His parents hoped their son would take over their stationery supply business but, at eighteen, after taking some courses at the Art Students League with John Sloan and Robert Henri, Adolph suddenly took off for Europe. He stayed for a year and a half, sketching and visiting museums. On his return in 1923, he completed high school, attended Parsons School of Design, and returned to the Art Students League. Gottlieb met Milton Avery and Mark Rothko in the late twenties, and the three formed lifelong friendships. Gottlieb's early work ranged from expressionist portraits of his friends and family to social-realist themes, and in the mid-thirties he and Milton Avery worked in similar styles. In the next decade, his enthusiasm for tribal and Indian art, the Jungian concept of mythic symbols, and the surrealist emphasis on the role of the unconscious fed the *Pictographs* of 1941–1951, whose painted grids contain literal or cryptic images. In the *Imaginary Landscapes* of 1951–1974, the emblems increased in size, the structure loosened, and the canvas is typically divided into two horizontal rectangles, with discs or rectangles floating above a flurry of large, energetic strokes. This imagery is further intensified in the well-known vertical *Burst* series, starting in 1957, while the later paintings explore more abstract forms in pure fields of color. Although, in 1970, Gottlieb suffered a stroke, he continued working until shortly before his death on March 4, 1974.

Esther Gottlieb was born on April 15, 1905, to Louis and Dora (née Hack) Dick, who emigrated from Austria to the United States in 1902. Raised in Danbury, Connecticut, she moved with her mother and three older sisters to New York after her father's death in 1919. She worked as a draper in the dressmaking industry, then attended the State University of New York in Oswego, receiving a teacher's certificate in the late twenties.

Returning to New York, she taught dressmaking and tailoring full time at the Brooklyn High School of Needle Trades (1931–1935) and the Manhattan High School of Needle Trades (1935–1960). She married Adolph Gottlieb in 1932. The couple spent summers in the country, often by the sea, as they were both keen sailors. In 1969, the Gottliebs moved into two floors of a loft building on West Broadway, the upper one becoming the studio. After her husband's death in 1974, Esther formed the Adolph and Esther Gottlieb Foundation, Inc., to reflect their mutual concern for other artists and to protect her husband's legacy. She died on November 21, 1988.

Sanford Hirsch, born on June 17, 1951, in Jersey City, New Jersey, became the administrator in 1976, of the Adolph and Esther Gottlieb Foundation in New York. Besides developing policy and programs, originating and helping organize exhibitions for the foundation, he has lectured and written on Adolph Gottlieb and his period. As vice-president of Artists Equity and chairperson (1991–1993) of Arts Action Coalition, he testified before the U.S. Congress on legislative issues, including the Visual Artists Rights Amendment, resale royalties for artists, and health insurance.

Stimulated by *Adolph Gottlieb: A Survey Exhibition* (2002) at the Jewish Museum, I was reminded of the altruistic, truly charitable side of the Adolph and Esther Gottlieb Foundation. I asked Sanford Hirsch, the director, if I could speak with him at the foundation's headquarters in SoHo, Manhattan.

· · ·

Had Adolph Gottlieb requested that a foundation be set up in his will?

Yes. He asked that half of his estate be used to establish a foundation that would provide both general support and emergency aid to mature creative painters and sculptors, but everything else was left to us to define. Initially, since the Gottliebs were not wealthy, we set up the support program on an annual basis to see how that would function. We had no cash when we started, so we borrowed ten thousand dollars and distributed it. Around 1982, we felt we had enough cash on hand and could project enough to set up a second program, specifically for catastrophic emergencies.

Was this the first artist's foundation in the United States to give grants to mature artists?

That's an interesting question. Adolph, along with his old friend, Mark Rothko, came up with the idea. Both of their wills, drafted by the same attorney, had similar language, the difference being that Rothko wanted to include all fields of artistic endeavor. The trustees of the Rothko Foundation were taken to court, and the court ultimately reformed the foundation and named new trustees. This was going on at the time the Gottlieb Foundation was seeking approval from the same attorney general, so there was some concern whether the Gottlieb Foundation would be allowed to function as a grant-making organization. That approval was given, and we began a grant program in 1976—the first, formed from an artist's estate, to make grants directly to individual artists. Of course, pub-

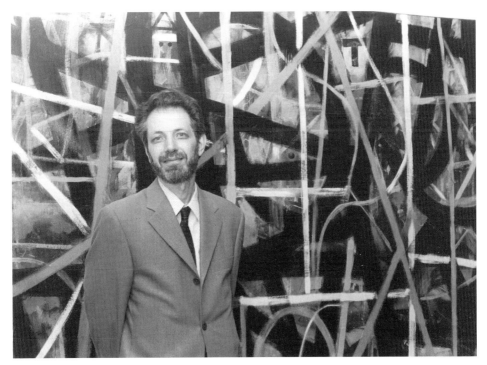

Sanford Hirsch in front of Adolph Gottlieb's painting
Labyrinth #3, Foundation Juan March, Madrid, 2001.
© Adolph and Esther Gottlieb Foundation/Licensed by
VAGA, New York, N.Y.

lic programs like the National Endowment for the Arts and the New York State Council on the Arts were already in existence before that.

Where did this interest and this sympathy with artists, particularly older ones, come from?

It was a reflection of his and Esther's personality, although the specific guidelines that we have, twenty years of mature work, is something that the Gottlieb Foundation devised. The Gottliebs were always known as people who would help if you needed a hand. In fact, at Esther's memorial service, a fellow who had been a lifelong friend (Adolph had been his summer camp counselor when he was a teenager) said to me, "I don't know what to do anymore. All my life I've known that if I ever got into a hard time, I could go to Adolph or Esther, and they would support me." Although the Gottliebs never had much money and could not be great patrons, they believed what artists did was important, and they very quietly supported their community.

Were the reserves of the foundation built up through the sale of the work?

Esther had a great hand in that. She was the president of the foundation from day one [1976] until she died twelve years later, leaving most of her estate—aside from a few

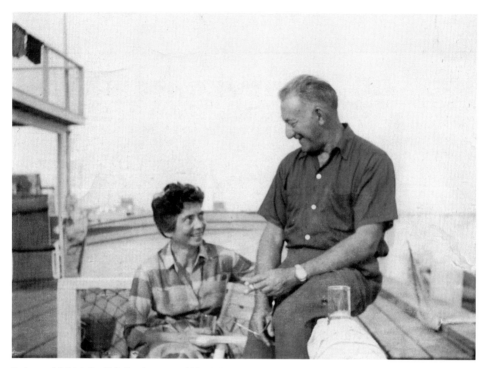

Esther and Adolph Gottlieb, Provincetown, MA, 1959.
© Adolph and Esther Gottlieb Foundation/Licensed
VAGA, New York, N.Y.

bequests to family members and friends—to the foundation. We first had to consider whether we could, in fact, realize the grant program that Adolph and Esther had wanted. We had the property that we're both now sitting in and a marketable collection of art-work. But to realize that market value, we couldn't just sell off the whole collection. We devised the idea of managing the sales of those assets just as you might the sale of stocks or bonds, so that the increase in the value of the work would build up reserve funds, and the grant program could last over a period of time. We felt that we'd be very lucky and doing a very good job if we lasted ten years. That, of course, was twenty-seven years ago, so we've been luckier than we anticipated! Last year we gave out four hundred twelve thousand dollars in both programs. Essentially, we hoped we could establish a model that other larger estates could emulate.

At what point did you become involved with the foundation?

I knew Adolph slightly, simply from living in SoHo. In the early seventies, virtually everyone there was an artist or involved in the arts, and everybody knew everybody else. One day Esther spoke to me about how intent she was on setting up a grant program and how much trouble she was having. I was young enough to think it wouldn't be that dif-ficult! Between us, and with the help of Dick Netzer, Esther's nephew [currently Profes-

sor Emeritus of Economics, Planning, and Public Administration, Wagner Graduate School of Public Service, New York University], who is now president of the foundation, we came up with a way.

What had you been doing until that point?

I'm a painter, myself, and I had worked for a couple of galleries and had done some work for the MoMA registrarial department. So I had some grounding in the professional art world, along with an art history background.

Could you tell me more about Esther Gottlieb?

When Adolph and Esther met, around 1930, they were both artists. They married in 1932, and Esther continued as an artist until 1938. When people asked her why she stopped, she would always give the same answer. She was not a large or imposing woman—about five feet tall, rather thin, very intense—but she would look them straight in the eye and say, "Because I knew there was room for only one art career in this family, and I was right."

It certainly would have been much more difficult for Adolph without Esther's financial support. She worked as a schoolteacher throughout the Depression and was also a great champion of the work, always. She would invite friends and collectors to dinners, and later, around 1941, she became the great registrar, insisting that Adolph make a record of every painting. Now we have these wonderful records that go all the way back. She also saw that the work was maintained properly.

Did Adolph have studio assistants during any part of his life?

Not very often. It wasn't something he was comfortable with. He preferred to do things himself. From the mid-sixties, off and on, he would have people come in and build stretchers and stretch canvases for him. After his stroke in 1970, he did need studio help and had an assistant who worked with him exclusively from 1971 until his death in 1974.

When the foundation began, how many people were involved—daily and on the board?

It began with Esther and me. She was up here every day. In one of my first experiences working with her—she would have been about seventy years old then—she called me over and said, "Give me a hand with this," and grabbed one end of a ten-by-twelve-foot painting. I quickly grabbed the other end, and we moved it! I had one part-time assistant for a couple of years who then became full time. In around 1980 or 1981, I hired a second full-time person, and I now have two additional part-time assistants.

There are five people on the board, and we have one formal meeting per year, some years two. But we have phone meetings every four to six weeks, so we're very much in touch all the time. It's a close enough board that I can reach everyone within a day or so if an issue comes up.

Now that the foundation has indeed survived, is the goal to continue well into the future?

We don't project an end date. We have always had the expectation that one day we will

use up our assets and that will be the last day we're around. I certainly hope that it's off in the future somewhere because there are still so many artists out there who need this kind of support. We're not the only source, and I'm still hopeful that other such foundations will form. Since the economy started to turn downward around 2000, the need on the emergency side, mostly medical, has grown hugely. Last year, we had roughly double the number of applications that we'd had the previous year—well over two hundred.

Most of these are either from people who can't afford health insurance, or from those who have stretched their budgets to get it and then discover it doesn't actually cover a lot of their costs or their living expenses while they're disabled.

Did I read that you give approximately ten individual support grants a year?

Yes, of twenty thousand dollars each. Some years, we've gotten twelve hundred requests for applications and eight hundred plus completed forms. For emergency grants, we don't set a number because we never know what's going to come up. We do set a cap of ten thousand dollars per event because medical debts accrue very quickly, and we don't have vast resources.

Would you ever sell Gottlieb paintings in order to specifically top up the reserves for the grant giving?

That's essentially what we do all the time, but it's a complex situation. Markets are fickle, and artists' favor in the marketplace also goes up and down. Since we're committed to having an exhibition program, we also have a body of work that's not for sale. We try to bring in a certain amount of money every year, projecting what our expenses will be and hoping to build up a little reserve, which we've been able to do. We have seen years when we've had zero sales, so I don't feel comfortable projecting. I'd rather try to be somewhat conservative and do good quality shows. We'll put good works on the market and keep the prices reasonable, although we don't have great latitude because there are other people out there selling and establishing market values.

Over the last twenty-seven years, which estates have modeled themselves on the Gottlieb Foundation?

The best—and my proudest—example is the Pollock-Krasner Foundation. Charlie Bergman, now a close colleague, spoke with me when they were setting up in 1985, and we found a great commonality of interests. They started funding individual artists in 1981 in a much larger way than we've been able to. They've provided, not only financial aid, but also a sense of hope among artists around the world, helping them see that they are part of a continuum.* There's also the Elizabeth Foundation,* not an artist's estate per se, but a private foundation that, to some extent, modeled its program on ours. I've had discussions with numerous artists' estates and foundations, but those are the key ones. Several years ago, I thought of a mentoring program that would match young apprentices with working artists. I discussed it with Peter Nesbett, director of the Jacob and Gwendolyn Lawrence Foundation, and he decided it tied in with their goals. This program has just begun.

What kind of legal advice do people need before setting up a foundation?

It's important to speak to an attorney who has an expertise in trusts and estates. Also, attorneys who have worked with artists understand the ways that they function. Before going to a lawyer, people need to sit down and think through their desires. If not for Esther's insistence from the very beginning that a grant program be a major focus, it would not have happened—this foundation might well have been an educational foundation that did nothing but promote the reputation of Adolph Gottlieb. That's perfectly legal and much easier to set up.

What specific goals does the foundation have for Gottlieb's work?

It's important that it is preserved properly—so that it ends up in collections where it will be appreciated and seen widely—and that there is good scholarship from different points of view. Lately we've been doing more in trying to show the work outside the United States where it's less known, and we've made some progress. The work has also been rather absent from New York until this last year. So that needs to be attended to. We have long-term plans, too, for a catalogue raisonné. Hopefully, within the next few years, we can have one volume out—thanks to Esther's hard work—of the paintings from 1941 to 1974. We'll do as much work as we can while we're around to compile information and see that there are good records. We've spent quite a bit of time, energy, and money on software to have a good database of Gottlieb's paintings, works on paper, and prints.

What are the numbers, approximately?

Roughly three thousand in total. Adolph was a prolific artist who began in 1923 or 1924 and started exhibiting in 1925. There are virtually no records from 1925 to 1941, except what we've picked up through reviews and little announcements. So there's a whole body of work to discover. We have pretty good records of works on paper for the forties and fifties. In the sixties, when he was producing more paintings, he was less diligent in recording works on paper. It's very difficult detective work because not everything is signed and dated. We can also spend months, if not a year, tracing one painting from collector to collector. Sometimes, when a dealer goes out of business and the records have disappeared, you reach a dead end.

Do you still have the two floors within this building, and are the paper records kept right here?

We have only one floor now, and we do keep the paper records here. The paintings are in a warehouse.

How many Gottlieb paintings were destroyed in his loft when there was that terrible fire in 1966?

Adolph never counted them. He never made an insurance claim. Before 9/11 [2001], that fire on 23rd Street caused the largest loss of life—fourteen men—for the New York fire department. Adolph's comment was, "So many people lost their lives; what I lost doesn't count." We've tried to make a count subsequently in the course of compiling records. There were well over two dozen major paintings lost. Also lost were the works of

Adolph Gottlieb in his Bowery Street loft, New York, 1968.
© Adolph and Esther Gottlieb Foundation/Licensed by
VAGA, New York, N.Y.

art made by his friends: paintings by Rothko, John Graham, and Milton Avery. It's impossible to know which or how many because the records burnt as well.

Were there any black-and-white photographic records kept elsewhere that you've been able to get your hands on?

Only a few. We recently found someone who had actually visited that studio a few weeks before and shot some slides. That was pure coincidence. I love it when that happens!

I noticed from the catalogues that you've worked with about three major galleries over the years since Gottlieb died.

Marlborough represented Adolph at the time of his death, but because of concerns about the Rothko case and other issues, never the estate or the foundation. Actually, the estate was never on the market. The foundation was represented initially by André Emmerich, then by Knoedler, and now it's with PaceWildenstein.

What are you looking for in the galleries that you choose?

That's a difficult question. Lynda Benglis, who's on our board and is an artist in her own right, once said to me that artist-dealer relationships are marriages. That's the best description I've heard. They're complex, and they go hot and cold. What we're looking for is a certain level of professionalism. At the outset, we're looking for an understanding of, and sympathy for, the works that we have, as well as a very high level of exhibition involvement and outreach, both to institutions and to collectors.

How does the fact that you want to have a good body of work for museum exhibitions affect your dealings with the commercial gallery world?

That's always something we're juggling. A good dealer will want to sell the best work, so we have to have it available for sale, but we also want to have some for exhibitions. When a dealer says, "I have a client for that painting," (one on view in a public venue— and it's happened more than once), do we say, "I'm sorry, you can't have it" or "You'll have to wait ten years," which amounts to the same thing? Or, do we say, "Well, I guess I can put another work in that show"? There's no hard and fast rule and, ultimately, you have to rely on the dealer's good faith and willingness to participate in the art world on your level. The better dealers (and collectors) understand and support our exhibition program. Our policy from the start has been that once a work is selected for a public exhibition (and that can be years before the exhibition opens), it will not be offered for sale until the exhibition is completed.

Will PaceWildenstein show works that are not for sale so that you have an opportunity to explore certain themes or periods?

Yes.

I was very impressed that there have been five exhibitions of Gottlieb's work this year.

It's really too much, but we had wonderful results. The survey show that is now at the Jewish Museum here in New York was done originally with IVAM in Valencia, then went to Madrid and to Wuppertal, Germany (the Von der Heydt-Museum). It wasn't planned to come to this country, but the curator of the Jewish Museum asked us if it might. There was a show of monotypes that the Juan March Foundation of Madrid asked if we would organize for two other museums, one in Cuenca and one in Palma de Mallorca. It is now in Richmond, Virginia [Marsh Art Gallery], where I was yesterday. There is also a show of tribal arts that the Gottliebs used to own and the *Pictographs*, which is now at the New Britain Museum, Connecticut, and will travel to the Krannert Museum (Champaign, Illinois), to the Lowe Museum in Miami, and to the Cantor Center at Stanford, California. The director of the New Britain asked me if I would do that show with them, and I agreed, not realizing that it would open the same week as the survey at the Jewish Museum. We are working on a show of Gottlieb paintings of the year 1956, which was a wonderful and important year for him, as well as for others. That will open, I think, in 2004, at the Hyde Museum in Glen Falls, New York. We're still discussing final dates and trying to arrange a little tour of that show.

Are there rewards in showing abroad?

It's a lot of work, but fascinating, since American art is still not that well known there. I would argue that Europeans don't even know the abstract expressionists whom they believe they do know: Pollock, Rothko, Newman, sometimes de Kooning. There haven't been many group shows of abstract expressionist work in Europe, and even fewer solo exhibitions. The show that's here now was really conceived as an introduction to Gottlieb's work; that's why it's so small and selective. The responses were fascinating because the audiences, especially in Valencia and Madrid (Spain having been closed for so much of the fifties and sixties), had seen none of this before. Yet, they're very sophisticated audiences, and the reception was overwhelming. The show got rave reviews in both places. A free local paper had given over the entire back page to photographs of the exhibition. The morning of the opening in Madrid, I was on a bus and all around me was this display of the show. It was quite amazing. The reaction of historians and critics in Europe is very rewarding and gives a whole different sense of the work.

Are there other areas of Gottlieb's work that you would still like to explore through publications and museum work?

Absolutely. There are a number of rich and diverse periods, so there's quite a bit to do yet. There are two museum projects that I hope to accomplish in the medium term. One concerns the *Imaginary Landscape* paintings [1951–1974] which, although his largest series, are not as well known as some of the other work, and it's fascinating to see the permutations over the years. Another is his close association with Mark Rothko. They met in 1925 and remained very good friends right until Rothko's death. Their work is closely related at most points in their careers— the critical juncture being 1938 to 1945, when they both embraced a Jungian belief in myth and universal symbolism. The root and seeds of much of abstract expressionism are in that joint effort, but it's too big for me to explore alone.

Do you feel that, because you're at the hub, you generate many of the ideas that then can be taken up by museum curators whose interests range more widely?

The best project would be a collaboration, as far as I'm concerned. I'm not necessarily at the hub; I usually feel like I'm under the wheel! But I make proposals for exhibitions, or just bring ideas up for discussion. I think there are logical ideas out there whose time will come. The *Pictographs* was one example. There are a number of scholars who do know Gottlieb's work quite well, and I would love to work with them.

Were you hesitant at first to write the catalogue essays yourself?*

Yes, very. My dear friend, former board member Lawrence Alloway, literally twisted my arm, saying something to the effect of, "You've got something to say, damn it, say it." That was very persuasive.

Is the broadening of your responsibility from administration to scholarship and writing something that now engrosses you?

Yes. I wish I had the luxury of being able to take as much time as I would like to research something—perhaps writing about it for twelve years before publishing. I enjoy

the dialogue with scholars and others and have always done a fair amount of public speaking. It's important to get a good sense of what people are seeing, and then to figure out how to understand and fill the gaps. And the perception of Gottlieb's work changes over time.

I notice that there isn't a biography of Gottlieb. Is that something that you are working toward?

I would love to see a biography of Gottlieb, but I don't feel I'm a good enough writer. I've never written a biography and don't want to learn on the job.

I wonder if we could tease out some differences between the approach family members take to looking after an artist's estate and yours?

I think I'm very lucky. I know a number of families of artists, and it is extraordinarily difficult for them, an exquisite form of torture for many. As close as I was to Esther and as important as she was to me and, I hope, I to her, I remain separate from the work. I go home at night, which is not true of family groups, especially spouses, who have the most difficult time because the art world tends to be very disrespectful toward them, male or female, though especially females. It's a funny thing, but a kind of jealousy arises: a dealer or curator will assume an attitude of "I'm the one who's supposed to be taking over here. You get out of the way." It used to stun me. I'd see the way different people approached Esther. Here's someone who is a full part of the career of the artist, who knows much of the work from its inception to its completion, and has a perspective that no one else in the world can have. How in God's name can you just dismiss her?

The art world is a business. Family members are able to say, "No, you can't do this now," or "This is the wrong thing to do." Certainly, they have that right, but it will be taken as an affront. The politics of the art world are such that, once you affront one of the powers, you've put the artist's career and reputation at a disadvantage. That's understood by both parties. Another thing that happens all the time is that the museum person or critic will say, "That work just isn't important." I'll get a little upset at that, but it's okay. I've seen a number of family members become very upset—enraged and offended—and walk away from those situations when they shouldn't. So it's tough.

Did Esther ever try to assert a particular interpretation of her husband's work, or restrict the archives in any way?

I can honestly say that we have always been willing to show people what we have and let them make whatever conclusions they will. Esther was really good about that on one level. On the other hand, she was very protective. When she sensed that people weren't on her wave length, she wouldn't talk to them. But, for the others, she opened up her records or archives from day one.

Presumably then, none of the records were given to the Archives of American Art?

A few when Adolph was alive. At one point, I did attempt to have virtually everything microfilmed by the Archives, but we simply couldn't work out a system whereby we could be assured the material would come back within a certain period, so it made no

sense. Serious scholars can make an appointment to visit the foundation and look through records. We hope to post transcripts of some material on our website in the near future [gottliebfoundation.org].

On the question of control, some estates and foundations try to place paintings very carefully. Do you?

In the real world, you can't. It, again, depends on your relationship with the dealer and his or her understanding of your goals. I don't feel comfortable about using a crystal ball. Collectors of major works of art will most likely want at least a significant part of that collection to be available to the public once they are gone. But they may feel their family should dispose of—and benefit from—it as they desire. I have to be realistic. The other side is that good professionals in the museums around the world, and in this country, will find significant works wherever they may be and, ultimately, get them into their institutions. So, I guess, on that level I have to come down to my own belief in the quality and the importance of Gottlieb's paintings.

Again, in terms of control, this time copyright, I noticed there was a Gottlieb magnet for sale at the Jewish Museum.*

We're pretty restrictive, I have to say, because we have the benefit of Esther having known what Gottlieb's view was. We will approve postcards and notecards if they are done well, but not tee-shirts or dinnerware, glasses, magnets, or anything else, simply because we want to reflect Adolph's views in everything we do.

Looking back, what has been most enriching for you?

To a great degree, this is my baby. I've been here from the very beginning. I'm very personally committed, and it has been continuously enriching. I've had so many moving experiences, especially with people we've given emergency funding to. There's one artist I think of repeatedly. We made grants to him, probably in 1986 or 1987, for his then nine-year-old daughter, who had a very rare form of brain cancer that couldn't be treated in the rural area where they lived. They had to come to New York for treatment, and we were part of making that possible. She is now a healthy, functioning adult. I still correspond with her father and get photos, et cetera.

I think of another artist, a sculptor who ran his hand through a table saw and needed to have it rebuilt, but didn't have the money. Once, at a gallery, a person I didn't know came up and put his hand out for me to shake. He introduced himself, and I realized I was holding the hand that we had paid to rebuild. Those things underscore how important such funding is in this country, where the prospect of any kind of public health assistance is so remote. One reason to keep going is to encourage, intimidate, or shame others into getting involved. Of course, another incentive is learning more about Adolph's work and the art of his times, which was an amazing fifty years in art history.

One last question. Yesterday, I was talking on the phone to Steve Polcari, the former director of Archives of American Art in New York, who told me that you were also running the Nancy Graves Foundation.

Yes. But I'm not the executive director. Nancy [1940–1995] was a friend, and she wanted to establish a foundation on the model of the Gottlieb. She was not that well off but was very committed in the same way that Adolph was. Also, her executors are people I've known, and they asked me to run it. When I said I couldn't possibly, they proposed I chair the board and help them set things up. We were lucky to find Linda Kramer, a former curator at the Guggenheim and the Brooklyn Museum, to be the executive director. She also was a friend of Nancy's, so it was a perfect match. The foundation offers three grants to individuals who have a track record in a certain field but want to try a different one; it has just made its second set of grants this year. As Nancy was always reaching out and doing film, video, and sculpture, that's fitting for her. Again, the idea is that the artist's foundation is an extension of the artist's personality.

November 2002

UPDATE

The foundation has increased the number of grants and amounts of awards. It gave twelve grants of twenty thousand dollars each in 2003, and twelve grants of twenty-five thousand dollars each in 2004.

FOR FURTHER INFORMATION

Alloway, Lawrence; Sanford Hirsch; Charlotta Kotik; Linda Kramer; and Evan Maurer, essayists. *The Pictographs of Adolph Gottlieb*. New York: Hudson Hills Press, in association with the Adolph and Esther Gottlieb Foundation, 1994.

Alloway, Lawrence and Mary Davis MacNaughton. *Adolph Gottlieb: A Retrospective*. Manchester, VT: Hudson Hills Press, in association with the Adolph and Esther Gottlieb Foundation, 1981.

Doty, Robert and Diane Waldman. *Adolph Gottlieb*. The Solomon R. Guggenheim Museum; and the Whitney Museum of American Art, 1968.

MICHAEL SOLOMON
ON THE
OSSORIO FOUNDATION

Born in the Philippines on August 2, 1916, Alfonso Ossorio was the fourth of six sons of sugar processor Miguel José Ossorio and his wife, Maria Paz Yangco. Alfonso went to Catholic schools in Britain (1926–1929) and then to Portsmouth Priory, Providence, Rhode Island (1930–1934), becoming an American citizen in 1933. While a student at Harvard (B.A. 1938), he spent three summers in England working with engraver Eric Gill. His works on paper during the thirties and forties reveal a Salvador Dalí–type of surrealism and, in the portraits, a form of magic realism. While he was briefly married to Bridget Hubrecht (1941–1942), he lived in Taos, New Mexico. In 1943, he enlisted in the U.S. Army, working as a medical illustrator until 1946. He then moved to New York City just as the abstract expressionist movement was beginning to emerge.

In 1948, he and the dancer Ted Dragon (Edward Frederick Dragon Young, born April 24, 1921) became lifelong companions. After meeting Jackson Pollock and Jean Dubuffet in 1949, Ossorio melded in a unique way the elegant arabesques of one and the childlike, primitive forms of the other. In 1951, he bought The Creeks, a sixty-acre estate in East Hampton, New York, which, from 1952 on, was his permanent home. He housed Dubuffet's "Art Brut" collection there (1952–1962) as well as works by his New York School peers, Jackson Pollock, Clyfford Still, et cetera, and his European friends. In the early sixties, Ossorio began to create fetish-like, sophisticated assemblages, which he called "congregations"—encrustations and appendages of glass eye balls, beads, antlers, and other sought-and-found objects. His outdoor sculptures were placed on the grounds of The Creeks where, from 1970, he also planted an arboretum of rare conifers. In 1988, he underwent heart surgery. After further medical problems, he died on December 5, 1990, at the age of seventy-four.

Michael Solomon, the son of abstract artist Syd Solomon (1917–2004) and Anne Cohen, was born on August 22, 1956. Throughout his childhood and adolescence, the family divided the year between the Hamptons and Florida. At fifteen, Solomon made the commitment to being an artist after winning a national award for printmaking. He graduated from the College of Creative Studies at the University of California at Santa Barbara in 1979. He worked with the sculptor John Chamberlain, in Florida, from 1980 to early 1984. In 1982, he married Claudia Spinelli, also an artist. Their son was born in 1987. Solomon received an M.F.A. from Hunter College in 1989. Later that year, they resettled

in East Hampton, where Solomon worked for Guild Hall Museum and for the artists James Brooks and Charlotte Park Brooks. In 1990, he became Alfonso Ossorio's assistant and, after Ossorio's death in late 1990, he organized the removal of the art estate to an industrial building in Southampton. When the Ossorio Foundation was established in 1995, Solomon became its director.

B. H. Friedman, who wrote the monograph *Alfonso Ossorio* in 1972 and whose dining room in New York is hung with paintings and assemblages by that artist, said, "You should visit the Ossorio Foundation for your book on artists' estates and see what Mike Soloman is doing for Alfonso's work." I remembered an amazing summer party at The Creeks when it seemed that the New York art world had gathered there in East Hampton, and another occasion when the Friedmans, Jon Schueler, and I arrived by rowing a boat across Georgica Pond. Alfonso took us round the newly landscaped garden and into the studio—as extraordinary as the late work itself. I wondered, therefore, what the new arrangements would be like now that The Creeks had been sold.

. . .

Here we are in the Ossorio Foundation in Southampton. Could you describe the building?

It's a large warehouse, about twenty-five hundred square feet, with twenty-eight-foot-high ceilings, and with two wonderful large skylights illuminating the main gallery. I looked everywhere—from New Jersey to Brooklyn, from New York to Montauk—for a space to put all the artwork and the archives that came from Ossorio's estate. Then a friend told me about this place. It was perfect because Ossorio's work is so maximal that you really do need space to look at it. I took my cue from Alfonso himself. At the very end of his days at The Creeks, the whole of the inside of the house was like a work of art. There were all kinds of objects besides his own on the walls. He said he would like it to be back the way it was in the fifties: a gray rug on the floor, white walls, very austere so that you could see his individual pieces.

Could you tell me what the purpose of the foundation is?

Our activities are basically to educate the world about Alfonso Ossorio, to show the various periods of his work that extend over sixty years. He was really an intentional artist from the age of ten, and he lived to be seventy-four. We have annual shows here, and others in the Michael Rosenfeld gallery on 57th Street in New York. We also make proposals to museums around the world for his work to be included in various shows, which it often is. A lot of scholars, curators, and people writing dissertations consult our archives for information on Ossorio, his colleagues, and his era. Right now a young man at Columbia University is working on Jean Dubuffet. In our archives we have about a hundred letters between Dubuffet and Ossorio, so it was a real find for him. This work with scholars has been a key factor in reframing Ossorio. A lot of people didn't really know what he was about until they accessed our archives.

Michael Solomon in Alfonso Ossorio Foundation, 2001.
© 2004 William Rivelli.

What else does the foundation own?

There is a large archive of letters and papers, including over two thousand letters from the thirties to 1990, from various colleagues and friends, some of whom are very important artists: seven from Jackson Pollock and Lee Krasner, more than sixty from Dubuffet, and others from Bill de Kooning, Clyfford Still, Barnett Newman, and Marcel Duchamp. The list is too long for me to keep going. Then there is a large archive of photographs that Ossorio collected, mostly by Hans Namuth, as well as the ones that he himself took of The Creeks. There are, maybe, as many as ten thousand images that Ossorio took of his property over a thirty-year period. It's been eleven years now since Ossorio died, and we still haven't got to the bottom of all the boxes that we moved here. There are over a thousand works of art as well, including editions of prints.

Could you break that down into different sections: paintings, sculpture, works on paper?

His first accomplished work was mostly printmaking: wood engravings, a few etchings, and lithographs. He studied at Eric Gill's workshop in Sussex, England, in the thirties. He also collected the work of Gill, Philip Hagreen, and the whole group associated with Gill. When Ossorio was admitted to Harvard in 1934, Edward Waldo Forbes, the curator of the Fogg Museum, asked Ossorio (a student!) to lend his collection of the wood engravings of Eric Gill and his contemporaries for a show at the Fogg in 1935.* Ossorio continued to make prints throughout his life, so there are probably about seventy different editions. The rest of the works in our collection are one of a kind: about a hundred sculptures or assemblages (he called them "congregations"), oils on canvas, and works on paper.

I remember that he also collected paintings of his friends. Do you still have any of those?

There's really nothing left of that collection. In the early fifties, he probably had the best collection of modern art in America, certainly the most avant-garde, because by 1949 he had met both Pollock and Dubuffet and was very close friends with both. They all traded work, and he also bought a considerable number of works of theirs. Ossorio's collecting sensibility seemed either to go for the ultimate painting or the very obscure and weird paintings by an artist. By 1960, I think he had over one hundred Dubuffets, including some of the really great pieces from the *Corps de Dame* series. He also had some of the strangest paintings of Dubuffet's—a little painting of a side of beef—and erotic drawings, which aren't widely known. It was the same with Pollock—he owned *Lavender Mist: Number 1*, 1950, but also a very minimalist and unusual Pollock drawing, consisting simply of a few vertical lines, sometimes erroneously referred to as the study for *Blue Poles*. We gave it to the Parrish Museum, their first Pollock. But most of the work that he collected—primarily Dubuffet, Pollock, Clyfford Still, a few de Koonings, and very important works by Lee Krasner—he sold in the mid- and late seventies in order to plant trees and install site-specific sculpture on his property. Somewhere in the files there was a letter to his accountants saying, "Dear Sirs, I am thinking of de-accessioning all my collection of art work to buy trees."

He bought *Lavender Mist* in 1951 from the Betty Parsons Gallery—where he and Pollock showed—for, I think, three thousand dollars. He sold it in 1976 to the National Gallery for $2 million. Of course, now it's probably worth $20 million. He insisted on *Lavender Mist* going to an American museum. Apparently, he had a higher offer—by another million—from someone in Germany. Most people think it must have been Peter Ludwig because he was the only collector willing to spend that kind of money at that point for the New York School. That's an interesting story, if it's true. He lived with these paintings, assimilated them, and then decided that, as he said in an interview, "I wanted the walls for my own work." After more than twenty years, it was time to sell. He said, "Let art pay for art."

Did he, himself, suggest a foundation in his will?

I believe so, but in the form of a suggestion and not a hard and fast legal command. Many artists, Alfonso included, tend to put off the future for living in the moment. He did try very hard at one point to make arrangements for his incredible property—sixty acres on Georgica Pond, considered to be the best property in the Hamptons, with a mile of waterfront. There was the house, the studio, other out-buildings, the cottage, plus a large collection of rare trees, art, and artifacts. He tried to give it away. He contacted his alma mater (Harvard), the Nature Conservancy, and I don't know how many institutions; everybody wanted something like a $10 million endowment. I think it was shortsighted for the various institutions to turn it down, although the request for an endowment is standard. Suffice it to say, nothing happened.

After Ossorio died, Ted Dragon inherited everything. He pretty much had to sell the property because, apparently, there was not that much cash. Two years went by before the property sold [for over $9 million]. I knew Ossorio my whole life, but only started working for him a little in late 1989. By late 1990, I was there constantly, including the day he went to the hospital in December, never to return. There was a very difficult period after he died. First of all, every art vulture in the world descended on us, thinking that there were Pollocks and de Koonings in the estate: "Oh, we love Ossorio's work—and, by the way, do you have any Pollocks?" So I went from being an assistant to being an unofficial protector of Ossorio's memory and legacy.

It's extraordinary that Alfonso hadn't worked out a better way to leave things.

They tried. One of the problems was, obviously, that they were a gay couple and had no legal relationship to avoid inheritance taxes. At one point, Alfonso had tried to adopt Ted, but that didn't work. The other important factor is that, from 1988 on, Alfonso was very ill. He had a triple bypass and a number of other ailments that came back to haunt and, eventually, kill him. He didn't have the physical or mental energy to sit around with lawyers figuring it all out. And I think this is something for others to take to heart: you had really better do it when you are young. When I came along, he knew that he only had a year or so to live. I didn't know, but *he* did. That was one of the more extraordinary things that has happened in my life—his hiring me and intuiting what role I was going to play.

What else happened after Ossorio's death?

Once I had finished cataloguing everything, I began looking for spaces. I found this building about six months before The Creeks was sold to Ronald Perelman in 1992, and moved all the art into it. It took us about two months because everything was hung all over the house, sometimes in very inaccessible places, and it would take a day to move each of these huge pieces down through little stairwells. The office and this upper section were here, though I designed the racks for the canvases.

What did Ted decide to put into the foundation from the sale of The Creeks?

Nothing much in terms of money. What Ted donated to this foundation was basically just Ossorio's art, all the archives and records, historical documents, and the like. He pro-

vided a minimal amount of money to build the racks, buy some equipment, and to pay me if something didn't happen with sales. I had to create a market to bring in income. And, ten years later, we've done so much with Ossorio that there is much more of a market than there ever was and a continual stream of some kind of money. It's not huge, but it's enough to keep us going, and family and friends of the foundation are so happy that they've banded together and are beginning to create an endowment.

How is the foundation run?

We have a board, of course, like all foundations, but a very small one—just Ted and me and Ted's sister-in-law. It will be expanding in the next year or two to include a couple of family members who have given some money for the endowment. I won't set up an advisory board until next year because it's pretty difficult to ask people to serve when you have no money.

Really, my whole effort over the last ten years has been overseeing the estate and understanding the priorities. There is the whole archive of photographs that need to be digitally preserved before they fade. But my position is that first you have to make a mark. Ossorio's work has to be redefined or discovered. It's taken a long time, but the situation has really changed. During Alfonso's lifetime, there were only two or three amazing individuals who had the foresight to collect his work. Now, we have a much larger base of younger collectors, some of whom are extremely prominent, as well as a number of corporate collectors and museums. For instance, in the last year Goldman Saks has bought two of his works on paper. These indications, as well as the attention we've had in the press and the reassessment of Ossorio by critics, show that part of the job has been done. Now I hope to grapple with other matters. There are a lot of situations like Ossorio's, where the artists are not blue-chip, but their work and achievements are not negligible.

The auction houses can be murderous with mid-level artists like Ossorio. Another indication that we've achieved something is that, this year, an Ossorio that would have been put up at Christie's East for two thousand dollars in the past was put in the main auction house—and reproduced in a color catalogue with Dubuffets, among others—and given a low estimate of twelve thousand dollars. That amounted to a huge difference in the perception of what Ossorio is all about. People are beginning to appreciate his work.

Another problem dealing with an older artist is that their collectors are their peers. If they are old or dead or no longer collecting, you need to find a new collecting base.

Ossorio was so much in the thick of things in the early fifties. Could you talk about why he didn't push his own career?

Primarily, I think that his wealth was the barrier. If Alfonso was poor and had done the same work, I think he would have had much more attention. Because he was wealthy and a very important collector of major artists, it was in the interests of the art establishment to see him as a collector. After all, a number of powerful dealers bought important works by Dubuffet, Krasner, Pollock, and Still from Ossorio, including Robert Elkon, Thomas Gibson, Arne Glimcher, and Robert Miller. And his work was very eccentric, so

they just waved it aside, "He dabbles, you know." They didn't understand the range of the work and, since he was rich, few felt the need to help him. Ossorio was exceptionally generous with artists—for instance, with the Pollocks. It wasn't only collecting art. For years he gave them checks every week to live on. I have the cancelled checks somewhere upstairs in the files. I know of hundreds and hundreds of works that he bought from different obscure artists to give them support.

What was Ossorio's attitude toward the dealers?

I think it was the typical love-hate. He was friendly with Betty Parsons but did not think much of her business practices. With Daniel Cordier and Arnie Ekstrom, he had a very productive exhibition life. Chuck Close once told me that, when he and his generation were coming up in the art world, the Ossorio shows at Cordier & Ekstrom in the sixties were "required reading." I think that Alfonso was so beyond everyone. Nobody wanted to get into the ring with him. [Art critic] Clem Greenberg was a minor compared to Alfonso intellectually. Harold Rosenberg probably was more on an equal level, but he, like everybody, shied away from discourse with Ossorio because he could out-think them.

The interesting critical response to Alfonso's work was always by artists. Pollock really loved his work. And, even though Ossorio was buying his paintings, he was not the kind of person who went around saying, "Oh, I love this guy's work because he buys my work." It was the same with Dubuffet. Dubuffet wrote an incredibly astute book on Ossorio, about the works on paper from 1950, that's about thirty pages long.*You would think that someone with that kind of money would publish it in English. Alfonso was too humble. But people who know Dubuffet's writing—and he was a prolific writer—say that it is one of the best pieces he wrote on art. We've had it translated by Richard Howard and are using the text in the project I'm working on with Dr. Francis O'Connor: Ossorio, Dubuffet, and Pollock, and their relationships. I think it would have made a huge difference in his career had it been accessible to Americans. He didn't feel that he should push any buttons. He just wanted to work.

I hadn't realized that he hadn't sold very much during his life. B. H. and Abby Friedman have a wonderful collection.

He did have a few good collectors. The major one during his life was Morris Pinto, who is also a Dubuffet and Antoni Tàpies collector. There may be a few new collectors who have surpassed him today, but Pinto was the mainstay. He probably had some of the best work of all three artists, at one time. But, when you have that kind of thin activity, most people don't call it a "market."

When he died, did he have a gallery representing him?

There were a couple of galleries that he worked with out here, but nothing on an international level. After he died, I was at a party talking to Virginia Zabriskie, who had included Ossorio's work in a group show on friends of Pollock in her Paris gallery. I said, "You know, Virginia, there is a lot more work than you think. It's not only the wall assemblages. There are incredible works on paper from the fifties that Dubuffet did a book on."

Alfonso Ossorio in his studio with B. H. Friedman
(behind), East Hampton, N.Y., 1966. Photo: Robert Skull.
Courtesy B. H. Friedman.

And she became very interested and had a show in her Paris gallery of the works on paper and some paintings from those years. That was a very successful show, particularly for 1992, which was very much the bottom of the art market in Europe. Arturo Schwartz bought a piece that, I believe, has now been given to the Tel Aviv Museum.

I also contacted the curator from the Whitney, Klaus Kertess, who is also associated with the Parrish Museum in Southampton and has always been interested in Ossorio. I showed him the amazing body of work done in the forties—very surrealist style drawings, colored drawings, and watercolors. He was blown away and did a show of about thirty of those pieces in the lobby gallery of the Whitney in 1992. That started the ball rolling in terms of a different kind of appreciation of Ossorio. We had to recontextualize the entire situation, based entirely upon art, not upon Ossorio being a collector and a friend of Pollock's, or the owner of a fabulous property and arboretum. We had tons of press and interest about The Creeks, but we no longer had the place. What we did have were the paintings, the assemblages, the drawings, and the archives.

I knew I needed strong New York representation for Ossorio's work, so in 1996 I found another dealer, Michael Rosenfeld. I know of no other dealer who does so much to educate the public on artists. He and his wife do substantive catalogues on every show, often with groundbreaking scholarly essays. If you look at the reemergence of many "lost" great artists, you find that it was Rosenfeld who took the risk of doing new shows on them. Of course, their championing of the work of African American artists is legendary. It was the foundation's partnership with Rosenfeld that pushed the appreciation of Ossorio over the brink.

Is the very long-term objective also to keep a body of work that would represent him as a museum collection?

To educate the world about Ossorio, you need a collection that you can show, drawing upon the archives to provide a context for Ossorio's life and work. The board has not really accepted that as the ultimate goal. I would really love to do a big book on The Creeks, which would not only be a book about the property and the conifer arboretum, although those are certainly the two biggest points, but also The Creeks as the story of art of the fifties. It's a huge undertaking when you have so many photographs to pick from. But that would be a crowning achievement. Or, we could do a Ken Burns style movie. There's not that much motion footage, but there are certainly a lot of stills that could be incredibly useful in telling the amazing Ossorio story, beginning with how his family came into money. Think of the whole historical process that made Alfonso Ossorio: born of two races, leaving the Philippines to go to England and then the United States, combining cultures, and having the resources and the mind to be a major force in the art world in terms of collecting and supporting Pollock and Dubuffet and "Art Brut." Of course, having an exhibition here each summer is one way to get people to come into the foundation. But it's a conversion of one person at a time. At some point, we are going to have to go to a different methodology.

Alfonso Ossorio (front, left), at The Creeks, c.1953, with
Halina Wierzynski, Jackson Pollock, and (behind, from
left), Ted Dragon with poodle, Kasmir Wierzynski,
Josephine Little with Abigail, and Joseph Glasco.
© Ossorio Foundation. Courtesy Pollock-Krasner House
and Study Center, East Hampton, N.Y.

Are you also working on a catalogue raisonné?

That is a goal of the foundation. But the demand for one is historically connected
with the rise in an artist's auction prices so, for the most part, it's useful to the art dealers.
They're also very expensive. Jackson Pollock's catalogue raisonné by Francis O'Connor is
four thousand dollars, and the reproductions are mostly in black and white—and there's
not that much work. He died in 1956, at the age of forty-four. He didn't live to be sev-
enty-four like Ossorio. What do you do with an artist who has four or five or six thousand
objects? I think that technology is going to change the catalogue raisonné. I've been talk-
ing with Dr. Francis O'Connor about putting the catalogue raisonné online instead of

publishing a hard copy. Although the goal is to be definitive, nothing ever is, and the computer version can be updated and, more importantly, easily accessed. Authentication is a big legal problem, too. But, I think, if we could do something eventually that was available online, then every university and every art institution could have it.

So what would be more useful in the short term?

Although Ossorio's work is consistent intellectually, it takes on a lot of different formats, and we want to explore each one. We don't say that we are going to show you everything that's absolutely best of a particular period, but we are going to give you a very good sense of it. We've done five exhibitions now. So, bit by bit, we're putting together a compendium of various periods of his work with either a museum or a gallery. We always insist that a catalogue is done and that there are a number of scholars involved.

You said earlier that you had some other ideas for future shows?

Yes. For instance, when he was married from 1940 to early 1941, Ossorio lived in New Mexico and did lots of paintings of Ranchos de Taos and that area. We want to do a show of all his paintings from that period at a place out there like the Harwood Museum, Taos, or the Georgia O'Keeffe Museum in Santa Fe. More importantly, the show on Pollock, Dubuffet, and Ossorio, from 1949 to 1952, is really about art at mid-century. I've talked to a number of curators, and it seems there aren't any shows about this period. Once the abstract expressionists and the School of New York took over from the School of Paris, the State Department organized all these shows of American art to go all over the world in the fifties and sixties. But that was a political perversion. Was there really such a thing as "American" art? There was a give-and-take going on among cultures and countries. That really needs to be explored. In particular, the influence of Dubuffet on Pollock, and Pollock on Dubuffet, through the rig key of Ossorio, is an absolutely fascinating story. That is why I'm so happy about this guy who is doing his dissertation on Dubuffet. Perhaps it will help bring out these trans-Atlantic connections. When Dubuffet was here, they went out to Chicago, where Dubuffet gave a famous lecture on "Art Brut." A lot of people say that the funky art in Chicago of the sixties was inspired by those talks that Dubuffet gave in 1952—The Hairy Who group, for instance. So, we're still ignorant about our culture because we've been taught that it was all American and nothing else. Ossorio was a major link between Europe and America.

Ossorio was also very influential in another respect. From 1957 to 1960, he and two other artists, John Little and Elizabeth Parker, ran a gallery called Signa in East Hampton and showed all the abstract expressionist, as well as the great "informal" painters from Europe: Fontana, Mathieu, Degottex, Fautrier. Everybody was in these shows and, because Alfonso was working with the Stadler Gallery in Paris and Michel Tapié, the Gutai group was also shown.* So, in little ole' East Hampton, you had Japanese, French, Spanish, and Italian abstract expressionists, and Americans! There were also symposia with Bucky Fuller, Philip Johnson, B. H. Friedman, and others. Does anybody know about that? This was a cutting-edge gallery in America. And they did it for four years, until they realized

they weren't getting their own work done, and then they quit. Helen Harrison did a show on that in 1990,* and that was how I got reacquainted with Alfonso.

How did you originally get to know Ossorio?

My father, Syd Solomon [1917–2004], is an abstract painter and, in 1959, the summer I turned three, my parents rented the gatehouse on Ossorio's property, The Creeks, which came with a barn-studio. Clyfford Still had worked there, as had the sculptor George Spaventa, when he was with Grace Hartigan. I'm sure the rents were exceedingly modest, so this was another example of Ossorio's generosity.

Then my parents bought a lot on Baiting Hollow Road in the Georgica section, which is now worth millions of dollars. At the time, they bought two acres and built the house and studio for about twenty thousand dollars! Soon, Pop Artist Jim Dine moved in next door, and Conrad Marca-Relli, Adolph Gottlieb, and Norman Bluhm all had studios and homes in the area. Motherwell had been in Georgica earlier. In the summer, every day at about one o'clock, all the artists from the entire community showed up at Georgica Beach. The morning people had finished working by then, and the night people were just getting up. That went on until about 1968, when the Village of East Hampton decided that you had to have parking permits. It was a great time while it lasted. The first artist-writers baseball game was played at our house, in my backyard, in 1966. So I grew up in the art world in the Hamptons in the fifties and sixties.

I was very lucky because I had other people besides my parents to talk to me about being an artist and look at my novice attempts. Jim Brooks [see Part 3] was the most important person for me, and the best role model. I knew Alfonso all through that period, too, but less well. I knew his work slightly—certainly the "congregations"—but I didn't know the works on paper from the fifties, the wax resist paintings that became a huge revelation when I went to work for him. It turned out, coincidentally, that I had already been dealing with opposites in my own work, mixing abstraction with the representational, and dealing with different kinds of media that resist each other, things that Ossorio had done in the fifties. So, when I encountered his work, it was, I think, very similar to his encounter with Pollock and Dubuffet. I was smitten.

You said earlier that you had half the year in Sarasota, Florida, and half in the Hamptons.

My father had to stay in a warm climate because of the frostbite he got during the Battle of the Bulge. His work is abstract, but with references to nature, somewhat like your late husband's. My parents were really responsible for bringing the School of New York to Florida. Syd brought all these artists down to teach at New College and to put on shows both at the college and the Ringling Museum. The collection of the Ringling Museum has works by Jim Brooks, Larry Rivers, Phil Guston, and others because my father encouraged them to come to Florida in the winters. My father's was the first live artist's work to be bought for the museum, at the suggestion of then MoMA director Alfred Barr.

I know you went to the West Coast to distance yourself from all the artists of your father's generation. But, when you finished college, didn't you return to Florida?

Yes, I worked for the sculptor John Chamberlain, who was a friend of the family's. In 1980, he wanted to set up a studio in Florida and asked me if I would go down there with him. Since I didn't like what was happening in the New York art world, I figured that it would be a great opportunity. So, I worked for John, setting up his studio and making the little Tonka Toy sculptures with him for a number of years on and off. He's a brilliant man, but very difficult at times. When I was with him, I took a hiatus from my own visual art, and so I knew there would be an end date. Also, coming from the art world, the one thing that I really wanted was to have a regular life, a healthy marriage, and to raise a child. I've seen so many people damaged by the art role models that they follow.

What was your next step, once you stopped being John Chamberlain's assistant?

Eventually, I went back to school to get an M.F.A. at Hunter College. That was an awful experience. The eighties were the height of that politically correct fascism that was dominating the art world, and so at Hunter it was nothing but reading and writing and arguing politically about things. I could hardly get any work done. I thought I would teach but, in 1989, when I graduated, it was the lowest point for attendance at art schools in history. So I came out here with my wife and baby, and I got reacquainted with Ossorio, among others. Then one day I went to see Alfonso with Helen Harrison, who is now director of the Pollock-Krasner House. Ossorio had a huge studio, and you couldn't walk from one end to the other. Not only was it filled with all the objects and bits and pieces that he made his art with, but with many of his own works, and there were stacks of works on paper on tables with plastic and dust on them. He just said, "Look around." I'm looking through the racks, and I pull out a monochrome gray painting with a little frame, and I happen to know that it is a Rollin Crampton painting. Now Rollin Crampton [1886–1970] was one of the first monochromatic painters of the fifties. Maybe ten people alive know who he is! I said, "Oh, this is really a nice Rollin Crampton." Ossorio looked at me like, "How the hell do you know what that is?" And that was it. That was my interview. He said, "Would you like to come and work for me?" I said, "Sure." And it went on from there.

Was it full time?

I was still doing some work for Jim Brooks and Charlotte, so it was part time until Ossorio died. Unfortunately, the man was so sick. He would come in, and we would start working—the nurse was always with him—but he simply couldn't work for more than an hour or so. I also got on with other things—if a place needs to be cleaned up, I can figure things out.

Even though it was very difficult for Alfonso, there were wonderful moments in that last year, particularly with the couple of hundred works on paper that he had done in the Philippines in 1950. They are done with a wax resist technique. You can apply wax to paper, either when it is a hot liquid, when it's melted, or when it's cold, rubbing it on like a crayon. Wax will resist water-based paint, like inks or watercolors, which are added on later. Many layers or levels can be produced, and what was so extraordinary was how separate and autonomous Ossorio's layers could be. Dubuffet said that he was playing on

many keyboards at the same time. He showed me how he made those pieces, all the variations. After they were done, some were coated entirely with a layer of wax. Every few years he would scrape off some very thin layers to make them clean again, using cloths, sometimes even using a little knife. Nobody really knew about this series. Some of them were done in pieces that had to be fitted together, so he had to show me how to do that, and how to mount and frame them. He divulged all these secrets that only I knew for a few years, until after he died, when we began showing them. The motor behind the whole reassessment of Ossorio's work really goes back to that period of the fifties. So he knew exactly what he was doing in telling me.

That was absolutely invaluable.

Yes, but then, of course, I didn't understand the implications. After he died, I realized that the Dubuffet book had been written about these wax resist works; they were the synthesis of Dubuffet's raw figuration and Pollock's psychological and gestural processes, a brilliant and prescient body of work. In my way of thinking, Ossorio was the first post-modernist.

The other surprising thing that I learned later was that he had said to his brother Frederick, "When I die, the family will discover the treasure I have left behind." I think that he was referring to these works on paper because they are just so damn exceptional.

Ossorio and I made one very small piece together. When he was at Harvard, he took a course where he worked in plaster. He carved letters and then covered them with gold leaf. He had kept just one. It said, "Ego Dominus," a little eleven-by-fourteen-inch panel, and he used this to make a last "congregation," by adding some other objects and his initials. It was in the last show he had while alive, at the Benton Gallery in Southampton in the summer of 1990.

Were you also able to start cataloguing and checking the dates of works with him?

There was a lot of that. Ossorio was pretty thorough. For instance, I mentioned that in 1990 Helen Harrison did a remake of the Signa Gallery shows. She could do this because he had kept every photograph of every installation of every show—every painting that had been shown. That meant he also had photographs of the work sent over from Europe. There was only one painting in the entire show that wasn't in one of the original shows. The records of his own work were less complete. For instance, no title or date is written on the photographs of many of his works. The photographs of works that we have I can identify. But, for those that are long gone, all I have is the photograph.

What was his system for titling and numbering?

He basically had the same system as everyone else: title, date, medium, size. However, he had a separate numbering system for the works from the Philippines because there were so many of them—about three hundred. We found the list of these in his diary. That was something else we found after his death, which has been incredibly influential. The diary starts in 1950 and is very personal. He writes about his homosexuality, which he didn't talk about all that much, and other conflicts of his life.

Ossorio's way of thinking remains with you?

My feeling is that art can't be just about art. It's got to be about life, just as Ossorio's pieces are not about art—they're about his life. They're very autobiographical. So, I decided to have a life and let art come out of it.

I saw that you had an exhibition of your portraits recently.

Yes. Two years ago, I had a show at the Heckscher Museum [in Huntington, New York] of what I call portraits. They were images of different hats as images of people—fairly big paintings done with beeswax and water-based paints on muslin. Some of them are of known personalities. There's one called *Walt* that is about Whitman, another on the country singer-songwriter Jimmy Rodgers. Others were more obscure. A few more were shown last year at Guild Hall. I've been following my interest in resists, using wax and water-based paint for ten years or so. Ossorio taught me the method.

October 2000

UPDATE

In late 2002, Michael Solomon left the Ossorio Foundation to pursue the demands of his own work. He has since built a new studio and was featured in the recent Abrams book *Studios by the Sea: Artists of Long Island's East End* by Jonathan Becker and Bob Colacello. He also serves as a trustee to the Tee and Charles Addams Foundation and has a consulting practice called Art Legacy, which advises artists, collectors, and heirs on how to plan for transitions. He is adviser to a new study program on Alfonso Ossorio, sponsored by a fund from the Ossorio family and being developed at Harvard University.

The Ossorio Foundation exhibition space in Southampton closed in 2003. The out-of-date web page is still available, but the email address is no longer valid.

FOR FURTHER INFORMATION

Friedman, B. H. *Alfonso Ossorio.* New York: H. N. Abrams, 1972.

Recent Ossorio catalogues are available through the Michael Rosenfeld Gallery, New York, N.Y.

SEVEN
UNTIMELY DEATHS

When death comes, unanticipated or premature, it always leaves devastation in its wake. In the case of an artist, the enormous sense of loss is compounded by the knowledge of gifts wasted and work unfinished. The paintings or sculpture then become all the more precious as the most vital embodiment of the dead artist, often leaving the family with conflicting feelings when the art is sold. The tensions are likely to increase as unforeseeable events have more than enough time to frustrate even the best laid plans of both artists and family members.

No case better illustrates the inability of the artist to protect his legacy than that of David Smith, who died suddenly in a car accident, in 1965, when he was fifty-nine. The artist had carefully formulated his will, leaving his estate in trust to his young daughters and choosing executors to cover his most pressing legal, artistic, and personal concerns. How could the artist have guessed that certain actions of the executors would run contrary to his intentions, or that his gallery would pursue the same questionable practices that later made the Rothko estate so notorious? For Peter Stevens, Smith's son-in-law, the damage to the daughters was irreparable: "The most upsetting thing was the physical loss of these objects that, to some large degree, represented their father."

Although Helen Bigelow was much older than Smith's daughters when her father died at forty-nine, she shared their experience of being excluded from decisions regarding David Park's paintings. She was left with the same sense of loss and craving: "My greed knows no bounds. It's not greed for money; it's a greed for those paintings!" Bigelow's mother remarried two years after her father's death, and her stepfather became the primary manager of Park's paintings, continuing even after his wife died. When, belatedly, Bigelow became the representative of the estate, few paintings remained. She also found herself perplexed by complicated questions of copyright and provenance, and frustrated over the lack of funds for conservation and for producing books on her father's works. Nevertheless, when she enters a gallery filled with his paintings, she recovers "the glow" that surrounded him as she grew up: It's "an overwhelming experience. It's a multidimensional, many-layered moment. It takes your breath away."

The sudden death of Gregory Gillespie brings us into a completely different realm. Shortly after a successful retrospective exhibition, and at a time when he was enthusiastically immersed in several art projects, the artist killed himself. In spite of the fact that

Gillespie's emotional life was characterized by a certain instability, nothing had prepared his wife for the suicide. In a state of devastation and shock, Peggy Gillespie was faced with both responding to her young daughter's needs and managing the artist's estate. A will had been made and a trust well planned, but she found herself confronted with vexing and unforeseen difficulties. Although she had an intimate knowledge of his work—initially posing for him—she had never taken on the more practical tasks that artists' wives frequently assume and with which she must now contend. She does, however, embrace the opportunity of editing Gregory's journal and discussing his work in the same open manner that he did, recovering perhaps in that way her man—"hilarious and engaging and warm" as he was.

<div align="right">D.C.</div>

PETER STEVENS
ON THE
DAVID SMITH ESTATE

So much about Smith does seem larger than life: his genius, his protean energy, his gargantuan appetite for work, his ambition, his sheer physical size, even his premature death at a critical time in his career.

—Karen Wilkin*

David Smith was born on March 9, 1906, in Decatur, Indiana. He and his younger sister were the children of Harvey Martin Smith, a telephone engineer, and Golda (née Stoler), a teacher. After a year at Ohio University, Athens (1924–1925), Smith moved to New York City. On the day of his arrival, he met the artist Dorothy Dehner, and they married the following year. On Dehner's recommendation, he attended the Art Students League, taking painting and drawing classes from 1926 until 1931, for the most part with the cubist painter Jan Matulka (1890–1972). After nine months in the Virgin Islands, he began, in 1933, making welded steel sculpture.

Inspired by the iron sculptures of Julio González and Pablo Picasso, Smith drew upon skills that he had learned in the summer of 1925 while working in the Studebaker automotive plant in Indiana. Although he continued to paint and was a prolific draughtsman, beginning in 1935, Smith concentrated on three-dimensional work, absorbing cubism, constructivism, and surrealism. In 1940, he and Dehner moved to a farm at Bolton Landing, New York, where he built a studio-workshop (Terminal Iron Works) and renovated the house. During the war, Smith worked as a machinist (1942–1944), assembling locomotives and M7 tanks in nearby Schenectady. Dehner left him in 1950, and they were divorced in 1952. From 1953 to 1961, Smith was married to Jean Freas, and two daughters, Rebecca and Candida, were born in 1954 and 1955.

During the 1940s and 1950s, his sculpture often had an open, linear quality like calligraphic drawing in space. Two Guggenheim Fellowships (1950, 1951) enabled him to amass material and work on a larger scale. Over the years, the two fields adjoining the house and studios became the site of his sculptures. Smith often worked more or less simultaneously in series, exploring different themes and imagery. The *Cubi* sculptures of the 1960s, for example, are stacked and angled geometric forms with highly polished, reflective stainless steel surfaces; while the *Voltri* and *Voltri-Bolton* series from 1962 and

Peter Stevens, November 2000. Photo: Magda Salvesen.

1963 are assemblages of steel tools, disks, and machinery parts with a hint of figuration; and the *Zigs* from 1961 to 1964 are monumental painted steel, geometric constructions. David Smith's work was gaining an international reputation when his truck overturned near Bennington, Vermont. He died on May 23, 1965, at the age of fifty-nine.

Peter Stevens, executive director of the estate of David Smith, was born on October 29, 1955—the second son of Melvin and Debby Stevens—and brought up in Suffern, New York. He graduated from Sarah Lawrence College, New York, in 1977, and in 1979 married fellow student Rebecca Smith, the daughter of David Smith. They have three children: Emma, Samuel, and Luke. Since 1979, he has worked as administrator of the Smith estate, curating, cocurating, and coordinating exhibitions. He maintains the archives, writes essays, and assists others with research on David Smith. He received the Chevalier de l'ordre des arts et des lettres in 1998 from the Republic of France. Stevens is a practicing sculptor who lives in New York City.

After Peter Stevens, the son-in-law of David Smith, had repeatedly been mentioned as an excellent source on artists' estates, I asked him for an appointment. He invited me to his loft in Tribeca, where he and his family lived, and which, at that point, housed the office of the estate of David Smith.

· · — ·

What arrangements for his work did David Smith make before his fatal car accident in 1965?

He had prepared a will that was very straightforward. His entire estate, including his works of art, would be left in trust to his two daughters, Rebecca and Candida, until they were twenty-five. Unfortunately, Rebecca was eleven years old and her sister was younger, so his chosen trustees were responsible for his artwork for a long time. Then there was a very large complication to do with the estate taxes. In fact, the David Smith estate became a landmark tax case, establishing the way all artists' estates in the U.S. are now treated. Smith sold very, very little work during his lifetime, really lived in poverty until fairly close to the end of his life, when he was doing rather well and the *Cubi* sculptures were being sold for high sums. The IRS came in and said, "Okay, you're selling these sculptures for twenty thousand dollars and there are six hundred of them, as well as other work, so the estate is valued at millions of dollars."

What traditionally happened was that the executors of artists' estates would have to

sell the work to raise the money to pay the fifty percent tax. But, when you sell six hundred sculptures in three months, you don't get anywhere near the full value, so the estates would end up not only with no money but, actually, in debt. So the David Smith estate went to court with the support of expert witnesses from the art community. The decision was that the appraisal of an artist's estate would not be based on the valuation of individual works, but would be evaluated as if the whole block of work were to be sold at once.* They came up with a mathematical formula, now referred to as the blockage discount. This also got a lot of press at the time of the Warhol estate.*

Unfortunately, the David Smith estate still had to pay the taxes while it was fighting the lawsuit. So the executors did have to sell a good bulk of the work. Later, the estate got a partial refund, but the family's collection was radically diminished. Smith's work was at the height of its popularity, especially because of his dramatic death, so it was to the advantage of the executors and the Marlborough Gallery to sell works during the strong market in the late sixties and seventies.

Who were the executors of the estate?

Smith chose three executors: Ira Lowe, the lawyer who had written the will; the artist Robert Motherwell, who had been a very close, personal friend for at least the last fifteen years of his life; and the critic Clement Greenberg, the most influential, if not the most vigorous, champion of his work. Motherwell was chosen because he was an artist for whom Smith felt a great affinity. He was a very bright man but, most importantly, I think, Motherwell had two daughters who were roughly the same age as Smith's. It was a very high priority to Smith that his life and his work be connected with his daughters. He also felt that Motherwell would, in some sense, be a surrogate father if anything were to happen to him. As for Greenberg, I think Smith really thought that his involvement with his work would help insure its continued recognition and appreciation. Greenberg was kind of a cutthroat promoter of work that he felt passionately about. Smith was mistrustful of dealers and, to some degree, museum people and critics too, but he might have felt that it was a necessity to have this advocate in the art world. I think that Smith believed he had covered the legal, the aesthetic, and the personal bases in these choices.

These three people were suddenly responsible for all the sculptures in the north and south field at Bolton Landing, the studio, and the house. What did they do?

I have to say that I'm a very biased reporter and also one who wasn't there. But, judging by how upsetting the whole process was to the people who were meant to benefit, I don't think they handled it very well. To begin with, there was a potential conflict of interests in that Ira Lowe functioned in his legal capacity for the estate when he was also a trustee. Motherwell took no particular interest in Smith's work, his career, or his kids. In fact, I believe he only went to Bolton Landing twice in his capacity as executor. Both Motherwell and Ira Lowe deferred to Greenberg in the important issues related to the work. Smith's estate didn't consist of much of anything besides his artwork, which—except for the sculpture that was still in Italy from an exhibition there, and the work that was traveling

in the U.S. through the Museum of Modern Art—was mostly at Bolton Landing. The property was maintained by his personal assistant Leon Pratt. The art had been pretty well documented and photographed by Smith, but not in an organized way, and none of the executors took seriously one of the most important responsibilities, a thorough and accurate inventory of the work. In fact, the fairly inaccurate inventory that they did wasn't even completed until almost ten years later, and a lot of things, I think, were missing. They sort of "walked," and there was no direct oversight of the physical handling of the work, of conservation, or even sales.

I'm sure that someone like Ira Lowe, whom I don't know at all personally, would disagree with me. I would admit that they did do good things, such as fighting this tax case and winning. Often they did try to do what was best for the work, but I don't think they put in the necessary time and effort. Ultimately, the court (the surrogate court that oversees executors) did have all their commissions cut in half because of their egregious neglect of their responsibilities. Motherwell finally resigned as a trustee, and his spot was filled by a local bank in Glens Falls, but that wasn't until some time in the seventies.

What exactly did Leon do?

He continued on as if David Smith was there, looking after the work and grounds and being responsible for shipping and receiving works. The trustees hired two people to do the cataloguing and the office management. However, nothing was done to conserve the work, and that became one of the big scandals of the David Smith estate—the sculpture was just left out in the fields and, therefore, several deteriorated. Greenberg decided that these painted sculptures were somehow problematic in terms of the overall work, and he didn't really care about them.

The other egregious thing that Greenberg did was to arrange for the removal of white paint from five sculptures. It was horrible for those five sculptures, but also because the general public got the impression that the estate had altered the surfaces of all of David's best work. When they see a late Smith, they assume that the surface is not the original. The fact that Greenberg, ten years after David Smith's death, decided to remove the paint that David Smith put on the pieces and allow them to rust was just something that was beyond the pale and led to his total loss of stature—certainly as an advocate and protector of this work.

How was the executors' commission set?

Unless the will specifies something different, New York state law sets a standard percentage of the value of the estate. The executors did receive a commission every year and were also allowed to charge their expenses to the estate, which were exorbitant. For example, chartering a private plane to go off to Bolton Landing. It was not a good situation, but those irregularities came about because there was a large amount of work and a market for it. This puts the estate in a tiny category of artists' estates. The executors did not have to worry about having a source of income; they could sell as much work as they wanted to, and they did. Not one of the executors had a long-term business plan. Basically, they sold way too much work too quickly at too low prices. You have a court in Upstate New

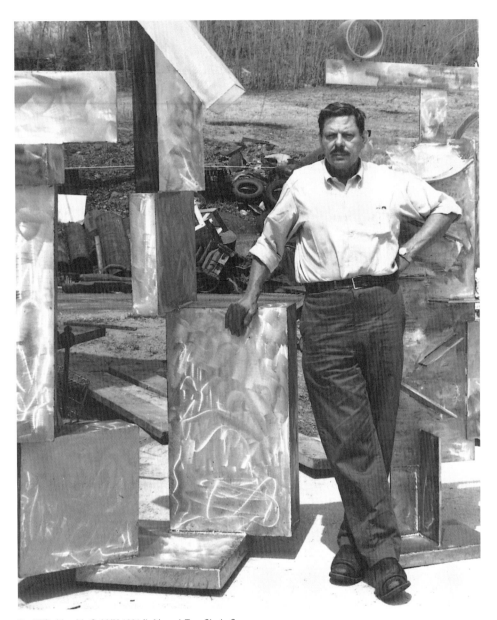

David Smith with *Cubi IX,* 1961 (left), and *Two Circle Sentinel,* 1961 (right), c.1961. Photo: David Smith. © Estate of David Smith/Licensed by VAGA, New York, N.Y.

York looking at the sculpture, and they think it's a piece of junk and that someone who could sell it for thirty thousand dollars is a genius. It's fiscally irresponsible to sell ten pieces at a certain price. They should, perhaps, have sold five at higher prices, but those are issues of hindsight.

The biggest problem was really the lack of personal consideration for the beneficiaries of the trust. The assets of the estate were the trustees' responsibility, and the intention of the will was that they would be there for his daughters. During that long time period of fourteen years, the balance went 100 percent toward selling the work. For Greenberg, who was a very arrogant person, the last thing in the world to consider was the feelings of those two young girls. He had what he saw as a much higher charge: the legacy of David Smith's artwork. So I would advise anyone planning an estate to state the priorities much more clearly than Smith did. Just naming two people who are the beneficiaries is insufficient because the trustees have complete leeway to do what they think is best. In fact, in 1979, when Rebecca turned twenty-five, it would have been impossible to find a judge in the country who thought the trustees did anything wrong, aside from the things they did which were basically illegal.

By 1979, had Bolton Landing, the house, the studio, and the land, been sold?

It's interesting that Smith didn't stipulate his intentions. The children were never consulted but, luckily, the property was not sold. It still belongs to Rebecca and Candida. The two extreme positions were: to sell the whole property; or to keep everything in place and open it to the public so that visitors could see how Smith worked. In fact, the studio was not preserved, and you could even argue that that was done out of personal consideration for Rebecca and Candida. This was their summer home, a living, changing place, and not intended to be a shrine to their dead father. But there could have been some middle ground, and his studio could have been well documented. There is just a scattering of photographs. A great Italian photographer, Ugo Mulas, was commissioned in 1965 to take photographs at Bolton Landing, which he did beautifully and poetically, but not systematically. They are more like an essay than a record of what was there.

Then Smith's studio was completely dismantled. All of his tools and equipment, and even fragments of sculptures, disappeared. The work in progress at the studio was basically just disseminated by Greenberg to other artists and friends and, to this day, we are trying to get some back. For example, we got back David Smith's etching press, and just recently I received from an artist in the Greenberg circle a saw that had been David Smith's. It's sad that there was no documentation or feeling for historical accuracy. Now it would be impossible even to say what tools David Smith had in his studio when he was working on these big sculptures. The other thing—I think encouraged by Clem—was allowing Leon to make his own sculptures, using some of the leftover things at Bolton Landing.

Did the children always live with their mother in Washington?

When Jean Freas and David Smith were divorced in the mid-fifties, Becca and Dida went to live with their mother. I think that separation really fueled Smith's fixation on them, because he missed them terribly, although they would spend summers with him as small children. As they got older, he would visit them, and they would go other places together. When their mother remarried in the early seventies, they lived in Westchester, New York.

When did you get to know Rebecca?

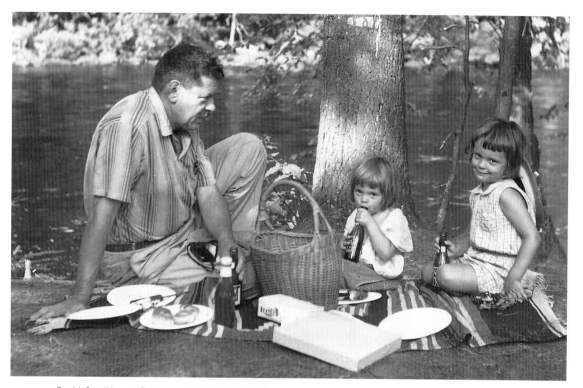

David, Candida, and Rebecca, c. 1959. Photo: David Smith. © Estate of David Smith/Licensed by VAGA, New York, N.Y.

I met Becca at Sarah Lawrence College long after her father died. We were married in 1979, which was coincidentally the year that Becca turned twenty-five. It quickly became apparent that she was very upset about her father's estate, specifically how it was being handled and mishandled by Clement Greenberg. Going up to Bolton Landing, she and her sister would see the sculptures vanishing from the fields with a total disregard for their feelings or input. Clem Greenberg was a formidable presence, but that didn't prevent Becca from trying to advocate her views. I tried to support her and, when Becca turned twenty-five, I said, "Well, now you have to take over this thing." Becca felt that she couldn't, that we should get someone else to do it. I say we, but it really was she and her sister—I was just an advisor.

The first thing we did was to get the trustees to agree—and we had to fight for this—to put up the money to construct a building so the work could be stored in a climate-controlled setting. That was actually before 1979. Then we got a very good lawyer and resolved that, although the IRS cases were still outstanding, we would have the artwork removed from the trust. There was also a battle of control over that, which we won. Once that happened, Greenberg didn't want to be involved anymore. By then, we felt that Greenberg was

disrespectful of large portions of Smith's achievement, and more interested in promoting the next generation of artists whom he now believed in. David Smith's work had become only an art historical connection, a building block that led to the next movement. I saw that Smith was coming to be seen as a kind of 1960's artist, when he was actually one of the first generation of abstract expressionists, and that really concerned me.

This crystallized for me at the time of the 1979 Whitney Museum's retrospective of David Smith's drawings. As I looked at these unframed drawings in the basement with Clem Greenberg and the curator of that show, Paul Cummings (a great admirer of David Smith's works on paper), I clearly saw that Greenberg did not respect this work. I physically stepped forward and put my body between Greenberg and the drawings. At that point, I realized I was going to be involved in some way. Becca's sister, Dida, was going off to school in Paris, and Becca didn't want to be involved. So, when the artwork was removed from the trust, I said that I would look after it until we found some really great art-world person who knew more than we did. I didn't know anything. None of us did.

We then instituted a policy of no more sales because, in some ways, the most upsetting thing was the physical loss of these objects that, to some large degree, represented their father. That's what they had of him, and to have these torn from them was really painful. We wanted to try to understand this body of work and how best to put it out into the world.

How much work was there at that point?

The bulk of the late sculpture had already been sold by the estate. Between 1965 and 1970, something was going on at the Marlborough Gallery that has been very well documented in books about the Rothko case. The two cases are almost identical. Why, then, was the Rothko case a huge scandal that ended up in litigation and was settled in favor of the family, whereas nothing happened in the Smith case? The fact is, there was a crucial difference: Rothko's will stipulated certain things that could objectively be shown to have been violated. David Smith's will left everything up to the trustees so, although the same exact thing happened to the two estates, in one it was egregiously illegal, and in the other it was perfectly fine. In our case, over two hundred major works were sold in less than a five-year period by Marlborough Gallery and, in some cases, to Marlborough Gallery, which is a horrible conflict of interests. Many, many major works were sold and undersold, particularly if Clem Greenberg didn't like them. It was perfectly legal. Whether it was right or wrong is a matter of subjective hindsight.

Did the Marlborough Gallery have an exclusive contract?

Clem Greenberg was relying on the gallery to do the sales, and then, when the Rothko scandal broke in 1971, he quickly removed the estate from Marlborough, not wanting to be tarnished by that scandal. He first went with Lawrence Rubin, who had his own gallery, and then to Knoedler in 1972, when Rubin became president and director there. What hadn't already been sold was the large body of drawings and paintings, although in his lifetime Smith showed them continuously. Luckily, Greenberg hadn't been interested in

them. So that work was retained, and that's where we started to try to understand this legacy that was left—to preserve for Becca and Dida something of their father, and also to solidify his place in art history.

We viewed the remaining sculptures as the "core collection," which could be loaned to exhibitions and museums. All the other sculptures that had been sold were scattered around, one in each museum and a lot in university galleries. There also had been very little interest on Greenberg's part in promoting Smith's work further in Europe. Smith had exhibited at Documenta in Germany, and he showed at the Spoleto Festival in 1962. The year of his death, he was showing in Paris and London. But Greenberg put an end to all that because he had this almost xenophobic hatred of Europe. His whole mission was to move the center of art to New York. Restoring Smith's reputation as an international artist was something that we saw as really important. We didn't generate our own projects, but we tried to facilitate other people's projects through the works we had.

So you've only used the core collection for loan, never selling from it?

Primarily. We have occasionally sold major works if we felt that it would ultimately serve Smith's reputation and enhance the understanding of his work. Most recently, the Tate Gallery acquired one of the major pieces from the family's collection, *Wagon, II*, from 1964. That was a very considered decision. It was almost like forming a partnership with the museum, and I feel that strengthens Smith's position. I have tremendous respect for Nick Serota, Jeremy Lewison, and the other curators at the Tate. Their passion for the work is so great that their ownership of part of that legacy is an added strength.

You're not planning, like the Clyfford Still estate, to place a part of the core collection in one particular museum?

That hasn't been our goal, and I don't think we have enough work to do both that and the other things I think are important. A number of institutions have a great, though not exhaustive, collection of Smith's works. The Museum of Modern Art, for example, has a few gaps, but it has *Australia* [1951]. Nothing like that exists in our collection, so we're not able to provide a complete survey of Smith's work. We feel that it's better to place works very selectively where they can add up to something in a more global and cumulative way. I don't think having a large body of work in one place works well for artists. I know that people like that idea but, when one institution becomes such a repository of a body of work, no matter how well intended, it becomes the custodian of that artist's reputation, not just the works.

Both the Museum of Modern Art in New York and the Hirshhorn Museum in Washington, D.C., do have concentrations of Smith's work. Did you work closely with Joseph Hirshhorn to see that his collection was broadly representative?

Actually, Hirshhorn's collection dates from before I was involved. He collected when Smith was alive, and he bought work over a period of time from both the estate and Marlborough. The Modern also bought work over time, and one of the really great pieces from our collection went to the Modern, one of the *Zig* sculptures.

As a gift?

It was an elaborate transaction and involved an exchange of works. They already owned a *Zig* sculpture, and we exchanged it for a different one, and also made a gift of part of it. The Whitney also has a very extensive collection of Smiths through acquisitions, although they don't have a major work from the sixties. It was the very first museum ever to buy a Smith sculpture during his lifetime. We also make extended loans from our collection to museums with whom we have special relationships. We did that first with the National Gallery when they opened the East Wing, which also, coincidentally, was around 1979. I worked with E. A. Carmean, who was the curator there, to develop an exhibition program. At times, they've had over a dozen works on loan, and still do. We've also done a similar thing with the Tate Gallery in London, and the Reina Sophia in Madrid has works on loan from us, too. We've lent individual works to the Tel Aviv Museum and the Carnegie, Pittsburgh, which enhance their own holdings. Sometimes museums don't want to take extended loans from private collections unless they're promised gifts, but since we're not in the habit of selling sculpture, they are more inclined to take these long-term loans.

Are there any good examples of core collections at one institution?

I have a very narrow vision, as I'm always focused on Smith. I think the reformed Rothko Foundation tried to do both: it left works to a lot of different institutions, but a large number went to the National Gallery in Washington. I think that was honoring Rothko's wishes, but I think it's a mistake. I haven't noticed that the National Gallery has become a special place to see Rothko's paintings. The Rodin Museum in Paris, which is dedicated to one artist, is a commercial enterprise, which I don't like. It was his wish that they would continue to make his work, and it certainly is the norm for sculptors' estates, but I see this as problematic. You can still buy a brand-new Rodin from that museum. Smith was totally against the idea of editions and casting. I guess there have been instances of painters' estates that have done that as well, most notably Pollock's, which did posthumous prints that are now considered to be by Pollock.

There are no editions of Smith's work?

He did a small number of works in the forties as editions of two or three. Very shortly after that, he became adamantly opposed to this. Having absorbed the ethos of abstract expressionism, he felt strongly that sculpture should represent the same personal, passionate conviction as painting, and that the object is the object the artist makes. It's like the Harold Rosenberg idea that the painting isn't a depiction of something; it's the evidence of action that's taken place. Smith was very vocal: he was against editions or any posthumous fiddling with his work. We have held true to that, although we've been approached on many occasions to do posthumous editions of his work.

I guess another notable case is the Julio Gonzalez estate, which did posthumous editions of six or eight bronze casts of unique iron sculptures that you can see anywhere in the world. The Gonzalez Center in Valencia is full of, in my opinion, copies—museum

gift-shop copies—but they were made by the estate and are considered to be works of art. Now, my view is completely colored by Smith's, and I think you have to go by the artist's view. Gonzalez probably didn't make any stipulations, so the family took that position.

In some ways, then, your role is that of a moral and ethical interpreter of Smith's attitude and outlook?

Yes. I don't mean to sound glib because these decisions are hard to make. I've agonized over them, and I feel that I've been given a lot of help by Smith. It's harder when an artist hasn't documented his views, as in the case of Gonzalez. But I'm not doing this by myself. My sister-in-law and my wife, in some way, have the moral authority to speak for their father. Smith's reputation has suffered *considerably* from the fact that he didn't do editions, that there is only one *Australia* in the Museum of Modern Art, one *Hudson River Landscape* [1951] at the Whitney. If there were 8 of each of those, and if you could just pick 20 of his greatest sculptures and multiply those by 8, that would be 160, so there would be 140 more great works of his out in the world working for him. Every museum in Europe that has no Smith could have three great Smiths. If that were the case, there's no question in my mind that he would be universally seen as a great artist. His work is not understood in Europe at all, mainly because they haven't seen it.

Have there been any other such decisions that the three of you have had to make where, on the one hand, it would be good for Smith's reputation to do something but, on the other hand, it would have been against his wishes?

That's a really good question. I'm sure it would be arrogant of me to think that we haven't done things he would have hated. Well, here's an example. We have to take a very strong view toward conservation, and there are certain things Smith might have done that would have enhanced the work, like repainting it. He specifically stated that he thought it was okay, but he was a very contradictory person. He also allowed that it might be beneficial at some point to regrind the surface of his *Cubis* if they weren't shiny enough, and that it would be okay for someone else to do it. In fact, although it's often stated that the calligraphic gesture is so personal to him, he did have Leon do a lot of the grinding. At that point, it was becoming more of a surface quality than a specific gesture, even though he did have a technique, which Leon used. There is no way on this planet, however, that we would ever authorize anyone, ourselves included, to touch the surface on one of those sculptures with a grinder. It's not purely a commercial decision. It's probably counter-commercial. If they were shinier and newer looking, maybe it would be for the better. I don't know. But, in instances like that, we have to say that Smith didn't know as well as we do, or at least the standards have changed. It's one thing for the artist to, as he often did, rework pieces. He restored and repainted a lot of his sculpture over the years, even going back to some of his early 1930s work in the sixties. We wouldn't do that.

I suppose you also have to be slightly contradictory in that you allow the painted sculptures to be repainted?

No, we don't. The conservators whom we work with basically treat the steel sculp-

ture as you would treat a canvas, as a support, like a wood panel, and the painting is the artwork. If there's damage or deterioration to a painted sculpture, we restore it the same way you would a painting. As with a Mondrian, you would never just sand it down or repaint it. So we don't do that. Now, the five sculptures that Greenberg had stripped of their white paint we had restored. We've had them brought back to being white, so that's a kind of a reconstruction of the surface that was there. But, in general, we have not, although there might be exceptions in some cases. Actually, there's only been one case in which we've done major in-painting of a piece; the paint had been severely damaged by Greenberg's leaving the piece out winter after winter. Using photographs, we have had this piece stabilized. A barrier, like a varnish, was put on, and then the in-painting was done over it to re-create Smith's surface. But, just as with painting conservation, in ten minutes you could wash off all the conservation and get back to that original Smith paint.

What do you see as your most important achievements since 1979?

The major overriding goal is to have the artist seen in his totality. The problem is that your motives can be suspect. For example, there have been reviews in the New York Times of exhibitions of drawings by Barnett Newman, Morris Louis, and others, suggesting that the work was inferior and only being shown to profit the estates. But Smith's work evolved in a crucial time in history, from the late twenties to the sixties, and covered many bases: surrealism, the development of abstract expressionism, the influence of the European avant-garde on American art—and he worked in different media. We've done exhibitions of Smith's photography, drawings, paintings—he painted throughout his entire career—and ceramics. They have usually been in commercial galleries because that's where we have free rein.

Sometimes we purposely avoid a didactic approach—questions of influence and development—because it can obscure the work itself. For example, we just did a show at the Gagosian Gallery of the late nudes from 1964 without any supporting or explanatory material. We didn't show how they relate to the early cubist drawings of 1932, or how his use of the figure evolved through his whole career, since we already had done two shows like that. It was time to just let those paintings exist on their own.

What publications would you be interested in?

That's one area where I haven't done a great job, and it's something I want to address. Rosalind Krauss was really the great contributor to the literature on David Smith because of her books Terminal Ironworks: The Sculpture of David Smith [1971], and Passages in Modern Sculpture* [1977] (with the one chapter on Smith). We also hope to update her catalogue raisonné, which was done as a typed dissertation in, I think, 1977. We have a Xeroxed copy. The quality of the work is great, and it's still very useful but obviously outdated. We'd like to have a high-quality catalogue raisonné—similar to the one on Jackson Pollock—that illustrates every one of David Smith's sculptures. He made under seven hundred, and that includes everything, from the smallest study fragment to his most major work. Ultimately, I hope we can produce a catalogue raisonné for the works on paper and for the paintings.

There is a body of literature that exists in museum exhibition catalogues, but I haven't seen anyone who seems to really be immersed in Smith's work, partially because there hasn't been a major show in this country lately. There was a retrospective in Washington in 1982, and one at the Guggenheim in New York in 1969. A really comprehensive retrospective is long overdue, and I'm excited because that will happen in 2006, the centennial of Smith's birth. Hopefully, it will spur a new consideration of the work and some real critical thinking about it.

There also hasn't been a major biography on Smith, although there was a very nice book by the artist Stanley Marcus in 1983. But we're really delighted that someone has started working on a serious historical biography.

Could I ask who that is?

It hasn't been made public yet, but I can say it's Michael Brenson. By giving him access to all the archives and helping with introductions to people, we will have some input, but we've chosen someone we can be totally removed from and trust to do a great job. In any case, Michael wouldn't touch the project with a ten-foot barge pole if he thought we would try to assert any editorial control.

I noticed that Candida has been writing on her father.

At the very beginning she was not that involved—she was a modern dancer and choreographer, and she pursued that actively and wonderfully. But she was always consulted on important decisions. Certainly, we never sold a work or planned an exhibition except together, although I always did all the administrative work. Then, around ten years ago, she started to get much more actively involved. She had gotten out of performance and choreography because of injuries and having children. Her deep personal connection to her father and her understanding of his work have been huge assets. She both writes and lectures about him. We work together as equals, bringing different kinds of passion and skills. She wrote two great essays for the book *The Fields of David Smith* and recently began participating in the production of the catalogues. She has great design skills, which I lack, and a sense of what she wants David Smith catalogues to look like. Because I'm the one who is more out in the public, I tend to get all the credit for what we've done. People come to me and say, "Oh, you're doing such a great job," but it's not me, it's both of us working together.

Let's go back to archives, records, and papers. I notice that a certain number are already in the Archives of American Art. What is there, and what have you kept?

The estate, thankfully, didn't lose all of those things. In a kind of haphazard way, the trustees just gathered up all of Smith's own papers and archives and shipped them off to the Archives of American Art. Luckily, there was someone there, Garnett McCoy, who made a huge contribution to Smith by organizing these archives. He did a book, unfortunately now out of print, which is a summary of Smith's writings drawn from the archives.* The estate deposited—it didn't give—the papers to the AAA, so they are actually still owned by Rebecca and Candida. They're there. They're on microfilm, and they're available to scholars. But they're not as completely archived as they could or should be.

Recently, we started taking back into our own possession all the works of art that were among those archives, like Smith's photographs, which we did an exhibition of at Matthew Marks Gallery in Chelsea [1998] and the Fraenkel Gallery in San Francisco. As a footnote, I was very concerned about the criticism that Smith did not view them, necessarily, as works of art. So, before I did the show, I asked the major curators at the Metropolitan and the Museum of Modern Art for their opinions. They thought it was worthwhile to do the show, so I went ahead with it, and that exhibition won the award of the year from the United States section of the International Association of Art Critics [AIGA] for the best photography show at a commercial gallery.

We took those photographs back and organized them ourselves. We exhibit them, and we have sold them. Because some of the very early photographs and negatives are very delicate and fragile, it seemed better not to have them stored in one centralized place. Some of Smith's early photographs are like hand-made negatives: he collaged pieces of different-colored acetate and then made prints from them, and we had the original acetate objects. Now they're in the collections of places like the Getty, the National Gallery, and the Metropolitan Museum, where they get incredibly good care and can still be studied by scholars. We haven't determined yet what will happen to every single letter and document—whether we will gift them to the Archives of American Art, or deposit them with a university like Harvard, which has a very extensive Smith collection already, or the Getty, which has another orientation toward archives and is building up an excellent one. The third choice is to do it ourselves so that it's done the way we want. For example, Sandy Rower at the Calder Foundation has done an amazing job organizing the archive of his grandfather. However, I really like what the Archives of American Art does because they have offices around the country and the work is available on microfilm. Even if we did withdraw more material, we would still try to work in conjunction with them.

In a way, you control the story of David Smith. Are there aspects that you would rather not see written about or known?

I don't think so. I tend to feel that the whole story should be told. Smith was a really complicated person; he had two very difficult marriages and was a tough person to live with. That's an area that's come out in stereotypical ways, which I don't think serves either him or his wives, or the work, in any positive way. We want the whole story of David Smith's life to come out because that was what his work was about.

How do you deal with those parts of the estate that you feel are less important?

Smith viewed his work almost like a diary, like a record of his life, and the idea of expunging part of it would be like expunging part of his life. I think Smith also wanted to exert control, and he wanted to be seen as this incredibly broad producer of all of these different things. He saved everything. He saved unfinished as well as cast, but abandoned, works. I think they held value for him; we wouldn't necessarily exhibit them, but we certainly would make them available to anyone who was interested.

You, yourself, are an artist. How have you balanced your own career and your job of looking after the estate?

I've accepted the fact that part of my life is devoted to administrative activities, exhibitions, and dealing with the world. In fact, during the last ten years, career moves on behalf of my own work have fallen by the wayside. My work in the studio is really a luxury I afford myself. Maybe if I hadn't been making sculpture and working in my studio, I could have gotten the catalogue raisonné done. There's a tradeoff. I also haven't been that interested in fighting the battles of the professional art world for my own work because I do that for David Smith's work. But, seeing that it's a fight for David Smith, who's in every history book, makes me think twice about devoting energy to fighting for myself. At some point, I will get back in the ring but, if I look back over the last twenty years, I can see that my life has really been enriched by what I've done with Smith's work.

You also said at the very beginning that the art world is quite a cutthroat world and very competitive.

Accepting the position of advocacy means that you're not necessarily always going to be fair. I do try, though. When people say they want to borrow three David Smith sculptures for a show of abstract expressionism, I say, "You know, David Smith wasn't the only abstract expressionist sculptor; there actually are other good people." But, ultimately, I have to be Smith's advocate. Whenever possible, I try to take a morally responsible position. For example, it somehow fell to me to decide which artist was going to be shown with David Smith in a museum exhibition. The painter they had chosen was Franz Kline, and I said that was unacceptable. We were showing very delicate, linear, vertical Smith sculptures, and they would disappear in front of the Franz Kline paintings. So I brought all these wonderful Barnett Newman paintings into the room, and the Smith sculptures looked fabulous, but the Barnett Newman paintings became scenic backdrops. I said, "No, I don't think it's in anyone's interest to have them look like that." The show ended up being a really beautiful installation of Pollock and Smith—the works really related to each other. I felt that I did what was morally right for art in general, and also what was best for Smith.

I've accommodated myself to the view that there isn't a morally good museum world and a morally bad commercial world. I think that, historically, the appreciation of contemporary art is linked with the marketplace, and I find it hypocritical that our society denies that. In Japan, you can work with a commercial gallery that is producing a museum exhibition. The Gagosian Gallery doing a show at the Met would be impossible. It couldn't even give money to a dinner party there. In fact, I think the museum world is more linked, in some ways, to commerce because there's more money at stake for museums. You can see that with what's going on internationally with the Guggenheim now: the whole city of Bilboa used the Guggenheim Bilboa Museum as part of its economic development. I'm not sophisticated enough as an economist to understand, but I do feel that I can at least form the judgment that there are vital overlaps. I'm totally, I think, in the minority viewing it that way. For example, there's now an organization of people, whom I respect very

much, who run foundations and meet informally. I said to a couple of them, "I'd love to come to that," and they said, "You're not a foundation." I thought, what am I doing differently from what you're doing? I guess it's the fact that if we sell a sculpture, we get to cash the check.

Do you feel that the artists who have set up foundations were genuinely concerned with charitable causes—helping younger artists or art institutions—or was it just a legal maneuver for avoiding taxes?

Whether it was the artist's intention or not, I think that the Pollock-Krasner Foundation and the Gottlieb Foundation do a great job. They've made a real difference in a lot of people's lives. The Judith Rothschild Foundation is another great example. So it's an area for a family like us to consider. There are also the examples of the Warhol and Henry Moore foundations, which support groups and projects rather than individuals. Their assets are tremendous. In fact, I think the annual donations of the Henry Moore Foundation are greater than those of the entire National Endowment of the Arts! David Smith was very emotionally supportive of younger artists. In fact, he felt that artists were basically up against everyone else in society. So we feel he would have supported setting up a foundation. Ours would be on a rather small scale. At this point, we would probably just try to insure that what we're doing could continue. It's like doing your will. You have to do it, but you have to keep redoing it as you get older and circumstances change.

Is it important for you to see that the prices for Smith's work keep rising?

Obviously we can sell any Smith for whatever we want. If you're running a foundation, you have fiduciary responsibility to sell for as much as possible. I do believe that it's a responsibility to the work to have the highest prices. Smith felt that way. I know someone who saw a show of his paintings in 1959. After it closed, he asked Smith if he had sold anything, and Smith said, "No, I didn't sell a thing." He offered Smith seventy percent of the retail price for one of the paintings. Smith said, "I don't price my work to sell it; I price it for what it's worth." We feel really strongly that one of our goals—I should really speak for myself because I think about it more, maybe, than Dida does—is absolutely to maximize the value and the perception of value of the work. I think selling a work to a museum is better than giving it because gifts are not necessarily treated in the same way. If the National Gallery bought three Rothkos for a huge amount of money, they would be up all the time. You give them three hundred, and they might not feel that they have to have them hanging. In some cases, I do think that it's good to give things away or to work with museums—and we have done that—but the art world is a place of commerce.

Do you work with one gallery exclusively?

Right now the only galleries we work with are in this country. We don't have an exclusive contract with anybody, and we don't sell a lot of work. What we've tried to do is work with galleries that have a passion and an ability to bring the best light to certain areas of David Smith's work. We haven't felt that there's any one gallery that really is in a position

to address all aspects of David Smith's career, although Gagosian is our central gallery. It can put tremendous resources behind Smith's work in both New York and London.

What would you say is distinctive about the way the David Smith estate is handled?

We've had to invent our mission, and the way we're going to try to achieve it, and decide what our level of commitment will be. This has a direct effect upon my wife and my sister-in-law, and people whom I care tremendously about. We assume that the work should serve our lives, although we are in service to this work and to this reputation. To some degree, we've held back from becoming a totally professional organization and running the estate in a very businesslike way. Certainly, we have not delegated anywhere as much as we could to other people, which to some degree limits the amount that we can do. Personal priorities sometimes take precedence.

What thoughts do you have about the next generation taking over?

We like to think that it's a ways off and, hopefully, it is because our children are young. I have a daughter who's eighteen, a son who's sixteen, and another son who's eight; Candida and Carroll [Cavanagh] have sons who are eight and three. We do think about it, though we haven't really made any plans. If any of the kids wanted to be involved, that would be great.

There really are two different considerations: the sculpture, and everything else. It definitely would be possible for us, in a few years, to sell every sculpture we have and to place them in good collections, but that's not our goal. I know my wife and sister-in-law both feel very strongly that they want their children to own important works of art by their grandfather. So that leaves room for what happens with everything else. It's important for artists' work to have a kind of advocacy. At a certain point, artists don't really need that, but I just don't know what that point is.

November 2000

UPDATE

The David Smith retrospective will open at the Guggenheim in New York in 2006, and will travel to the Centre Pompidou in Paris and the Tate Modern in London. In mid-2002, the estate of David Smith moved into an office space at 333 Hudson Street, New York. White walls, stainless steel trim, and hanging felt dividers give the two thousand square feet a cool elegance.

FOR FURTHER INFORMATION

Krauss, Rosalind E. *Terminal Ironworks: The Sculpture of David Smith*. Cambridge, MA: MIT Press, 1971.
Smith, Candida N. *The Fields of David Smith*. Photographs by Jerry L. Thompson. New York: Thames and Hudson, 1999.
www.davidsmithestate.org

HELEN PARK BIGELOW,
DAUGHTER OF
DAVID PARK

He was special, we were proud of him, we adored him. But even if I didn't resent David's dedication to his work, it had many influences on me. Dedication to my own work, for one thing, plus the completely transparent fact that to this day I am overcome by anxiety if called upon to "bother" a special, important man with a need of my own.

—HELEN PARK BIGELOW*

David Park, the third of four children of Unitarian minister Charles Edwards Park and Mary (née Turner) Park, was born on March 17, 1911, and brought up in Boston. During his school years, all he wanted to do was paint and draw and, finally, his family allowed him to follow his artistic inclinations. After one year at the Otis Art Institute in Los Angeles (1928), he moved to San Francisco. He and Lydia (Deedie) Newell (1909–1990) were married on June 30, 1930, and their two daughters, Natalie and Helen, were born in 1931 and 1933. David Park spent 1929 and 1930 as a stonecutter for Ralph Stackpole, and worked on various projects for the WPA through the early 1930s. Although very aware of Diego Rivera's work and the social realism prevalent at the time, Park's own figurative paintings were less programmatic and more concerned with people at leisure.

Between 1935 and 1941, the family lived in Boston, where David taught. His work became more influenced by the synthetic cubism of Picasso. They then moved back to Berkeley, California, which remained their base. In 1945, Park joined the faculty of the lively California School of Fine Arts in San Francisco (after spending the war years working as a machine operator for General Cable Company). He played the piano in the now famous faculty-student Studio 13 Dixieland band. In 1952, he resigned from CSFA over the dismissal of fellow artist Hassel Smith, a sign that the school was becoming more conservative. He became assistant professor of art at the University of California at Berkeley in 1955. His four-year experimentation with an abstraction of flattened forms came to an end in 1949. From then until his premature death on September 20, 1960, he developed his signature figurative paintings and drawings of bathers, cyclists, boaters, nudes, and portraits—his brushwork becoming increasingly painterly and gestural.

Helen Park Bigelow, born in 1933, is the younger daughter of David and Lydia Park.

She married Robert Green in 1951, had three children, eventually divorced, and married Edward Bigelow in 1980. They live in Palo Alto, California. For many years a potter, she now works on writing projects and, with her sister Natalie Park Schutz, takes care of her father's legacy.

In 1992, after Jon Schueler's death, I arranged for his paintings and drawings from the fifties and sixties to be transported back to New York from a warehouse in Connecticut. Among his personal belongings was a whiskey box full of reel-to-reel tapes. With great care, technicians re-recorded them, and I heard the 1951 Dixieland music of the Studio 13 Jazz Band from the California School of Fine Arts. The players included David Park on piano, Elmer Bischoff on trumpet or cornet, and Jon Schueler on the double bass. I sent Helen Park Bigelow cassettes of her father playing, and we finally met at the Wiegand Gallery of the College of Notre Dame in Belmont, California, just prior to the opening there of the Jon Schueler retrospective in 2000.

. . .

What has happened to the work of your father, David Park?

When he died at forty-nine, he left about a hundred oils, a hundred gouaches, numerous pencil drawings, black-and-white ink wash drawings, and studio drawings mainly done from a model in drawing sessions with Elmer Bischoff and Dick Diebenkorn.* My mother, Lydia, who was two years older than David, remarried in 1962. During most of that twenty-eight-year marriage, her English husband, Roy Moore, took on the reins of managing David's paintings.

My mother occasionally gave paintings to various museums because she considered it the best way for numerous people to see them. This conflicts somewhat with the theory that paintings should be exhibited and sold because competition and trading are one of the major ways of keeping interest up. But my mother and Roy did sell paintings every now and then. When she died in 1990, only some early work and a fair number of splendid black-and-white ink wash drawings remained. She had arranged for these to be divided between the Santa Barbara Museum of Art and the Oakland Museum of Art. All that was left in the estate were works that my sister and I owned, given to us by my parents over the years.

Natalie and I stumbled into being the representatives of his estate with no real information about what that meant. Suddenly, we had to deal with copyright issues and permissions for reproduction of my father's work. We often have absolutely no idea who the owner of the painting is, and it's very difficult to track work, although we have tried. Is it sufficient to get permission from us? If we own the painting, then we can confidently say yes, but copyright issues are complex, and nobody that I talk to seems to know anything.*

It is fascinating that your mother's second husband took on the responsibility.

I think that it couldn't have been easy for him because of the attention David's work brought to Deedie. But my stepfather enjoyed the fact that his wife was the widow of an

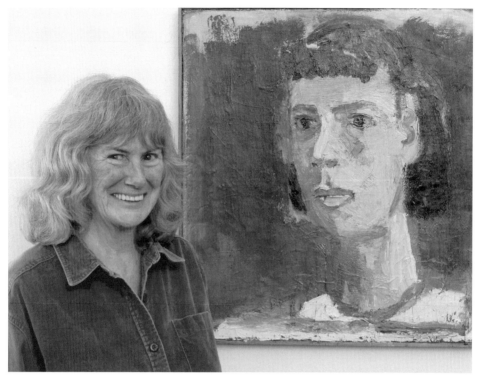

Helen Park Bigelow with *Lydia,* the 1956 portrait of her
mother by her father, David Park, 2004. Photo: Edward B.
Bigelow. Courtesy Edward B. Bigelow.

important painter. By taking charge and managing David's work, he became quite posses-
sive about it.

What was his background?

He was headmaster of one of Britain's boys' schools, Mill Hill, just outside London.

Was he managing the paintings from Britain?

At first. Seven years later, when he retired, they came to Santa Barbara, bought a little
house, and lived there for the rest of their lives.

When David died, the paintings were with the Staempfli Gallery in New York, and it
represented him until 1970, when the Maxwell Galleries in San Francisco took over. In
the 1980s, Larry Salander and Bill O'Reilly asked if they could handle David's work, and
they put on three very beautiful shows in New York. That was a wonderful move.

Was it Roy who found the new galleries?

No, he never went out to look for a gallery, and neither had David. Staempfli
approached my father before he died, and his was the inaugural show there in 1959.
David was extraordinarily grateful that his work was getting attention because it meant
that Deedie was going to be financially okay. He had no savings or life insurance policy.

How do you think Staempfli got to know his work, since it had been mainly shown on the West Coast?

I'm not sure. But his work had been reviewed in national magazines; there had been some traveling exhibitions; and he'd been recognized as the person who started what came to be called the Bay Area Figurative Painting movement. Paul Mills, the director of the Oakland Museum who put on a show exploring this work in 1957, was the one who coined that phrase.*

Was your father upset that his work wasn't represented by a West Coast gallery at the time of his death?

David didn't put time or energy into selling his paintings. He submitted to shows, believing that if his work was good, it would be recognized. All his effort went into painting.

During that terrible period of illness from 1959 to 1960, did he talk to your mother or to you about what he wanted for the paintings?

My father was very glad to be with George Staempfli. But he felt bad because, after the gallery had put out a lot of money to do a big show and publish a catalogue, he got sick. Those were the last oils that David did, except for one more that he painted when he returned from New York in the fall of 1959. He had a lot of confidence in George and knew he would advise my mother well and try to get the paintings into museums.

Do you think that your mother had a business meeting with George Staempfli?

No. I can't believe there was much planning. And after she went to live in England, she was floundering a little bit about how to deal with her first husband's legacy and, at the same time, be a loyal and involved wife to her second husband. I don't think that this combination was easy on her.

Perhaps it's rather amazing that Roy didn't mind your father's presence and wasn't jealous?

He probably was, but the way he tried to deal with it was by taking the high road. Once he said something very disparaging about my father. Anybody is entitled to a moment of anger, but it showed a side I don't think my mother ever knew about. He called David a second-rate American painter. Of course, anything American was inferior because he was British—except perhaps the weather in Santa Barbara!

But he did choose to live in America.

Well, Deedie was an absolutely tried-and-true California girl. She needed to come back here to the sunshine. And I think that he saw that need and responded to it in a generous way. Theirs was a many-sided relationship.

Over the years, did your mother ever feel that she should invest money in ads or a special catalogue?

No. There wasn't any money, and she wasn't an assertive businessperson. She believed completely in David's work, that it was always going to be viewed with respect and appreciation. She was right.

Do you think that Roy, despite what you said, was more ambitious than your mother?

No. I think he was trying to be responsible. I don't think he saw what he was doing as a contribution to the world of art, but as something that he had to do in order to take care of his wife's affairs.

Did David, your mother, or Roy ever keep back certain key paintings?

No, and I think Deedie was terribly torn about that. I remember seeing that a certain painting wasn't in her house any more and asking what had happened to it. She could barely get the words out that it had been sold. It was very traumatic for her. I think she wasn't really sure she wanted it to be sold, but she had gotten talked into it. She had sort of given up on her own ability to be decisive. She was getting old, and she was taking a backseat to her husband's wishes.

What were those wishes?

I don't know whether he was selling a painting because he wanted to see the money in the bank, or because he was being treated flatteringly by someone who wanted to buy it, or whether he was actually making a businesslike decision. He didn't have any interest in sharing his decisions with my sister or me. I think, in fact, he was afraid that we would say things that would confuse Deedie. So the easiest thing for him was to not include us. He trusted that he was doing the right thing and, therefore, she would be pleased.

Did you resent being left out?

I would have liked to be more in the process. But I guess my primary motivation was making things easy for my mother.

Looking back, do you feel that there was anything more that your mother and stepfather could have done?

Definitely. But they didn't know it. Painter-friends would talk to me about where David's work should be and things that should happen. When I repeated these conversations to my mother, they would upset her terribly because she didn't want to suggest to her husband something other than what he had set in motion. He was a very controlling person and hard to approach. So it wasn't until Salander-O'Reilly had those shows in the eighties that the work came forward in the way that it should.

During your father's lifetime, how involved was your mother in helping him?

She was his other pair of eyes. He wanted her to see everything. They talked about every painting. When there were lists to be made or an important letter to be typed, they worked on it together. She took his work utterly seriously, and his work was the center of his life and of all our lives.

The whole household revolved around your father?

Absolutely. His time and energy for work were the most important things, and we all totally accepted and respected this. I have been asked a hundred times if I resented it, and I can't remember any such feeling in the household. He took it seriously so, of course, we did.

Having been so involved in his work during his lifetime, didn't she feel she could be

more of an advocate once she and her second husband were in California?

She was a private, quiet person, and she was in a condition of loss that she never recovered from. It was a half of her life that got cut off.

During the marriage, had she supported the family at all?

This is a wonderful story. Soon after David rejected abstraction and made his return to the figure in around 1949, he resigned from the faculty of the California School of Fine Arts. I got married at that point, as did my sister six months later. Deedie and David never had any money at all. She worked at the university, and he taught and sold two or three paintings a year for two or three hundred dollars apiece. When he resigned from the school, it was a big cut, and he was scrounging around, doing odd jobs. He decorated liquor store windows and did entrepreneurial sorts of things.

Then Deedie, one day in 1952, said to him, "I don't think you should waste your time doing this any more. It's ridiculous. We should just find a way to get by on my salary alone. We have fewer expenses now without the children, and I think you should give all your energy and time to painting." And he did, calling it the "Lydia Park Fellowship." It was a sacrifice for her because she did not love working and was not a career woman. But he made good use of the time. The "fellowship" ended when the University of California invited him onto the faculty in 1955, and that meant she could quit her job. Then she had her short but very good time of being able to putter around the house and garden.

Did you know about the "fellowship" at the time?

Oh, yes. I was proud of her. I loved my parents' union. I loved their love for each other. Kids do, and I was newly married at the time. There wasn't friction and fighting and all that sort of stuff between Deedie and David, so it was wonderful to be with them.

When your parents met, was your mother working?

No. She was twenty-one, and David was nineteen. She went to visit her brother, a sculptor named Gordon Newell, who was rooming with David in San Francisco. They fell head over heels in love and got married in June 1930. We were born soon afterwards, Nat

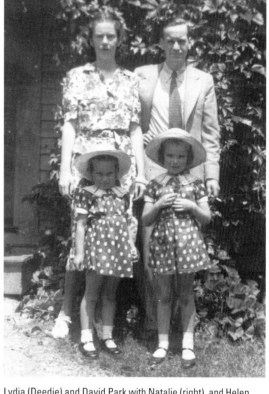

Lydia (Deedie) and David Park with Natalie (right), and Helen, California, c. 1936. Courtesy Natalie Park Schutz.

in 1931, and I in 1933. Deedie didn't work until 1941. The war had started, and she got a job at the University of California Press while David was with the General Cable Company. Later, she moved to the interlibrary loan department at the University of California Library and worked there. She always started in a clerical-secretarial position and worked her way up to positions of responsibility. She was probably an absolutely wonderful employee—responsible, capable, and bright. She liked being in touch with libraries all over the world, but she did not like giving up her life to a job. She never complained. I just somehow knew she didn't like it.

Children, of course, are usually completely self-absorbed, but did David try to involve you in his activities in the studio?

We never bothered him when he was working. But he would ask us what we thought of paintings as if he really wanted to know. It was probably a very good way for him to get these self-absorbed kids to look at a painting! It was always a difficult challenge. We both have memories of not knowing what to say and feeling very self-conscious. We wanted to be profound, and we couldn't.

You said that, by the time your mother died, there was actually very little left in the estate. Did your mother not want the responsibility to go down a generation?

No, no, no. I don't think she had thought about the responsibility in that way. She was tremendously proud that David's work was gaining attention, and she was staggered by the money that people were paying for his paintings* because she had been there when, once in a while, something sold for two hundred dollars. I don't think it ever dawned on her that Nat and I would end up having strangers call us to ask for provenance or copyright clarification. There were no goals, no intent, nothing. Everything that happened just sort of happened.

Will the paintings that you and Natalie own go down to your children?

They will. But we and other members of the family still have them on our walls. Most of us have early paintings and a very few of the later works. Some estates have hundreds of paintings to deal with. We don't have that, although I wish we did.

When your mother died, did Roy continue to look after your father's estate?

Yes. He had emphysema. It was a last-ditch effort to be in control of the world. It made me angry, but at the same time I felt for him. He was dying, and he was very alone. He was in California, and his heart was in England.

You mentioned earlier that their wills stipulated that all work that they owned would be divided between the Oakland and Santa Barbara museums.

We had always known that was the initial intent, but then Roy told us after Deedie died that he had rewritten the will so that everything was left to us except for two oils that went to his two sons in England. This seemed wonderful to us. They loved my mother and were devoted to these paintings. But he got confused and never had changed his will. So they went to the two museums. My mother's strong feeling all the way through was that this was the best place for them. I ended up feeling that this was the natural order of things.

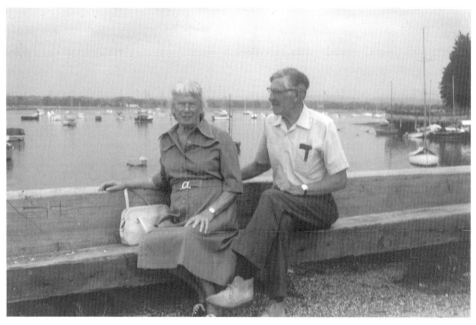

Lydia (Deedie) and Roy Moore, Bonham, Sussex,
England, 1977. Courtesy Natalie Park Schutz.

Had Roy or your mother talked to both museums?

Not at all. The executrix of the estate was a woman at Wells Fargo, and she managed everything very nicely. The museums got together and kind of drew straws and divvied up the works.

Have they exhibited the paintings and lent them to shows elsewhere?

Some have come up from storage and been shown, but a lot of them are down there. That's what happens. The museums can't show their entire collections all the time. They only have so much wall space, just as in our living rooms we can't put everything up.

Do you think it was a sensible idea to divide the paintings?

I feel fine about it, even though neither museum is in a major city. It fell out the way it did, and now the San Francisco Museum has acquired some wonderful paintings by my father. I'd probably leave mine to it, but I'm not going to because I want my children to live with their grandfather's paintings.

Would you have liked to receive some big sales now?

You mean, would it be fun to have a nice big fat amount of money in my bank account? I don't know. I love some of that work so much. There's a huge 1959 painting called *Daphne*—of all David's work, it's probably my favorite, except for a couple of the big row boat or canoe paintings that are just fantastic. If I were to be in the unbelievable position of owning such a painting, would I be able to sell it? I can't imagine it! When I hear stories about a David Park painting selling for a lot of money, I think, God, what would

David *think*? It always tickles me to think of that.* My greed knows no bounds. It's not greed for money: it's a greed for those paintings!

There aren't projects that you would have done if some of the sales were going directly to you?

Oh, yes. I'd have conservation work done on a lot of things. We have a lot of cracked paint, which, bit by bit, my sister and I are dealing with. It's very costly, but the people at the San Francisco Museum of Modern Art do absolutely beautiful work—in particular Jim Bernstein, who is just brilliant at it. So, yes, if I had a lot of money from the sale of an oil, I'd put it back into the others.

What about publications?

Yes, I have a dream publication in my mind. The last works of David, done after he was told that he had between three and six months to live, were gouaches. He sent us out for paper and materials, and he painted every day that he could, maybe a couple of hours a day. He was in terrible pain from bone cancer. I don't know how many he painted, but it might be a hundred or a hundred and twenty. They are *marvelous*, and a book of his gouaches would be a gorgeous thing, and it would be a *privilege* to be able to give money to a project like that. I've had that idea for some ten or fifteen years, but have I done anything about it? No. So, I'm not a very good businesswoman. Also, if there were anybody who wanted to do a catalogue raisonné, I would certainly support that.

Other than copyright questions, what have you and your sister had to deal with since your stepfather's death on January 1, 1992?

Not much. Provenance questions from time to time. Sometimes that's painful because a photograph of a painting will be sent to us that we both instantly know is not by David, and we have no alternative but to say so and carefully explain why, dashing somebody's hopes.

Do you have anyone whom you can go to for advice?

Not really. From time to time, we ask within our networks for the names of lawyers who know something about artists' copyrights but haven't ever ended up with any good referrals. Usually the question goes away before we get the answer. I feel rather irresponsible not knowing about these matters. Natalie feels the same way. We've always worked closely together.

Who holds all the records, and your father's papers?

There are no papers. My mother and father threw everything away, ongoingly. The most interesting and constructive thing being done is that Nancy Boas in San Francisco is writing David's biography, *David Park: A Painter's Life*. She is a marvelous researcher and a diligent worker, and has gathered together everything that does exist. Nat and I have boxes and boxes of stuff, including personal letters that Deedie and David wrote to friends who were letter keepers and who returned them to us many decades later. We keep everything that comes our way and, at some point, we will decide whether to give all that to the Archives of American Art or to our children. What Nancy is eventually going to do with

her body of paperwork, I don't know. My sister and I laugh about the fact that Nancy Boas is the source of information on my father now. She knows more about him than we do.

I believe that Nancy has been working on your father's biography for some ten years. How much time have you spent with her?

In the early years, much more. We were on the phone a lot, and she also talked to everybody else in the family, friends, and a lot of other people.

Phyllis Diebenkorn told me it took about three years to help John Elderfield and his staff get the 1997 Whitney Museum of American Art retrospective together.

Yes. We spent a lot of time with Richard Armstrong, the curator of David's Whitney show in 1988. Whenever there's a show, it's extremely time-consuming! Now, for Phyllis [Diebenkorn], take anything I've said and multiply it by thousands. Dick left an *enormous* body of work, lived many years longer than David, and is infinitely better known. Phyllis and her daughter and son have a huge task.

Have you had to rearrange your life in order to deal with these requests from curators or from writers?

No, I just weave it in. My husband, Ed Bigelow, is a professional photographer, and we have done our best to catalogue in film and in photographs as much of David's work as we possibly can. That's an ongoing, big project. And now, of course, we have to digitalize all of it, but that is quite up Ed's alley. We spent a lot of time in the Salander-O'Reilly Galleries photographing during those three shows of David's work in the eighties. We have a great collection of slides now, and people contact us about that sometimes, again bringing up those copyright issues.

Could you talk about your own interests?

I made pots for a living—for just under twenty years. That was my first artistic passion. I made a very modest living. I was a single mother then, with three children, but we survived. Also, ever since I was a young teenager, I've been involved with writing. I have a novel that's being looked at by publishers now, and I've written a lot of articles and essays. Now I am writing a book, *David Park, The Man Behind the Paintbrush*. It's a big project, and it's just beginning. I have other books in my mind as well.

What about Natalie?

My sister has four children. She was a gifted and generous teacher with a passion for education, becoming fluent in Spanish so that she could communicate better with the parents of so many of the kids in her classes. She's now retired and doing genealogical research on the Park family. She will self-publish that book, and it will go to the historical societies that have helped her, and to family and friends.

Is she as fascinated by your father's work as you are?

Absolutely. We both adored him. He was a very exciting human being and great fun to be with. We both feel a tremendous connection with him and with his work. It's colored and informed our whole lives.

Do you talk to other daughters or widows about what they are doing?

Much less than I would like to. I wish that I could manage my life better and see Adelie Bischoff and Phyllis Diebenkorn. I love both those women. I'd like to get to know Gretchen Diebenkorn, Phyllis's daughter, a little bit. We only see each other every ten or fifteen years, yet I've always had such a warm feeling about her. No, I've not been a consistent gallery- or opening-goer, and I'm not a part of the art scene at all. I could have been, but I've been filled up with my own life, family, and friends.

The main reason for not being more in touch with art galleries is that there isn't a body of work for sale anywhere. Salander-O'Reilly Galleries don't have holdings now. No gallery has any Park works to speak of, although some may have a very few things that they bought on the secondary market. There was never a large body of work. David scraped canvases and reused them. He threw away all the nonobjective work from between 1946 and 1949 that he didn't like.

I get phone calls from people asking if I know anybody who has a painting for sale. Unfortunately, the answer is always no. In fact, I remember when Richard Armstrong was putting together the 1989 Whitney show, he said that he had not ever encountered family members and friends of a painter who were so loath to part with any work.

When there are new exhibitions of David Park's work, do you make a point of going to the openings? Do you see yourself as your father's representative?

I don't go for public reasons. But I have to confess that one of the wonderful things about growing up being David Park's daughter was standing in the glow that was around him. There *was* a glow around him. And I get a little bit of that when there's an opening. It's a connection that is very important to me. At openings I'll also run into people whom I haven't seen for a long time, and who cared about him. And, of course, as you know, to walk into a room where this person's work takes over the entire gallery is an overwhelming experience. It's a multidimensional, many-layered moment. It takes your breath away.

February 2000

UPDATE

The Hackett-Freedman Gallery in San Francisco has become the main representative of the work of David Park.

FOR FURTHER INFORMATION

Armstrong, Richard. *David Park.* New York: Whitney Museum of Art, 1989.

Di Piero, W. S., and Helen Park Bigelow. *David Park: A Singular Humanity.* Essays. Hackett-Freedman Gallery catalogue, 2003.

Jones, Caroline A. *Bay Area Figurative Art: 1950–1965.* Berkeley: University of California Press, 1989.

PEGGY GILLESPIE, WIDOW OF GREGORY GILLESPIE

A constant back and forth, give and take. I want to control and limit my reality so that it does not overwhelm. I want guaranteed hours of solitude where I can feel free to create. There is a lot of instability in the world and so I seek to make an art that is disturbing, self-challenging, and self-questioning. It is important to me that I use this anxiety for a worthy purpose.

—GREGORY GILLESPIE*

Gregory Gillespie, born on November 29, 1936, was brought up in a Catholic family in Roselle Park, New Jersey. His mother was committed to a state mental hospital when he was five years old. He studied at Cooper Union in New York City (1954–1960) and at the San Francisco Art Institute (1960–1962). Awarded a grant, he left for Italy in 1962 with his wife, Frances Cohen (married 1959), and their son, Vincent (born 1961), to study the Italian Primitives, Masaccio, and Lorenzo Lotto. Their daughter, Lydia, was born in 1963 in Florence, and they moved to Rome the following year. The Gillespie family returned to the United States in 1970, and they settled in Massachusetts. In 1978, Greg separated from his wife and began a relationship with Peggy Roggenbuck. Their daughter, Julianna (Jay), was born in 1987. Gillespie's portraits, landscapes, and strange, self-confessional private narratives reflect the imagery, symbolism, and eroticism of Italian and Indian painting. The paint can be applied quite broadly or in a tight, hyper-realistic, super-detailed way. The Forum Gallery in New York gave him his first one-person show in 1966, paying him a monthly stipend and representing him until his death on April 26, 2000, when he hanged himself in his studio.

Peggy Gillespie was born in New York on March 24, 1948, the only child of lawyer Murray Elman and his artist-wife, Naomi (née Geist). She grew up in New Jersey and Manhattan. A theater major, she graduated with a B.A. from Smith College, receiving an M.A. in 1970. After a brief marriage to Paul Roggenbuck (1970–1973), during which they lived in Oklahoma City and Crested Butte, Colorado, she began a master's degree program at the University of Oklahoma (1978), which she finished in 1984 while living in Massachusetts. Her friendship with Gregory Gillespie, whom she met in 1970, developed into a close relationship. After some seven years of being together, they married in 1985.

Along with Dr. Jon Kabat-Zinn, Peggy co-founded the University of Massachusetts Medical Center's Stress Reduction Program in circa 1979, and she became its assistant director, as well as a counselor in the palliative care unit. In 1996, Peggy co-founded the nonprofit organization Family Diversity Projects in Amherst, Massachusetts. She has also written major feature articles for the *Boston Globe Sunday Magazine*, *Redbook*, *Yoga Journal*, and *New Woman*. She is the interviewer-editor of three books, and curator of four traveling photo-text exhibits created under the auspices of Family Diversity Projects. In addition, she is the coauthor of *Less Stress: An Integrated Program for Relaxation* (Signet, 1988) and *Last Night on Earth* (Pantheon, 1997), the autobiography of the dancer Bill T. Jones.

Peggy Gillespie telephoned me in September 2002 when she was researching galleries for the work of her late husband, Gregory Gillespie. Jeffrey Bergen, the director of the ACA Galleries in New York, was expressing a great deal of interest. She quizzed me extensively about how well the ACA was managing Jon Schueler's paintings: its record of selling his work to museums; general sales; whether I was paid in a timely manner and given the names and addresses of new owners without a hassle; and its ability to attract reviews and publicity. We met a few weeks later in New York at the book signing of *Nothing to Hide: Mental Illness in the Family*, and then talked several times on the phone.

·　　·　　·

Can you discuss the search for a new gallery in New York after you left the Forum Gallery?

It took about a year. We started out by getting recommendations from artists, collectors, and gallery owners. We sent out material on Greg and talked on the phone. Then three or four galleries came up here, to Belchertown [Massachusetts], to visit. Some people never call you back; others seem to be really interested, but then say they are too busy to even talk. We also asked for a lot of references for each gallery. That's when I called you. We were close to going with Jeff Bergen of ACA Galleries in New York, as he has an excellent reputation and seemed to have a lot of museum contacts, which was one of my main concerns. I really appreciated his energy, his belief in Greg, and his understanding of the art, but our estate lawyer felt strongly that we should choose from a larger pool, as Jeff was among the first people we had seen. I agreed that it would be worthwhile to explore more possibilities.

Knoedler, another excellent gallery in New York City with a worldwide reputation, had expressed some interest, and I was following up with that. We discussed representation with the Michael Rosenfeld Gallery, but he ultimately felt that, as much as he loved Greg's work, he didn't have the time to do it justice. Some other excellent galleries were interested but decided they didn't have the ability to take on another artist, especially in these lean economic times. Then a curator at the Museum of Fine Arts in Boston who is doing a show of Greg's at the Fogg in Boston,* said, "Oh, you should go to Salander-O'Reilly Galleries. Larry's a good friend of mine." I called, and immediately Steven Har-

vey, the gallery's director of contemporary exhibitions, told me he wanted to come up to the studio. He arrived with Leigh Morse, the director of the gallery, and they were both extraordinarily interested and knowledgeable about the work. Leigh had seen Greg's 1977 retrospective at the Hirshhorn Museum, and had never forgotten the power of his work.

Soon afterwards, Robin Freedenfeld and I went to their gallery. I was immediately impressed by the beautiful space and their huge and friendly staff. We handed over ten paintings, all wrapped by me in Bubble Wrap and masking tape and, by the time we got upstairs to meet with Larry Salander, Leigh, and Steven, the staff had whisked the works away and had them beautifully displayed in an exquisite room. I remembered once going to a show at Salander-O'Reilly years before with Greg, when he wished his work could be seen in such a space and felt jealous of his friend who was showing there. Ultimately, it was a tough decision because I really liked Jeff Bergen, but we decided to go with Salander-O'Reilly. I think it is the right choice, but who knows? Our advisors felt that its prestige would immediately boost Greg's reputation.

I remember you saying that a contract would be very important to you.

They suggested basing our relationship on a verbal agreement, but I said that, as much as we trusted that, we needed to have a contract for the estate. They were amenable, and we negotiated. They ended up being very flexible and generous. The contract is for three years, with a commitment to two shows, one in March [2003] of smaller work, and a bigger one in a year and a half or two.

You mentioned Robin Freedenfeld was with you at Salander-O'Reilly?

I have a co-trustee, Robin Freedenfeld, a wonderful artist and one of Greg's close friends. She is very organized and efficient and has helped tremendously. Legally, because the paintings didn't go into the Gregory Gillespie Revocable Trust until December 31, 2002, I could have made the decision myself (as executrix of Greg's estate), but Robin and I have worked together right from the start.

Had Greg thought about his estate before he died?

Greg and I wrote our wills with a lawyer who specialized in estates and trusts, and it was very well planned from a tax standpoint. Our daughter, Julianna (Jay), and I are the beneficiaries of the trust. There were paintings and sculptures that already belonged to me, and some that were Jay's—given on birthdays, Christmas, Valentine's Day, and as sweet gifts from Greg to us over the years. The rest of the works—other than his bequest of five paintings to each of his older children—about four hundred paintings, and lots of drawings, lithographs, and etchings, went into the trust. If Jay and I both die and she has no heirs, the trust would go to certain charities Greg named, like Amnesty International.

Is it difficult for you to remain in the house where there are so many memories?

After Greg died, when I was probably still in shock, it was hard for me to imagine staying so close to such a painful experience. Wisely, I didn't make any decision that first year. Three years later, I'm glad I stayed. Moving Jay from a secure place she loved would have been terrible, too. The land is exquisitely beautiful—with the mountains in the distance,

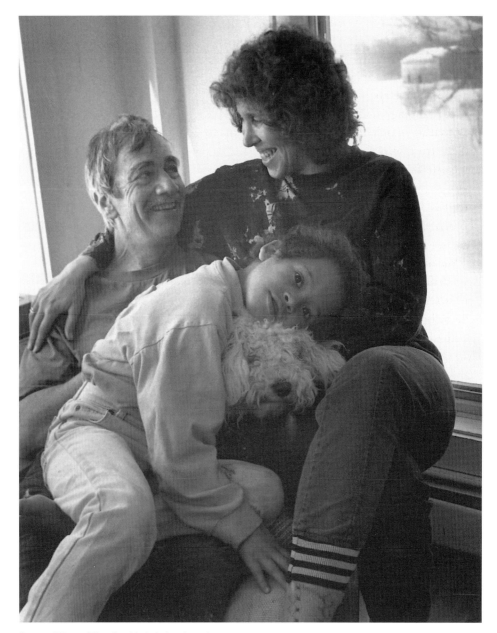

Greg and Peggy Gillespie with their daughter, Jay,
c.1994. © Gigi Kaeser. Courtesy Gigi Kaeser.

not a house in sight, and the constantly changing wide-open sky. Maybe when Jay goes off
to college in two years, I'll reconsider.

I don't want to push away the memories of Greg. The house is still filled with photos
of him and some of the artwork he gave us. Right now I'm in the kitchen, and I'm look-

ing at a photograph of one of the paintings, a sculpture that he made for me for my birthday, a little painting he gave me for Christmas, and a pumpkin that he painted on the wall. The first painting he gave me is behind my shoulder.

What about the studio?

The studio is about a hundred yards behind the house. But it made me too nervous to have the paintings there, and I moved them to the storage vault of a gallery in Northampton about seven miles away. I heard in December that the Judith Rothschild Foundation gave the trust thirty thousand dollars to catalogue, preserve, and document Greg's work. Some paintings need conservation. We'll be hiring people for the photography, and perhaps a graduate student intern for some of the jobs. We are also hoping to digitize transparencies, and we need to find out where all the other paintings are, to make sure we have photographic records of them. There are probably at least three to four hundred works out there that have been sold over the years.

You mentioned previously an upcoming book on Greg?

I definitely want that. I had initiated the project before I went looking for galleries. For *Nothing to Hide*, I interviewed the former CEO of Abrams books, Paul Gottlieb. Sadly, right before the book was published, he died suddenly of a heart attack. He was helping me look for another dealer and told me to submit a book proposal for a monograph on Greg. So, I was all excited about that. Abrams did say that if we got a museum show or a really big gallery show in New York, they would be interested. So I'm still hoping.

You also said that you have a job elsewhere?

Yes. I work full time for the nonprofit organization Family Diversity Projects, which I and the photographer Gigi Kaeser founded. Since 1993, we've created four exhibits, each accompanied by a book. *Nothing to Hide: Mental Illness in the Family* is the most recent. We've just won a big book award from the National Alliance of the Mentally Ill–NYC Metro branch. Our three earlier projects were: *Of Many Colors: Portraits of Multiracial Families*; *Love Makes a Family: Portraits of Lesbian, Gay, Bisexual, and Transgender Parents and Their Families*, which actually has been our most popular and controversial exhibit; and *In Our Family: Portraits of All Kinds of Families*. We're in a very big transition right now, without a managing director and exhibits manager. Gigi and I are suddenly being asked by the board to take on all the responsibilities. We have funds through July, the end of the fiscal year, so my job is in jeopardy unless we are successful in fund-raising quickly.

Is there any income?

The traveling exhibits, which go to schools, museums, colleges, libraries, and corporations, brought in about $100,000 a year. In order to continue to do that, they have to be marketed. We have many other ideas—books and exhibits on women activists, learning disabilities, body images in women, and men overcoming violence—but we need funding to hire people. Unless Greg's artwork starts to sell, it's hard for me to do something for free now.

In the best of all worlds, how would you divide your time?

In my ideal world, I would be able to work on my own projects most of the time and hire professionals for many of the other jobs. I'd still be an advocate for Greg's work as much as I could, but individuals can't approach museums—certainly not widows. That is why I'm really grateful that we have such wonderful, committed dealers now. I did a lot of work to get that. It didn't just happen. Just supervising this grant will be time-consuming. I'm interested in the results, but going over slides and making lists of paintings to be insured—then revising those lists—figuring out the best digital photographers and counting up transparencies are not my favorite ways of spending my time. However, I would truly love to be involved in editing Greg's journals.

Tell me about the journals. How far back do they go?

Way back. He didn't date a lot of them, but he certainly began during his first marriage, probably thirty years ago. They're handwritten in spiral notebooks.

They wouldn't be too intimate for publication?

Parts would not be relevant, but there's a lot about his personal struggles with paintings, issues with the art world, and money that would be fascinating. He wrote well, too. I helped him edit sections for his catalogues and for Provincetown Arts, which published a little excerpt in the summer of 1999. One of our difficulties was that he always wanted me to help edit his journals for a book, but I was so busy that I would say, "I just really can't focus on it." This was partly because I felt publishers were not going to bring out the book of an artist who was only moderately well known. So he would get frustrated with me because I wasn't willing to give up my work to do that.

Often, I did feel his work was more important than mine, in part because he was bringing in a larger percentage of the income for many years. It wasn't that he was at all sexist. He was a feminist, if anything, and tried to work at being an equal partner, but he was a genius. He was doing masterpieces that would go down in the history of art. Although he and I both valued my work as contributing to social change and helping to reduce prejudice in the world, it still sometimes seemed less significant to me than his. At other times, I would feel the opposite way. Art is so often only accessible to the middle-class and the wealthy, and what I was doing was trying to help marginalized people become more visible and powerful.

But Greg never stopped wishing that I would take the time to focus on him, his writings, and his art. He often wanted critiques in the studio. If I'd say, "I'm busy working," or if I didn't like one of his works, he would get hurt. I'd say, "But I can't lie to you. This one is a masterpiece, this one is fabulous. But this is ugly to me." Mostly, I loved what he did, but there were certain grotesque pieces that I didn't like.

Perhaps you needed to maintain a certain distance?

I think it was healthier to have my own work. At the same time, I was incredibly involved day to day with what he was going through. Often he would smoke marijuana when he was working, almost every day for years at a time. Sometimes it would be a little hard. He'd be in a completely different space from me, using his magnifying glass to

paint all those little details. But, while I worked at home, I was often down at the studio, every day or every few days. I suggested a lot of things that he changed. We especially had fun moving objects around to see if they would work in different paintings, taking photographs, playing. So I shared his life in the studio, but I do wish I had put more emphasis on the journals.

Do you feel that the paintings were a form of personal communication with you, too?

Some of them, definitely. He just really didn't have the kind of normal boundaries that most people have about their intimate lives. The paintings were often symbolic versions of some of his personal struggles. It was his way of dealing with his demons, his past, his childhood, our life together, and his issues with his older children.

Did you mind having your private life made public?

I'd gotten used to it. He was the least private person on this planet, and he had a lot of friends. Sometimes it would get kind of annoy-

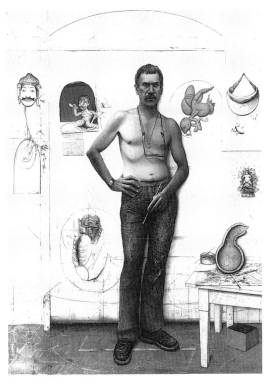

Gregory Gillespie, *Self-Portrait with Squash,* 1986, mixed media on wood, 96" x 69". Private collection. © Gregory Gillespie Revocable Trust.

ing because he would tell people whom we weren't even close to intimate things about our lives. It wasn't as hard as having to deal with a huge portrait of yourself naked! But I got used to that, too—being at a show and standing around with all these paintings he did of me naked, and talking to people who were looking at them. He would also paint Jay naked when she was little. As she got older, she hated it and didn't want them shown. Finally, he decided to put them in safekeeping for her. But there are others. A few weeks ago, when we were at Greg's first show at Salander-O'Reilly, she was looking at the gorgeously detailed painting *Julianna in the Forest* of 1991, and she said, "That's really a cool painting. I don't want you to sell that."

Did you pose for Greg?

Yes, for a great number of his paintings. When we first began living together, I worked part time at the University of Massachusetts Medical Center in the palliative care unit, and later as the assistant director of the stress reduction program, but I only worked three long days each week. We were madly in love, in what Greg and I called "stage-one" bliss, so posing was really fun for both of us, and it gave us time to talk and be playful. Later on, my work became a fifty-hour-a-week job, so I had to stop posing. If he were doing a portrait

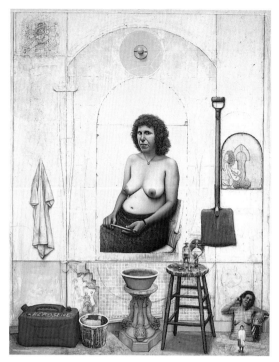

Gregory Gillespie, *Fertility Shrine,* 1991, mixed media, 110" x 84".
© Gregory Gillespie Revocable Trust.

of me, he'd take photos and then I'd go down periodically if he wanted to work on a specific area of my body or face.

How involved were you before in organizing things like the inventory and photography?

Not at all. But neither was he. He was very disorganized, and the studio was a chaotic mess; he liked it that way. His dealer kept all the records. Greg didn't have a clue where his works went until he finally insisted that the gallery give him that information. It was like pulling teeth, actually. He had these little file cards with paintings the gallery had on consignment—nothing too organized. He hired students and young artists to help with things like his slides.

For his catalogues, he would often ask for help with writing statements or editing interviews he'd given to other people. And he would ask me to interview him about his life and art with the idea that, someday, we would get a book published of his journals and these interviews. We certainly talked over everything about his relationship with dealers, plans for museum shows, and his fantasies and hopes for the future. Generally, though, I didn't get into the details of the work as I have to now.

Was he available much to his family?

He was a fabulous father to Jay. He adored her and always shared the responsibilities. He also always tried to help his daughter from his first marriage, Lydia, a lovely girl, who had severe psychiatric problems. He was concerned about his son a lot as well, and always offered support and friendship to him. But he was always an obsessive artist. For example, we would alternate who would put Jay to bed but, as soon as he finished, he'd head down to the studio and paint for several hours. It was hard to get him to go on vacation. He especially liked to go to Provincetown [Massachusetts], where he would teach at the Fine Arts Work Center for a week every summer and have the studio for several more weeks. He could spend half the day on the beach with us and then go to the studio. Or, he'd wake up at 6:00 A.M., get his French Roast coffee, bike to his studio, work for hours, and then bring back muffins for Jay, who would just be waking up.

At home or on vacation, we would do some negotiating about his not painting every single day. I remember one Thanksgiving, when everybody was relaxing and talking in the

kitchen after the big meal, and suddenly Greg said, "Well, folks, I'm going down to the studio." All of our friends thought he was joking, but he wasn't.

Could we go back to the beginning of your relationship with Greg?

I met Greg in 1970, just after he and his wife and two young children came back from Italy and moved to the farmhouse next to where I lived with my soon-to-be husband. I remember inviting them to our wedding, which we had in the field. I would go to the studio, and I thought I'd never seen greater art in my life. He told me that he loved the way I looked at his work. We were just friends, and I liked his kids. Then I moved away. When I returned in 1978 to join the staff at the Insight Meditation Center, which is about forty-five minutes from here, I asked him if he would take care of my dog while I was working. To thank him, I invited him to a Bob Dylan concert. His wife, Fran (also an artist) was away at the MacDowell Colony—they were still married but having big problems. Greg told me that she was very volatile and angry a lot of the time and had been treated periodically for psychological problems. Later, he told me that Fran had been diagnosed at some point with bipolar disorder, which was striking to him since his mother was similarly diagnosed when he was a little boy.

That night at the concert, we saw each other in a new way. I was thirty, and Greg was forty-two. His personality was so open, honest, and engaging, playful, full of fantasy. We wound up having a relationship for a few months, but I never thought he would leave Fran, nor did I encourage him to. But, when she returned, the marriage broke up. It was very painful for her, and I still wish we could have avoided that.

When was Jay born?

Greg and I were together about seven years before we got married, and Jay came along two years later. It was thrilling. Greg fell wildly in love with her from day one. The birth announcement that he wrote says, "We are head-over-heels, bonkers about Miss Julianna May Gillespie." Jay is a fantastic child. He taught her to use power tools, and they made amazing art projects together. She loved going to the studio with him and making art. He would work on projects for school with her, and she adored him.

When you were with Greg, was he manic-depressive, or were there times of illness?

As far as I know, Greg never was diagnosed with clinical depression or any kind of mental illness, certainly not in the course of our twenty-two years together. There were times when Greg himself wondered if he had a mild form of bipolar disorder, but his only manic activity was to paint thirty paintings at once. Some people with bipolar disorder whom I interviewed for *Nothing to Hide* talked about starting many projects but never being able to finish one. That certainly wasn't Greg's problem.

Greg himself called his focus on painting an obsession. After a show, if he didn't get the reviews or sales he wanted, he would be down. But, within a week, he'd be painting wildly again. However, he would see people, including me, either as a saint or someone really bad and rejecting. Apparently, he was very close to his mother when he was little, and suddenly she would turn on him, angrily cursing. He'd be totally trusting one week,

and the next he'd feel I didn't really love him and I wasn't close enough to him. He called himself the "yo-yo." But the art is what probably helped him function so well after such a dysfunctional start in life. It gave him a focus and a way to express his demons.

What led to his death, do you think? Was his work not going well?

Not that at all. He had just had a very successful retrospective that traveled around the country*—although he would have liked it to have gone to the Whitney or the Met. It got great reviews everywhere, and there was a big article written about him on the front page of the Sunday Arts and Leisure section in the *New York Times*—a very positive piece with pictures [October 31, 1999]. But he was always chronically dissatisfied. If there was anything that depressed him, it was that he didn't get to be super-famous. At the same time, he would say, "I don't want that because then it could destroy my work." He was very ambivalent. We would often joke about it, and I'd call him, saying "Hello, this is so-and-so from the Met. We're going to do your retrospective." He really yearned for the approval. He probably would have been happy if he had been on the cover of the *New York Times Magazine*. I told him, "You've been on the cover twice of the Arts and Leisure section. That's fantastic." Although he had Buddhist views about nonattachment, he was very, very ambitious. He wanted his work to be recognized and celebrated. But he certainly didn't feel any different about the art toward the end of his life. In fact, things were going very well in the studio and, after some very hard years, we were very close.

What I and many of his friends and art colleagues think happened is that Greg reacted to taking medication. He was worrying about a lot of family difficulties at this time. Since, previously, medication had made him less of a yo-yo and much calmer, we talked about whether it might be helpful again. His psychiatrist prescribed some and immediately, within a week, Greg had a dramatic personality change. He became extremely depressed and anxious. For the first time, he couldn't sleep. Literally, he was up all night. He was in misery, and he would say, "C'mon, drug, start working." He couldn't figure out what was wrong.

I had never seen him like that. As he got worse, he would talk about being homeless if his paintings wouldn't sell (he was in a lot of debt to his dealer because of the advances and relatively few sales), and all kinds of crazy stuff. He looked exhausted. He would get up in the morning and say his thoughts were just racing. For the first time ever, he couldn't paint and thought he was never going to be able to. I remember telling him that he needed to get sleeping medication right away, as the medication was clearly not helping him. Although I was worried about him, I never for a moment imagined he would take his own life.

He was never, I'm sure, plotting suicide because he desperately wanted to get better. He had just ordered two thousand dollars' worth of paints. He had just about finished having the barn next to the studio rebuilt as a summer sculpture studio. He was all excited about some big sculptural pieces he had done in the past year, and thrilled that he would have the space to expand on this kind of work. He had an appointment with Robin, who

was to photograph him for a new self-portrait. He had made a videotape the week before he started taking medication with a local filmmaker. He talked about how happy he was with our relationship now, and that he wouldn't ever want to leave the family. Three weeks later, he killed himself.

The week after he died, there was a front-page article in the *Boston Sunday Globe* on Prozac and the suicide link [May 7, 2000]. Then a book came out from a Harvard professor detailing endless stories exactly like Greg's, the lawsuits, the lies of Eli Lilly, and the fact that, in Germany, Prozac comes with a warning about suicide risk.* There was an ABC News 20/20 program [June 21, 2000] in which several people described how they had become psychotically suicidal on the drug, even though they had no desire to kill themselves. If somebody knew enough to take them off the drug, immediately their suicidal thoughts disappeared. If only this information had come out a week earlier, I believe we could have saved Greg's life.

Were you and Jay out at the time?

Yes, I was out for the day. One of the last things I said to him that morning was, "Here's the name of a good sleeping pill my friend gave me, so please call your doctor right away." I picked Jay up from school, and we brought Chinese food home. But he didn't show up for dinner. The studio was dark, and I didn't see the car, so I just assumed he was out. By about ten o'clock, I started to get very worried, thinking he might have been in an accident because, if he were going out, he would always leave a note or call me. At around eleven, I called a friend, who said to me, "Why don't you check the studio?" I said, "No, he's not there. If he was, he would have called me." But I went to check and, when I saw his car, I thought, "Oh, he got the sleeping pills, and I bet he went to sleep." I was so relieved. Then I walked in, and he was dead. I was in shock. I was in agony. This was the last thing on earth I ever thought Greg would do.

How did you manage?

Having a child, you have to recover fairly quickly and deal with your life, get your child back to school, cook meals, take care of the house, et cetera. For a few weeks, I don't think I could even drive, so people took me places. I had wonderful friends who helped me enormously. It's hard to imagine recovering without their love and support. I went to a very powerful grief workshop at Kripalu Yoga Center in Lenox, Massachusetts, a few months after Greg's death. I also had, and still have, my spiritual practice of mindfulness meditation and Buddhist-based understanding of the inherent impermanence of all of life's experiences. I had experienced death many times, though never a death by suicide, but I do believe strongly that all of our experiences are potentially ways to grow more compassionate, and kinder and more aware. So, with the support of my spiritual friends, I've always understood that Greg's death could also be a way for my dharma practice to grow deeper. Some of my friends are Tibetan Buddhist practitioners, and we also did some Tibetan practices to help Greg's soul-spirit-essence move on toward his own freedom and peace, and that was healing to me as well.

Do you think that Jay sees herself as part of the continuation of her father's legacy?

Jay is definitely appreciative of his art and, even as a teenager, has spoken of her desire to help with her dad's artistic legacy when she grows up. She is very interested in meeting the art gallery folks and especially likes Leigh Morse, the head of Salander-O'Reilly, and Nina Nielsen, the owner of Nielsen Gallery in Boston. She jokes around with them and seems to understand the importance of developing a good relationship with them. I think she will be a wonderful representative for her father someday.

Talking about the galleries, what did go wrong with the Forum Gallery?

I think I will just say this: Greg had a wonderful relationship with Bella Fishko, who ran the Forum Gallery for many years. She thought he was a genius and really championed him, and did very well in terms of sales and shows. When her son took over, sales went way down, and Greg considered leaving Forum. But he had been on a stipend for years;* when there were only two or three sales a year, he got more and more in debt to the gallery. He didn't know for sure if he would find another gallery in New York, and he worried about supporting himself and the family. Despite his reputation, he felt really insecure. And you can't really investigate other galleries very much if you're still with a gallery. He also felt loyal because of Bella, but there were further difficulties: the Nielsen Gallery decided not to represent Greg's work for several years because the people there had a conflict with the Forum Gallery. A year after Greg died, the estate wound up having a big struggle with Forum about how the debt was to be paid. We were negotiating when the Forum Gallery served the estate with a lawsuit. It was truly a shock to me because we were trying to figure out how much cash and how many paintings to give them. Anyhow, it was a complex case, and we settled with them.

Did you return to Nielsen Gallery in Boston?

Yes, I love them. They are really great people, and they sell Greg's work to terrific collectors.

What was Greg's relationship with the art world in New York?

He stayed away. He wanted to be in the museums, but he didn't play the game. He liked living up here and being totally focused on his art, not trying to be part of a scene or trying to curry favor from critics. He was asked to do a cover of President Carter for *Newsweek* or *Time*, but wouldn't "sell out," as he put it, or do what other artists would do to get ahead.

Now that Greg is not here, would you like to create a context in a horizontal way with other artists whose work might fit loosely into the same category of surreal or paranormal realism?

He wasn't part of a group or a movement. I always thought it was an incredible strength that, unlike some artists' work that gets so repetitive, Greg's was always evolving, always changing. There were elements of Bosch and Breughel, of Bellini and other artists he loved in Italy, and of Indian and Asian art, but it was still, as everybody always said, uniquely him.

Do you dread being asked to explain some of the allusions or to interpret his private world?

Oh, no, I love it. Greg would give these great talks. I certainly heard them a million times, and I would never be bored going to them. He was hilarious and engaging and warm. People would ask him, "What does this mean?" and he would simply say, "I don't really know, but here's this painting of me when I was getting my confirmation. This is my mother—I often use women turned away like that, and it seems probably. . . . I don't know, but I'd guess it's my mother because she was insane and left me when I was five." And he would go into trying to figure out the paintings, like an interpreter of dreams. So I will always be open to talking about them to the best of my ability. I would be happy to do that.

Did he discuss the mutilations and eroticism in his painting?

Yes. A lot of that stuff came from his rebellion against Catholicism and being brought up to think sex was bad. He would talk about a time when he was little and built a woman out of blocks and put breasts on her. He got punished. Something that looks grotesque in his work isn't necessarily reflecting *his* violence toward sex or women at all. It was more the way the world treated women, or the way sex is seen from Catholic teaching—your hands are going to be cut off if you masturbate. He said he never thought of the erotic ones as pornographic: he just saw them as fertility shrines, showing the incredible, miraculous nature of conception. It wasn't that he was trying to be sexual as much as showing life—pain and death and impermanence, but also celebration. That's why I think his work is so universal and affects people, if they are open to his appreciation of the mystery. That's how he would have put it, I think.

February and March 2003

For Further Information

Carr, Rani M.; Donald D. Keyes; and Carl Belz. *A Unique American Vision: Gregory Gillespie*. Essays. Georgia Museum of Art, University of Georgia, 1999.

EIGHT

A CERTAIN DISTANCE

It is difficult to know whether personality, circumstances, or the contours of the heir-artist relationship itself most influences the emotional stance of those who assume responsibility for the estate. In time, one might expect that a certain calm would replace the initial fervor and tension. We have also seen, however, that the more intimate and long-lasting the relationship, the more intense the identification, and the greater the attachment to the art that remains. Drawing the line between one's own life and the dead artist's legacy is a delicate and precarious balancing act. Sometimes we find that the strongest relationships create a sense of self-worth and confidence on the part of the heirs that fosters independence and a resistance to becoming thoroughly absorbed in the legacy. Heirs are thus spared guilt and self-recrimination, as well as the nagging question, "Would the artist be pleased with what I have done?"

The composure that underlies Rae Ferren's words reflects both the many years that separate her from her husband's death and her firm sense of her own desires and priorities. Confident of her own identity—as mother, contributor to her husband's legacy, and artist—she has purposely avoided an obsessive concern with John Ferren's work after his death. The choices she has made reinforce our sense of her commitment to the ways she could best serve her husband's work—performing, for example, the surface cleaning of the paintings that her skills as an artist allow, and establishing a trusting and enduring relationship with one gallery. She is neither distressed by factors she cannot control, such as paintings undersold on the secondary market, nor haunted by projects she feels unable to take on, like editing a collection of his lectures and other writings. While her attitude, and the advice she gives to other heirs, is defined by a matter-of-fact realism, one feels that her perspective is most informed by "the philosophy of life and the spirit" that she shared with her husband.

The same lack of urgency characterizes John Crawford's approach to his father's legacy, although he, too, feels an intense devotion to the man and his values. A sculptor himself, he has had to choose between completely dedicating himself to "endless projects" that would promote Ralston Crawford's work and developing his own interests. Thus, after the intense effort of organizing his father's art after his death in 1978, which culminated in the Whitney retrospective of 1984, John and his two brothers—feeling that their "main filial responsibilities" had been fulfilled—returned to concentrating on their

own careers. Pursued by dealers during the first few years, they have now settled into an exclusive relationship with one New York gallery. They are comfortable with the knowledge that it can oversee the operation, although acknowledging that dealers will not always have the same kind of commitment that the family might have. Most apparent is his confidence that things will work out in the long term, and that his father's work will find its way into public collections.

The companion of Leon Polk Smith for over forty years, Bob Jamieson conveys a similar ease with his current position as executor of the artist's foundation. Their very close working and living relationship; their shared passion for music, reading, and gardening; and their instinctive understanding of each other seem to have left Jamieson confident in his new role, despite recognizing that he will never be as articulate as his friend. Without any family to interfere or any desire to have others help him with his tasks, and with the loyal support of two galleries, he feels he has successfully kept the work on display and is sustained by the artist's perpetual presence in his life: "Leon's not going to go away, ever."

Neither a longtime companion nor a family member, Joan Marter, executor of the Dorothy Dehner Foundation, is unique among this group in that she is an art historian who has written extensively about the sculptor's work. Although a close friend of the artist for eighteen years, her relation to the legacy is primarily defined by her professional status. Because she is a full-time faculty member, the energy that she can devote to the foundation is severely limited.

Marter emphasizes that her position allows her to keep a certain distance from the work because she can view it more objectively than family members can, who might be guided by either strong emotional attachment or economic interest. Knowing that the main responsibility to the estate is hers, she performs the essential tasks without sacrificing her professional or family life. With a clear sense of purpose and confidence, she focuses on her own values and goals: getting the most representative work displayed in collections, facilitating exhibitions and sales, and continuing her own research on the artist.

D.C.

RAE FERREN,
WIDOW OF
JOHN FERREN

I have always been involved with color. On the other hand the abstract expressionist experience did permit me to use color in a freer way than I might have otherwise. I mean harmonies and dissonances, dissonances and harmonies, colors that ordinarily do not function together.

—John Ferren*

John Ferren, the son of Verna Zay (née Westfall) and James William Ferren, was born on a Blackfoot Indian Reservation in Pendleton, Oregon, on October 17, 1905. Because his father was an Army officer with the Indian Service until circa 1911, the family moved continually. They then lived in San Francisco, where John's brother Roy was born and, afterwards, Los Angeles. In 1923, upon completion of high school, Ferren returned to San Francisco, where he apprenticed himself to an Italian stonecutter and worked on his own sculpture independently. He turned to painting following an extensive trip to Europe in 1929. In 1931, he was back in Paris, where he met Mondrian, Miró, Arp, and Giacometti, and participated in gallery exhibitions, receiving acclaim for his nonobjective paintings. He was married to Laure Ortiz de Zarate from 1932 to 1937. A one-person show at the Pierre Matisse Gallery brought him to New York in 1938, and the outbreak of war prevented him from returning to Paris.

Ferren began painting figuratively and from nature—drawing on imagery of the American Western desert. He married Inez Chatfield in 1941. Then, joining the war effort, he became a civilian employee with the Office of War Information, working in Algiers, Italy, London, and France. In 1946, he moved into a loft at 52 East 9th Street in New York. Conrad Marca-Relli was in the studio below, Franz Kline above, and Hans Hofmann across the street. Beginning in 1946, Ferren taught at the Brooklyn Museum Art School and Cooper Union and then, from 1952 to 1970, at Queens College. An eloquent speaker on modern art, Ferren lectured at other college campuses and contributed to avant-garde publications. He was divorced from his second wife in 1948, and married Rae Tonkel, an art student, in 1949. In the mid-fifties, he developed a personal form of abstract expressionism, incorporating a strong architectural substructure with a flurry of expressive, controlled brushstrokes. A year in Lebanon (1963–1964)—where, sponsored by the State

Department, Ferren served as artist in residence—stimulated his interest in Islamic art and architecture, leading him to the mandala form and a return to geometric explorations. He died on July 24, 1970.

Rae Ferren, the second child and only daughter of David Tonkel, a manufacturer, and homemaker Rebecca (née Weiss) Tonkel, was born on June 29, 1929, in Brooklyn, New York. Determined to become an artist after high school, she attended the Brooklyn Museum Art School from 1947 to 1949, where she studied with John Ferren, marrying him in 1949 when she was twenty and he forty-four. Their son, Bran, was born in 1953. Between 1950 and 1956, the Ferrens spent summers in their house in Los Angeles. They sold it in 1957 and bought one in East Hampton, New York, which, from 1967 on, they used year-round. In 1972, after her husband's death, Rae began working at Guild Hall, East Hampton, becoming associate curator and registrar. In 1987, she left to work full time as a painter. She has regularly shown her landscapes and still-lifes—inspired by the impressionists and Bonnard—in exhibitions since the mid-seventies.

After Jon Schueler died in 1992, like other heirs of artists' estates, I had to spend a good deal of time looking not forward, but backward. When the listing and photography were finally completed, I needed to have the whole estate appraised for tax purposes. Not having any experience in such matters, I phoned Rae Ferren, whom I had met occasionally at the Katharina Rich Perlow Gallery in New York (where both our husbands exhibited). She had the reputation of being direct and levelheaded, and was indeed helpful. Ten years later, I contacted her again.

. . . .

I was keen to talk to you, Rae, because you have been dealing with the John Ferren estate for thirty-two years. Have the responsibilities changed?

I never made it a full-time job. I myself was an artist and, shortly after John died in 1970, I had the opportunity to work at the Guild Hall Museum in East Hampton. I really didn't want to continually dwell upon a man I loved who was now dead. I have seen widows who were so obsessed with the lives of their husbands that, in the end, it was very harmful to them emotionally.

What I'm concentrating on now comes from the fact that I am an artist and understand the nature of oil painting. I'm well prepared, after some trial and error, to safely clean the dust and fingerprints off the surface of the Ferren paintings. But I'm only a cosmetician, so I call in a conservator for works that need restoration. In the beginning, when I would go to shows, I would see all this grime from the New York warehouses on the paintings, so I made the decision that I would not send anything to a gallery unless I had gone over it.

As far as the choice of a gallery dealer, I could have looked around for opportunities, but I opted for exclusive representation with the Katharina Rich Perlow Gallery in New York. I got to know Katharina in the early eighties when she was the active partner in the

Rae Ferren, sketching in her garden, c. 1996.
© G. J. Mamay. Courtesy Rae Ferren.

A.M. Sachs gallery. It satisfied me greatly to be able to put my trust in her and not have to wonder about what to do with the paintings. I think it's worked out well for both of us.

Did your husband share the same sense of loyalty to one gallery?

I'm not sure about that. In a way, but John had been through quite a few galleries.* He was, I think, a pretty reasonable person when it came to business relationships, but a living artist might have reasons to change a gallery that don't apply to an estate.

What kind of agreement did you work out with Katharina?

Originally, I stated my expectations in a written contract concerning commissions, the number of one-person shows I wished to have, what I would be supplying in the way of John's work, and shared expenses. The terms of our agreement are in accord with what most professional galleries have at the present time. I think putting this all down in writing avoided misunderstandings. I certainly learned that it's useless to make unrealistic demands of a gallery in terms of publicity. These expenses have to be shared, or else gallery dealers would soon be out of business.

What kind of advice would you give to people who had newly taken on artists' estates?

Well, it doesn't hurt to do a little reading without getting into deep books on law. After John died—even that long ago—I was able to find information on contracts, and I followed the advice. A good contemporary source is a small guide on artists' estates and the law published not long ago by the Marie Walsh Sharpe Foundation [*A Visual Artist's Guide*

to Estate Planning]. I recently went through it for information on a tax matter because accountants I had questioned didn't have the answer.

My problem was that in the fifties, unlike now, there were no blanket exemptions on the inheritance tax for spouses. Therefore, an artist was advised to give as many works as possible to his survivor before his death. However, any gift from that time is now worth very little as a deduction if donated to a museum. How in the minds of the IRS an object that has incredible value if sold through a gallery suddenly has no value in terms of tax deductions, I can't comprehend, but that is the law.

Are you thinking of setting up a trust or a foundation to deal with future tax problems?
Not at the present time.

How large was the estate?
I can't go into it numerically, but it was a good size. I had a lot of material to work with, let's put it that way.

Is it a problem that John's work is associated with a diversity of approaches rather than a signature style?
I work with what I have. I can't call it an advantage or a disadvantage. It's not like you have a choice in the matter. Every artist leaves a body of work that is not all of one piece.

Did you talk over what might happen to the work with John?
Not at all. I don't think he ever thought he was going to die. But he got prostate cancer. The best thing that happened to me was poor Bernard Reis, who ended up so badly with the Rothko estate. But, to me and to the other artists I knew, he was a very worthwhile person because he freely gave advice. He and his wife were lovely people, and they had artist parties, wonderful artist parties. John had written a will by hand and signed it, but that wouldn't have been legal. At a party, Bernie asked John if he had a will and then offered to write one up for him. He never asked to be paid. He probably did that with other people, too; he knew that artists didn't have that on their minds. Anyway, I would not have had a legal will without Bernard. It was completely uncomplicated. John just left everything to me. Bernie also provided me with advice after John died and gave me the name of a very fine accountant. Settling the will took plenty of time, and then it was contested by the IRS. But the accountant prepared me for that. He said whenever there is a large list of works of art, you can be sure that it's going to be contested.

Do you think it's really true that a lot of artists don't plan for the future?
Certainly with the artists of the fifties, there was very little thought about the future—aside from knowing to give works to your wife and writing on the back of them, "This is a gift to my wife." Now the whole picture has changed. I think ninety percent of successful younger artists have gone through the university system and have learned whatever they know—from making the art to showing it—while they're in school. So, who knows how they feel about the work and leaving it?

Are you in favor of estates donating works to museums?

Unless an artist is very well known, it's hard to give a work to a major museum, and small ones often specialize in works by artists of the region. You also have to be careful because the museum can specify in writing that it will accept work on an unrestricted basis, which means that it can be deaccessioned—in fact, it doesn't even have to be accessioned to begin with—and can be sold by the museum at auction at any time. So, if unknowledgeable people give a large group of works to a museum, things can go very wrong, and the work might be completely devalued. There are not only auction houses like Sotheby's and Christie's, but all kinds of little ones and eBay. They'll sell work for anything, just to get it off their hands.

Do you feel almost a personal humiliation when a work of John's goes for a song on one of these occasions?

You can't help it—it's happening all over, particularly with the Internet now.

Sometimes artists have a geographical connection with certain areas. Have you been able to develop special relationships with California, New York, or Paris?

I haven't. I have given works of John's to museums, but usually only when I've received a tax credit. That rules out giving paintings that John gifted to me. I have also opted for museums that have shown an interest in his work, like the Whitney. Two years ago, we showed a selection of works on paper from the thirties there, and I knew that the curator of prints and drawings, David Kiehl, wanted one for the museum. So, at the close of the show, I didn't feel that he needed to wait for the museum trustees to decide on a purchase. I simply made a gift of a particular work that he liked.

Actually, I was very interested to see that there were quite a few beautiful images of your husband's work on the webpage of Gary Snyder Fine Art. Are you dealing through him as well?

No, not at all. I only work through the Katharina Rich Perlow Gallery.

How does he get the work?

These are works from Paris in the thirties, which were sold to collectors before I even met John.

And how does he own so many?

Ask him. That's privileged information, you know. There are two possibilities: either he has purchased them, or they are on long-term consignment by owners. But they don't have anything to do with me or the Perlow Gallery.

In your experience, what kinds of approaches have proved detrimental to the reputation of the artist?

When I worked at Guild Hall, I saw several instances where families made mistakes. Without understanding the work, secondary relatives sometimes have a fantasy about making a lot of money. When that doesn't happen, the relatives end up squabbling among themselves, and the artist gets forgotten. So I would say—if one had the choice—an artist should have a healthy, younger spouse who can take care of the work! The worst-case scenario, however, is leaving works without any responsible person. Who knows the num-

ber of paintings that have gone into damp basements or storage? At least an attic is dry and less likely to be subject to destructive mildew.

Are there projects that you haven't tackled yet?

I haven't set up personal archives of John's writing and letters. Soon after he died, the Archives of American Art asked me if they could microfilm the material. The director advised me that I should not give them any material that I might want to get published later. Although I could put a restriction on it so that scholars would have to get my permission to use it, how do you know how responsible a particular writer is going to be? John lectured a lot on art at colleges and universities, as well as to art groups, particularly in the days when no one knew what abstract art was. So there's original material there, and it really is up to me to protect that. At this point in time, I have not given them the actual letters and correspondence. I like keeping that for myself.

What did you decide to give to the Archives of American Art?

I let them microfilm anything that I had, except for personal material—you know, he had two wives before me—which I will keep for posterity. I had a lot of letters to Ferren from the thirties, forties, and fifties, and I let them copy school and military records and all the correspondence between him and other artists.

Do you plan to publish the lectures and talks?

No, I really don't—unless an interesting opportunity comes along. I did gather together copies of certain speeches that had already appeared and gave them to the Pollock-Krasner House; the director was happy to have them. My son will inherit all of that, and he can figure it out.

If there were to be a biographical study planned, would you cooperate or think the project intrusive?

I don't hesitate to speak to art historians. If the right person came along—like in a marriage—I would be interested and would cooperate. But it's not something that I would go out and look for.

Do you feel a responsibility to keep everything for a future biography? Would you hold back or even throw some material away?

There always is that kind of censorship from a spouse who inherits. People can be hurt, and who needs that? It's bad enough that you have certain art writers who re-create artists' lives. I'll never forget when Lee Hall wrote that quite slanted and embarrassing book *Elaine and Bill: Portrait of a Marriage: The Lives of Willem and Elaine de Kooning*,* and anyone who knew Elaine at all was very offended by it. You can't stop people from writing what they want, really, but why give them ammunition?

Have you felt that looking after the estate has eaten into the time that you would have liked for you own work?

It's a heavy responsibility. We're talking about works that are often six feet in height and almost that in width or larger. The only way that I can prepare them and have them photographed is to move them to my own studio, so it definitely cuts into my own

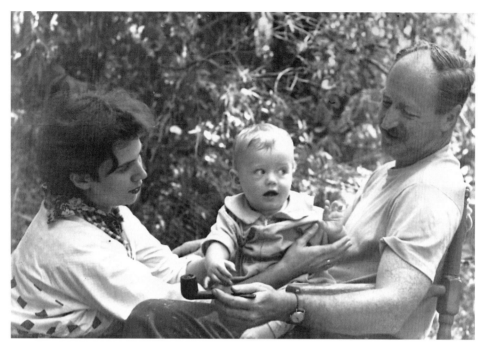

Rae and John Ferren with their son, Bran, Los Angeles, 1953. Courtesy Rae Ferren.

space—not large—and time. But I have to do it. That's as much as I will do. That's why I can't even think about other areas, like biographies. Yet, John had a whole earlier life in Paris, a very interesting life.

Do you ever feel that your own position as an artist is taken less seriously because you're thought of as the widow of John Ferren?

Once I met John, I thought making a career of art was appalling. I was horrified at what the real world was like and what an artist went through. I was all of eighteen, filled with idealism from high school, and then I discovered that the wonderful world of art wasn't wonderful at all. I wouldn't have had a child if a career was on my mind because being a mother certainly became the major thing in my life—that and helping John do his work. I always painted on vacation, though. And now I'm not after a New York gallery. I just want to be able to work.

In what ways were you able to help John with his career?

I helped him, not so much with business—though, if he had a problem with a gallery, he talked to me about it. He would also go over talks and lectures with me to see if there were rough spots, and I felt free to make suggestions. I did learn how to type, which certainly didn't interest me in art school, nor at any other time—but I could see it would be very useful. I went to school and, in a few months, learned touch-typing. Believe me, it wasn't too difficult to switch over to a computer much later.

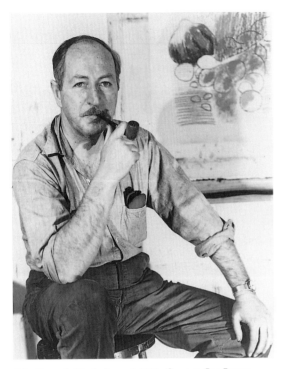

John Ferren in his studio, early 1950s. Courtesy Rae Ferren.

Where did you and John live when you met right after the war?

We lived in New York, but the most exciting thing in the world was going to California for the summers. He had already had his house completed after framing it himself. John's main painting time back then was there. College professors stop work in mid-May, so we had until Labor Day. That's what teaching, I'm afraid, meant—that he didn't have the time he wanted throughout the rest of the year. Then, when our son started high school, we moved to East Hampton. [Wilfred] Zogbaum had sold off two and a half acres to us around the same year he sold de Kooning his property. Artists who had bought land in the Springs in the forties paid nothing because no one wanted it.

Did John build another house and studio there?

There was a small house with a studio in it that Zogbaum had been renting to an artist for the summer. Therefore, we just had to add on a living room and put in a furnace. Some years later, John built a separate studio.

And that's been your base ever since?

More or less. We had, of course, to give up our living place in New York in 1967. But John was teaching, and he maintained a studio on Spring Street. We could use it to sleep over when I would go in. But I had a child at school, so I gave up the city at that point. That was very difficult. Yes, I really missed life in New York. It's a three-hour commute. At first, I would take courses at the New School. After John died, I went in to help my aged parents while holding down the Guild Hall position. But that didn't leave time to do anything else. Now, I really just go in when we have a show of John's or some special thing comes up.

As time went by, did you begin to use John's studio on the property as your studio?

No. The funny thing is that my son, Bran, asked to use it when he went into business by himself, and now I'm on an adjoining property that he purchased so we could have a little more space. He was an electronics wizard from the time he was a little boy. Now he's in California—he's founder, cochairman, and chief creative officer at Applied Minds, Inc.

Do you think Bran will be able to do what you've done?

Well, he is a businessperson, a designer, and a scientist. So he has a very worldly background and knows very fine professionals if it comes to legal or estate matters. There won't be a problem on that score.

Are you concerned about what will happen to your own work?

You know, quite honestly, Magda, I don't paint for posterity. I just want to be as good an artist as possible and turn out work that, to me, speaks well of me.

But John definitely wanted a national reputation?

I'm absolutely convinced of that. He may not have been a good businessperson, but he wanted to be a profound artist, and he wanted his work to have meaning in the large sense of the word.

Looking back over the thirty-two years, what are some of the things that you've done that have pleased you most?

It's pretty straightforward. Number one, I'm a caretaker—that's the meaning of the word "curator"—and I've preserved the work to the best of my ability. I'm also very happy when it is placed in either a good private collection or public collection.

So there are definitely moments of joy and satisfaction?

Yes, and they have nothing to do with making as much money as possible. This quest for achieving wealth—I guess it escapes me. I would certainly always like to have enough so that I'm not going to be in the poorhouse, but I don't need a lot more than that to be doing what I want to do. I'm not a person who has a stock-trader mentality, and my husband was even less of a businessperson. I think our present materialistic outlook on life eliminates the spiritual element, and we have to come to terms with this problem. The philosophy of life and the spirit—that was a very big thing when I met John—in our own lives and in those of our fellow artists, those who are now called the New York School.

June 2002

FOR FURTHER INFORMATION

Herskovic, Marika, ed. *New York School Abstract Expressionists: Artists Choice by Artists*. Franklin Lakes, N.J.: New York School Press, 2000.

Lévy, Sophie, ed. *A Transatlantic Avant-Garde: American Artists in Paris, 1918–1939*. Berkeley: University of California Press, 2004.

Sandler, Irving. *A Sweeper-up after Artists: A Memoir*. New York: Thames and Hudson, 2003.

JOHN CRAWFORD,
SON OF
RALSTON CRAWFORD

I look to the left and to the right, ahead and behind. Then I paint from memory and from the thoughts about the things I have remembered.

—RALSTON CRAWFORD*

Ralston Crawford, born on September 5, 1906, near Niagara Falls in Canada, moved with his parents, George Burson and Lucy (née Colvin) Crawford, and two older sisters to Buffalo, New York, in 1910. His father was a Great Lakes shipping captain until the war, when he turned to insurance and real estate. After high school, Ralston Crawford worked for six months on tramp steamers in the Caribbean and Central America. He then studied at the Otis Art Institute in Los Angeles (1927); the Pennsylvania Academy of Fine Arts, Philadelphia; and the nearby Barnes Foundation (1927–1930), where he was introduced to the work of Cézanne and Juan Gris. In 1930, New York became his base, although he traveled frequently, both abroad and within the United States. From 1932–1939, he was married to Margaret Stone from Wilmington, Delaware (1912 –1993), by whom he had two sons (James and Robert, born in 1934 and 1936). His paintings of coal and grain elevators, bridges, ships, water tanks, and Pennsylvania barns, with their clear silhouettes and flattened color forms, associated him with the precisionists.

While teaching at the Cincinnati Art Academy (1940–1941), the first of many teaching stints, he met Peggy Frank (born 1917). They married in 1942, and Neelon and John were born in 1947 and 1953. Enlisting in the Air Force (1942–1945), he became chief of the visual presentation unit of the weather division. His experience with portraying movement while there, coupled with his witnessing the atomic bomb test at Bikini Atoll in 1946 and the devastation of Dresden in 1950, introduced images of fragmentation in his increasingly geometric, abstract work. This multifaceted vocabulary alternated with a starker handling of earlier themes that anticipated his hard-edged paintings of the sixties. His extensive work with photography after 1938 dealt both with abstracted architectural images and his longtime interest in New Orleans jazz musicians. In 1970, he and Peggy separated, and he was diagnosed with cancer that year. Forceful new shapes entered his late paintings—stemming from the conical hoods and waving banners of penitents in Seville during Holy Week. He died on April 27, 1978, and by request received a traditional jazz funeral in New Orleans.

John Crawford, born on June 26, 1953, the youngest son of Ralston and his second wife Peggy Crawford, was brought up in New York City and educated at Friends Seminary and Saint George's School, Providence, Rhode Island. He often joined his father, during school vacations, at his various teaching jobs or on his travels. He gained a B.F.A. in sculpture from the Rhode Island School of Design in 1975, and then worked on fishing boats, oil rigs, and passenger boats for six months. He lived in Tuscany (1976–1986), where he was apprenticed to blacksmiths, learning how to make farm tools and working on his own sculpture. In 1987, he converted seven thousand square feet of a former gelatin factory in Brooklyn into a studio. Since 1998, his interest in the ironwork of West African cultures has informed his work.

After meeting John Crawford at an art opening in New York, I went to Brooklyn to see his African "currency"—spare, clean-lined, forged metal abstractions. I also admired the rich array of African fabrics that he had imported. Downstairs, I visited his vast studio, with its heavy machinery for both making and moving his sculpture. We made plans to talk about his father's work.

John Crawford with *Torn Signs* by Ralston Crawford, 1974, oil on canvas, 54" x 72", Salander-O'Reilly Gallery, April 2004. Photo: Nick Knezevich. Courtesy Magda Salvesen.

You mentioned you no longer had to be very involved with your father's estate, that a good dealer freed you to get on with your own work?

It's a matter of choice. The estate doesn't take care of itself, but I think that I and my brothers have fulfilled our main filial responsibilities. Endless projects could be taken on that would help memorialize my father's contribution, but we all chose to spend time on our own lives. So we more or less leave the responsibility with the dealer. Actually, I'm interested in proposing a book similar to the one you put together of your husband's writings. I have all my father's papers. But we're fairly passive with regard to projects that require a family member to take them on.

I consider our father's work as underdeveloped in terms of his place in the pantheon. If I see a moment or a potential situation, I try to explore it. For example, when somebody did a little film about me for Italian television, I brought up my father's films as a possible project. I'm not going to produce a film myself. Anyway, that is Neelon's area; he has already made a great film about our father that could serve as a basis for a larger project.

Your father's estate is quite unusual in that there are no women involved. Can you tell me a little about your mother and the role she played before she and your father separated in the early seventies?

She came from Cincinnati and was the first director of the Modern Art Society, now the Contemporary Art Center, which she and some friends started in 1939. My father was invited to teach at the Cincinnati Art Academy, and that's how they met. She married a Christian, an artist, and a divorced man eleven years her senior who was not from Cincinnati!

Besides bringing up two children, how involved was she with your father's work?

Very involved and supportive. For the next twenty-eight years, she played a key role in his career, helping organize exhibitions, keeping records of sales—doing all that secretarial and curatorial sort of work. She was also my father's primary correspondent and receiver of extremely important and intimate letters from him on many subjects. After his death, she wasn't involved in looking after his estate, but she's continued to be available as a resource, giving interviews and so forth.

Without the responsibility of the work, did her life take off in a different direction?

Yes, I would say so. She had always taken photographs—my father taught her—but she had her first professional exhibition after he died, and has had many since then. She's traveled a lot, moved to Paris in 1994, furthered her Zen practice, and any number of things. She's working on a book on the Yemen at the moment—her own photographs and text.

What arrangements did your father make for the estate?

It was left to three of his sons. There was an intense period of work and effort at the beginning, culminating in the Whitney retrospective in 1984. Between 1980 and 1984, we cleared the studio and organized the work. We had to figure out what we wanted to do. The Whitney also did further sorting, so the work was eventually fairly well inventoried.

Did you do most of the work because you were in New York?

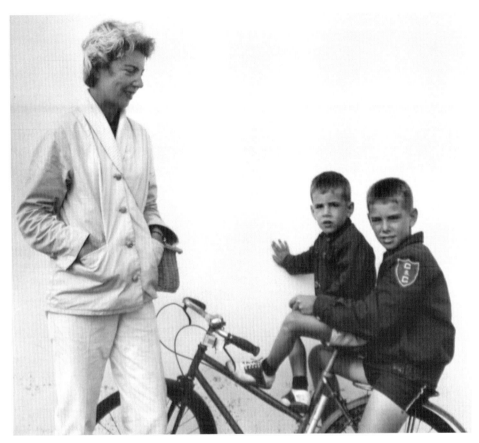

Peggy Crawford with John (left), and Neelon, 1957.
Courtesy John Crawford.

Actually, at that time Neelon was living in New York, too. He gravitated toward more of the business end, dealing with the galleries. Bobby, who wasn't around, took on the financial part. He kept the books. There are benefits to having three people and three different points of view, but there were also differences that we had to work out along the way. I handled the work itself and was in charge of most of the organizational stuff, which was very time-consuming.

Was there much work left for you to deal with?

Yes, a good body of work. Of course, there's less of the earlier work because it had the most time to sell.

Did your father talk to you about what he hoped you would do with his work?

Not much. He had cancer, which was in remission, so there was some time to talk, but we didn't really discuss the estate. We talked more about personal family matters. I went home, he came to Italy, we wrote a little, talked on the phone. But, for the last two years of his life, I had limited contact with him because I lived in Italy.

Did the Whitney retrospective make it easier to find a gallery for your father's work in New York? I believe he had left Zabriskie Gallery in 1975 to sell work directly from his studio?

Actually, there was a lot of interest at the time of his death. We got taken to lunch a bunch. We finally decided to work with the Robert Miller Gallery. At that time, it made a lot of sense, as he was very involved with American modernism. Then he took on more European and contemporary work, so we moved to Hirschl & Adler and, recently, to Salander-O'Reilly Galleries.

Did you divide the work up into three, rather than keeping it as one body?

We did.

How did you divide it up?

Oh, we tried different things, then eventually something worked. I really don't know. We ended up with three groups, which each brother was content with. It was fine.

Have your brothers in Michigan and Wyoming formed connections with galleries in their states?

Not so much. Salander-O'Reilly has an exclusive. It's in everybody's interest to do that. Who owns what makes no difference as to what's shown.

And, when something is sold, the proceeds go to the person who had owned that piece?

Pretty much, yes. So it's very simple.

I know there's lots of time, but will your individual thirds go down the line?

None of us have children. I hadn't really thought about it. Both my brothers are married and, if they should die before their wives, then I imagine we'll continue working together.

Have you three chosen paintings that you keep back?

There are some personal favorites, but most of the work that's in the estate is available. I have a few small ones that, for sentimental reasons, I plan to hold on to. Then I have a few photos and works on paper that are incredibly, shall we say, "liquid"—highly sought-after works that I'll keep almost like an insurance policy. If I break a leg, I can take care of it.

Your father's work is usually shown or written about in conjunction with the precisionists.

That's a little frustrating since it is a relatively brief part of his work. One painting, *Overseas Highway* (1939)—a great painting—became an icon of the time when it was published in *Life* magazine in February 1939. It captured the moment and became such a calling card that this earlier precisionist work is much better known and couples him with Charles Sheeler, Stuart Davis, and Niles Spencer, et cetera. *Overseas Highway* was my father's contribution to a prewar mentality—a totally positive view of industrialization. But he was in the war and, in 1946, was the only artist at the atomic bomb tests on Bikini. That experience fundamentally changed his work. He continued to make paintings that had a

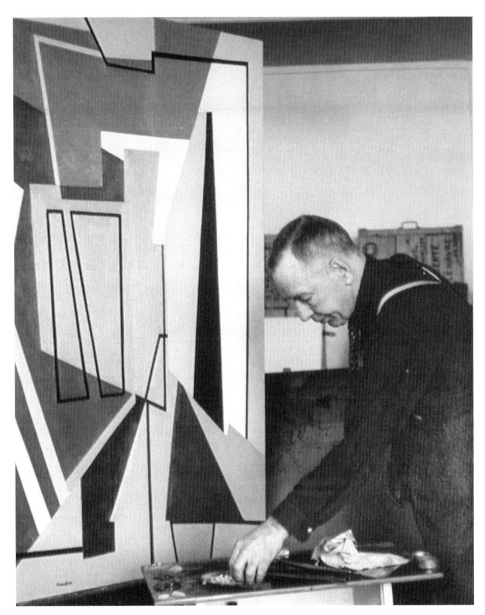

Ralston Crawford in his studio, c.1960. Photo: Peggy
Crawford. Courtesy Peggy Crawford.

kind of serenity to them, but others reflect his experience with the bomb. Industrial and
scientific advances could no longer be considered as our salvation. I honestly think that
my father was an artist who continued to grow throughout his career, and his real contri-
bution occurred later.

Have you any ideas of how you can change the prevailing views?

You can attempt to change the consensus by relentlessly putting forth the information. It's very time-consuming. Earl Davis has the opposite problem with his father. The work that is considered "Stuart Davis" is the late work, and the whole forty-year chunk before that is less known.

Do you think that Salander-O'Reilly Galleries will be able to find strong writers and put on thematic or period shows?

Yes. Larry Salander is incredible. But I think the gallery and the inheritors of an estate have different points of view. There's always a certain amount of work that is taken on by families. You can't expect a gallery to do the kinds of things that you, Magda, are doing for your husband's work. Galleries do some things, and they don't do others.

Do dealers tend to categorize your father's prints and photographs somewhat differently?

There is a tremendous connection between all the media he worked with, and this is generally recognized. Besides the quality of the work itself, I think the most important contribution he made is to have left such a clear path via his photography of how American modernist painting is made.

As a son, do you naturally identify with your father's work?

I do. I would say he's not my only influence, but he's probably my biggest since he had a father's influence on me as well. I grew up around him and had an intensive exposure to his work. I suppose that doesn't always happen. I guess Kiki Smith, Tony Smith's daughter, is a different example. She really went her own way.

However, you're a sculptor rather than a painter. Was that to find a different space for yourself within the art world?

Maybe, partially. But what's similar is the general tenor of my values. I believe in looking at things and in drawing. I believe in making things. They don't even teach that kind of visual language in school anymore.

Are your brothers in a similar position?

I think so. They're both photographers. Actually, they were filmmakers at first. But that was prior to video, and I think just the logistics of producing and showing art films was so incredibly difficult that they both moved into photography.

Have you given any of the paperwork, the records, to the Archives of American Art, or to the Getty Museum? Or, have you kept all of it?

Basically, I've kept them because I want to go through them again. Right now, anyone who wanted to write on my father would have exclusive access to the papers. As I said, a very nice little book of his writing could be done, but I may or may not take on the editing.

Would the material for the book come from journal entries and letters?

A bit of everything—letters, speeches, artist statements, some limited journal-type stuff. He was a good writer.

Are you good at keeping records of your own work because of having to deal with your father's?

John Crawford in his studio, April 2004.
Courtesy John Crawford.

I think there could be no word to describe me other than pathetic in the paperwork department! I would like to hire somebody to do it.

As a child, were you in his studio a great deal?

Not a great deal. His studio on East 23rd Street was around the corner from where we lived [on Gramercy Park]. I guess I was in there once a week or three times a month, something like that. We took a lot of wonderful trips together. He traveled at least twice a year to Europe and to New Orleans, a very important place for him. My brothers were older, in college, away, so they took fewer trips with him. But they were involved with some projects, particularly revolving around his filmmaking.

Did he usually have a studio assistant?

He had a darkroom and, almost my whole life, he had a printer, a very good photographer named Fred Price. My father would be painting in the front, and Fred would come out and show him a print, and he would say, do it this way, do it that way. That's how most of the photographs were made—in his studio, under his direct supervision. And Fred would also, if needed, stretch canvases, and all that.

Where did he do his lithography?

In Paris almost entirely. There are a couple of prints made elsewhere, but he worked

mostly with Desjobert and Mourlot Frères in the early and middle fifties. We lived in France for a year a couple of times.

You mentioned that you'd inherited your father's values, but do you also feel that you inherited his lifestyle?

I have. I love to travel. I lived in Italy for about ten years—maybe seven out of ten years, as I came back and forth. And I'm anxious to do something similar again. My life as a sculptor is much more sedentary than I would like. I have a great place [on Bergen Street], but I tend to get a little cloistered here. I'm interested in living in other cultures. If I can work things out, I will probably go back and forth to Africa—maybe set up a studio and stay there part of the year, as I did in Italy.

Has being the son of a well-known American artist opened any doors for your sculpture?

No, not in terms of a commercial gallery or shows. I try to keep things separate. Occasionally, my work, the African iron objects, and my father's work overlap. I've had people visit for one and leave with the other, or visit because of all three put together.

Do you have a lot of requests for reproductions of your father's work?

Yes, from museums. It's always fine.

You don't worry about the quality of the book or the quality of the reproduction?

No.

Do you do the digital photography yourself?

Yes. I grew up with all these photographers, so something rubbed off on me. I shoot my own work, in general. I'm reasonably proficient.

Do you sometimes donate your father's work to museums?

Sometimes we make gifts.

There are quite a lot of galleries advertising Ralston Crawfords on the Internet, so the secondary market looks as though it's quite active.

I should check that out.

Do you have any preferences as to where your father's work goes?

If a painting goes to a private collection, someday it will be sold and maybe then go to a museum. In the long run, these things take care of themselves. I do feel that it is important to keep certain photographs and paintings together, as the photography can show the anatomy of his paintings in a very thought-provoking way. I wouldn't want to see those connections lost.

Have you got an exhibition planned for your own work?

No, I don't. I will be in a group show at the National Academy of Design in May–June 2004, and I have a piece right now in a show of contemporary sculpture, curated by Frank Herreman, at the Museum for African Art, titled *Material Differences*. I'm very happy with that piece, and with the company I'm keeping. For close to four years, I've spent a lot of time learning about and collecting this African metalwork, not looking very much at contemporary work. I have a lot of directions that I'd like to explore based on this experience. The piece at the Museum for African Art, which is a kind of hybrid of John Crawford before

he studied African metalwork and John Crawford after, is one of them, so it's starting to bear fruit.

<div align="right">June 2003</div>

FOR FURTHER INFORMATION

RALSTON CRAWFORD

Agee, William. *Ralston Crawford*. Pasadena, CA: Twelve Trees Press, 1983.

Freeman, Richard B. *The Lithographs of Ralston Crawford*. Lexington: University of Kentucky Press, 1962.

Haskell, Barbara. *Ralston Crawford*. Whitney Museum of American Art, 1985.

JOHN CRAWFORD

"Making Dichotomies Work." *Sculpture* 19, no. 7 (September 2000), pp. 16–21.

ROBERT JAMIESON,
COMPANION OF
LEON POLK SMITH

I am drawing two forms with one line, and I am having to think of both sides of the line, feel both sides, know both sides. And one side is no more important to me than the other.

—LEON POLK SMITH *

Leon Polk Smith was born near Chickasa, Oklahoma, on May 20, 1906, the eighth of the nine children of William Elliott Smith and Samantha Pauline (née Smith), farmer-ranchers, descended from Cherokees. Between 1925 and 1931, Polk Smith worked as a laborer at various oil-drilling and road-building sites in the Southwest, trying to prevent his parents from losing their farm. When this was unsuccessful, he enrolled at Oklahoma State College, now East Central University, in Ada. He received a B.A. in English and a teaching certificate in 1934, taking numerous art courses in his final year. He then taught children English in Oklahoma, and began painting in his spare time. Between 1936 and 1938, he spent summers at Teachers College, Columbia University, getting an M.A. in art and educational psychology. He taught art or supervised art education in various states, including four years at Mills College of Education, New York, traveling during vacations. After 1958, he accepted temporary visiting artist jobs.

His early paintings reflect an interest in American scene painting and surrealism. In the 1940s, the work of Mondrian and other European modernists inspired his paintings; clean-edged planes of pure color were arranged around an implied grid. In 1954, drawings that he saw in a sports catalogue emphasizing the curvilinear seams of balls led him to an exciting breakthrough. It was first evident in circular-shaped paintings with a few straight or curved, bold wedges of color that seemed to expand beyond the picture plane. During the following four decades, he explored—with a clarity of color and an inventiveness of form—variations on his personal sense of geometry. He died at the age of ninety on December 4, 1996.

Robert Mead Jamieson and his twin sister, Marjorie Alice, born on an apple farm in Athens, New York, on March 9, 1926, were the last of five children born to William Harry and Marie (née Mills) Jamieson. Because of farming difficulties, the family soon moved to his grandmother's house in Patchogue, New York, where his father worked on contract-

ing jobs. In 1944, Bob enlisted in the Navy as a hospital corpsman (rising to PhM 3c, pharmacist), serving during World War II in the Pacific until the surrender of Japan in 1945. After a period at home on Long Island, he moved into New York City in 1949. He worked at the main New York Public Library and, the following year, at the Donnell Branch. In 1952, he met Leon Polk Smith and, thereafter, was his companion. On the GI Bill, Bob took night classes at the New School for Social Research, gaining a B.A. in 1960. He worked in the library of the Columbia Eye Institute from 1953 until late 1966. Bob then assisted Leon, traveling with him to exhibitions in Europe and America and, occasionally, accompanying him on teaching jobs. They bought a house in Shoreham, New York, in 1966, lived there until 1978, and then resided primarily in New York.

In the early nineties, Leon Polk Smith instructed me on the educational theories of John Dewey at a party in the loft of artist Yvonne Thomas. His companion, Bob Jamieson, with his puckish grin and innuendo-filled conversation, had a lighter touch. Several years after Leon's death, I was admiring his rigorous, hard-edged paintings hanging in a special room at the Brooklyn Museum, when I decided to ask Bob how he was managing. I visited him in his small fourteenth-floor apartment on Union Square, with its expansive New York City views.

.　　.　　.

Let's begin at the end, with Leon's will. Did he leave you the whole estate?

I was left his estate because, as he said, he was the last leaf on the tree. He had no immediate family left, and we had been together for over forty-two years. So it was sort of natural. I became an executor of the estate, and the Leon Polk Smith Foundation was established. Of course, we had to generate the finances for it, and that has come along a little bit. The gallery helps. It sells a work, and then that money goes into the foundation.

Who are the other officers?

There are five trustees: one is a lawyer, another a retired lawyer, and another, Bob Buck, was the director of the Brooklyn Museum of Art. Now he's at Marlborough.*Then there is the critic Carter Radcliff, who had known Leon's work for years. I'm the fifth, sort of a secretary. We chose together, but primarily Leon wanted a museum person and a critic, and we always had the lawyer. He is a litigating lawyer and has an interest in art; he was recommended by one of the museums.

How often do the five trustees meet?

Every three or four months. It's not always easy to get together because of their various business schedules. We meet two or three together, and then I write up the minutes and send them out, so we keep in contact.

Is distributing funds part of the mission statement?

Yes. If there are enough, they go to mature artists who work in geometric abstraction, but we haven't yet been able to do that.

What was left in the estate?

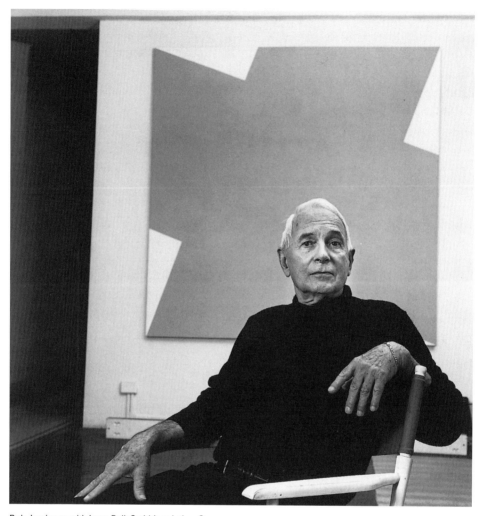

Bob Jamieson with Leon Polk Smith's painting *Cross-roads Grey,* 1978, acrylic on canvas, 82" x 82", New York, 2001. © 2004 William Rivelli.

All the paintings were left to the foundation except my own collection. I have about six or seven of Leon's works. Of course, I have a will, too; it stipulates that when I die, everything goes there as well. I have some relatives, but when Leon and I discussed the wills, we realized that my relatives were never interested in my life, and they weren't interested in Leon's life, so there was no reason to involve them. The trustees will then be in charge and work through the gallery they choose to be with. Now we are with Joan Washburn in New York. She's well known and showed Leon for a number of years, although he had other galleries, too. She has an exhibition of Leon's work maybe once a year, and I try to get another show as well.

We had one just recently in Germany, in Bonn [2001].*That was a beautiful show. It was at a new institute for discreet mathematics that has a collection of calculators from ancient times up to today, and they're all, of course, originals. Fascinating! We've had a gallery in Friedberg since 1987; Adelheid Hoffmann, who runs it, contacted the institute, and they came over here and set up the show.

Did the very beautiful catalogue of that show require a contribution from the foundation?

No, and they paid my way over to Germany, too. I couldn't have gone if they hadn't. The foundation can contribute, if necessary, to framing, photography, or other art services that an exhibition calls for.

Do you enjoy going over and representing Leon?

Oh, yes. They said, "You have to come over!" They do feel that I'm now representing him. It's a university town, and the opening was very well attended. The director gave a little lecture comparing the digital concept to geometric art, which was quite fascinating. And the institute purchased a work, also. Of course, I don't speak German, but they all speak English.

So you feel that you have a good connection in Bonn, and that things have opened up elsewhere in Germany, too?

Yes. Galerie Hoffmann has done well in other cities. In Ludwigshafen, which is south of Mannheim, there was a big retrospective at the Wilhelm Hack Museum [1989]. A beautiful, big exhibition. That was when Leon was alive. Germany has always been very open, even Berlin, as years ago the Nationalgalerie had a one-person show [1984]. So there's quite a history. Heidi Hoffmann also has connections in Switzerland.

Did you always handle all the paper work for Leon?

He, as you know, would work every day, and I would handle the mail and correspondence. It was very amusing, in a way, because I always would reread, edit everything, correct spelling. He was a very clear thinker, an excellent thinker, but he didn't dot his i's or cross his t's, so we were a nice combination!

Do you use a computer now?

Not yet, but now I've got into fax, and what a time-saver. Money too. I fax to Germany all the time, and it really is great. I'm not against computers, but I'm really not in need of one—or do you think I should?

I learned when I first edited Jon's autobiographical writings in the eighties. Now I use one all the time, but mostly as a glorified typewriter.

I see. I'd take it for that, too. I'm thinking of trying to get some material together for a book on Leon, a kind of biography-memoir. But the project is only in the baby stage. I have people in Germany who would, perhaps, help with this. There's a lot of material on the subject, interviews of Leon published in German and English, and French too, from the time of an exhibition in Grenoble. I want to keep his work and name alive. Time goes by so quickly that people are inclined to forget. So it's up to me to do that in every way I can.

Would you also draw from Leon's letters, do you think?

Well, he never wrote letters much unless it was business or to his immediate family in Oklahoma.

Have you got an archive of photographs?

Yes, but they're going more and more into the wind, gone with the wind. Every time you have an exhibition, somebody wants photographs. I'm very stingy about that now. It's terribly expensive, too. If someone asks for transparencies for a publication, I send them slides. Sometimes they come back and say they want a transparency. I send them some if I have duplicates. We don't live forever, so what are you going to do? Just have them in storage all the time?

Approximately how many paintings and works on paper were there when Leon died?

There were quite a number.

A few hundred, a thousand?

Oh, the works on paper, I would say a thousand or more. And I would say about three hundred or four hundred paintings.

Did you catalogue this work?

Yes. In the beginning, I just did that for my own purposes—and his—although he didn't care to have me catalogue anything. Maybe that was getting a little too close to his private world, and I didn't blame him. I was just doing it to help. I would draw a sketch when a painting left, and then we would know where it was. When it came back, I would make a note, too. If something sold, it was good to have the reference.

If you've been doing that from the very beginning, then you probably are up to date.

Not with the very early work, no. I began in the late fifties and, as time went on, I brought the records up to date. After a while, Leon realized that there was a value to it, and then the photos, transparencies, and slides were all done. I enjoyed this work very much. I felt good when he complimented me, saying, "Well, you drew that one pretty well." I began to get the feel of his drawings, his work. Now I can identify one if someone asks, "Is this a Leon Polk Smith?" I really have a good eye. Joan [Washburn] has called a couple of times, asking me to authenticate paintings.

Where was his studio?

Here at 31 Union Square West. We had three spaces here. This was an old bank building, and it was raw when we took it in 1978; the wind went right through the windows. We had to do everything. We're in an "L" here. You go that way, and you make a turn to get to the studio. It worked very well, just beautifully, and he did a lot of work here. After he died, I couldn't afford to keep the studio section, so a photographer in the building took it.

You didn't, like many artists, move out to the country?

Well, we did for one period. In 1966, we left the city and went out to Shoreham on Long Island, on the North Shore, a very beautiful, wooded, private village. We bought a house with two acres of garden and meadow, surrounded by trees. Leon's studio, a stucco building once used as the village firehouse, was across the court. It was a very good

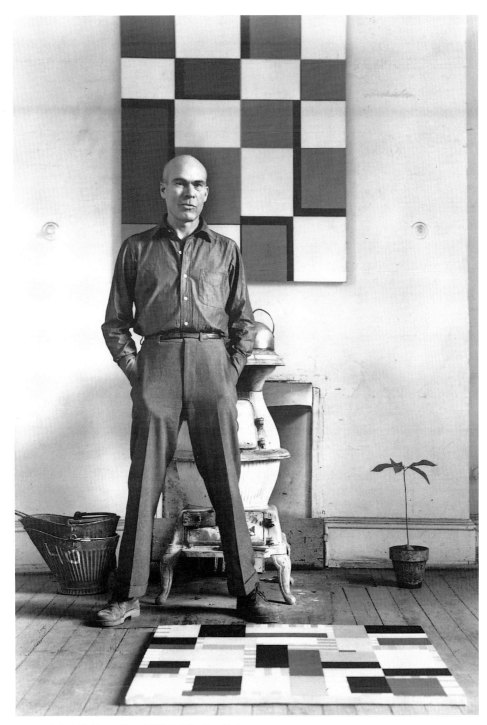

Leon Polk Smith in his studio at 51 W. 10th St., New York,
1951. Photo: Gene Pyle. Courtesy Bob Jamieson.

working area. We didn't have a New York place for about twelve years. Then, in 1978, we found this place on Union Square because Leon felt he should get back to the city and evolve, get going, have another break in the city. We had a gallery in Manhattan at the time, the Denise René gallery, and also the Galerie Chalette, which was up near the Guggenheim.

Are you comfortable going out to the house in Shoreham now, or are you lonely?

Oh, no. I may be alone, but I can never be lonely with all his work around. And it's very beautiful out there. You have to keep it up, though. I'm always busy, there or here. I go out, maybe, every other weekend.

You were raised on Long Island?

Yes, we had a lovely childhood. We weren't wealthy, but we never felt poor. We were all musical, and our home was filled with instruments—violin, trombone, piano. In the summer, we had glorious times at the beach.

When did you first meet Leon?

In the spring of 1952. I was working as a librarian at the Donnell branch of the New York Public Library. I was just about ready to enroll at the School of Library Science at Rutgers University, New Jersey, to take a degree when Leon said, "You don't have to do that anymore. What are you going to do with it? You can do enough here." He was a very sweet person that way. When he said that, I said I would never, ever leave him. Period. I never did.

Do you think that if you hadn't responded to the work, you could have lived with him?

That's an interesting question. You know, love is a wonderful thing, and it's deep. When I first saw his work, I knew how special it was. If you don't care for it, there's sort of a negative feeling there. It'd be difficult. I had known some artists before who were articulate, so I could understand the depths that he had. It was quite a wonderful experience to find someone who was not just painting "stuff." That was very important, I think.

Did you and Leon work well together?

Very well. We understood each other very well. So we had no problems. We worked together stretching canvases, using our hands to pull the canvas over the frame. We never had to use a clamp, and he was very good at the details: the corners, hammering, et cetera. I never painted, but we would discuss painting. If he came across a new idea, we would always talk about it and, you know, it was a celebration. There were seven or eight different periods of his work, and it was fascinating and exciting to be with him.

Were there lean and dry periods?

Well, seldom. He was always working. If there were a lean time, maybe we'd go away. We did take a couple of trips, and that was the time to relax a bit and think of another step. But it was very rare that there was a dry spot.

Did you feel that one of your jobs was to enable him to continue to work?

Oh, I think so. I was always there to help and encourage, but he was a very optimistic person. We had such fun. He enjoyed life very much, and he had interests. He read a lot— we were both great readers. I like a good mystery by Josephine Tey. He had a very open

mind to new discoveries in science and history. He too loved poetry very much. He read philosophy, art history, and psychology. We both loved music, too. Leon liked to play Far Eastern and Indian music very loud, which was a little jarring. He knew Martha Graham very well, and we would always go to see her, as well as other contemporary dance groups. Leon had a good ear.

When we were on Long Island, he would garden. He grew tomatoes, eggplant, and so on, and we planted trees and lilies. It was really very beautiful. The quiet life is wonderful, intoxicating. But there was the labor. We would take all the limbs off the trees as far as we could reach from the ladder. It was cathedral-like.

Bob Jamieson (left) and Leon Polk Smith, New York, 1993.
Epstein Photography. Courtesy Bob Jamieson.

So it wasn't a relationship where you were the steady person and he was more volatile?

I don't think so. He was very energetic. He had more energy than I ever did, but it was a very complete relationship. Very compatible.

When you look back, what were your strengths? What were the skills that you were able to bring to the whole operation?

I guess myself [laughter]! I helped Leon a lot socially. He was somewhat opinionated, and if the evening got a little out of hand, I was always there to calm things down. That's as far as I'll go!

When Leon went up to a gallery for business or whatever, did you always go, too?

Yes, I was with him most all the time. It's necessary to be diplomatic. A companion covers most everything, and then, of course, you have a devout interest—you love the work. You could explain Jon's work to people, too, couldn't you?

To a certain extent. Did you?

No, I never had to. He was a great talker, very articulate. He taught for a long time and could handle groups very well. They all loved listening to him.

Has your role changed since Leon's death?

It hasn't changed greatly, no. I just go on answering mail, letters, and queries. I'm not called upon, except for exhibitions. But I feel I'm developing the ability to answer some of these requests about his work. I'm not as articulate as Leon. Absolutely not. Maybe I'll develop that.

Do you keep back key paintings for personal reasons?

I would never let any of the ones in this room go. Not at the moment.

People like Irving Sandler see Leon's work as part of the hard-edge abstractionist movement.* Are you interested in that group of artists, or just in Leon's work?

I never really extended my thinking in that way, although I'm aware of the question. I suppose I have to get beyond just thinking of Leon's work now and think more broadly about geometric abstraction. Leon never thought of himself as part of a group.* He felt he was quite alone in his work. He and Irving Sandler didn't get along very well for that reason.

Since Leon came from Oklahoma, do you have any special relationships with that part of the country?

In 1986, East Central University in Ada, Oklahoma, gave him the distinguished alumnus award as outstanding contributor to the community. That was very touching for him. That was at the end. In the beginning, I don't think they understood the work and didn't celebrate it. Oklahoma has a very poor representation of abstract art, unfortunately. But I want some of his work there, definitely. He tried, but they never showed interest, and he was a little upset about that. I think it hurt him that they were not mature enough or didn't educate themselves about his particular work. I did donate one work to the Museum of Fine Arts in Houston, a very fine museum, and in his region.

The closest relationship is, therefore, with the Brooklyn Museum?*

They showed great interest, and that was wonderful. We were happy that he had a place for his work at that time, particularly here in the United States. In Europe, they were much more receptive, and he's in all the museums.*

How did the room at the Brooklyn Museum come about?

I think the director there came and suggested it, so Leon made it happen.

Leon donated the work and, in return, did they promise that a particular room would always be his?

In a way. I think each director changes policy. The contract makes you feel that it would always be the way it was presented in the first place. But you don't know how variants get in there. So far, they've kept their word, but not to the full extent. It's not always visible. Sometimes they use that room for something else, like special exhibitions. But they're supposed to always have some of his work up.

It doesn't seem, Bob, as though you feel too burdened by the responsibility of looking after the estate?

Never did I ever feel burdened. I may later on. I don't think I've been doing little details like I used to, but I've never thought of having other people do anything. I couldn't afford them for one thing and, if I could afford them, I don't know if I'd like that either.

Do you think that someone else in your life could ever accept this ghost of a person whose work is so important to you?

I think other people would have to deal with that, but they would never be a part of

the past. They would like to, I'm sure. Probably, over the years, they may become a part of it. But Leon's not going to go away, ever. That's true.

October 2001

UPDATE

The University of Iowa Museum of Art, Iowa City, received thirteen thousand dollars in 2002 from the Judith Rothschild Foundation toward the acquisition of the 1946 painting by Leon Polk Smith, *Center Columns, Blue-Red*. In February 2003, Bob Jamieson, to cut down on the upkeep of two places, gave up the apartment in Manhattan and moved to the house in Shoreham, New York, which he and Leon had owned since 1966. The documentary *Leon Polk Smith: Full Circle* by Jerry Gambone, which had received a fifteen thousand dollar grant in 1998 from the Judith Rothschild Foundation, was completed in 2003. Bob hopes there will be a public showing of it soon. As 2006 will be the centennial of Leon's birth, Bob and gallery dealer Joan Washburn are thinking about approaching museums for a special retrospective of his work.

FOR FURTHER INFORMATION

Gassen, Richard W. *Leon Polk Smith*. (In German, French, and English.) Wilhelm Hack Museum, Ludwigshafen an Rhein, Germany, 1989.

Leon Polk Smith: American Painter. Essays by Carter Radcliff, Brooke Kamin Rapaport, Arthur C. Danto, and John Alan Farmer. New York: The Brooklyn Museum, 1996.

Leon Polk Smith im Arithmeum. Catalogue for the exhibition at the Arithmeum, Forschungsinstitut für Diskrete Mathematik, Bonn, Germany, 2001.

JOAN MARTER
ON THE
DOROTHY DEHNER
FOUNDATION

I had no idea until recently that I have created a sort of autobiography of my life in my work.

—Dorothy Dehner*

Dorothy Dehner was born in Cleveland, Ohio, on December 23, 1901, the daughter of Edward Pius Dehner and Mary Louise "Lulu" Uphof. Her father, a pharmacist, died of pneumonia in 1912. After the death of her mother in 1920 from rheumatoid arthritis, and her only sister from tuberculosis, Dorothy lived with her maternal aunt in Pasadena, California. First interested in acting and dance, Dorothy studied in Pasadena and Los Angeles before going to New York City to enroll at the American Academy of Dramatic Arts (1922–1924). After a trip to Europe in 1925, she returned to New York and enrolled at the Art Students League, taking courses in painting and drawing until 1931. She met David Smith in 1926 and married him the next year. They lived in Brooklyn and then, after 1940, year-round at the house they had bought in 1929 at Bolton Landing, New York, where David Smith set up his sculpture workshops.

Dehner's early paintings reflect an interest in synthetic cubism but, living in the country, she adopted a more representational approach. Then, in the mid-forties, a macabre, surreal element entered her work, perhaps reflecting both the aftermath of the war and the inner turmoil of her life. Her drawings of microscopic organisms led to the biomorphic abstractions of the late forties, which combined strong linear drawing with washes of color. After her divorce from David Smith in 1952, she returned to New York and studied engraving at Stanley William Hayter's Atelier 17, subsequently becoming an innovative printmaker. In 1955, she married New York publisher Ferdinand Mann and lived with him until his death in 1974. Sculpture became her dominant art form beginning in 1955. Her first solo exhibition in New York took place in 1957 when she was fifty-five. Her vertical "totems" and horizontal "landscapes" are cast bronze assemblages that include circles, moons, wedges, and arcs with textured surfaces. In the early seventies, her forms became more monumental; in 1974, she turned to constructed wood sculpture with clean-cut surfaces and, in the eighties, to large corten steel pieces. Acknowledged as one of the few abstract expressionist women artists, she died in New York on September 22, 1994, at the age of ninety-two.

Born in 1946 and brought up in Haverford, Pennsylvania, Joan Marter received her B.A. (1968) magna cum laude, from Temple University and her M.A. (1970) and Ph.D. (1974) from the University of Delaware, where her dissertation was on Alexander Calder. She has taught art history at Pennsylvania State University (1970–1973), Sweet Briar College (1974–1977) and, since 1977, at Rutgers University, New Brunswick, New Jersey, where she is currently distinguished professor of art history and director of the certificate program in curatorial studies. Joan Marter has curated fourteen exhibitions and published six books. These include *Alexander Calder* (1991); *Off Limits: Rutgers University and the Avant-Garde, 1957–63* (1999) (as editor and principal essayist); and *American Sculpture in the Metropolitan Museum of Art*, volume 2 (2001) (coauthor/contributor). She lives in New York City.

From 1996 to 2000, I was chair of acquisitions for the Friends of Art, Sweet Briar College. When Dorothy Dehner's name appeared on the faculty wish list, I contacted Joan Marter at the Dorothy Dehner Foundation in New York City. Rebecca Massie Lane, director of Sweet Briar Galleries, and I visited the small studio on Union Square, chockablock with sculpture and filing cabinets, to look at works on paper. Joan made it clear that she expected us to buy one work from the Kraushaar Galleries before she would donate one. It was her way of measuring our interest and supporting the commercial gallery that represents Dehner's work.

. . .

How did you come to be president of the foundation?

I knew Dorothy for eighteen years, and I had written various catalogues on her work.* Before she died, she asked me if I would be willing to serve as an "advisor," along with others, placing her work, et cetera; I agreed. Then, because of the death of Irwin Mann, her original choice, I became executor of her estate, which I did get a fee for. I just felt that someone needed to see that the foundation came into being. Maybe if it were a paid job, I would have worked on it a little more aggressively than I have in the last year or so. But my life has just become too busy, and the art market is not so good. Having set it up, I can basically maintain it without too much responsibility or too many hours. I've been doing this for a long time now.

Are you full time at Rutgers University?

Yes. I'm distinguished professor of art history, specializing in the twentieth century. In addition to all the students I teach—eighty-five this semester, some graduate, some undergraduate—I have about seven dissertation students to advise.

Have you steered any of your graduate students toward dissertations on Dorothy Dehner and her era?

One student has already written her dissertation on Dorothy Dehner.* I was her advisor, even though she was at Yale. I also have students working in that period. One is writing her dissertation on women and abstract expressionism, but she's not including Dorothy. There's no need to. The earlier dissertation information is available and has been used in some exhibition catalogues.

Joan Marter at the Dehner Foundation, October 1997,
holding *Nauplia #1110,* 1950, ink and watercolor on
paper. Sweet Briar College Collection, gift of the Dorothy
Dehner Foundation, 1998. Photo: Rebecca Massie Lane.
Courtesy Sweet Briar College, VA.

Are there other projects that you want to bring about?

I would like to have a major exhibition of her work, as well as more exhibitions of
the period of her production in which she could be incorporated. I did one myself called
Women and Abstract Expressionism in 1997 at Baruch College, which included Lee Krasner,
Elaine de Kooning, Joan Mitchell, and others. Dehner was the only sculptor in the show.
That kind of exhibition is important because it sets the person in a context of her peers.
So I would like both to see solo exhibitions and to help people who want to do an exhi-
bition that includes her work.

What other contexts would be relevant for Dorothy Dehner?

There are a number. I just had a student do an excellent research paper on artists from
the Art Students League in the 1920s—a very distinguished group that includes Dorothy.
That would make a wonderful exhibition. Something could be done with the forties,
maybe a show of images relating to World War II, because she has quite a number of them,
and so does David Smith. Years ago, in 1984, I organized an exhibition exploring the rela-
tionship of David Smith and Dorothy Dehner that could have another life somewhere. Her
work of the fifties is very interesting, so she could be included in a show of that decade,

especially women artists of the period, as well as in an exhibition of the New Sculpture Group. Since she studied at Atelier 17 with Stanley William Hayter, her work would fit into an exhibition of his New York period. And finally, she was at the Tamarind Institute in New Mexico, so she could be included in a show of its lithographers.

When you first took over the foundation, approximately how many pieces of sculpture and works on paper were there?

Hundreds of works, including perhaps two hundred fifty drawings. I can't remember exactly, but I have a database with all the information. There must be around thirty editions of prints, so over a thousand prints in all, counting the proofs. Of course, a good many of those have already left the studio.

And the sculpture?

At least one hundred pieces.

Which is not an enormous amount.

No. But some of them are very big.

You were able to keep her studio on Union Square to house the collection?

That's right. The foundation has her studio now, which, as you saw, is rather small. Not everything is there because the dealer has things as well. She also had the room next door, essentially for storage, which we no longer have.

Are there still five directors of the Dorothy Dehner Foundation?

Yes: one museum director, David Levy from the Corcoran Museum of Art, who was closely associated with Dorothy throughout her life; a younger art historian, Ann Gibson, who's a specialist on abstract expressionism; and the artist Sandra Lerner, who was a good friend of Dorothy's for many years. Then someone named by Dorothy in her will resigned, so I suggested a substitute, the art historian Martica Sawin. They all knew Dorothy.

According to *A Visual Artist's Guide to Estate Planning*, 1998, your operating budget is about forty thousand dollars.

That's probably a little high because we don't really do very much now, other than to pay the rent.

How often do you and the other board members meet?

I talk to them informally at various times about what's going on, and we try to meet once a year. It's very hard because they're in different places. If I feel that I need to have someone's approval or opinions, I contact them.

It's lucky that you live reasonably close to Union Square. What's the relationship between the foundation and the residuary estate?

There is no estate now. The foundation is completely independent.

Has there ever been any connection between members of the family and the foundation?

Dehner had no blood relatives. She had stepchildren, but none of them are involved.

Was that her wish?

No. They were asked if they wished to be involved and decided not to be.

Even Melanie Thernstrom, who wrote the article in the *New York Times* [June 9, 2002] about her step-grandmother, didn't want to be involved in the foundation?

No. I asked her to join the board of directors, but she didn't want to.

Were you surprised by their lack of involvement?

No. Only one of them was interested in her work, and he died—the stepson, Irwin Mann. I wasn't surprised. This is a stepfamily. She had a fairly substantial estate and gave most of her money to them and other beneficiaries, so why would they be interested in her artwork? The foundation is nonprofit, so there's nothing in it for them.

A *Visual Artist's Guide* uses the Dorothy Dehner Foundation to suggest that a foundation can be effective despite having only a fairly modest endowment. Is it correct in saying that the foundation was set up with $110,000?

Dorothy did give ten percent of her liquid assets to form the foundation. Maybe at one time there was that amount. A lot of money was consumed recovering artwork consigned to dealers, which involved lawyers.

What has the foundation been supporting lately?

The foundation does not normally give grants unless the project has something to do with Dorothy's work. We have, at times, given some support to various exhibitions when there was a publication that involved Dorothy Dehner. But a percentage of the total assets of the foundation has to be distributed every year, either in the form of artwork or money. Since the foundation has very little money, we donate art instead—mostly drawings and prints—and usually to educational rather than municipal collections or art museums. I tend to let them approach me because I feel that, if places are interested in having her work, they are more likely to show it. I don't want to have to solicit. And I haven't had to.

Why do you favor educational institutions?

Because many of those others are in a position to purchase. There's a fine line that one has to walk. We also have the Kraushaar Galleries in New York representing the artist's work. If it's discovered that I'm giving away artwork, why should people buy? The dealer tends to sell to individuals but, at times, she has also sold to institutions. So I don't want to undercut that. I look mostly to educational institutions that have a museum or a gallery but have limited acquisition budgets. The Yale University Art Gallery, for example, now has a nice collection of Dorothy's prints and drawings. So does the Fogg Art Museum of Harvard. We've also given to Sweet Briar College in Virginia and Skidmore College in Upstate New York. I like the idea that an educational institution offers the opportunity for young people to study the work, and hope that the students will learn from these examples. Since these gifts are works on paper, they are not going to be exhibited on a regular basis but taken out from time to time.

Do you make a clear distinction between the sculpture and the works on paper when you're making a donation?

Definitely. The sculpture is much more valuable, and you want it to be displayed and

Dorothy Dehner in her studio on Union Square, New
York, 1966. Photo: Dan Budnik. Courtesy Dorothy Dehner
Foundation.

not put in storage. I've given very few sculptures away. But we did give one to the Art Students League, where Dorothy was a student. In fact, her memorial service was held there. They very much wanted to have a sculpture, and it's always on view in the entrance hall, which is one of the reasons we gave *Sanctum with Window* [1990] to them. We also gave them some Dehner prints.

You mentioned that the current directors knew Dorothy Dehner. As they all retire, what will happen?

As time goes on, some younger people will be added. The foundation will have less and less to give away, so its role will be limited.

Still, it will take a long time to distribute and sell thousands of works on paper?

Yes, it will probably continue for the foreseeable future.

What about your broader role, Joan? Do you see yourself writing more on Dehner?

Yes, not a biography, but a discussion of her work in relationship to David Smith's, and how her art relates to their life together.

Would you like to see a biography?

A woman in Texas, Martha Nodine, is writing one.* Since 1994, she's done a lot of research and produced some chapters. I'm happy to assist with other people's work, and there are things in the studio that could be helpful. Dorothy has, for example, scrapbooks

of reviews, exhibition catalogues, and brochures, so scholars might want to look at that material.

What happened to the rest of her papers?

They have already been donated to the Archives of American Art.

Is it difficult not to have them at your fingertips?

No. I go to their New York branch to use them myself. Everything is microfilmed and accessible.

Looking back on how Dorothy Dehner organized her will, do you feel that she thought everything through and did the best she possibly could have for her work?

I think she liked the idea of having a foundation set up when the lawyers suggested it. Her will read that it "could" be formed, and her stepson assumed the responsibility of doing that when he was the executor. I think that if she had been more determined to have this foundation, she would have supplied more money for it. She put her art in, but not enough of her estate, so what the foundation can do is really limited.

What would you have done if you had had more money?

What I'd like to do is to publish a major book—that would cost maybe fifty to sixty thousand dollars to produce—with lots of beautiful plates and illustrations of her work. It would center not so much on the text, but on the images and would be something that could be distributed widely. But the foundation doesn't have that kind of money. I also would like to repair more of the sculpture and get many more drawings framed and matted properly. I have already received a seventy-five hundred dollar grant from the Judith Rothschild Foundation for preserving works, and we spent all the money just sending a few of the pieces out for repair, cleaning, and new bases. If I had more money, I could have that done without applying for grants to do it.

I noticed that the Judith Rothschild Foundation has recently contributed twenty thousand dollars to the DeCordova Museum and Sculpture Park in Lincoln, Massachusetts, to acquire *Fortissimo*, 1993, painted steel by Dorothy Dehner. Were you instrumental in that?

I sure was. I talked to the Rothschild Foundation about having a museum apply to them for an artwork that would then be a partial gift from us and a partial purchase on their part. They were supportive of the idea because this is something very tangible. I think they worry a little when they just hand out money to families of artists for something like archives. This kind of project is to everyone's advantage. The curator at the museum is someone whom I know, and that piece has been on loan to the museum for a number of years. So I suggested, after I had the conversation with the Rothschild people, that the curator should apply for the grant.

You have become a facilitator in many ways.

All the time. I apply for grants and help others to do so. If something is leaving the studio, I arrange for the shipper and wait for the men to arrive. I meet museum curators there and show them what we have. If work needs to get framed for an exhibition, I take it to the framer. If a dealer wants to show a work at the Chicago Art Fair, I have to be there to help

select the piece. The dealer in Washington [Susan Corn Conway] called me earlier today to say she's coming in several weeks. I don't know exactly what she has in mind at this point, but we'll organize something together.

Any connections with galleries abroad?

Not yet.

Do you ever feel this responsibility as a burden?

Not now. I did at the beginning because I have a job, a husband, and a child. It was a tremendous amount of work setting up a database for all the artwork. I also spent days with an appraiser. Because I still have the law firm to help with the accounting, I don't have to prepare the tax returns, but I have to review and sign them.

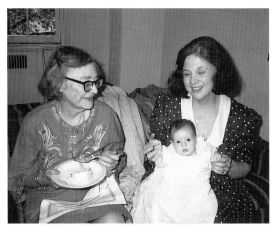

Dorothy Dehner, with Joan Marter and her daughter, April 1986. Courtesy Joan Marter.

Did you have a close friendship with Dorothy, along with the art historical connection?

Yes, I spent a lot of time with her. We had dinner together, sometimes at my apartment, and she came to my daughter's christening. When she was given an honorary degree at Skidmore College in 1982, I went with her, as I did when she was invited to a conference at the University of Cincinnati, *Sculpture Works by Women*, in 1987. It was almost like being a family member.

In a way, you are doing what other family members do.

That's true, but I also did quite a number of exhibitions of her work, as well as writing about it and reviewing some of her gallery shows for art publications. Not too many artists have art historians as members of their families. Also, since it is a nonprofit foundation, I have no vested interest in whether or not something sells or where it goes—so my biases come from the direction of art history. I want to make sure that the best examples of Dorothy's work go into collections where they're going to be seen. This is exactly what I said to the dealer this morning.

I think family members might be concerned about what the art is worth, and they probably also are attached to certain pieces, which might work against their being objective. There are things that I like better than others, but I can also be very objective. When people come, I can say, "Don't take that one, it's not as good as this one." As an art historian, I also can say that certain works are more important than others in terms of her career or whatever, and I know her work better than most people.

Do you have a little collection of Dorothy Dehners yourself?

I have a few things that she gave me at various times when she came to visit. Actually, when I organized an exhibition, she gave me one of her paintings. But I don't really have very much.

As directors, don't you feel that, as none of you are paid, you can agree to award yourselves a drawing or . . . ?

We've never done that. I have a very tight inventory. Every time something gets sold or is given to museums, I give the inventory number to the accountant at the law firm.

There have been other estates and foundations where remuneration has been an important issue.

All the directors of the foundation knew Dorothy. No one has complained about not being paid and, as I mentioned, I try to talk with them, rather than meeting, to save time. I just don't like that kind of complication to do with fees. It's the way I feel about the keys to the studio—I have the only set. People say to me, "Oh, you can hire someone to do certain things to save you time, and it wouldn't cost you that much." But I feel that I'm ultimately responsible for the work, so I should be the one.

March 2003

UPDATE

After the donation from the Dorothy Dehner Foundation to the DeCordova Museum and Sculpture Park in Lincoln, Massachusetts, was finalized, the piece *Fortissimo, 1993* (previously on loan) was repainted and moved to a more prominent location. *Stretcher Series, 1992,* aluminum and copper, is now installed in the lobby of the Alexander Library of Rutgers University, New Brunswick, New Jersey, a gift from the foundation. Unfortunately, Susan Conway, one of the more enthusiastic dealers who had personally known the artist, closed her gallery in Washington, D.C. Before she moved to Santa Fe, all the Dorothy Dehner work on consignment was returned to the foundation.

FOR FURTHER INFORMATION

Marter, Joan. *Dorothy Dehner: Sixty Years of Art.* Seattle: University of Washington Press, 1993.

NINE
TO THE FUTURE

The Mark Rothko trial represents a turning point in the history of the art world, as well as in the lives of the artist's heirs. Not only must the Rothko children set out to create a future sharply distinguished from the past when they take control of their father's estate, but representatives of art galleries and foundations realize that, henceforth, they will live in its shadow.

Kate Rothko's feeling of euphoria at being able at last to live with her father's paintings is countered by a sense of total disillusionment with the practices of the art world. How does she, and later her brother, reconcile their intensely personal feelings for the paintings and the commercial aspects of the art world that are impossible to avoid? How will each find a distinctive way to preserve the Rothko legacy, that "intangible" connection to their father?

The other interviews in this chapter deal with general questions about artists' legacies and their preservation at this pivotal time. Stephen Polcari, former director of the Archives of American Art in New York, questions the benefits of the proliferation of art foundations. His concern is the diminishing probability that the letters, other writings, records, and photographs of artists will be concentrated in a central repository, guaranteeing free access to all researchers and art historians. With government cuts and competition from private foundations, especially the Getty Museum, the archives' future is indeed delicate.

Ralph Lerner, a specialist in art and estate law, considers questions about the probability and practicality of changes in matters relating to taxes and inheritance. Against the background of pending congressional legislation, he discusses such issues as the flagrant discrepancy between the tax benefits allowed for donations by artists and those by collectors, and the contrast between the capital gains tax on art and on other financial assets. Even though, like Polcari, he sees the advantages of allowing the free market its reign, he is outraged by the administration's refusal to adequately fund the arts, considering the "phenomenal amount of tax revenue" and other less tangible riches they bring. He suggests ways in which Europe might serve as an instructive model.

It seems fitting to end with Jack Cowart, director of the Roy Lichtenstein Foundation, whose belief in the cross-fertilization of ideas and whose emphasis on the spirit of cooperation leaves us with a new sense of possibility. Although he is skeptical of certain aspects of the art world, a contagious sense of wonder resounds, whether he is talking about his

own appreciation of Lichtenstein's art or his response to the projects of others. As he says in the longer version of his interview: "We're endlessly astonished, amazed, amused, insulted, delighted, depending on how it goes, when we show people our candy store." The foundation and estate take their cue, here as elsewhere, from the personalities of the artist and the heirs. In this case, the deadly serious business of protecting the legacy coexists with a lightness of touch, a sense of humor, and an openness to whatever surprises the future might bring.

D.C.

KATE AND CHRISTOPHER ROTHKO, DAUGHTER AND SON OF MARK ROTHKO

The progression of a painter's work, as it travels in time from point to point, will be toward clarity, toward the elimination of all obstacles between the painter and the idea, and between the idea and the observer.

—MARK ROTHKO*

Mark Rothko, the fourth child of Jacob and Katya (née Goldin) Rothkovich, was born on September 25, 1903, in Dvinsk, Russia. His father, a Jewish pharmacist, left for the United States in 1910, followed by his two eldest sons. By 1913, Rothko, his sister, and his mother had joined the family in Portland, Oregon. Seven months later, his father died unexpectedly. Rothko entered Yale in 1921, but left for New York City in 1923, attending the Art Students League from 1924 to 1926. He taught part time at Center Academy, Brooklyn (1929–1952), and then full time at Brooklyn College until 1954. He married Edith Sacher, a jeweler, in 1932, and then twenty-four-year-old Mary Alice (Mell) Beistle, an illustrator of children's books, in 1945. Their two children, Kate and Christopher, were born in 1950 and 1963.

Rothko's dreamlike urban landscapes of the thirties were followed by paintings reflecting his interest in mythology and archaic and primitive art. Figurative elements became more calligraphic in the surreal "seascapes," which by 1947 had morphed into loose, diverse shapes of flat, glowing color. These he refined into larger, soft-edged rectangles floating above one another, often using darker, moodier colors in the sixties. In 1969, he moved out of the family brownstone into his large studio on East 69th Street. There, on February 25, 1970, after a period of ill-health and depression, he committed suicide.

Kate Rothko, Mark and Mell Rothko's daughter, was born on December 30, 1950, in New York City and attended the Dalton School. She was nineteen and a student at Brooklyn College when her father died. She married fellow student Ilya Prizel in 1974 and moved to Baltimore to study at Johns Hopkins University medical school. While still at college, she initiated a lawsuit against the executors of her father's estate and the directors of the Mark Rothko Foundation, which she won in 1977. In 1982, Kate completed her residency in pathology at Johns Hopkins, and the Prizels moved to Washington, D.C.,

where their children, Peter, Natalie, and Lauren (born in 1981, 1984, and 1990) were raised. An academic pathologist and transfusion medicine specialist in the Baltimore-Washington area for twenty-two years, Kate is currently on the faculty of George Washington University School of Medicine.

Christopher Rothko, born August 31, 1963, in New York, was six and a half at the time of his father's death, and not yet seven when his mother Mell died of hypertension due to cardiovascular disease in August 1970. He lived with his maternal aunt, Barbara Northrup, and her husband in Columbus, Ohio, until 1975, when he went to McDonogh, a boarding school within easy reach of his sister, Kate, and her husband in Baltimore. He graduated magna cum laude from Yale University in 1985 and obtained his Ph.D. in clinical psychology from the University of Michigan in 1995. In 1993, he married Lori Cohn, and their children, Mischa, Aaron, and Isabel, were born in 1995, 1998, and 2002. Since 2000, he and his family have lived in New York City, where he now looks after the Rothko collection full time.

Before he died, Mark Rothko formed a foundation to receive his paintings. The three executors (none of them family members) of his estate were also on the board of this foundation, whose purpose, they declared, was to give grants to elderly and needy artists (rather than to nurture Rothko's legacy). Within seven months, the executors sold a hundred paintings at a cut-rate price to the Marlborough Gallery and consigned the remaining 698 to it for twelve years. The proceeds were to be split between the foundation and the Rothko children. In November 1971, Kate Rothko, realizing that she and her small brother would inherit no work by their father, petitioned, through her guardian, the New York Surrogate Court to remove the three executors, to stop Marlborough from selling the paintings, and to void the two contracts. Some seven teams of lawyers representing the different interests sued and countersued until the Matter of Rothko was resolved in Kate Rothko Prizel's favor in December 1975. Marlborough was ordered to return 658 Rothko paintings to the estate and to pay a fine of $9.3 million. It lost its appeal in November 1977. The complexities of the case are described in *The Legacy of Mark Rothko* by Lee Seldes.*

There was a clear conflict of interest in that Bernard Reis, as executor and officer of the foundation, also worked for Marlborough, whose owner, Francis K. Lloyd, arranged for many of the paintings to be "sold" to "collectors" and newly formed "corporations" and shipped out of the United States after the restraint against sales. Eventually, Lloyd returned seventy-eight of these "sold" paintings to the estate as a credit against the fine. He was indicted in 1977 for forgery and tampering with evidence, and was found guilty in 1983. The surrogate court appointed Kate Rothko Prizel as the executor of the Rothko estate and found new officers for the reconstituted foundation. The trial involved millions of dollars in legal fees. When Kate's own lawyer, Edward Ross, from Breed Abbott & Morgan claimed $7.5 million, she sued him and won.

In a conversation with Lee Seldes about the Rothko trial, she advised me to speak to Christopher and Kate Rothko myself, and she put me in touch with them. We met for a

Christopher and Kate Rothko, 2004.
Photo: Magda Salvesen.

preliminary chat in a café and arranged to talk about the way they had reclaimed their father's legacy.

. . .

Let's begin with you, Kate. It's 1978. The trial is over; the ghastliness of those years is behind you. What next?

Kate: In 1978, my priority was to sell a minimal number of works—to cover the costs of legal fees—so I could have the opportunity to live with them. I'd never been able to hang a Rothko until that time. Although I still feel very much that way, certain realities of the art world make some of my goals unrealistic. My perspective has also changed as my family has grown up.

Christopher, you were only fifteen at the time the trial ended. How much of it entered into your consciousness as a child and teenager?

Christopher: I was really very fortunate that Kate and her husband, Ilya, with whom I lived for many years, did a wonderful job of shielding me. I was aware that the trial was going on, but it was not part of my day-to-day life. When I became a teenager, paintings

by my father came back into our possession, and I was involved in planning exhibitions and choosing galleries. That was exciting. These paintings that had just been sort of mythic for a decade—an idea rather than an actuality—all of a sudden had substance again and were before the public eye, and our eyes, for the first time in many years.

Kate, you had no gallery, and you weren't even living in New York City. How did you manage?

Kate: I suppose I was giving some consideration to the estate during the four years that the initial lawsuit dragged on. I had a very limited number of advisors and supporters during that period but, perhaps for that reason, they became all the more important to me. I very often turned to two of my father's artist-friends, William Scharf and Daniel Rice, and the art critic Katherine Kuh, who had a long-standing knowledge of my father's work. William Scharf, who was one of his closest artist-friends, helped with registrar-type details for the recovered works, in addition to being a personal and artistic advisor—a wonderful combination.

I believe Judge Midonick had ruled that the Rothko Foundation would own five-ninths of the paintings recovered from Marlborough. Selecting the four-ninths that you and Christopher would inherit must have been quite a responsibility.

Kate: Yes, I was quite anxious, but it was actually a very friendly process because William Scharf was on the board of the reformulated Rothko Foundation. We didn't expect, however, to face such decisions as which paintings to sell to cover legal expenses, or how to divide the paintings with the foundation. Actually, we came up with a very good system for the mechanics of the division, which was to pre-group the paintings, even pairing them, balancing one against the other. That system continued to work well for Christopher and me when we ultimately divided our collection in about 1993. There is always twenty-twenty hindsight, but now Christopher and I are able to joke about this: "I really should have chosen that painting! Won't you lend it to me to hang on my wall?"

Christopher: I think we can joke about that because we both feel pretty comfortable with the division we made.

Kate: We have been blessed to be able to work together so easily and to see virtually eye-to-eye on what we think of one painting versus another.

Can you be more specific about what you had to do in managing the estate? You had certain advantages, since by 1978 your father's name was already well established.

Kate: We had to make a complete inventory of the work. A rough one had been done in the last eighteen months before my father died. But various versions of this were floating around, and the Kodachromes were terrible, in many cases unidentifiable. Paintings had been stored in multiple locations so, after the trial, we had to consolidate them and make sure that everything had been returned. Numerous unknown drawings and sketches from much earlier years appeared, and none of them had even been numbered or signed. I remember sitting down with William Scharf and trying to sort through them.

By the time the lawsuit ended, there was a lot of pent-up interest in Rothko that led

to a large 1978 retrospective at the Guggenheim Museum, which then traveled around the country. Only at that point did we begin to step back and understand that we could not possibly manage the estate out of the warehouse, and that a commercial gallery would have to be involved. Of course, this was something I was a little leery about at that point, so a lot of agonizing went into the decision.

Did you interview gallery directors?

Kate: My husband and I interviewed fairly extensively but, finally, in 1978, we selected Pace Gallery in New York.

You must have been especially careful about contracts and agreements?

Kate: Absolutely. From the very beginning, all contracts with the gallery were limited, never extending for more than two years. Specific paintings were listed as part of the agreement and, certainly, nothing approaching a significant portion of the estate was involved.

Have you worked exclusively through Pace since then?

Essentially—largely through a gentleman's agreement. The first six to eight years, we had actual contracts, and then more specific agreements surrounding a particular exhibit.

Christopher, what led to your decision to leave your work in psychology and manage the estate full time?

Christopher: When I was finishing up my graduate degree in the mid-nineties, I found myself getting more and more involved, not only in the organization of exhibitions, but also in helping curators secure loans of paintings from others. I found that I was tremendously interested, and I had a great deal to contribute. In some cases, I felt that some of the people involved did not have the same degree of experience with all aspects of my father's work as the family. Probably the fulcrum was the 1998 retrospective that went to the National Gallery, the Whitney, and then on to Paris, after which I became increasingly hands on—not just with exhibitions, but with catalogues and reproductions, too. Finally, after moving to New York in 2000, I realized that part of the reason I hadn't set up a psychology practice was that my real passion was my father's art.

Kate, was it a relief for you to step back a little?

Kate: I think so. It was psychologically problematic for me to be involved with the art world on a daily basis because of my experience with the lawsuit. In fact, one thing that has kept my husband and me from moving back to New York is my cynicism. So, in a sense, it has been a great relief. I feel satisfied that my contribution was to bring the paintings back—for both the family and the foundation. I feel very good that Christopher doesn't come to the task with the same emotional baggage as I did, and that he finds his involvement very satisfying. I think there's been a good transition.

You never considered giving up your own career in order to look after the estate?

Kate: No. Even before my father died, I felt it was very important to divorce myself from the art world—perhaps because I was growing up as he became well known. You walk into a high-school or college art class, and someone recognizes your last name, and

you lose your anonymity. I moved out of New York for medical school, and I even went through a period when I denied being related to my father to avoid publicity. But part of that was just the process of maturation, as I had probably been one of the shyest teenagers and young adults imaginable. Being able to take pride in the connection and not feel discomfort with it took me a while—not because I wasn't proud of my father's work, but perhaps I wasn't secure with my connection to it. Things might have evolved differently had the lawsuit not taken place. It certainly changed my whole image of the art world.

When you married Ilya Prizel in 1974 and took your husband's name, was that a way of forming a new identity through him and with him?

Kate: It definitely was at that point. By the time I was getting ready to graduate from medical school, I decided I wanted my degree in my maiden name. So I now have a sort of split identity. I actually find it somewhat of an irritation, particularly when I go to an art-related function and find my place card in my married name because I have to explain why I'm there. That's something Christopher does not have to deal with.

Yes, after all, for twenty-two years you were the main administrator of the Rothko collection.

Kate: Yes. I don't look back on anything with major regret but, at the same time, had I been on the scene day-to-day, things like the catalogue raisonné might have moved ahead more quickly than they did. Also, at times I have stepped back from a painting at an exhibit and questioned whether I would have chosen that one had I been more directly involved. But I think I feel quite comfortable with my major decisions. For example, I always tried to be very careful about copyright in order to control how the image was used. Now that there are numerous requests, I am most grateful to Christopher for handling them. Because we usually see eye-to-eye on these matters, we don't need day-to-day discussions of which requests to approve. There's nothing I can look back on with total dissatisfaction, although practically every time I've sold a picture I've said, "Did that really *have* to be done? Should I have sold a different painting?"

What general guidelines have you formed for yourselves about copyright?

Christopher: Again, this has been an evolutionary process. If it's a poster or card, so long as it's the entire image, not cropped or overprinted, and if it's a reputable publisher, we usually say okay. There are, for instance, little note sheets that come in a stack and, when you rip them off, the image is destroyed since it extends to the edge. That's what we want to avoid. The primary criterion is that the painting be seen as my father intended. With anything that involves text, be it an art book, book jacket, card, or advertisement—which occasionally we will allow— we ask to see it so that the image is not used inappropriately or as a sales pitch. We usually don't allow images on items like umbrellas, T-shirts, toilet paper rolls (I actually had that request!).

Kate: If I can just add a little anecdote. About five years ago, I was shocked to get a call from a friend who had gone down to the Phillips Collection in Washington, which has owned a group of Rothkos for a great number of years. This friend said, "Did you know

they're selling T-shirts of Rothko?" I immediately called up and explained that this was something that we do not permit. "Well, I'll have to talk to some people and get back to you," was the reply. I thought, well, I'll give her the benefit of the doubt. Then she called back and said, "We've decided we will remove them from our store. But I hope you don't mind; I'm going to give one to each of the staff members." I said, "You've completely missed the point. It doesn't have to do with whether you're making a profit off it or not. It has to do with the fact that we don't want to see people walking around Washington in Rothko T-shirts." So that is something we have tried assiduously to avoid, although we haven't been entirely successful, particularly when there's an institution that believes the copyright lies with them and doesn't even check with us.

There are a number of beautiful catalogues from the retrospectives and exhibitions, and the James Breslin biography on your father. What else would you like to see done?

Christopher: The completion of the catalogue raisonné of works on paper. That is essential because there is a huge portion of the work that is largely unknown to the public. Our father's legacy is well documented and preserved. However, I would not mind seeing a second biography, only because I think it's helpful to have another perspective. Although I think Breslin did a wonderful job of getting a lot of factual material out, he is quite assertive in his interpretations about the work and my father's personality. Sadly, with each passing year, fewer people who actually knew my father are still alive, so there would necessarily be even more reliance on secondary sources. Bill Scharf is really our only living connection to my father at this point.

Kate: The reconstituted Rothko Foundation had an oral history program, and those documents are now in the Archives of American Art—which I'm embarrassed to say I have not had time to go through in detail. I think that both connections in the art world and some family members were interviewed.

My father also had quite a close relationship with the art historian Robert Goldwater, and they had discussed his writing a book about the art as opposed to a biography. Unfortunately, this got caught up in the legal turmoil, and then Robert Goldwater died rather unexpectedly in 1973, and the book never came to fruition. The possibility of someone else taking over lingers in my mind.

Christopher: My father left a fair bit in terms of writings about art, both individual pieces and letters, but also an unfinished book that I've edited for publication [*The Artist's Reality*, 2004.]. Kate and I looked at this manuscript a number of times and tried to decide whether it was appropriate to bring it out. Obviously, we concluded that it was sufficiently important, and we'll see what the world says come the fall.

Kate: For years, I agonized over who could bring this book to fruition, so I was actually quite relieved when Christopher decided to.

Can you say a little about the book?

Christopher: My father wrote it in the early 1940s, well before he was a well-known artist. He does not discuss his own work directly. It's really his perspective on what an artist

does and what makes art effective, so it necessarily has to be the same perspective he took in creating his own work. I should add that it's not a collection of essays, but a book with a clear direction, moving through a series of points, not exactly toward a conclusion because it's unfinished—we know there are chapters he didn't write that he had planned. But a series of common themes run through it.

Christopher, to turn to your own writing. The art historian David Anfam told me that you gave a very good paper on your father in St. Petersburg last year.* Does that come out of your clinical psychology background?

Christopher: I was asked to write on the psychological aspects of my father's work specifically because I'm trained as a psychologist. But I was quite aware as I was writing it—and I would have to say almost subversively—that it's not a terribly psychological approach, that it really comes primarily from my own experience with the artwork. I'm not psychoanalyzing my father but looking at some of the psychological mechanisms through which the artwork moves us.

Kate: Yes, as I sat and listened, I realized that many of the things he had put into words very much expressed how I reacted to the paintings. It was really a wonderful experience.

Kate, do you have a special relationship with the work that your father did when you were growing up?

Kate: It's true that my relationship with the paintings that I lived with is very different from my relationship with the earlier paintings. And what I remember hanging in the house was almost exclusively what my father had recently completed, although I think that by the sixties he may have brought back some earlier paintings from the fifties. And I know there was one particular painting, *Slow Swirl by the Edge of the Sea* [1944], that I was very attached to—which he actually purchased back from the San Francisco Museum of Art in the mid-sixties, partly because it was the first painting my mother had seen him paint. Now I regret daily that it is not with the family, but my mother had promised it to the Museum of Modern Art after her death. I can step back and look at the earlier work more objectively because I didn't grow up with it. And it was an incredible revelation for me when I did get to know it much later. I can say the same about my father's life. It's very strange to read a biography because I felt I knew my father very well, but there were thirty years of his adult life before I was born.

Whereas for you, Christopher, in a way you're dealing with the myth of your father, since you were only six when he died. What are the plusses and the minuses of that situation?

Christopher: It definitely has both. There are paintings that I remember growing up with including, above all, *Slow Swirl at the Edge of the Sea*, but it's absolutely true that I know more about my father from talking to other people and from seeing the work than I do from personal experience. My memories are pretty hazy. What has been so interesting for me, reading through his pages and pages about art, is that I find that we share some of the same, sometimes crazy, biases. Who else would come forward and say he doesn't like

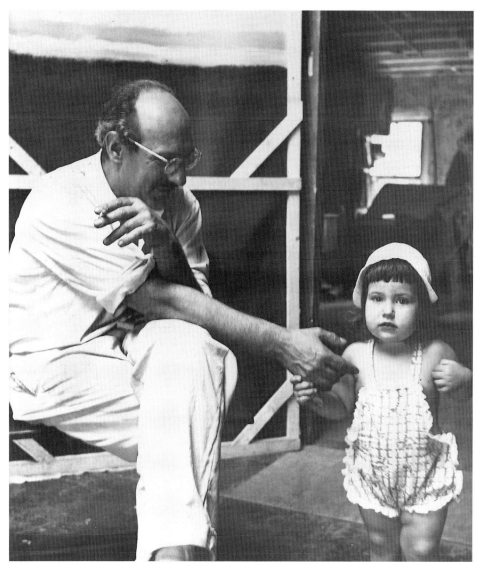

Mark Rothko and daughter, Kate, early 1950s. Photo: Henry Elkan. © 2004 by Kate Rothko Prizel and Christopher Rothko.

Michelangelo? I don't like Michelangelo either. Somehow there's this intangible connection, something that we share, which makes me feel that I get the paintings in an innate way, extending beyond my direct experience with them.

 Kate: While reading through the first draft of the book, I also felt this strange connection. My father was not a person who discussed art at the dinner table—at least not with the family—and yet I feel so much of the book resonates with what I've always felt about

his painting, particularly that his approach to painting was very philosophical. It's interesting that, somehow, this must have come across to me as I was growing up.

Is it still a pleasure for you to represent your father at openings here and abroad?

Kate: I still take a lot of pride in the work. The centenary events in 2003 were emotionally significant for additional reasons. But, even with the radio interview we did last week with Lenny Lopate [WNYC, February 9, 2004], I came out feeling good about having talked about the paintings again, reaffirming the connection.

Going back now to the foundation that was reconstituted after the law case—the officers distributed the paintings, giving a great number to the National Gallery in Washington. Was that a good idea?

Christopher: I think their job was particularly tricky because my father did not leave a clear mandate for his foundation, and his supposed desires were filtered through the board of the previous foundation, some of whom were the very ones who defrauded the estate. So, to what degree the charter was drawn up in order to facilitate that deceitful process, it's hard to know. The second foundation really did not have a clear direction given to them by the artist, and the officers chose an interpretation that I think was valid: primarily, the protection, preservation, and proper placement of the artwork. They were less involved with the charitable work than my father had desired, although they did make some donations. Placing the largest share of the estate at the National Gallery was, I think, a very good idea. There are two ways they could have gone about it. They could either have distributed Rothkos as broadly as possible or found an institution—and I really can't imagine a better choice than the National Gallery—that would essentially become a study center, organizing exhibitions, events, and colloquia. That certainly has happened. Whether having the works more broadly distributed would have also been a good thing, I think, probably, yes. But I don't think you can do both. If I were the director of the foundation, I'm not sure what choice I would have made. Kate may have a different opinion.

Kate: Not at all. I'm actually very happy that the works went to the National Gallery. At first, I was somewhat surprised that an arrangement involving New York City had not been made. But I recognize, in retrospect, that they probably could not get a commitment to keep them together as a group, hanging at least some of the pictures all of the time, and with an agreement never to de-accession. What also appealed to me about the National Gallery is that they quite often organize exhibits that travel to small museums around the country. I guess the one question I would raise—and others have, too—is why so few individual gifts were made to museums outside of the United States. I really don't know the thinking that went into that. As administrator of the estate, I was very much kept at arm's length by the new board of the foundation. They felt, probably more than I, that it was a conflict of interest for me to be even informed of what the plans were.

Are you now in a position where you are able to place paintings or partial gifts in European or other museums to remedy this disparity?

Christopher: Part of these questions will be determined by the tax situation. If the tax-man is going to dictate that we can't pass everything on to our children, I will be gifting a number of works. I don't know exactly when I will do it or if I'll do it before it's absolutely necessary, but I will certainly be looking into distributing works around the world. Right now, there's a great deal of interest in Rothko in Central Europe, Asia, et cetera.

Kate: I certainly second that. Even if it were my greatest desire, and my children were one hundred percent committed, we would not be able to keep everything in the family. I think my father would be very happy with our looking outside the United States. Not that he was not proud of being an American—he was of the immigrant generation that immediately assimilated—but, in another way, he thought of himself as a man of the world. He didn't actually get citizenship until 1938.

Would the fact that your father came from Russia play a part in your thinking?

Christopher: I think the largest considerations would be where the greatest interest in Rothko was, and which institutions could best care for the paintings. There are social and political concerns too, although they are always shifting. How stable is the region politically? What is the level of anti-Semitism—which my father had been a target of? Of course, I don't know what the case will be thirty years on, but I feel that I need to make a decision that is as informed as possible by the current situation and previous history.

Kate: Yes, things change over time. For example, my father would probably never have sent a painting to Germany, but our perception is that, since World War II, it has become an attractive location for paintings and a country where there is an interested audience. One certainly is not whitewashing Germany's role in World War II, and I never would have made such a decision shortly after my father died, but since then we have supported exhibitions there. Politics do shift. For example, the St. Petersburg exhibition was supposed to have traveled to Istanbul, but I suspect it will not now because of the anti-Semitic terrorist attacks.

Is the fact that your father was Jewish relevant to his art and to certain museums?

Christopher: It's a very interesting question, and it's one that we do grapple with because my father really tried to make himself a painter, not a Jewish painter. That said, there are many people—and many whose opinions I respect—who talk about specifically Jewish elements in the work. These are more philosophical than painterly issues, but fascinating all the same. When we are considering exhibitions, it's something that we bring up. If, for instance, we decide to do an exhibition or a program with an institution that is specifically Jewish, does this pigeonhole my father in a way that he would not have wanted? At the same time, we may regard the institution very highly and think the project would highlight a real issue, whether my father felt explicitly that way or not.

Kate: It's hard to know what my father would have wanted. Growing up, I heard very few references to Judaism, not just in regard to his painting, but in his life, certainly in his family life. But, from what I've learned since, I think he was much more involved with

Jewish issues than I had any concept of. So he clearly never really lost that connection despite his desire to be a universalist.

Christopher, do you also try to think about your father's specific wishes when you're making decisions?

Christopher: Absolutely. He did not leave particularly detailed instructions, but his few statements make clear how he wants the paintings displayed, how important it is that the work is appreciated and looked at with a sensitive eye. He was extremely protective of his work and very concerned that it would be misunderstood. So, anytime we make a decision, I think first and foremost about what my father would have wanted. The same is true when we think about putting together groups of paintings in an exhibition, or even what paintings we would sell and where we would sell them. When we don't know his explicit wishes, we try to keep the spirit, and we know more or less how he liked the paintings hung.

Kate: I know there have been times when we knowingly have not followed his wishes, and I think the best example of that is group exhibitions. My father preferred his own paintings to be seen together, at worst in a room adjacent to a room of another artist's. But, if we have felt that the other pictures and artists are worthy, we have contributed to group shows. Sometimes when I am in the National Gallery, I remember that my father was very concerned about the right audience. There the audience is everyone who comes through Washington, some of whom will be sensitive and others not. I suppose I can rationalize that exposing more people will, in the long run, be a benefit. But sometimes I stand in the room and listen to the comments of tourists rushing through, and I wince. These are the trade-offs that one inevitably makes.

When you visit the Tate or PaceWildenstein, do you try to get the new generation of curators and assistants who are mounting the Rothko paintings to think about how your father wanted them lit?

Kate: I think we obsess about lighting, but I'm not sure we don't sometimes end up making a compromise. There is a great tendency now to use bright lighting, so we constantly try to tone it down. I remember that, during my father's 1961 exhibition at MoMA, he was notorious for turning down the rheostat a little further. The other issue is natural light. Most of the times I saw my father's paintings exhibited during his lifetime, they were not exhibited under natural light, but the great trend in museum architecture now is to use it extensively. Even if it's toned down to prevent light damage, it still isn't incandescent light.

What do you think would have been your father's reaction to the enormous interest in his paintings? And, how would he have felt about his room at the Tate and the installation of his paintings in the Menil chapel in Houston?

Christopher: Let's start with the specifics of the chapel and the room at the Tate. I think he would have been thrilled. There's nothing he wanted more than a controlled environment with just his work. I think he would have loved it—and I think he would have gone

Mark Rothko in East Hampton, N.Y., 1964.
© Hans Namuth Estate.

in and changed it! At the 1961 MoMA retrospective, he was rehanging paintings, perhaps even after the show had opened, and certainly up to the very last moment. With the chapel, maybe he would have been less inclined to do that because he literally had a studio here in New York—God knows how he found it—that simulated the space of the chapel. But still, to the degree that he could have changed it, he would have because he was very precise in that way. He understood the very delicate balances.

In terms of the groundswell of interest in the work—yes, it is probably at an all-time high. I believe it would have made him very happy *and* uncomfortable because, from what I understand, his response to success was to be very pleased and flattered by it, and then to question it. If people weren't responding, he wondered if he were doing something wrong; if people responded too well or too easily, he felt that, perhaps, he was doing something wrong. He wanted to make this very intimate connection and, if it got too broad or too easy, he would not be sure he was making exactly the connection he thought he was.

Kate: I think my father would have been pleased with how many young people attend the exhibits, not because he necessarily respected young people's opinions—because I

would say that was not the case—but because he would see that his art was having an impact from generation to generation, and that he had achieved that type of immortality.

As far as the two specific installations go, yes, I think he would have been very happy because each was created as a space for his paintings. Probably, if he knew how many permutations the Tate installation has gone through, he would be up in arms. He thought that it was meant to be a single permanent installation the way the chapel is. Also, one of the great draws of the Tate for him was Turner. Now, with the Tate Britain and Tate Modern, the physical connection between the Rothkos and the Turners is severed, and that would be upsetting to him. In terms of the chapel, I don't know what he would have thought about the lighting. Of course, there was a lot of controversy about that; one can argue that he should never have had a falling-out with Philip Johnson, who was perfectly correct in thinking that you needed this high spire in order to diffuse Houston light. The feeling in the chapel is so different at night, with the incandescent light and, to me, that is what he would have reacted to most positively. However, one of the things that visitors find most fascinating is the changes in the pictures with the change in the natural light. It's a shame that my father didn't get to experience this.

Do you think you have been influenced by the way your father always tried to maintain control: attempting to be his own dealer by selling from home, and assigning paintings to Marlborough?

Christopher: But how much of that do you think was really orchestrated by Bernard Reis?

Kate: I think some of it was, but you're right in saying that he still wanted to maintain some control. He must have had enough confidence in his stature in the art world by 1963 to think that he could manage these arrangements himself. But, as he approached the end of his life, one of his concerns was losing his control over Marlborough. And that, I think, is when other people came into play, unfortunately.

Is there anybody who cares as much about the legacy as the family?

Christopher: Frankly, if I didn't think that I knew and understood the paintings at least as well as anyone else, I would not put myself in the position of being at the vanguard of Rothko activity. That said, there are many curators and art historians whose opinions I respect tremendously, and whom I feel I learn from every time I interact with them. The essential difference is that they're working with lots of other artists, which gives them both less intensity of focus and a much broader perspective than I have.

Do you feel that your responsibility is to maintain a sharp focus on Rothko's work?

Christopher: I really don't feel I'm in a position to have the broader perspective. Dealing with the artist as a part of an era—that's something that I try to get away from, and try to get other people away from as much as possible, specifically because that is what my father did not want. He wanted painting that was universal: timeless was the word he used. He wanted to create art that communicated on such a core level that it could speak to anyone, even if they were five thousand years removed from us, although—I will give

you a quick glimpse of the book—he says that inevitably the philosophical and artistic, spiritual and intellectual climate that artists are part of will necessarily be expressed through their work. Philosophically, I understand that, and yet I think he was trying to create something that goes a step beyond.

What about the question of influence?

Kate: That's interesting in regard both to influences on my father and those whom he influenced. It's very hard for me to step back and look at those questions because I know how strongly my father would have felt about them. From everything I've read, both art historians and the minimalists themselves see him as a very strong influence, while my father would adamantly have said that his art was totally disconnected from them in any way, shape, or form. Of course, much of this argument focused on his philosophical view of art as opposed to what one sees on the canvas. So, it's very hard to put my father in perspective in terms of the whole era. I, therefore, prefer just to focus on his art and not get involved in some of these art historical arguments.

Are there certain interpretations that really seem wrong to you?

Christopher: For me, it's the interpretation of the later paintings, the facile way of saying that the paintings get darker because he's depressed, and his art ultimately leads to the suicide. If you know the body of work, you see that view time and again contradicted by bright and effusive paintings that he was simultaneously working on. I think this simplistic notion ultimately refuses a real grappling with the work and reflects a misunderstanding of the spiritual elements at the core. When I say spiritual, I don't mean in the larger religious sense; I mean in terms of an internal, and not very quantifiable, response.

Kate: The only instance I can think of when I tried to use my clout to avoid something was the showing of a television production many years ago. By withholding copyright to the images of the paintings, we had hoped that we could stop them. Unfortunately, we ended up not being successful. They simply said they were going to fake the paintings, which I'm certain they would have, given the lack of quality, of this production.*

Christopher: Today, I think we would have been successful since we are a little more familiar with copyright laws.

Your father was very careful sometimes about who was allowed to own his work.

Christopher: That's not an area that I think either of us especially feels drawn to, but a museum is always our first preference. The second is substantial collectors, although that can be a double-edged sword because sometimes they turn over the paintings relatively quickly. So it's a little bit of a dicey process.

Are there other goals that have not been mentioned?

Kate: I would say our ultimate goal—but rarely possible to achieve—is to place groups of paintings, either ones that we feel were originally intended to be together, or those that work well together. Our one real success in that vein was to place one of the alternative groups to the Tate Gallery murals in the Kawamura Memorial Museum in Japan, where it's permanently installed in its own pavilion. These are obviously rare

opportunities—not just because of the money needed to purchase a group of works, but because of the permanent space required.

Is there another grouping that you would like to see realized?

Kate: It would be wonderful if we could place together, or create a room for, a group of paintings that my father did in the last years of his life—what have sometimes been called the black and gray paintings. We've also thought about some works on paper of that period, which form a unique group. But, again, to find the appropriate venue isn't easy. The space and permanency commitment is very, very difficult to achieve at this point.

Anything else, Christopher?

Christopher: Future shows. Exhibition lead-time at museums is very long, and in 2004 you need to be thinking about 2008, or 2010 in many cases. So, just when you feel you can rest up a bit because you have gotten one exhibition out, you really need to be thinking about the next. I find at times that I'm so busy "returning serve"—dealing with the day-to-day aspects—that I don't have the time to make long-range plans. And then I regret that I haven't put aside some of the things that may be less important.

Can one ever have too many exhibitions of Rothko's paintings?

Christopher: Absolutely. Around 2000, I said, "No big retrospectives for a while." There had been too many big shows in the previous six years, and multiple ones per year if you count different stops for each show. You're not going to get the loans from collectors in that situation, and additional exhibitions would have ended up compromised. Even if we're dealing with the global cultural art market, there's still a saturation point. You have to keep people a little bit hungry!

Kate: There were about twenty years between the two American retrospectives—probably not unreasonable. Now that there have been a number of shows in Europe, we may not have additional audiences there unless we have a new venue. Another problem is that, in recent years, the likelihood of an American lending to a show in Europe, which is the third stop after two in the U.S., is really slim. So we've tried to put on a lot of pressure to get European loans. It's discouraging—as the paintings become more valuable and begin to be viewed as investments, people become less willing to lend to exhibitions. Yes, there is a risk whenever we lend to a show but, if the paintings are sitting in the warehouse, they're not being seen the way they should.

Do you have the names and addresses of most of the owners of Rothko's work? So often in catalogues the caption says "Private Collection."

Christopher: I don't pretend to know all the various private collectors. Sometimes the gallery dealers know. Oftentimes, I need to send a letter to a curator at the National Gallery, who will forward it to the collector, but who is not at liberty to reveal the name to me. As long as these collectors are willing to let their paintings be seen publicly, it's their prerogative if they want to remain private.

Kate: The individual private collector has to have that assurance of anonymity. That was certainly true when David Anfam tracked down "owners" of the paintings that I knew

were still owned by Marlborough and probably not disposed of in the most legitimate fashion. But, if those paintings were to be included in the catalogue raisonné, that information had to remain confidential.

Christopher: On the other side, many times the curator will ask me to convince a given collector or museum to agree to a loan that they have so far refused. Frankly, I am surprised that a remarkable percentage of the time they will if I make the personal contact, so I do. So, even if I'm not curating the show, we are always in on the ground stages—making loans, et cetera. If the exhibition is not the best, I feel as though it is partially my problem. We're so identified with the work that the outcome of the exhibition is part of the family's legacy—whether we want it to be or not.

You both express your intimate relationship to the paintings so movingly that it makes me wonder how you reconcile these feelings with the commercial aspect of the situation.

Christopher: On numerous occasions, after a painting is sold at auction—and I should just clarify that we've never sold anything at auction or directly benefited from an auction sale—people come up and congratulate me, and it seems very strange. This is not what the art is about. However, it's very expensive to maintain the work. It's a constant drain to do it correctly, and we're not even doing it as correctly as we would like. The fact that the paintings are valuable makes it more expensive to take care of them, but it also is helpful in that, occasionally, we do make sales.

Kate: You're right. The immediate reaction to high prices at auction is, "That's very flattering." Then you step back and say, "Is that really an advantage to us?" We once thought we could leave a substantial number of paintings to our children and, in a sense, this success is interfering with that. Certainly, during the lawsuit, the whole question for me was the paintings themselves. There was no possibility that any monetary settlement was going to make up for the paintings, and that had nothing to do with anticipating that there would be this incredible increase in value. In fact, at the time one might have thought it would have been advantageous to agree to the settlement, particularly when we were not that optimistic about the outcome. So, for me, it was always the paintings, and I can separate the two worlds emotionally. One of the saddest outcomes of the sales that were made by Marlborough is that many of those purchasers bought the art as an investment and either resold it or, sometimes, buried it in someone's vault, where it still sits, never to emerge but maintaining its value.

February 2004

For Further Information

Anfam, David, ed. *Mark Rothko: The Works on Canvas*. National Gallery of Art, Yale University Press, 1998.
Breslin, James E.B. *Mark Rothko: A Biography*. Chicago and London: University of Chicago Press, 1993.
Weiss, Jeffrey. *Mark Rothko*. Washington: National Gallery of Art, 1998.

Stephen Polcari, born in 1945 in Boston, received his B.A. from Columbia College, New York, in 1967, his M.A. from Columbia University in 1971, and his Ph.D. from the University of California, Santa Barbara, in 1980. His concentration and research interests are in modern and post-war art and intellectual, cultural, and political history and theory. He has taught at various colleges and universities, most notably the University of Illinois, Urbana-Champaign (1979–1983) and the State University of New York at Stony Brook (1983–1990). He has contributed to many exhibition catalogues and magazines, participated in symposia, and curated exhibitions (for the institutions he has worked for and as guest curator of others). He has published *Abstract Expressionism and the Modern Experience* (1991), and *The Portal/Pousette-Dart* (1998). He is currently the John Garber Drushal visiting professor of art history at the College of Wooster, Wooster, Ohio, and is working on two books: *Jackson Pollock's Design for Change* and *Mid-Century American Art and Modern History*.

In the early 1980s, F. Ivor Avellino approached Jon Schueler about giving his papers to the Archives of American Art. Although I shared Schueler's conviction that this material should be in the public domain, I subsequently found it expensive and time-consuming to go to Washington, D.C., when I was researching information for the publication of Schueler's autobiography *The Sound of Sleat: A Painter's Life*. None of the Schueler material has so far been put on microfilm, even though the restricted access was removed in 1993. A later request to have the material temporarily transferred to New York so that I could work in the AAA office there was turned down due to severe government cutbacks. Curious to find out about current strategies for collecting material from artists or their estates, I talked with Stephen Polcari, who had spent seven years as director of the New York branch of the Archives of American Art.

. . .

Steve, what are some of the most recent changes?

The preservation of artists' records during the last twenty years has become increasingly complicated. First, the American family now often includes several husbands and wives, and so the artist's belongings get scattered and even lost. For instance, everybody would be fascinated to hear about the first Mrs. Clyfford Still, her life with Still, and whether she has any records, letters, or works, which could be invaluable to scholarship.*

Often, collecting for the archives and trying to preserve records, you have to negotiate among family members. Sometimes you can't. Material ends up in the hands of a new spouse of a former artist's spouse who has no direct connection with the actual artist, and it gets burned or discarded.

A second issue is longevity. There's time for more marriages, and the children and grandchildren of all those marriages double and triple the complications. Up until the 1960s, the average lifespan was about sixty years. Now it's about eighty, and you have famous artists whose lives the public wants access to, whose papers are kept by family members for another twenty years. There is, for instance, a Mrs. Archipenko,* one of the wives of Alexander Archipenko. The great cubist sculptor died decades ago, but his wife is still alive and can control access to his papers.

A third major change is the establishment of foundations. In the eighties, the government started taxing artists' estates. The issues of museum donations and tax deductions got very complicated; the artist could only deduct from a museum gift the cost of the work's potential in terms of paint or canvas, and not the real worth of the work of art. Well, foundations were a way to beat this situation, and they kept most of the works, as well as the papers and records of the artist together.

The aim of the Archives of American Art is to get papers into the public domain so curators and scholars can pursue their work without prolonged delays and without having to comply with the families' wishes. Foundations, however, not only keep papers within the family, but often inhibit scholarship by being uncooperative and by exercising favoritism.

Furthermore, the material isn't always given professional treatment—archival processing and protection, such as the right paper or the right acid-free folders. The public handles the papers, which is damaging, and not necessarily under the best security conditions.

However, the recent cuts in funding to the Archives of American Art don't encourage the artist's family to entrust material to it.

Yes, the Archives of American Art, the single agency devoted to the collecting and preservation of the papers of American artists, can no longer even actively pursue papers, and it has discontinued its big oral history program. The office of the archives in New York, the leading city of the arts, is small and really has no presence.

However, no other country has a national agency devoted to the collecting of papers of artists of all ages and eras. Anybody who's ever done research in Europe immediately runs into the problem of knowing the right people in order to get access to the collections. We would get letters from European scholars asking permission to use the archives. In America, you don't need permission. Just show up, and it's there. Five minutes later you will have the microfilmed papers of major cultural figures.

When you were in a position to choose from an artist's estate, what papers and what material were you looking for?

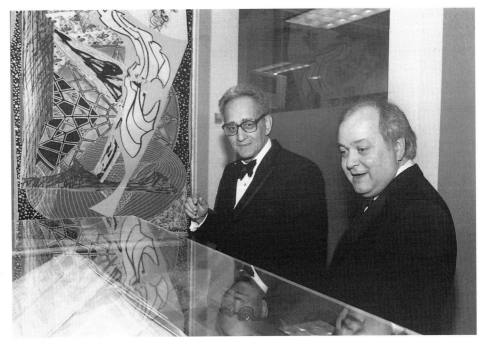

Stephen Polcari (right), with Frank Stella at the Archives
of American Art, 1993, celebrating the donation of
Stella's notebooks. © Stephen Tucker.

My impulse is that one should err on the broad side. One doesn't know what in the future we'll want to know or what will be important. There are no criteria for artists, and we also have collected the records of art historians, collectors, dealers, and galleries; any letters, manuscripts, teaching notes, clippings of the artist's career, notebooks, and sketchbooks. We didn't have the facilities to take real works of art, but we own more than half a million small works on paper and are probably the biggest unknown repository of these works in the country.

Our collection of photographs documenting artists' work and informal, personal photographs was up to three quarters of a million. Some of these are very interesting. If you look closely at art books, you will see that many biographical photographs are from the archives.

I also collected information relating to the economic and social history of an artist. For instance, we have collected the checkbooks of Frank Stella. Now people think that's odd, but actually it's quite wonderful. Wouldn't you like to have the financial records of Michelangelo?

We do microfilming, which is an old and venerable tradition. Technology comes and goes, but microfilm lasts forever. The archives sends these microfilms all over the world as interlibrary loans.

Has the archives made use of the Internet?

Yes. All of our collection has been computerized in the last five years and can be accessed through the Smithsonian Institution sites. There is a brief description of what the archives has, when it was collected, its accessibility, et cetera. The raw material still isn't completely on the Internet, but transcriptions of oral histories and other things are.

Where is the vast amount of material kept that the archives owns?

It is processed in Washington, and the most frequently requested material is kept in a warehouse in Washington proper, and one in Maryland. Material seemingly not in great demand is in the salt mines of West Virginia along with other national records. There's a ton of material there, which can be retrieved within a short time. The archives had fourteen million items when I left. Thirty to forty percent of it is on microfilm.

Some artists leave their papers to universities. Do they compete with the archives?

No. The archives can't do everything. The Museum of Modern Art has a much larger profile than the archives, and artists who had shown their work there thought it would take their papers. But the Museum of Modern Art can get swamped by this kind of material. We cooperate with them, suggesting to artists that they come over to the archives instead. It is really a complicated issue.

How well can the archives respond to requests for copies of photographs? And, how do you respond to those people who feel that the material not microfilmed is rather inaccessible?

The archives does respond to requests for photographs, and loans its works on paper for exhibitions—which are both time-consuming. There's really no easy solution for researchers. Shipping boxes back and forth is prohibitively expensive and dangerous to the materials. As the regional offices are cut back, the national office in Washington becomes even more important.

Do you expect material to be in good order before you accept it?

We take collections in any order—from garages, basements, attics. Incidentally, as a way of securing a collection, we've accepted some with limitations of access during the artist's life or the life of the spouse, when this seemed a reasonable compromise.

In view of cutbacks, does the archives need to rethink its purpose?

Some people now want the archives split off from the Smithsonian, but I don't see the funding for it. My attitude is that, maybe, the country will get confident again and spend more money on government institutions. The archives has problems, but there's no substitute for it. The art world is a multibillion-dollar industry that needs to recognize its responsibilities. People don't realize that the archives is partly a private institution with a board of trustees that is supposed to raise thirty or forty percent of its budget annually. The unique aspect of America's art funding is that it is based on the need for the private sector to always do more than the public sector. You must understand that people giving grants, et cetera, want their names up in lights. I just hope there's some mature person with deep pockets who contributes from time to time to the archives.

Does the artist's family get any tax deductions by giving papers to the archives?

Yes, there are tax write-offs for anyone who donates. We can't suggest what they should be since we're a government agency, but professional evaluations are made all the time. It's the American way.

Is it undignified to emphasize estates giving away works of art? Peter Stevens, who looks after the David Smith estate, feels that museums value a work less when it is gifted.

I don't agree. Museums should be getting gifts because there are very few acquisitions—only when it's necessary to fill a particular gap in the collection.

Despite your reservations about foundations, are there some that have worked very well to promote the artist's work, and to get the artist's work out into museums and into exhibitions?

There are some foundations that really do a wonderful job. For instance, the Gottlieb Foundation here in New York has a mandate to do shows, encourage publications, do conservation, and preserve what papers there are. They have been very active in promoting the work for twenty-five years. That's kind of ideal. It also supports artists. These programs can be creative in a way the archives cannot. The Motherwell, or Dedalus Foundation, as it's called, has a branch that gives out money for shows that promote modern art and modernism. It also awards grants for arts education, which reflects Bob's own interests.*

Then there is the Pollock-Krasner Foundation. It has works, of course, and Lee Krasner left $30 million to this foundation in 1984.* It gives grants to individual artists, not organizations or institutions. I was involved in preserving the house and studio in Springs, New York, that Lee and Jackson purchased in 1945. It's become the Pollock-Krasner House and Study Center, run by the Stony Brook Foundation, a nonprofit affiliate of Stony Brook University. Lee didn't leave any endowment for this property and the reference library, but she did leave money for an annual fellowship and residency for a scholar, which is a pretty good use of her profits.*

Other foundations are set up without any works at all, just with several filing cabinets of papers. I don't see why they have to exist separately from the Archives of American Art.

Which foundations don't have much work?

The Barnett Newman Foundation is one. By the time Annalee Newman, the widow, died in May 2000, she had given away virtually all the works to museums around the world. She did fund a catalogue raisonné for Newman's work, which the foundation is overseeing and which will be very useful.

Do you think that there is a genuine philanthropic intent rather than just using the foundation to stop the money from going to Uncle Sam?

I think there are mixed reasons. Either Uncle Sam decides how the money will be spent, or you make your own choice. Foundations have to give a certain percentage away—five percent annually. We understand the self-interest involved, but those who benefit culture or society, whatever the reasons, shouldn't be denied their freebies.

Is there a more equitable kind of taxation system that we should be working toward?

I don't know any system that is fair. The market is not a great system. Having the government affect things is not a great system. There's no great system. Don't forget, American cultural institutions have long been funded from private money, and a few deals, tax abatements engendered by government, work very well.

The Europeans are now trying to encourage this American idea of private philanthropy for the arts. It's nice to be fully funded by the government and have no worries, but that's a very centralized and controlling situation. We have a free-range, free-for-all system. It's the nature of America, and no one really wants centralization. Who would you have as art czar? God forbid! We had one with Clem [Greenberg] for twenty years, and no one was really happy about that.

Don't the trustees of museums have much more power now than in the past?

You know, in America you can achieve social importance through cultural generosity. Trustee boards are filled with social climbers. What can we say? Don't social climb? It's been around since the beginning of time. Artworks have become so expensive that curators can't buy as much as they once did. They truly have to depend on the generosity and kindness not of strangers, but of their trustees. I don't see a way around it, except by having an adequate acquisition fund once removed in terms of the trustees. But careers of directors are built around the acquisitions and buildings they have gotten.

Does the Getty Museum play a role in contemporary art?

Yes, this the fourth major change. The Getty is now a competitor, collecting papers concerning twentieth-century American art, and it offers money, which we can't. We have lost collections to the Getty from people who had promised them.

Which artists have sold their archives to the Getty?

Harold Rosenberg's daughter sold the collection—under consideration for the archives—to the Getty, despite knowing that Harold [art critic and writer] probably never set a foot in California. The artist Allan Kaprow's material, promised to the archives, went to the Getty. The Getty is a force unto itself. What the Getty wants, the Getty gets. We were in neck-and-neck competition for the papers of Leo Castelli about five years ago. Leo said the papers should go to the Archives of American Art, but the Getty offered quite a substantial amount of money. In the end, they never could close the deal, and he died. They'll probably be sold by the very young widow of Leo, an Italian woman who now is in charge of the situation. The Getty needs to fill up those beautiful buildings with important manuscripts. But the Getty, unlike the archives, won't microfilm material or put its catalog on the Internet, so scholars will have to go to California to see what it has. At one time, the Getty said that if it collected papers the archives was interested in, they would share them with us. But then they dropped that policy, and now it's catch-as-catch-can, and the Getty can catch quite a bit.

I had always hoped that Peter Stevens would formally hand over the David Smith papers, on loan for some forty years, to the archives. A lot of work went into cataloguing them and putting them on microfilm. But, about two years ago, Peter requested all the

photographs and exhibited about a hundred of them at Matthew Marks Gallery here in New York in 1998. The price for some was $200,000. They never came back. But, of course, the David Smith estate is probably supporting the two daughters, Peter, and their children [see Part Seven].

In fact, it wouldn't surprise me if many collections from the generation of the sixties don't come to the archives. For instance, Roy Lichtenstein had always indicated that his papers would go to the archives, and we honored him at a special dinner party, but after his death his widow decided to set up a foundation. Dorothea Tanning has already set up hers. There's nothing we can do about this. I guess you'd have to change the tax laws to change the attitude because that's what's causing all this foundation forming. But we did get Frank Stella's material.

November 2000

RALPH LERNER
ON ART LAW

Among the most remarkable phenomena of the last decades . . . has been the escalation of the public's interest in art. . . . Then, as the result of the huge financial implications of art transactions, the laws governing them have mushroomed, as has their complexity. In the 1950s "art law" did not exist.

—Pierre N. Leval*

Ralph E. Lerner has been a partner in the New York law firm of Sidley Austin Brown & Wood since 1987. He was educated at Bucknell University (B.S. 1964), Boston University School of Law (J.D. 1967), and New York University School of Law (L.L.M. in taxation, 1969). He is a specialist in art law and individual tax and estate planning, general counsel for the Appraisers Association of America, and chair of the art law committee of the Association of the Bar of the City of New York. He is the coauthor, with Judith Bresler, of *Art Law: The Guide for Collectors, Investors, Dealers, and Artists.*

I had hoped to interview Philip Rickey on how he and his brother would manage the estate of their father, the sculptor George Rickey, who died in 2002. However, as my request was a little premature (plans were still being worked out), Philip instead introduced me to his lawyer, Ralph Lerner. As Lerner's book on art law has become standard reading, I was delighted to arrange a telephone interview with him.

. . .

Mr. Lerner, how do changes in law relating to art come about?

Change comes from interested parties like the Art Dealers Association of America, the National Artists Equity Association [now defunct], or the Association of Art Museums Directors obtaining the support of a member of Congress, particularly one with connections to the finance committee.

Can you comment on the radical changes in taxation related to artists' estates since 1969?

Since the Tax Reform Act of 1969, artists—as opposed to collectors—are unable to deduct the full market value of their artwork when they make donations to charitable institutions. Therefore, the number of gifts by them has declined drastically. The bill pending in

Ralph Lerner, 2001. Courtesy Sidley Austin Brown & Wood.

Congress, the Art and Collectibles Capital Gains Tax Treatment Parity Act, deals with this question.* It would allow the deduction (at fair market value) to be offset against the income of that year from sales of work or professional activities. It's been introduced for years and refined, and it's gotten to a point that it actually has a chance of passing.

Who is introducing that bill, and what else does the bill deal with?

Republican Senator Pete Domenici from New Mexico and Democratic Senator Charles Schumer from New York. Of course, both these senators are concerned about their own states. Santa Fe has the third largest art market in the country, according to Domenici.

The other section of the bill is concerned with capital gains parity, lowering the capital gains rate on the sale of artworks and all collectibles, to fifteen percent rather than the current rate of twenty-eight percent. Congress is always screaming about simplicity and unnecessary complications, and then it decides to penalize art collectors.

Why?

General hostility to the arts, and everything to do with the arts, from our Congress.

To turn to the droit de suite, or the resale tax, on artwork. In your book, you explain that French law allows artists to collect three percent of the sales price of an artwork when it is sold at a public auction, and that now the European community is trying to harmonize the variations of such laws among its members.* But you appear to feel that it is too complicated and expensive to adopt in the U.S.

It's a dead duck, 100 percent. It'll never pass in the U.S., even though, of course, you still have it in the state of California, where an artist receives five percent of the resale price during his lifetime and for twenty years after death. I don't think it's a great help to artists anyhow. Congress would reconsider the resale royalty only if the European Economic Community adopted a unified standard and if international copyright treaties required compliance by the United States.

Another way that artists are trying to exercise control is through urging their galleries to negotiate a right of first refusal when an artwork is being resold by their client.

Do you approve of this?

No. It may work with the first purchaser, but then it becomes a restraint on free trade. The marketplace should dictate the price of the art. Maybe, from the artist's point of view, it offers some protection, but I think free trade should always win out.

But, isn't it a way for the gallery, which may have borne all the financial risks in show-ing and promoting an unknown artist for many years, to have the possibility of making a profit?

Yes, but the second and probably the most important aspect is that the gallery and the artist don't want it dumped on the marketplace at a cheap price. That would impact future sales for the artist.

You also discuss the various moral rights of the artist, or the droit moral subscribed to by the 117 members of the Berne Convention. You suggest that the U.S. was very slow in adopting these rights, which seek to protect the integrity of the work as an expression of the artist's personality or spirit.

VARA (the Visual Artists Rights Act of 1990) represents a belated victory in this area for the United States. It's a step in the right direction, although it still falls short of the pro-tections envisioned by the Berne Convention's Article 6bis. It protects an artist from hav-ing his work tampered with, gives him the opportunity to reacquire a work before it is destroyed, to withdraw or modify a work, and so forth.

The battle over the Richard Serra sculpture involved a droit moral, the Right of Integrity. You probably remember that *Tilted Arc* was installed in Federal Plaza in downtown New York in 1981. The sculpture immediately generated controversy. At the public hear-ing in 1985, Serra testified that the sculpture was site-specific and that to remove it would be to destroy it. He also stated that if the sculpture was relocated, he would remove his name from it. The jury voted in favor of removing the sculpture. When the appeal by Serra failed, in 1989, federal workers during the night cut *Tilted Arc* into three pieces and carted it off to a scrap metal yard.

What other moral rights are important?

Perhaps the most controversial and interesting is the Right of Authorship or the droit de paternité, which applies, for instance, in France. It's the right to prevent the work from being attributed to anyone else or attaching the artist's name to works that he or she did not create. It affects the authentication of works of art because in France the artist's descen-dants have those rights, although they might not be particularly knowledgeable. Once it gets outside of the direct descendants of the artist, I think it becomes a tricky business. It's open to misuse and subjectivity.

In the U.S., we sometimes have the artist's widow or family authenticating work, but usually we have self-appointed people who prepare a catalogue raisonné. This is some-thing I urge artists to do, thereby establishing their right to say something is either authentic or not authentic. There should be a blood relative, too, who has knowledge of the artist and his or her work; it should be a group decision, not that of one person.

If there's a foundation, the people selected should deal with most matters of authen-tication, using archival records. This is an area that I think is in a state of flux right now. There really isn't any case in the U.S. that recognizes the French law, and the French law itself is a little vague.

Even in America there have been all sorts of difficulties to do with people who think they've got a Jackson Pollock or an Andy Warhol.* When the authentication board disagrees with them, they sue despite having agreed not to.

Yes, that's correct.

Turning to tax law as it affects inheritance: artists and their survivors can set up foundations, make annual gifts worth up to eleven thousand dollars of works of art, decide whether it is worthwhile to donate artwork to not-for-profit institutions, and get involved in other planning techniques to reduce taxation. What are the strengths and the weaknesses of the American system compared with, for instance, the British, German, or French?

The American system, I think, is the best because the income tax reduction provides a real incentive for people to give property to public museums. You can buy something for one thousand dollars. If it appreciates to a worth of ten thousand dollars, and if you donate it correctly, you get a deduction of ten thousand dollars, which saves you a minimum of thirty-five hundred dollars in tax. So, you get your cost back, which is one thousand dollars, plus a twenty-five-hundred-dollar profit, which is not taxed—so it's a great tax shelter. Most European countries do not have that kind of incentive. The European system is better when it comes to inheritance tax.

Why?

Because in France and, I think, the U.K.—unlike the U.S.—you can arrange to pay part of your estate tax with works of art. I had an estate that included some ten or eleven fabulous items that had been on loan to the National Gallery in Washington for twenty years. I told the IRS, "Look, we'll give you these items in payment of the tax. You can appraise them, and we'll just offset that amount against our tax." When I got hold of the people in Congress to discuss this, I could not convince them. They said it would show favoritism, and they came up with all kinds of excuses. It just didn't make any sense to me. Instead of being available to the public, some of those treasures are now privately held. Both Maine and New Mexico have some provision at the state level.

An accountant called David Schaengold argued that an art estate should be viewed for tax purposes as an interest in a business, and the taxes at death based on actual—not future—earnings.* So he is advocating a deferred tax. Doesn't that seem rather sensible?

I don't actually agree with that. Not only is it not practical for the government, it's also a good thing for the artist to be done with the IRS. There are ways to reduce the tax: set up a foundation, apply for a blockage discount, et cetera. If you don't pay the tax when the artist dies, you will later at ordinary income rates. Maybe that would work, but the current system is so inbred that it's not realistic to expect Congress to enact a change.

You don't think so? After all, we do accept the sales tax on almost everything we purchase. We know that in the state of New York there's an 8.625 percent tax on the sale of works of art, unless they are sent out of state. Of course, that doesn't always work smoothly, but the complicated apparatus for collecting that state tax is already in existence.

Well, Jerrold Nadler, a New York City representative, has already tried this. He rein-

troduced the Artists' Estate Tax Fairness Act (H.R. 147) in January 2003, which seeks to amend the Internal Revenue Code of 1986 to exclude from the gross estate the value of works of art created by the deceased artist. However, it was referred to the Committee on Ways and Means, and I can't see it ever getting passed.

Going back to dealing with current estate taxation, you very vividly suggest the difficulties for the professional appraiser and discuss the system of blockage, which is important to the gift tax, as well as for federal estate taxes. Critical of the discrepancies in court pronouncements, you have devised your own three-tier categorization of the artists' works: major works, less important works (those that can be sold with considerable effort and over many years), and insignificant works (mere studies and unfinished works not usually sold). The smallest discount would apply to category one, and the largest for category three. Have your ideas filtered down into the system?

I've used it in the administration of estates at least half a dozen times, and the IRS accepted it. So, yes, that's how blockage is interpreted now. The court valuation of the Warhol estate in 1994 was unusual. It allowed a twenty percent blockage discount for the 4,118 paintings, twenty percent for 66,512 photos, thirty-five percent for 5,103 drawings, and thirty-five percent for 19,086 prints. However, it failed to take into consideration the medium in which the artist usually worked. The market for Warhol's Polaroid photos at his death was negligible, so the discount should have been much higher. My system is more rational and, as I said, the government seems to agree.

Could you comment on the proliferation of artists' foundations? This seems to be quite an American way of avoiding estate taxes.

There are more of them, in part because I've been lecturing for years that that is a correct and smart estate planning methodology. Taking the lesser property and putting it into a foundation gives you the ability to substantially reduce the tax. The second advantage is this: Let's suppose an artist has left five hundred items of which one hundred are great, three hundred are medium, and two hundred are poor. Even though you have blockage that could apply to that, if I gave half of those items to a foundation, I still apply my blockage as if there were five hundred items owned at the time of death, not two hundred and fifty. So the discount that I'm allowed for tax purposes is based on five hundred even though two hundred and fifty are zero tax because they go to a foundation. I can leave the other two hundred and fifty—the nonfoundation items—to children at a much lower tax rate. It works out as a very good planning technique.

Interesting. Are there any other advantages to forming a foundation?

A foundation gives you a central place for administering the artist's works, whether there be a catalogue raisonné or not, and exerting some control over the market and the licensing or reproducing of images. So there aren't a lot of children out there, each trying to sell through a different dealer, or whatever.

With the new electronic technology for digital imaging, are we going to see a change in copyright law to do with the reproduction of artists' works?

I don't really know where that's all going. I'm not a copyright authority, but it's the commercialization that is much more difficult to control. If an image is stolen and put on a tee-shirt or some commercial product without the artist's permission, the artist can sue for damages or hire a person to stop the unauthorized use of the image.

Yes, the Artists Rights Society (ARS) and the Visual Artists and Gallery Association, Inc. (VAGA) control the use of images for the artists or institutions they represent, and collect copyright fees for reproduction. The result is that it is often extremely expensive for art historians to have as many reproductions as they would like in their books.

Yes. Publishers always want the authors to go out and obtain all those rights. It's time-consuming, but that's the society we live in. In my experience, you only pay a very nominal amount for reproduction rights. If the use is educational and enhances the artist's reputation, then I encourage my artist clients to let their work be reproduced for free. It's to the artist's advantage to get their images in books.

What about the diminishing role of the Archives of American Art because of government cuts? Do you think there is a national obligation to try to save the nation's cultural records, including artists' papers?

Absolutely. It's an embarrassment how the U.S. government treats the arts. The arts bring in a phenomenal amount of tax revenue to this country; yet, if you need funding for the arts, it's almost nonexistent percentage-wise compared with other countries. A sports team can build a stadium with public funding, or gain tax concessions, even though it won't bring in a fraction of the attendance or revenue that museums generate. I think the U.S. government should be embarrassed by the way it treats the arts. It curtails not only funding for the Archives of American Art, but for the National Endowment for the Arts. It's absolutely outrageous.

Which countries present alternative models?

I think the British, French, and German governments are all very supportive of art and realize that it's crucially important. Spain was very supportive of building a new museum—it brings in a huge number of people. Their governments buy art for the nation. The European countries laugh at us. The fiasco with the Brooklyn Museum—it's a joke.*

Are there now law firms that only specialize in art law?

No. There are some single practitioners who do a lot of art law but, if you want to earn a living, you have to be able to do multiple things. So I'm a tax lawyer by training, and I do trusts and estates.

Since the second edition of your book, have there been major changes that will necessitate a third edition?

Yes. One is the Copyright Term Extension Act that Congress passed in 1998. By extending the 1976 Act by twenty years, the United States's duration laws virtually harmonize now with those of the European Union. That means that, for works created after January 1, 1978, copyright protection will endure for the life of the author plus an addi-

tional seventy years. For works created but not published or registered before January 1, 1978, the term also endures for the life of the author plus seventy years. These are two of the main points. For artists this, of course, applies to the control over the reproduction rights of their work. For pre-1978 works still in their original or renewed term of copyright, the total term is extended to ninety-five years from the date the copyright was originally secured. This delay of work entering the public domain was criticized by some groups as being an unwarranted victory for the huge media and music conglomerates, which reap large profits from copyrighted movies, songs, and cartoon characters, and so on. In fact, the Eldred V. Ashcroft case challenged the Copyright Extension Act of 1998 but lost in January 2003. By the way, in 1790, copyrights in the United States lasted only fourteen years.

Is there anything else relevant to artists' estates that will be coming up in the near future?

There's a possibility that private foundations, to keep their tax-exempt status, may have to pay out more than five percent of their assets each year (perhaps six percent), or that the five percent be entirely spent on charity, rather than being able to include administrative expenses like rent and salaries in that target amount. This came up in the House of Representatives this May [2003].

If they repeal the U.S. inheritance tax, that will radically change how artists' estates are handled, and then there may not be artwork going to foundations or museums because there'll be no incentive.

Could you remind me of the present situation?

Under the new law signed by President Bush in June 2001, the value of assets exempted from the death tax gradually increases until, in 2009, it reaches $3.5 million. In 2010, the tax would be entirely eliminated, making it a good year to die in for your heirs. The tax then reverts to 2001 levels (allowing an exemption of $675,000 before taxation), but the Republican-led House of Representatives this June [2003] voted to make permanent the repeal of the estate tax. The Democrats called it totally irresponsible, and I doubt it will come into being. But I expect that a generous exemption will be in place again by 2011.

On the whole, you feel that the American system of taxes related to art is reasonably fair?

As long as it's modified by blockage and a generous gift exemption, the system seems to work.

November 2003

For Further Information

Lerner, Ralph E., and Judith Bresler. *Art Law: The Guide for Collectors, Investors, Dealers, and Artists.* 2 vols. New York: Practicing Law Institute, 1989; second edition, 1998.

JACK COWART
ON THE
ROY LICHTENSTEIN
FOUNDATION

I am nominally copying, but I am restating the copied thing in other terms. In doing that, the original acquires a totally different texture. It isn't thick or thin brush-strokes, it's dots and flat colors and unyielding lines. It seems to be anti-art, but I don't think of it that way.

—Roy Lichtenstein*

Roy Lichtenstein was born to middle-class parents, Milton, a real-estate broker, and Beatrice (née Werner) Lichtenstein, on October 27, 1923, in New York City. He and his sister grew up on the Upper West Side. He studied with American scene painter Reginald Marsh at the Art Students League in 1939, then at Ohio State University from 1940 to 1943. In 1943, he entered the United States Army, serving in Europe as a cartographic draftsman until 1946. He returned to Ohio State, and after obtaining a B.F.A. degree that June and an M.F.A. in 1949, he taught there until 1951. In 1949, he married Isabel Wilson, assistant in the nonprofit 10–30 Gallery in Cleveland. Their sons, David and Mitchell, were born in 1954 and 1956. Between 1951 and 1957, Lichtenstein worked intermittently as an engineering draftsman in Cleveland and at other designing jobs while continuing to paint. His final period of teaching was at New York State College, Oswego, from 1957 to 1960 (where his work was abstract expressionist), and at Douglass College, Rutgers University, New Jersey, from 1960 to 1964. His first paintings of comic strip characters and speech balloons appeared in 1961. With their exhibition at Leo Castelli the following year, he was launched as the leader of the new pop style and moved into New York City in 1963. He was divorced in 1965 from Isabel, who received custody of the children, and married Dorothy Herzka in 1968. In 1971, they moved to Southampton, New York, but after 1982 they maintained the option of living and working in the city.

A lifelong interest in the machine quality of printing, whether in newspaper and magazine advertisements or in art magazines and books, as well as the art deco style, provided a wealth of material for Lichtenstein. Usually working in series, he began in the mid-1960s —with deadpan humor and using emphatic forms and colors—to make pop versions of twentieth-century styles, working his way through cubism, futurism, surrealism, and so on. Beginning in the early 1980s, he created witty sculpture cutouts, sub-

sequently fabricated on a large scale for public plazas or sculpture gardens. He died of pneumonia on September 29, 1997, at the age of seventy-three.

Jack Cowart, who was born on February 7, 1945, and brought up in the western suburbs of Philadelphia, received his B.A. (history) in 1967 from the Virginia Military Institute, Lexington, Virginia, and his Ph.D. (art history) in 1972 from Johns Hopkins University, Baltimore, Maryland. He was assistant curator of paintings at the Wadsworth Atheneum, Hartford, Connecticut (1972–1974); curator of nineteenth- and twentieth-century art at the Saint Louis Art Museum, St. Louis (1974–1983); head of the department and curator of twentieth-century art at the National Gallery of Art, Washington, D.C. (1983–1992); and deputy director-chief curator of the Corcoran Gallery of Art (1992–1999). His major publications include monographs and studies on Roy Lichtenstein, Henri Matisse, Ellsworth Kelly, and Manuel Neri. In 1999, he was appointed the founding executive director and member of the board of the Roy Lichtenstein Foundation. He is married, has two children, and lives in Virginia and New York.

The double storied, skylit, sixty-by-eighty-foot former studio of Roy Lichtenstein in the West Village of Manhattan now houses the foundation that his widow formed in his name. Its new function is reflected in the office compartments and the bank of filing cabinets that take up two sides of the room. But, as I saw when I went to visit Jack Cowart, the foundation's director, the presence of Lichtenstein was still strongly felt: his painting wall has been left intact, and his paintings and sculpture—on their way to or from the warehouse—could be seen in the main area of the studio, while his prints hung in the room upstairs where we talked.

. . .

You were in the museum world for many years. What enticed you to move from Washington to New York, and to become the executive director of the Roy Lichtenstein Foundation?

After I finished the Matisse paper cutouts show of 1977, I decided that I wanted to work with a living artist. I hit upon Roy Lichtenstein. He hadn't had a lot of exhibitions since the retrospective at the Guggenheim in 1969, so I pitched him the idea of doing an exhibition of recent work and then touring it around the world. I was based at the Saint Louis Art Museum at that point, but I spent a lot of time staying with Roy in Southampton on Long Island. He and Dorothy were very generous, and we got to know each other. I had an art historical, curatorial way of thinking—quite different from Roy's—but he put up with me. We were periodically together in the early 1980s when the exhibition *Roy Lichtenstein 1970–1980* traveled, and we stayed in contact.

When I was called by the National Gallery in 1983 to take over the twentieth-century department, he was the first artist I invited to create an artist's room. Every five years or so, I would dream up another way for us to do something. Or, if Roy needed an essay for an exhibition catalogue, I would sometimes get a call. Being involved with the Meyerhoffs

Jack Cowart, Roy Lichtenstein Foundation, 2004.
© Kevin Ryan. Estate of Roy Lichtenstein. Courtesy Roy
Lichtenstein Foundation Archives.

as they formed their collection for the National Gallery put me in continued contact with Roy, and the Gemini print exhibition at the National Gallery in 1984 was another big project that involved his work.

I certainly wasn't aware that he was deathly ill in the summer of 1997—by then I was deputy director and chief curator at the Corcoran Gallery of Art—so it came as a big shock to me when Roy died so quickly. It also came as a relative shock when Dorothy revealed that there was a plan for a foundation and asked me to participate. It was intriguing, but I didn't want to move from Washington, especially since my wife's career is there, and we had deep community roots. Dorothy said, "Oh, you don't have to. We'll be very flexible about it. I can't think of anyone better." I probably could, but I didn't want someone else to get the job!

So I live in this guesthouse beside Roy's former studio when I am in New York, and then, from Virginia, I can annoy the staff by e-mail, fax, and phone. Maintaining constant communication is a major part of our operation, especially with Mrs. Lichtenstein, who travels a good deal.* Our job is to give her the freedom she deserves. She is less resident in Manhattan than previously, staying on the eastern end of Long Island during the summer and in Florida during the winter. She travels a good deal, but we try to stay in touch as best we can.

The Barnett Newman Foundation is a small, functional office space in midtown, rented after Annalee Newman died, whereas you work in Lichtenstein's studio and are surrounded by his work.

Certainly it is a great privilege. It is a constant delight to be able to hang things up for ourselves and then learn from them. Then, because I live here with his art, I can actually watch television and look at a Lichtenstein sculpture at the same time—and begin to think about what was in Roy's mind. We want to maintain the studios in a way that will allow curators and others who want to think about Roy's work to breathe a little bit of that air and to understand the scale of things, the light, and the setting. At the same time, I'm not trying to create a mausoleum. I think he does still inhabit these spaces in some way. The paint marks and the studio materials are still there. But this New York space wasn't his only studio. From 1988 to 1997 was a good run. If he had lived here forever, that would have created a very heavy burden, I think, similar to that of maintaining the Brancusi studio.*

The Southampton studio that Roy was in from 1970 onwards would be a harder

place to disengage from. The National Trust for Historic Preservation and the Henry Luce Foundation have funded a project looking into the problems and requirements for preserving artists' studios. I'm watching from the side.

So, besides the possibility of visiting Georgia O'Keeffe's studio in New Mexico in the future, one might also be able to visit the Lichtenstein studio, the de Kooning studio, and so on?

Yes, and there's a whole group of living artists like Cindy Sherman, Chuck Close, and Julian Schnabel on the eastern end of Long Island. Should Roy's be managed by the Parrish Art Museum in Southampton, or should it be part of a consortium of artists' studios? Should it be independently funded by the foundation? Should it be torn down? Should it be moved? Do we let it, like Alfonso Ossorio's, get sold to a private individual? If it becomes a public facility, you have to have a parking lot, the handicap facilities, the ramps, and so on. Georgia O'Keeffe had dirt floors. What do you do with dirt floors and five hundred people? You can't. You ruin the studio by trying to save it. But people still want to make pilgrimages. Do you buy into the pilgrimage site, or do you forget it? Delacroix's studio on Place de Furstenberg in Paris is a great evocative setting, but Gustave Moreau's feels dusty and dead. Dorothy and I do kick these questions around as part of the open agenda. The house in Southampton is going to a Lichtenstein family member. Nobody wants to have a studio open to the public in their side yard, with people knocking at the door, saying, "Can we come in?" like at the Pollock-Krasner House at Springs, New York.

Would you ever think in terms of setting up a Lichtenstein museum elsewhere?

No, for many reasons. Roy didn't want one. The family doesn't want one, and we're not interested. We couldn't anyway because we only have very early Lichtenstein or relatively middle to late Lichtenstein. Increasingly, Roy was able to keep back more work, but he sold almost everything that he was making in the 1960s in order to stay in business, to stay alive. You can't have a Lichtenstein museum without some of the great pop sixties masterpieces. We wouldn't want it to look like the Fernand Léger Museum in Biot, which has all the things that Léger couldn't sell, or late works, and none of the core.

Did you have any previous experience dealing with the complications of foundations?

Having lived through the Rothko Foundation situation when I was at the National Gallery, I prayed heavily that this was not some kind of bear trap. I'd also witnessed the O'Keeffe heirs suing each other until the day they decided to settle and become a foundation. But Roy was scrupulous in his relationships and very clear. I felt that we were starting with a completely fresh charter. And, like Roy, it was joyful.

After the wide scope of the museum world, does focusing on one artist suit you?

I've been in the museum business for twenty-seven years. I must have been involved with three hundred or five hundred exhibitions, thousands of objects, two-hundred-thousand-square-feet of gallery space, fifty staff members, and endless reports. It is wonderful at this stage of my life—and having developed a certain cynicism about the museum, gallery, and collecting world—to be able to work on "one" subject. Actually, my

job involves the same kinds of things as museum work: publishing, research, exhibitions, management of objects. We have a mini-museum collection here. So it's very curatorial, art-historical, political, and amusing, and it's very family-related. There are four of what I call our technical side: myself, my managing director, the accountant, and the lawyer. And then there are the four Lichtenstein family members: Roy's two sons, his sister Renée Lichtenstein Tolcott, and his widow. We don't have outside members on the board. However, it's not insular or secretive. Although there is a charter that states the five basic purposes of the foundation, in typically Lichtensteinian fashion, we are quite content in our board meetings to adjust or add to them as needs demand. We're in total control—not total control, relative total control—of our own destiny. We can do what we want, responsibly, and have the luxury of setting a course under our own steam and then navigating it. When Roy did something, he did it very well. And now Dorothy Lichtenstein, too, insists on a very high level of quality, which directly relates to my nine years with the National Gallery, where we had enormous resources and very high expectations.

Could you talk a little bit about the financial structure of the organization?

The foundation clicked into existence at Roy's death, beginning as a legal entity with no assets. We're private and will only give grants if we have an income greater than our own needs. The foundation exists to facilitate exhibitions of the work of Roy Lichtenstein, to publish catalogues raisonnés, and to encourage new scholarship. We also want to do good deeds and be a model of good management for artists' foundations. The end game is to get Roy's remaining art into major urban centers, cultural complexes, and museums.

When we had our first board meeting, we asked ourselves how long we wanted to stay in business. O'Keeffe sunsets in 2006, the Judith Rothschild Foundation in 2018. We roughed out about thirty years, or until the last person who knew Roy still cares. It depends, too, on how deep the family involvement of his sons and grandchild will be. We came up with three interlocking ten-year plans. This all relates to the financing. Dorothy gave the money from the estate to run the foundation. I'm also informal chief policy advisor to the estate. There are other direct links in that Cassandra Lozano, the part-time managing director of the foundation, is also part-time administrator of the estate, and the accounting teams and the lawyers are the same.

We began with a primary donation of art from the estate to be sold over time, if proper placement came up. Eventually, some were placed, providing around $10 million. That created the "starter endowment," which we put into treasuries and fixed return investments. The income meets about half of our operating expenses. The rest are check-written from the estate. Recently, we've fabricated some objects, and the sales will fill in some of the gaps in funding and be set aside for ongoing major projects like the catalogue raisonné.

What would improper placements be?

A lot of people bought the work for resale and profit, especially the paintings of the sixties. That was fine in the old days when Roy was making new stuff every year. But, as

his position becomes more secure over the years, certainly the idea is to place all works with primary institutions, or to identify collectors who have very firm commitments to an institution so that there is a high probability, something like ninety-nine percent, that their acquisition will eventually go there. There are, though, some things in the estate that can be sold to new and upcoming collectors in an attempt to get them to appreciate the work.

With somebody like Lichtenstein, whose work is already so available in museums, is there really a need to keep proving his worth?

Yes, Roy is ubiquitous. He, himself, I think, was in general wonderment about his success. He was certainly a driven, professional, and ambitious artist and very sure of his own talent, but making art was his primary purpose. He believed that if the work was good, it would stay on the walls, but the question didn't keep him up late at night.

However, there's more to Roy than the comic paintings from 1962 through 1964. That was two years out of a complex artistic career that spanned forty-seven. We are very keen to reveal these other aspects of Roy's work, whether it's the American or art-historical cartoon pieces of the 1950s, the *Perfect/Imperfects* and the *Brushwork* paintings from the 1980s, or the *Interiors* of the 1990s. The Louisiana Museum is now doing a retrospective, *Roy Lichtenstein: All about Art*, which we hope will not be like every other retrospective. We want to see an idea that goes beyond the known ideas. Books are still to be written that will recontextualize and reevaluate the work, going beyond the existing studies, including my own. For example, we have a German Ph.D. candidate, Karen Bandlow from the University of Heidelberg, living with us in this house for the next three months. She's researching Roy's acceptance in Asia and his use of Asiatic motifs, and she's been converted from a Chinese art historian to an American contemporary art historian in the process. She reminds us that Roy lived from 1951 to 1957 in Cleveland, which has a great Asian collection from Japan, China, and Korea, and he must have picked up something there.

We have an archive that was transferred as a gift about a year and a half ago from the estate: the papers, object records, and photographs of Roy. All the filing cabinets and their contents are now ours, as well as the library, but not the real-estate property. Our databases now say that Roy produced some five thousand unique works—each of the print editions counts as one. If there are five thousand in all, I can figure what your next question is—how many works are there in the estate?

Exactly!

At this stage, the foundation has fifteen objects—major paintings, sculpture, collages, and drawings—things that we wanted to make sure were not lured away by the marketplace. I don't want to give numbers, but it's fair to say that of the twelve hundred paintings that Roy produced during his lifetime, the estate holds a relatively minor number. However, Roy made—and kept for future work—at least three thousand drawings: *croquis*, finished drawings, studies, work in sketchbooks, et cetera. So we have a major reference base here. Following our advice, the estate spent a lot of time getting them measured, mat-

ted, inventoried, and organized in solander boxes. We've got them plus the paintings, collages, and maquettes, all recorded digitally so we can share this information. We also have a big website with a tremendous amount of data on it. A vast number of major paintings, various major drawings, collages, prints, and other works are out in the world.

Ours is the obverse of the Warhol Foundation. When Andy died, there were thousands of objects that came immediately into the foundation. The plan was to sell them as reasonably as possible to make up an enormous endowment and give great grants for the advancement of the visual arts. Ours is not like that at all. It's also not like what I imagine the Morris Louis estate to have been at the beginning, when a lot of his work wasn't documented, with unstretched stain paintings on rolls that had never been seen. Almost everything that Roy made was shown, documented, published—except perhaps his pre-1960s works—mostly because he had annual exhibitions at Castelli from 1962 on. He didn't change galleries on a whim, but just stuck it through with Castelli. So we're working with a relatively accessible situation and are also doing two or three exhibitions a year. There are no secrets.

Roy's *Times Square Mural,* which was installed in 2002 in the subway at 42nd and Broadway, was actually finished in 1994, three years before Roy died. Are there other murals that were commissioned but not installed? And you mentioned new fabrications of sculpture?

There are one or two large-scale sculptures that he left as maquettes because the specific commission didn't go forward in the 1980s. There are designs for others, done on spec in the mid-1990s, that also were not executed, although the ideas were sufficiently developed. They will be seen as time goes by: one will be installed on the Cantor roof garden at the Metropolitan Museum next month [May 2003]. But if there are too many post-Lichtenstein judgments to be made, we don't do it. We err on the side of caution.

We'd really like to remake the *Greene Street Mural,* which was done for the Castelli gallery on Greene Street in 1983, and then purposely destroyed because Roy wanted it to be temporary. If we do, it will not be as an art object, but as a mural-graphic experience, without value, as a recasting, on portable panels. That project may get lost, however, because we're also trying to do a book of great photos of Roy, a new chronology, oral histories, and the catalogues raisonnés. We're working on three retrospective exhibitions and a show for Brazil as well—and things always happen you don't ever anticipate.

Many estates talk a great deal about conservation costs. Is that a worry or a burden for this foundation?

So far, it's not. Roy was working with very professional, stable, specifically made, materials. They have a good life span. If we need to have something conserved, we'll have it done. His pre-1960 work is more fragile, and we are overseeing the renovation of some of those owned by the estate. We also want to make sure that Roy's early work owned by others is preserved. We have yet to work out some kind of formulation for helping them, or for reacquiring the work and then fixing it up ourselves. We fully believe that museums owning

the artist's work should take care of what they possess. But, if people have problems that impact their ability to show Roy's work, we'll have to consider that as a conservation program for the future. I know the Morris Louis Conservation Fund said that because Louis worked on unprimed canvas and the paintings tend to degrade visually, they would underwrite a program to facilitate their restoration by their known practitioners.

We're working on an artist's material archive at three different institutions that would allow scientists to create databases of information about Roy's materials. We haven't signed a deal and haven't made a transfer. But we will. We're dancing cheek-to-cheek with one institution. The other two are just verbal agreements that this would be a good thing to do.

By the time of his death in 1997, had Roy drifted away from the Castelli gallery?

No, Castelli was still the gallery of record. I don't think there was ever any formal contract of representation when he came into the gallery in 1962, and there wasn't an exit one. Leaving had nothing to do with Barbara [Castelli] or anybody else.* In her recent interview for *Art & Auction*,* she said that it would not be appropriate for her to represent the Lichtenstein estate and foundation.

Whose decision was it to move from the Castelli gallery to Mitchell-Innes & Nash?

In between moving from the Castelli gallery to Mitchell-Innes, there were two or three years of being nowhere. But the board kept getting pressure from aspiring galleries, and we had been informally looking at all of the applicants. We decided that we had little interest in either sales or exhibitions, but wanted a gallery to organize things and shield us from getting too involved in the occasional deal or two. Dorothy and I had both known Lucy and David for a long time. We took a board vote and had them come down and make a presentation to us. We said, "Okay, we like your thinking. Draw up a contract." We needed the agency of somebody whom we could trust and who wouldn't be intrusive or directive, but would, at the same time, be consummately professional. Roy probably would have gone with some other dealer. He needed a larger space and a different relationship to contemporary artists. But Roy's not alive, he's not producing annually; it's no longer about annual shows of big work. It's about a careful management of the finite legacy.

I know the National Gallery in Washington has a very good collection of Lichtenstein prints following Roy's gift of 154 of them in 1995. Do you want to facilitate other museums' forming major holdings of Roy's work?

I let in a word earlier about my wariness about museums. However, I admire and, in some cases, understand them all too well and realize the pressures they are under. Roy always wanted his work to be accessible to the public, and museums remain the best, if somewhat flawed, institutions by which one can have that global access. We also believe in institutions of higher learning, university galleries, and study complexes. We believe in large institutions like the Getty and small ones like semi-private museums, so we are pretty inclusive.

Dorothy and the board are much more attentive when people approach us rather than

my making blind telephone calls to curators. When they come to us from this country or abroad to organize an exhibition, to add to their collection, to learn more about the artist, or to suggest a publishing project, we like to respond to them. If we find a work on the secondary market, even something that we would like to buy ourselves, we're inclined to call the museum that's approached us and say, "You were looking for a *Mirror* painting of the 1970s. Are you aware that there's a great one coming up at auction?" We'll try to realign work in the outer world before offering one of our own.

Unlike the Motherwell foundation [the Dedalus Foundation] or the Warhol—that say, "Ok, here's the appraised value of the work; we'll sell it to you for half price"—we don't own much work. The estate is set up to provide for the heirs. The foundation is second or third or fourth in line from those front-end costs and needs, and we understand that. We're not about wanting to be the richest foundation in the neighborhood, and we haven't come to the point of large donations. That could come twenty years from now if the foundation is winding down. Then a large group of drawings, or the rest of the print archive, or a collection of maquettes might be gifted to institutions where art history and connoisseurship are taught, both in this country and abroad.

In actual fact, is it necessary for you to make a great distinction between the paintings in the estate and the paintings in the foundation, since you're giving advice on both?

Officially, it's inappropriate for us to be overly involved in the affairs of the estate per se, though we do have an overarching sense of quality control, and we share the same art dealer for certain sales. Dorothy has great expertise in her own right. Over time, more will come from the estate to the foundation, but this beginning-small approach has been very good. She and the family have well exceeded their allowance to claim tax benefits—it is pure philanthropy.

Turning to Dorothy Lichtenstein—your website states that she's been involved in the arts since the 1960s. What has her particular role been within the art world?

In the early sixties, she worked with Paul Bianchini at his gallery in New York. She helped him put together the *American Supermarket* show in 1964, which gave her the chance of working with some Leo Castelli artists and getting them in on this joint project. That was how she met Roy. They got married in 1968 and, I would say, her primary noninstitutional role has been as an involved and sensitive enthusiast. She's very interested in the Trisha Brown Dance Company and other things, usually through her many personal friendships. She's open to new ideas and has a wide inquisitiveness and great intelligence. The foundation is Dorothy's foundation. She is the initiator, the president, and she is not a figurehead. I wouldn't contemplate doing anything that would run contrary to her instincts or her level of comfort.

Was she deeply involved in Roy's career previously?

Dorothy was the more gregarious partner. She is elegant, engaged, verbal, fun, funny, and she didn't take the position of an Annalee Newman type. She created her own independent sphere and was not the mouthpiece for Roy's art. She also has a fantastic mem-

ory for the details of the last thirty years. Our oral history program will have endless interviews with Dorothy for as long as she will put up with them. She was involved in so many aspects of Roy's life, and sometimes much more in the art than I might have thought. While she traveled a lot—taking these long treks to China or Africa—Roy, who hated to travel, would be home beavering away.

Were these trips sometimes to do with his work?

Not really. Dorothy is inquisitive, and so she would directly experience other cultures in ways that Roy might not. He would say, "All I need are pictures of it." Her involvement in the art world has been as a partner, as a social and softening agent on behalf of Roy. Then, because she is also close friends with so many of the Castelli artists, and those of the next generation—such as Jeff Koons, David Salle, and Julian Schnabel—she has an indirect but almost tangible presence in the art world and an enthusiasm for it. It's hard to suggest all this on a website for the foundation. She always was behind Roy, strategi-

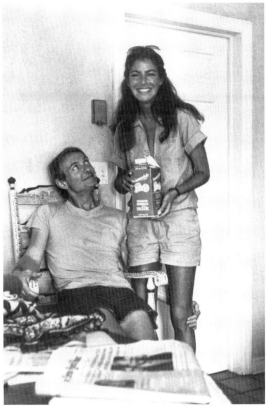

Roy and Dorothy Lichtenstein in Southampton, N.Y., 1977. Photographer unknown. Courtesy Roy Lichtenstein Foundation Archives.

cally, purposefully, personally. When I first met the Lichtensteins in 1977, it was Dorothy, and also Olivia Motch, Roy's studio manager, who facilitated access, dovetailing all the arrangements for social interaction with Roy. Dorothy's also very good at remembering who said what to whom about the endless commissions and benefit appearances and charity things that Roy got talked into on an annual basis.

The art historian Lloyd Goodrich is said to have said something like, "Never believe the widow, and never listen to the children!"

And never believe the artist or the critic, or anybody else! We get through that by triangulating everything. We're now running a strictly informational, oral history program and making wonderful discoveries. Since 2002, Avis Berman has been taping the people who knew Roy substantively during his lifetime, and then *Rashomon*-like we find the truth is someplace in the middle. We have a fascinating time building up the similarities and contrasts, themes and variations from these multiple sources.

The Lichtenstein family is different from more polemical families in that they are

casual about their importance. There's no family line that has to be adhered to. We reach edges of sensitivity, but we're not out there to prove a point. Roy had his own kind of internal history that he didn't share, so we can only arrive at some suspicion of it by inference. That means talking to artists whom he talked to. A lot of these are names no one will know. I can go to Bob Rauschenberg, Jim Rosenquist, and Claes Oldenburg, but Roy may not have told them the most revealing things. He told more to people like Stan Twardowicz, whom he was really buddies with, or Spike Landsman, who was interviewed at various times and let his guard down. They were with him at times of particular growth and change. We're not intending to publish a biography of the artist, or these oral histories per se, but we, as well as researchers, can use them as raw data—to be taken with all of the usual caveats—to help us solve certain problems like dating of objects and chronology, especially for the catalogues raisonnés.

Did Roy enjoy socializing in the broader sense?

I think he did like to be relatively social in a cozy way with a certain number of artists. Did he like going to the Warhol factory? I think he liked to see the scene because he knew he didn't have to participate in it and that he could withdraw from it at any time. He would be taken into these mega-experiences by Dorothy or by friends, and he had a kind of wry, tolerant wit and wisdom about them. "David Byrne? The Talking Heads? I really like jazz," he would say, "but it works fine. I'll use it later. I'll think about it."

How much were Roy's two sons involved in their father's world?*

Once Roy and Isabel separated in 1963, the boys spent a formative period living with their birth mother outside Princeton. Mitchell eventually spent a lot of time with Dorothy and Roy in Southampton. David was fairly independent in ways that had to do with surfing, music, and doing his own creative things, but he did spend some time there. To the best of my knowledge, they had a very comfortable relationship with both Dorothy and Roy. Dorothy invited them to be senior officers of the board. There was never any question of either giving up his career, but we ask them to participate as much or as little as they want. I'm sure Roy said, "Well, you know, yes, Dorothy, if you want to, why don't we invite Mitchell and David and Renée to sit on the board?"

Apparently, there weren't many letters in the files. Is that because Leo Castelli took care of most things to do with his career?

I have about ten letters from Roy in the whole archive. He was not a man of the written word. He would talk on the phone a certain amount, but mostly he had other people do the talking for him. The studio assistants, the studio managers in particular, certainly Leo, and the gallery would do the deals and all the paperwork. I don't have access at this stage to everything in the Castelli archives, as they are still privately owned. There is some correspondence from his old buddy artists. He would be tortured for several months trying to figure out how he could write a response. He would usually start with, "I'm sorry it's taken me so long, but writing is not my thing. I'll be lucky if I get to the bottom of the page," and he'd say, "I'll really try hard." His longest letter known to me is about three

paragraphs and, if he gets to the back side of the sheet, it's "Phew, I made it!" There are family letters written in 1945 from Europe during the war to indicate that he was still alive, and to comfort his father and mother. But that's the longest string of coherent correspondence. He was much more a talk-to person when he wasn't working.

What about his various studio assistants, who have a kind of insider's knowledge they might reveal?

These issues of disclosure and nondisclosure have to do with the judgment and the sensibility of people. He was generous toward them; they will always be generous toward him. A filmmaker came in last year wanting to do a film about the man, not an art history film. We kind of gritted our teeth and said, "Go ahead and interview these people, but we don't think there's a story. Maybe you can tell us there is." Six months later he came back and said, "You know, I talked to a lot of people. I was really trying to juice them up, but they just said, 'Roy was a nice guy.'"

That means that the emphasis will be on the work and not on the personality or the myth?

I felt it was such a privilege to be asked to come into this start-up situation because I admired both the art and Roy's behavior to people. There was a level of trust very quickly between Roy and me. "Do you want to read the text that I've written?" "Not necessarily. I trust you." That's the way we work with museums now. "You don't have to pre-clear your essay with us. If you want to show it to us, terrific. We'll correct it for factual error, but your spin is your spin. We trust you; we'll take that gamble." There's no family line and no one fixed esthetic. We're still amazed and intrigued by the new information we get from the foundation manager Cassandra Lozano, an artist herself, who worked with Roy as the studio manager for seven years.

What is the foundation's attitude toward intellectual copyright? At the 2003 College Art Association meeting, the difficulty and the expense that scholars have in obtaining reproductions for their books was discussed.*

The estate currently holds the copyright on Roy's work and will for the foreseeable future. It is managed by Shelley Lee, who comes in once a week on behalf of the estate. Basically, the net from that operation offsets the cost of having her come in and do quality control. She makes sure that the color is done properly, that there's no overprinting and no bleeding, that a Lichtenstein image is not going to be on a tea cozy and on at least properly made coffee cups, et cetera. The estate has also always subscribed to the major international copyright societies, such as CISAC [International Confederation of Authors and Composers Societies], and expects those copyright associations to do their proper vetting and billing and control, and every now and again a minor check arrives.

We're pretty accommodating when people come to us with specific needs. Michael Lobel, for example, was publishing his Ph.D. dissertation in book form for a commercial operation with the Yale University Press [*Image Duplicator: Roy Lichtenstein and the Emergence of Pop Art*], and he came to us and said, 'We're really having trouble with copyright fees and get-

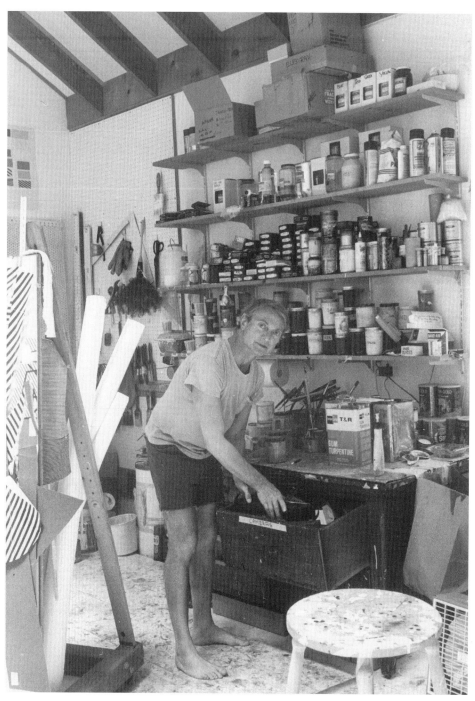

Roy Lichtenstein in his Southampton studio, late 1970s.
Photographer unknown. Courtesy Roy Lichtenstein
Foundation Archives.

ting photo rights, and therefore my thesis on Roy," which we kind of admired, "when published, will be underillustrated." I said, "Have Yale write me a letter telling us the cost to handle the rights and reproduction fees, and we will offset that with a grant." Obviously, it's in our best interest to have books on Roy illustrated and in color instead of just fields of gray text.

We have our own difficulties. Because we have so many photographs of Roy by so many professional photographers, we are constantly negotiating with them to come up with a reasonable fee. Whether it was work for hire [when the photographer doesn't own the copyright] or not is always an open question. What's the standard fee? There is none. Is it two hundred dollars or is it one thousand dollars?

What is your position on royalties?

We often gain more in other ways. I mean, the Louisiana Museum in Denmark is giving away 32,000 of their Lichtenstein publication, so the estate will disregard any royalty share on that. If it goes to hardbound, then we might ask for a nominal fee. Roy always split royalties with the institution. He felt that the institution took the risk of publication and put the front end into it, so he wanted to advance their net gain. We don't have our own product line, and we are under no obligation to market the name to keep, for example, a grant program running.

You mentioned previously that directors of foundations meet together. Do you gather once a month?

That's far too ambitious. When I moved up here, I said, "Okay, what's the peer group?" I had worked with the Rothko and O'Keeffe foundations and realized that they all beaver away in their little cells and don't talk to each other. I didn't want to reinvent the wheel, so I built a list of artists' foundations by going to GuideStar on the Internet and by contacting people. I phoned Arch Gillies at the Warhol Foundation and suggested we get together and form a loose association, and then help other artists making plans for their foundations. About twelve or so foundations assembled here for lunch. It's a freewheeling thing and has no administration. The best scenario is that we try to meet about two times a year. At first, it was basically show-and-tell. Come to our house, we'll show you what we look like, what we do. If we have things on the agenda for discussion, fine. If not, it's social. We just went over to the Dedalus Foundation, and last summer we went on our first field trip, to the Josef and Anni Albers Foundation, outside of New Haven. Our summer trip this year is to the Archipenko Foundation in Bearsville, New York. So it's just, "Gee, it's nice to get together. And, by the way, talk to me about how you filed your 990-PF. Oh, who's your counsel for warranties if you get an attribution blowup that somebody's going to sue you about?"

Now I have a little databank of almost all known American artists' foundations, those evolving for deceased artists, and others being planned by living artists. It's open source material. If someone asks how many foundations there are in the U.S., I'll say, "Maybe forty or forty-five. I'll email you the doc." If there's a question about what you do when

you find a fake, I'll say, "I don't know. I'll call Sandy Rower at the Calder Foundation. He does this all the time." It's just a loosely disorganized, spiritually sympathetic group of like- and unlike-minded foundation workers. It's not only in New York. It extends to the Chinati Foundation in Texas [set up by Donald Judd], the Midwest, and the West Coast.

We actually did take a name, the Council of Artist Foundations, because we wanted to encourage IFAR [International Foundation for Art Research] when it was organizing a conference on catalogues raisonnés, and also to give members of the group an opportunity to write letters to their Congresspeople in support of artists giving their work to museums and receiving some tax benefit during their lifetimes. There was a split within the group about lobbying or not lobbying. We ourselves had nothing to gain because our artists had already given and gotten nothing, but we could work on behalf of living artists. While not taking an official position, our emotional position is that cultural institutions should, with proper controls, work out lifetime gifts from living artists rather than leaving it to the estate. So many opportunities are lost; things are sold many times for the wrong reasons—for death taxes, et cetera. In France and Britain, it's a case of national patrimony, and they tend to release the tax burden in some way.

The group also discussed gifts of archival material to institutions. Artists and foundations sometimes find they can't get access to their own archive again without forty-eight releases and a service fee, so we're thinking of developing a group position for those institutions that wish to donate collections but want to be able to get them back when needed.

Do you spend quite a bit of your time authenticating work?

Well, Cassandra will occasionally be expected by the auction houses to help with that. We don't have a formal board that does authentications or appraisals. Informally, we'll say, "Yes, it is in the Castelli registry or, yes, it is in Roy's studio records." And we're glad to help because then we know where the work is, and it helps our catalogue raisonné process. We don't expose ourselves or anyone in the foundation to the possibility of legal claims. Some foundations are quite structured and aggressive on this whole issue, and they do prevail six months of trial later. We don't think that Lichtenstein authentication issues are of such profound moment that we want to get into that. I think we can solve them all person-to-person, at a lower level.

Which foundations are more concerned with authentication?

Well, in public record, the Pollock-Krasner Foundation has been involved in landmark cases dealing with authentication issues. *Lariviere v. E.V. Thaw* is a recent case.* That's good case law. Certainly, the Andy Warhol Authentication Board is separate from the foundation. The Calder Foundation is very aggressive in going after known forgers of Sandy Calder's work.

It seems as though the artist's foundation has become a new entity within the art world, creating new and specialized jobs for art historians, assistants, lawyers, and accountants.

It certainly has. There's a necessity for estate planning and the management of large

bulks of material when artists are dying with such enormous holdings of their own work. How does one act strategically, or just responsibly? There is the possibility also of substantial asset buildup, or the hope that, maybe, a nonfunctional, nonfiduciary estate can be converted to some cash at some point. And, if there isn't a market for the work at present, it can at least be properly distributed to responsible, adopting agencies. The foundations are this intermediary point. We are not all alike by any stretch of the imagination and don't intend to be. We feel wonderfully idiosyncratic, operating within our guidelines established legally and ethically. It's wonderful to be free but, at the same time, I always try to figure out what Roy would have wanted. Largely, he would have wanted not to be troubled by a lot of our troubles. It's our duty to carry on an intensity of investigation that no other institution would be so crazy to do, to indulge our love and our excitement for the work in ways that are responsible and that keeps us going. So we're deep mining. Museums can strip mine, but we can really dig tunnels, burrowing through layers of rock on behalf of Roy, maybe figuring things out.

April 2003

For Further Information

Lichtenstein: Sculpture and Drawings. Essays by Jack Cowart, Cassandra Lozano, Naomi Spector, and Agustín Arteaga. Washington, D.C.: The Corcoran Gallery of Art, 1999.

Lobel, Michael. *Image Duplicator: Roy Lichtenstein and the Emergence of Pop Art.* New Haven: Yale University Press, 2002.

Waldman, Diane. *Roy Lichtenstein.* New York: Guggenheim/Rizzoli, 1993.

NOTES

INTRODUCTION

viii *Samuel Menashe:* Samuel Menashe, born in 1925, lives in New York City. Recent publications include *Penguin Modern Poets*, with Donald Davie and Allen Curnow (vol. 7, London, 1996); and *The Niche Narrows: New and Selected Poems* (Jersey City, N.J.: Talisman House Publishers, 2000).

viii *Book by Jennifer Clement:* Jennifer Clement, *Widow Basquiat* (Edinburgh, Scotland: Canongate Books, 2000).

ix *Dorothy Lichtenstein photograph:* Photograph by Dudley Reed in *The New Yorker* (May 26, 2003), pp. 66–67.

ix *Book by Musa Mayer:* Musa Mayer, *Night Studio* (Cambridge, MA: Da Capo Press, 1997), p. 34.

ix *Susanna Heron quotation:* Sarah Lyall and Carol Vogel, "Pangs of Loss to Art World after a Fire," *New York Times* (Friday, May 28, 2004), E29.

x *Book by Jill Snyder:* Jill Snyder, *Caring for Your Art* (New York: Allworth Press, 1990).

x *Guide to Estate Planning: A Visual Artist's Guide to Estate Planning* (published by the Marie Walsh Sharpe Art Foundation, Colorado Springs, Colorado, 1998).

x *Book by Francine Prose:* Francine Prose, *Lives of the Muses* (New York: HarperCollins, 2003).

x *Barbara Haskell quotation:* From the *New York Times* (Oct. 31, 2000).

xii *Book about art dealers:* Laura de Coppet and Alan Jones, *The Art Dealers* (New York: Clarkson N. Potter, 1984).

xiii *Group venture contact information:* The Art Connection, www.theartconnection.org; Senior Artists Initiative, www.seniorartistsinitiative.com; Estate Project for Artists with AIDS, www.artistswithaids.org; and Artists' Legacy Foundation, 248 3rd Street, #737, Oakland, California, 94607.

xiv *Artists Archives of the Western Reserve:* For example, in 2000 it was reckoned that a 21½-sq.-ft. space @ $40 a square foot would require a fee of $15,650 to cover the annual payment of $860, which would be covered by an estimated 5.5 percent yearly interest. Recent low interest rates must have caused problems for this interesting scheme.

xiv *Michael Kimmelman quotation:* See "Life Is Short, Art Is Long," *New York Times Magazine* (Jan. 4, 1998), p. 23.

PART ONE:
INTRODUCTION: FORMIDABLE ANTECEDENTS

3 *Carol Mancusi-Ungaro:* Director of conservation at the Whitney Museum of American Art, New York, as well as director of the Center for Technical Study of Modern Art at Harvard University. The memorial gathering for Annalee Newman was held at the Metropolitan Museum of Art, New York, on January 29, 2001.

PART ONE:
B. H. FRIEDMAN ON LEE KRASNER AND ANNALEE NEWMAN

5 *Books by B. H. Friedman:* School of New York: Some Younger Artists (New York: Grove Press, 1959); *Jackson Pollock: Energy Made Visible* (New York: Perseus Books, 1995).

6 *An art writer:* Reportedly Grace Glueck of the *New York Times*.

10 *Ben Heller bought* One: Heller bought *One* (1950) for $8,000 in 1955. It now belongs to the Museum of Modern Art in New York.

12 *Motherwell's treatment of his daughters:* Robert Motherwell left his daughters "Two (2) easle-size [sic] paintings created by me . . . (with) a total value of not more than $300,000. . . . None of the paintings selected . . . shall be 'major work' or 'museum work'" (Last Will and Testament of Robert Motherwell, signed July 16, 1991).

PART TWO:
ANNE E. PORTER, WIDOW OF FAIRFIELD PORTER

19 *Fairfield Porter to Tibor de Nagy:* Written circa 1965, during the Vietnam War, and quoted by John T. Spike, in *Fairfield Porter: An American Classic* (see references), p. 172.

19 *Parrish Art Museum:* Out of a total inventory of some 1,304 oils, studies, and works on paper by Fairfield Porter, and 40 prints, the estate presented 186 of its collection to the Parrish Art Museum, Southampton, N.Y., in 1980.

21 *James Schuyler:* The mercurial, homosexual poet James Schuyler (1923–1991) lived with the Fairfield Porter family between 1961 and 1972. He often read to Fairfield Porter while the artist painted.

25 *Anne Porter's book of poems:* Anne Porter, *An Altogether Different Language: Poems, 1934–1994* (Cambridge, Mass.: Zoland Books, 1994), p. 22.

PART TWO:
YVONNE HAGEN, WIDOW OF N. H. (TONY) STUBBING

27 *N. H. (Tony) Stubbing quotation:* Excerpt from Stubbing's statement published in *N. H. (Tony) Stubbing: Retrospective* (London: England & Co, 2000), p. 2.

35 *The Sound of Sleat:* Jon Schueler, *The Sound of Sleat: A Painter's Life,* Magda Salvesen and Diane Cousineau, eds. (New York: Picador USA, 1999).

37 *The Findhorn Community:* A community in northeast Scotland. Tony and Yvonne spent five summers there (1977–1982) while Tony was working on two large oils: *Toward an Iona Blue* and *Findhorn River Green.*

PART TWO:
HARRIET VICENTE, WIDOW OF ESTEBAN VICENTE

39 *Jules Feiffer quotation:* From Feiffer's memorial tribute to Esteban Vicente, read by Kurt Vonnegut at the American Academy of Arts and Letters, New York, on November 8, 2001.

PART TWO:
PHYLLIS DIEBENKORN, WIDOW OF RICHARD DIEBENKORN

50 *Gerald Nordland quotation:* Gerald Nordland, *Richard Diebenkorn* (New York: Rizzoli, 1987, revised 2001), p. 7.

51 *Dan Hofstadter quotation:* From Dan Hofstadter, *Temperaments: Artists Facing Their Work* (New York: Knopf, 1992), pp. 170–171.

51 *Wiegand Gallery, Belmont:* The touring exhibition *Jon Schueler: About the Sky,* sponsored by Sweet Briar College, Virginia, was at the Wiegand Gallery, College of Notre Dame, Belmont, California, January 28–February 26, 2000.

52 *Jane Livingston quotation:* From *The Art of Richard Diebenkorn* (New York: Whitney Museum of American Art, 1997), p. 12.

52 *Drawing nights:* Diebenkorn, David Park, and Elmer Bischoff met together to draw from the model while they were faculty members of the CSFA in the late 1940s, and between 1959 and 1966, Diebenkorn joined Bischoff, Frank Lobdell, and others to sketch on Wednesday nights.

54 *Diebenkorn vacation:* The one-week visit to Cabo San Lucas, Mexico, took place in the 1970s. Richard Diebenkorn had an exhibition every other year, and sometimes every year. The couple (and friends) often went to Mexico for long weekends.

57 *Diebenkorn exhibitions:* These were, respectively, at Lawrence Rubin–Greenberg Van Doren Fine Art, New York, 2000; Artemis Greenberg Van Doren, 2002; and John Berggruen Gallery, San Francisco, 2003.

57 *Jane Livingston quotation:* From Jane Livingston, *Richard Diebenkorn: Figurative Works on Paper* (San Francisco: John Berggruen Gallery, 2003), p. 11.

57 *Legion of Honor show: Richard Diebenkorn: Clubs and Spades,* California Palace of the Legion of Honor, January 19–April 28, 2002 (twenty-five prints and drawings that use the clubs and spades motif, from 1981–1982).

PART THREE:
ADELIE LANDIS BISCHOFF, WIDOW OF ELMER BISCHOFF

64 *Bischoff paintings in storage:* Adelie Bischoff thinks that only one of Elmer's oils was destroyed. But works by artist-friends such as Hassel Smith, Jim Weeks, Richard Diebenkorn, and Frank Lobdel were also burned.

67 *"Sorry to interrupt":* Thirteen houses were burnt in the Bischoffs' neighborhood on that occasion. However, after Adelie evacuated her mother and the dog, the wind shifted, and their house was saved.

67 *New York gallery arrangements:* The Salander-O'Reilly Gallery in New York City has been interested in the work of both Elmer Bischoff and Adelie Landis Bischoff.

PART THREE:
CHARLOTTE PARK, WIDOW OF JAMES BROOKS

69 *James Brooks quotation:* From *James Brooks Oral History Interview,* conducted by Dorothy Seckler for the Archives of American Art, 1965.

71 *The Club:* Founded in late 1949 by artists in New York, the Club met in various rented premises in the East Village. It organized panel discussions and the occasional concert and symposium, providing a social meeting place for artists and others in the art world for more than a decade.

75 *Meg Perlman:* An independent art consultant in New York City, Perlman handles the Pierre Matisse estate and has helped with arrangements for James Brooks's paintings since the late 1980s.

76 *James Brooks in hospital:* After a severe crisis of Alzheimer's and other health problems, Jim Brooks returned home circa 1989–1990, requiring full-time care and a hospital bed in the living room.

77 *Anne Abeles's dissertation:* Anne L. Abeles, "James Brooks: From Dallas to the New York School" (Ph.D. dissertation, City University of New York, 2001).

79 *Judith Rothschild Foundation:* The foundation awarded the Brooklyn Museum $4,000 in 1997 to conserve works for the exhibition *Rediscovering James Brooks: WPA Murals and Other Figurative Works.*

PART THREE:
REGINA CHERRY, WIDOW OF HERMAN CHERRY

83 *Rothschild Foundation grant:* The Judith Rothschild Foundation gave Regina Cherry $5,500 in 1996 to inventory and properly store canvases and drawings by Herman Cherry.

84 *Herman Cherry catalogue:* The Pollock-Krasner House and Study Center received $5,000 from the Judith Rothschild Foundation in 2002 toward *Herman Cherry: Paintings on Paper,* Martha's Vineyard, 1956, an exhibition and catalogue. The show was seen the same year at Gary Snyder Fine Art in New York City.

84 *Herman Cherry's murals and easel projects:* During this period (1978–1981), Herman Cherry worked on murals for the Self Help Community, Forest Hills, N.Y. (1978); Saint Malachy's Church, New York, N.Y.; and Pomonok Community Center, Queens, N.Y. (1977–1980).

85 *Alcopley:* The medical scientist Alfred L. Copley (1910–1992) was also an artist (using the name L. Alcopley). See *One Man–Two Visions, L. Alcopley–A. L. Copley, Artist and Scientist* (New York: Pergamon Press, 1993).

89 *Jewish Museum show:* Former museum director and art historian Gerald Nordland confirmed by phone on March 28, 2004, that so far there has not been a positive response to the proposal for this exhibition from the Jewish Museum in New York City.

90 *Francis Bacon case:* In March 2000, lawyers for the estate of Francis Bacon accused Marlborough International Fine Art of consistently undervaluing many of Bacon's paintings, which it bought outright and then resold for substantially higher prices. The same lawyers and accountants represented the gallery and artist, and a Marlborough director was appointed one of the three trustees of the estate, which was left to John Edwards, Bacon's younger companion since 1976. Settlement was reached in February 2002, and the John Edwards Charitable Foundation was set up that year to promote the legacy of the artist. Mr. Edwards died of lung cancer in March 2003. See Martin Bailey, "The Estate of Francis Bacon Drops Legal Action Against Marlborough," *The Art Newspaper* (Apr. 2003), p. 7.

90 *Cherry catalogues:* They are *Herman Cherry: Monoprints* (City University Graduate Center, 1985); and a catalogue from the 1989 retrospective at Ball State University Art Museum, Muncie, Indiana. There is also a catalogue with some black and white reproductions from Cherry's 1967 exhibition at the University of Kentucky, Lexington.

90 *Una Dora Copley:* Copley (born 1951) looks after the estate of her mother, the Icelandic-American artist Nina Tryggvadottir (1913–1968) and that of her German-American father, L. Alcopley (1910–1992).

92 *Campbell article:* Lawrence Campbell, "The Blurred Edge," *Art in America,* volume 78, no. 12 (December 1990), pp. 158–161.

PART THREE:
MAY STEVENS, WIDOW OF RUDOLF BARANIK

93 *Rudolf Baranik quotation:* From David Craven, *Poetics and Politics in the Art of Rudolf Baranik* (Atlantic Highlands: New Jersey Humanities Press, 1997), p. 57.

94 *James W. Hamilton, M.D.:* Hamilton, who has written on the relationship of early trauma and unconscious motivation in the creative process of Edward Weston, Piet Mondrian, and Mark Rothko, interviewed me about Jon Schueler after the publication of the latter's autobiography, *The Sound of Sleat: A Painter's Life* (New York: Picador USA, 1999).

101 *Rudolf's article:* Rudolf Baranik, "Report From Havana: Cuban Conversation," *Art in America,* volume 75, no. 3 (March 1987), pp. 21–29.

102 *Namaste:* Quoted in the catalogue *Rudolf Baranik, Elegies: Sleep, Napalm, Night Sky* (Columbus: Ohio State University Press, 1987), Biographical Notes, p. 83. The Sanskrit word *Namaste* means "I bow to the divine in you."

PART FOUR:
JEANNE BULTMAN, WIDOW OF FRITZ BULTMAN

107 *B. H. Friedman quotation:* B. H. Friedman, "In Memoriam: An 'Irascible,'" *Arts Magazine,* no. 60 (Jan. 1986), p. 78.

107 *"the world I had always wanted to know":* Interview with Irving Sandler, January 6, 1968, quoted by April Kingsley in the catalogue *Fritz Bultman: A Retrospective* (New Orleans Museum of Art, 1993), p. 29.

107 *Geometry and mythological symbolism:* See Evan R. Firestone's article, "Fritz Bultman's Actaeon Paintings: Sexuality, Punishment, and Oedipal Conflict," *Genders* 34 (2001), for the most recent analysis of Bultman's use of mythology.

108 *Hans Hofmann:* Hofmann (1880–1966), the German artist, opened his art school in New York in 1933. Summer sessions were held in Provincetown, Mass., starting in 1934.

109 *"we lived there year-round":* Donald Windham reports that Jeanne's mother, despite her doubts about her daughter's choice of partner, helped the Bultmans to buy this land, sending her a little over $1,000, the money she had put aside for her to have a wedding back in Hastings, Nebraska, like those of her sisters. See his essay in the catalogue *Fritz Bultman: Collages* (Athens: Georgia Museum of Art, University of Georgia, 1997).

111 *rentals in Provincetown:* Over the years, the shack in Provincetown turned into a house. The artist Tony Smith, whom Fritz met in Chicago at the New Bauhaus in 1937, designed it in 1945 and helped erect the five-sided, vaulted studio. Later, the cottage was built. In New York, the basement and garden were rented out.

111 *Robert Motherwell:* Motherwell, October 19, 1988, quoted in the catalogue *Fritz Bultman: A Retrospective,* (New Orleans Museum of Art, 1993).

111 *"if he woke up at night":* Evan Firestone suggests that Fritz often suffered from insomnia. See his essay in *Fritz Bultman: Collages* (Georgia Museum of Art, 1997), p. 31.

112 *Stained glass:* The first stained glass windows were made in 1976 for the chapel of the House of Bultman, the funeral home in New Orleans. These were fabricated in New Jersey. Later pieces were made by Jeanne Bultman.

112 *stained glass commissions:* The most significant one was in 1981 for seven windows, each twelve by six feet, at Kalamazoo College in Michigan. Jeanne Bultman executed all of them from the collages. The collages themselves are now installed opposite the windows.

112 *ill with cancer:* Fritz also had four earlier major operations, in 1963 and 1964, for intestinal cancer.

113 *four exhibitions:* In 1999, there were Fritz Bultman shows at the Gallery of the College of Staten Island/CUNY; Miami-Dade Community College, Kendall Campus Art Gallery, Florida; Galerie Simonne Stern, New Orleans; and the Reynolds Gallery, Richmond, Virginia.

113 *New Orleans show: Fritz Bultman: A Retrospective* originated at the New Orleans Museum of Art in 1993 and toured to the Greenville County Museum, South Carolina; the Art Museum of Western Virginia, Roanoke; and the Provincetown Art Association and Museum in Massachusetts.

113 *father and sister involved in museum:* Fritz Bultman's father served as a trustee of the New Orleans Museum of Art in 1943 and donated works to the museum. Fritz's sister, Muriel Bultman Francis, was a trustee for nearly three decades. Her collection, mainly of nineteenth and early twentieth-century drawings, was also bequeathed to the museum, and was the subject of the exhibition *Profile of a Connoisseur* in 1985. It seems that neither was interested in the contemporary art of their time.

114 *Evan Firestone's articles:* See above (*Fritz Bultman: Collages*). Also see "Fritz Bultman's Collages," *Arts Magazine,* no. 56 (Dec. 1981), pp. 63–65; and "Fritz Bultman: The Case of the Missing 'Irascible,'" *Archives of American Art Journal,* no. 34 (1994), pp. 11–20.

PART FOUR:
ANNE ARNOLD, WIDOW OF ERNEST BRIGGS, WITH BOB BROOKS

124 *Gruenebaum Gallery:* Gruenebaum Gallery, Ltd., 38th St., New York. When Thomas Gruenebaum closed his gallery in the late 1980s, his stable of artists was left without representation and scrambled to recover both money and works of art.

PART FOUR:
ANITA SHAPOLSKY ON HER FOUNDATION AND GALLERY

133 *Artists Equity:* Regina Stewart, director of New York Artists Equity Association, Inc., reports that the

major holdings of the Art Bank, formed from a bequest by Tamara Kerr, who died in 1995, are of abandoned art estates. With only two staff members and extremely limited storage space, the ability to promote these artists' work is minimal.

PART FOUR:
JEFFREY BERGEN ON THE ROMARE BEARDEN ESTATE

138 *Romare Bearden quotation:* From "Rectangular Structure in My Montage Paintings" by Romare Bearden, *Leonardo* 2 (January 1969), p.18; quoted in *Romare Bearden: His Life and Art* by Myron Schwartzman (New York: H. N. Abrams, 1990), p. 204.

141 *Romare Bearden coauthored book:* Harry Henderson and Romare Bearden, *A History of African-American Artists: From 1792 to the Present* (New York: Random House, 1993).

144 *Benny Andrews (b.1930):* The activist artist founded the Benny Andrews Foundation in 2002 to support minority artists and art teachers, as well as African American galleries and cultural institutions.

144 *Faith Ringgold (b. 1930):* Ringgold, best known for her narrative quilts and children's books, formed the Anyone Can Fly Foundation in 2002. Its mission is to expand the art establishment's canon to include artists of the African diaspora, and to introduce the great masters of African American art and their art traditions to children as well as adults.

PART FIVE:
MARCH AVERY, DAUGHTER OF MILTON AND SALLY AVERY

149 *Sally Michel Avery quotation:* From her introductory essay for *Milton Avery: Major Paintings* (New York: Grace Borgenicht, 1984).

151 *Cleveland Museum of Art exhibit: Landscapes, Interior and Exterior: Avery, Rothko, and Schueler,* July 9–August 31, 1975.

154 *Hirshhorn and Neuberger:* Joseph Hirshhorn (1899–1981) donated his collection to the Hirshhorn Museum and Sculpture Garden in Washington, D.C., while Roy Neuberger (b.1903) gave his to the Neuberger Museum of Art at SUNY, Purchase, N.Y.

157 *Harvey Shipley Miller:* Miller is also a trustee of the Judith Rothschild Foundation.

PART FIVE:
CHRISTOPHER SCHWABACHER, SON OF ETHEL SCHWABACHER

161 *Ethel Schwabacher quotation:* From *Hungry for Light: The Journal of Ethel Schwabacher,* Brenda S. Webster and Judith Emlyn Johnson, eds. (Bloomington: Indiana University Press, 1993), p. 227.

161 *The rejection of her book:* The biography by Ethel Schwabacher, *Arshile Gorky*—with a preface by Lloyd Goodrich and an introduction by Meyer Shapiro—was eventually published, with revisions, in 1957 by Macmillan for the Whitney Museum of American Art. The Whitney had mounted a memorial exhibition of Gorky's work in 1951. Ethel Schwabacher contributed an essay to the catalogue.

163 *Brenda (Schwabacher) Webster:* Born in 1936, she is a freelance writer, critic, and translator. She lives in California and has three children by her first husband, Richard Webster. Two of them now have children of their own.

165 *Richard Pousette-Dart and Bill Baziotes:* Evelyn Pousette-Dart and Ethel Baziotes represent their late husbands, who died in 1992 and 1963.

169 *Family members competing with each other:* When Joseph Cornell died in 1972, he bequeathed his work (approx. 235 pieces) to a charitable trust for unspecified purposes. His niece, Mrs. E. J. Batcheller, and his sister, Mrs. Elizabeth Benton, had in their possession some 118 pieces, each with no proof of donation. The estate sought to recover the work from the two relatives for the trust. An out-of-court settlement was reached in 1975, when the estate agreed to pay the gift tax and to permit Mrs.

Batcheller to retain 88 percent and Mrs. Benton 90 percent of what they possessed. The potential difficulty for dealers is that there are three separate sources for Joseph Cornell's work, which can affect things like price structure.

170 *Brenda Webster's autobiographical novel:* The Last Good Freudian (New York and London: Holmes & Meier, 2000), extracts cited, in consecutive order, from pp. 183, 33, and 182.

PART FIVE:
HELEN MCNEIL, DAUGHTER OF GEORGE MCNEIL

172 *George McNeil quotation:* From the video *George McNeil: The Painter's Painter,* directed and produced by Paul Tschinkel, 1991.

175 *Lillian Orlowsky's description:* From George McNeil, *Bathers, Dancers, Abstracts. A Themed Retrospective* (Provincetown Art Association and Museum, 2002), p. 21.

175 *Irascibles' photograph:* The famous photograph of fifteen of the eighteen painters who, along with ten sculptors, had written an open letter to the *New York Times* in 1950 objecting to the Metropolitan Museum of Art's conservative attitude toward contemporary art. It was published in *Life* magazine on January 15, 1951. George McNeil did not sign the letter, and B. H. Friedman wonders why he and some fifteen others were not directly involved. See "The Irascibles: A Split Second in Time," *Arts Magazine* (Sept. 1978), pp. 96–102.

PART SIX:
SANFORD HIRSCH ON THE ADOLPH AND ESTHER GOTTLIEB FOUNDATION

191 *Adolph Gottlieb quotation:* From an interview with Adolph Gottlieb by Martin Friedman, August 1962, quoted in *Vertical Moves, Adolph Gottlieb: Paintings 1956–73,* PaceWildenstein, May 2–June 8, 2002.

196 *The Pollock-Krasner Foundation:* Between 1985 and December 2003, the foundation has awarded 2,503 grants, totaling $35 million to artists in sixty-three countries. See www.pkf.org.

196 *The Elizabeth Foundation of the Arts:* The foundation runs a grants program to assist artists in creating a body of work and in gaining recognition for their work. It also owns a twelve-story building at 323 West 39th St, New York, where some 120 workspaces are available at below-market rates for artists.

200 *Catalogue essays by Sanford Hirsch:* Hirsch has contributed many essays in catalogues on Gottlieb, including: *The Pictographs of Adolph Gottlieb* (New York: Hudson Hills Press, 1994); *Adolph Gottlieb* (New York: ACA Galleries, 1995); *The Beginning of Seeing: Tribal Arts and the Pictographs of Adolph Gottlieb* (New Britain, Connecticut: New Britain Museum of American Art, 2002).

202 *Gottlieb magnet:* The magnet, fabricated for the Currier Museum in New Hampshire, which presumably thought it owned the copyright of the image, was subsequently withdrawn from the market.

PART SIX:
MICHAEL SOLOMON ON THE OSSORIO FOUNDATION

207 *Eric Gill and contemporaries at the Fogg:* Ossorio, one of the twelve lenders, contributed forty-eight items to *Drawings, Engravings, Illustrations, Ivories: Thomas Derrick, Eric Gill, Philip Hagreen, David Jones, Denis Tegetmeier* (Fogg Art Museum, December 6–31, 1935).

210 *Dubuffet's book:* Jean Dubuffet, *Les Peintures Initiatiques d'Alfonso Ossorio* (Paris: La Pierre Volante, 1951).

214 *Gutai group:* Formed in Osaka in 1954, the group's work was considered akin to abstract expressionism, and it pioneered later directions such as "happenings." The art writer Michel Tapié traveled to Japan in 1957 to make contact with its members. He promoted their paintings in Europe and in the United States.

215 *Helen Harrison's 1990 show:* East Hampton Avant-Garde: A Salute to the Signa Gallery, 1957–1960, Guild Hall Museum, East Hampton, N.Y., 1990. Catalogue also by Helen A. Harrison.

PART SEVEN:
PETER STEVENS ON THE DAVID SMITH ESTATE

221 *Karen Wilkin quotation:* From Karen Wilkin, *David Smith* (New York: Abbeville Press, 1984), p.7.

223 *David Smith court case:* Estate of David Smith v. Commissioner, 1972–1975.

223 *Warhol estate:* The value of the works of Andy Warhol (1928–1987) was not important for estate taxes (as the works has been left to the Foundation for the Visual Arts, a tax-exempt organization) but was immensely important to the attorney for the estate, Edward Hayes, whose fee was based on a percentage of the estate's assets. The Christie's evaluation, which included "blockage," was $103,353,000, whereas the appraiser for Hayes valued the same works of art at $708 million. The appellate court, in 1995, finally awarded a fee of $3.5 million to Edward Hayes (rather than $10 million that he had sought). See Ralph E. Lerner, *Art Law: The Guide for Collectors, Investors, Dealers, and Artists* (2nd edition, 1998), for a discussion of the Smith, Warhol, and other cases.

232 *Rosalind Krauss book:* Rosalind Krauss, *Passages in Modern Sculpture* (New York: Grossman/Viking; London: Thames and Hudson, 1977).

233 *Garnett McCoy book:* Garnett McCoy, *Archives of American Art: A Directory of Resources* (New York: Bowker, 1972).

PART SEVEN:
HELEN PARK BIGELOW, DAUGHTER OF DAVID PARK

238 *Helen Park Bigelow quotation:* From "Helen Park Bigelow: Fathers and Daughters," *San Francisco Examiner Magazine* (Sunday, Sept. 21, 1997).

239 *Drawing sessions:* Both Elmer Bischoff (1916–1991) and Richard Diebenkorn (1922–1993) were close friends of David Park. He met regularly with them between 1953 and 1957 to draw from the model.

239 *copyright issues are complex:* Copyright ownership for David Park's work will now be governed by the Sonny Bono Copyright Term Extension Act (CTEA) of 1998. This means that unless Park specifically signed over or registered the copyright of particular paintings, the copyright that he automatically owned during his lifetime on all his sold and unsold work is passed on to his heirs for seventy years after his death.

241 *Paul Mills:* Mills was director of the Oakland Museum. His 1957 exhibition *Contemporary Bay Area Figurative Paintings* traveled from Oakland to the Los Angeles Museum of Art and the Dayton Art Institute, Ohio.

244 *Lydia Park staggered by price of paintings:* For instance, on October 5, 1989, the year before Lydia Park's death, David Park's *Untitled* (undated oil on canvas, twenty-five inches by twenty-seven inches) was sold for $88,012 at Sotheby's, New York.

246 *What would David Park think?:* Park's *Boy with a Flute* (1959, oil on canvas, fifty inches by forty inches) was sold at Sotheby's New York for $779,500 on November 12, 2002.

PART SEVEN:
PEGGY GILLESPIE, WIDOW OF GREGORY GILLESPIE

249 *Gregory Gillespie quotation:* From *Gregory Gillespie: New Works* (Forum Gallery catalogue, December 2–31, 1999).

250 *Fogg Art Museum: Life as Art: Paintings by Gregory Gillespie and Frances Cohen Gillespie* (December 6, 2003–March 28, 2004), catalogue essay by Ted Stebbins.

258 *a successful retrospective:* Organized by the Georgia Museum of Art, Athens, in 1999, it was also shown at the San Diego Museum of Contemporary Art, 1999; the List Visual Art Center, Cambridge, Massachusetts, 1999; and the Butler Institute of American Art, Youngstown, Ohio, 2000.

259 *book about Prozac:* Joseph Glenmullern, *Prozac Backlash: Overcoming the Dangers of Prozac, Zoloft, Paxil, and Other Antidepressants with Safe, Effective Alternatives* (New York: Simon and Schuster, 2000).

260 *Forum Gallery stipend:* Gillespie's stipend increased from about $6,000 in the late 1970s to $7,500 a month.

PART EIGHT:
RAE FERREN, WIDOW OF JOHN FERREN

265 *John Ferren quotation:* From the interview with Ferren by Dorothy Seckler in Springs, N.Y., June 12, 1965 (Archives of American Art, N.Y., John Ferren Papers, p. 26).

267 *quite a few galleries:* John Ferren first exhibited in Paris with Pierre Loeb (1936). In New York, he had one-person shows at the Pierre Matisse Gallery (1936–1938); the Stable Gallery (1954–1958); the Rose Fried Gallery (1962–1968); and the A. M. Sachs gallery (1969). His widow kept the estate with A. M. Sachs until that gallery closed. Katharina Rich Perlow took on many of the artists when she opened her own gallery in 1985.

270 *Lee Hall book:* Lee Hall, *Elaine and Bill: Portrait of a Marriage: The Lives of Willem and Elaine de Kooning* (New York: HarperCollins, 1993).

PART EIGHT:
JOHN CRAWFORD, SON OF RALSTON CRAWFORD

274 *Ralston Crawford quotation:* From a 1947 statement, reprinted in *Ralston Crawford*, by William C. Agee (Pasadena, CA: Twelve Trees Press, 1983), p. 34.

PART EIGHT:
ROBERT JAMIESON, COMPANION OF LEON POLK SMITH

284 *Leon Polk Smith quotation:* Excerpt from a conversation between Leon Polk Smith and d'Arcy Hayman, *Art and Literature* 3 (autumn-winter 1964), Societé Anonyme d'Editions Litéraire et Artistique, Lausanne, Switzerland; reprinted 2001.

285 *the trustees:* The two lawyers are John Bergman and Gordon H. Marsh. After several years with the Marlborough Gallery, Robert T. Buck is currently executive director of Exhibitions International in New York City.

287 *recent exhibition in Bonn: Leon Polk Smith im Arithmeum, Forschungsinstitut für Diskrete Mathematik*, Bonn University, Germany, September 4, 2001–February 17, 2002. Catalogue in German, French, and English.

292 *hard-edge abstractionist movement:* See Irving Sandler, "Hard-Edge and Stained Color-Field Abstraction, and Other Non-Gestural Styles: Kelly, Smith, Louis, Noland, Parker, Held, and Others," in *The New York School: The Painters and Sculptors of the Fifties* (New York: Harper & Row, 1978).

292 *Leon never thought of himself as part of a group:* Though invited, Smith never joined the American Abstract Artists group, founded in 1936 by Ilya Bolotowsky, Josef Albers, and Ibram Lassaw. The exhibitions they and other members organized promoted hard-edge abstraction.

292 *Brooklyn Museum relationship:* The gift by Leon Polk Smith of twenty-seven paintings and works on paper was installed in the Brooklyn Museum in 1993. This was followed by the 1996 exhibition and catalogue *Leon Polk Smith: American Painter*. Robert T. Buck was director at the time.

292 *European museums:* European museums owning the work of Leon Polk Smith include: Museum Ludwig, Köln; Nationalgalerie, Staatliche Museen Preußischer Kulturbesitz, Berlin; Neue Galerie-Sammlung Ludwig, Aachen.

PART EIGHT:
JOAN MARTER ON THE DOROTHY DEHNER FOUNDATION

294 *Dorothy Dehner quotation:* From the catalogue *Sculpture and Works on Paper* (New York: Twining Gallery, 1988), essay by Dorothy Keane-White.

295 *Marter's catalogues on Dehner's work:* Dorothy Dehner and David Smith: *Their Decades of Search and Fulfillment* (New Brunswick, N.J.: Zimmerli Art Museum, Rutgers University, 1984), pp. 4–19; *Dorothy Dehner, Sixty Years of Art,* Katonah Museum of Art (New York: University of Washington Press, 1993), pp. 4–15; *Dorothy Dehner, Journeys, Dreams, and Realities* (New York: Baruch College Gallery, 1991), pp. 3–5; and other catalogues. Marter also wrote "Dorothy Dehner at Twining Gallery," *Sculpture,* volume 7, no. 5 (September/October 1988), pp. 90–91.

295 *student dissertation:* Flora Esther Tornai (now Thyssen) submitted her dissertation, "The Sculpture of Dorothy Dehner: The Abstract Expressionist Work," to Yale University in 1999. Now an assistant professor of art at the Sage Colleges, Albany, N.Y., she continues to write articles on Dorothy Dehner and her circle.

299 *Martha Nodine:* Nodine, of San Antonio, Texas, met Dorothy Dehner in 1993. She taped nine interviews with Dehner during the last year of her life, and has also interviewed friends and family. A three-volume historical-social biography is planned.

PART NINE:
KATE AND CHRISTOPHER ROTHKO, DAUGHTER AND SON OF MARK ROTHKO

305 *Mark Rothko quotation:* Part of a statement by Mark Rothko and Adolph Gottlieb sent to Edward Alden Jewel and published in the *New York Times,* "The Realm of Art: A New Platform and 'Globalism' Pops into View" (June 13, 1943). Quoted in James Breslin, *Mark Rothko: Biography* (Chicago and London: University of Chicago Press, paperback edition, 1998), p. 246.

306 *book by Lee Seldes:* Lee Seldes, *The Legacy of Mark Rothko* (New York: Holt, Rinehart, and Winston, 1978; and New York: Da Capo, 1996).

312 *St. Petersburg conference:* "Mark Rothko and the Inner World," a lecture given by Christopher Rothko at the Mark Rothko international conference, held in St. Petersburg, Russia, December 17, 2003.

319 *faking Rothko paintings:* "The Rothko Conspiracy" was a BBC docudrama aired by PBS in May 1983.

PART NINE:
STEPHEN POLCARI ON THE ARCHIVES OF AMERICAN ART

322 *the first Mrs. Still:* Clyfford Still married Lillian August Battan (1907–1977) in the summer of 1930. Their two daughters, Diane and Sandra, were born in 1939 and 1942.

323 *Mrs. Archipenko:* Alexander Archipenko (1887–1964) married Frances Gray in 1960. Both of his wives were sculptors.

326 *Robert Motherwell's foundation:* The Dedalus Foundation awards three kinds of annual fellowships: doctoral dissertation fellowships in art history, senior fellowships in art history and criticism, and master of fine arts fellowships in painting and sculpture. It also, through the New York City Board of Education, provides five scholarships of fifteen hundred dollars each to graduating high-school seniors who intend to further their studies in fine arts or art history.

326 *Pollock-Krasner Foundation, Inc:* Lee Krasner donated $10 million in securities and $30 million in paintings. The assets for this foundation for the year ending June 30, 2002, were $52,516,061. Its total giving was $3,571,000 (see Foundation Directory online, through the Foundation Center, 79 Fifth Ave, New York, N.Y., http://fconline.fdncenter.org).

326 *annual fellowship and residency:* Stephen Polcari was visiting scholar at the Pollock-Krasner Study Center in 1990 when he was working on his book *Abstract Expressionism and the Modern Experience* (Boston: Cambridge University Press, 1991).

Part Nine:
Ralph Lerner on Art Law

329 *Pierre N. Leval (judge, U.S. Court of Appeals, Second Circuit) quotation:* From his *Foreword to Art Law: The Guide for Collectors, Investors, Dealers, and Artists,* by Ralph E. Lerner and Judith Bresler (New York: Practicing Law Institute, 1989; 2nd ed., 1998).

330 *Art and Collectibles Capital Gains Tax Treatment Parity Act:* The act was introduced by Senator Pete Domenici in March 2001, in January 2003, and—joined by Senator Charles Schumer to make the bill a bipartisan effort—in October 2003.

330 *European community harmonizing variations of laws:* Beginning January 1, 2006, Britain will introduce a droit de suite to implement the 2001 Directive of the European Parliament. The details are still being worked out.

332 *Andy Warhol Authentication Board:* The board has decreed that only artworks that the artist was directly involved in producing and supervising can be considered a Warhol original. Evidently, some works were printed from acetates of the originals by people Warhol had not even met.

332 *David Schaengold:* In *A Visual Artist's Guide to Estate Planning* (Colorado Springs, CO: The Marie Walsh Sharpe Foundation, 1998), pp. 53–54.

334 *Brooklyn Museum fiasco:* New York Mayor Rudolph Giuliani, in 1999, tried to withhold financial contributions to the Brooklyn Museum when it mounted the controversial exhibition *Sensation.*

Part Nine:
Jack Cowart on the Roy Lichtenstein Foundation

336 *Roy Lichtenstein quotation:* Statement made in February 1983, quoted in *Roy Lichtenstein* by Lawrence Alloway (New York: Abbeville Press, 1983), p.106.

338 *Mrs. Lichtenstein:* Dorothy (née Herzka) Lichtenstein was born on October 26, 1939, in New York City. After obtaining her B.A. from Beaver College (now Arcadia University), Pennsylvania, in 1960, she worked at the Paul Bianchini Gallery in New York from 1963 to 1969, meeting Roy Lichtenstein in 1964. They married in 1968. Her book, *Pop Art One,* was published in 1965. She became an Officier de l'Ordre des Arts et des Lettres in 2000.

338 *Brancusi studio:* The sculptor Constantin Brancusi (1876–1957) bequeathed the whole of his studio and its contents to the French government. It has been reconstructed outside the Pompidou Center in Paris.

343 *Barbara Castelli:* Barbara Bertozzi, Leo Castelli's third wife, already managed the gallery before her husband's death in 1999 at the age of ninety-one. The Leo Castelli Gallery, now at 59 East 79th St., is much smaller than the former space in SoHo.

343 *Interview with Barbara Castelli:* The interview, "Act Two," by Anthony Haden-Guest, appeared in *Art & Auction,* volume xxv, no. 5 (May 2003), pp. 48–50.

346 *Roy Lichtenstein's two sons:* David Hoyt Lichtenstein, a graduate of Columbia University with a B.S. in electrical engineering, a former rock musician, recording engineer, and software developer, is currently working independently. Mitchell Wilson Lichtenstein, a graduate of Bennington College and Yale School of Drama, has acted in film, television, and theater, and is currently a screenwriter.

347 *College Art Association discussion:* "Clearing Rights and Permissions: How to, Why to, When to," sponsored by the CAA Committee in Intellectual Property and the Association of Art Editors, CAA conference, February 22, 2003.

350 *Lariviere authentication case:* In *Lariviere v. E.V. Thaw, the Pollock-Krasner Authentication Board, et al.,* the court held that an owner who had signed the Authentication Board's application form containing an agreement not to sue the experts for their opinion cannot then sue the board if its opinion was not what was hoped for. See *IFAR Journal* 3, no. 2 (spring 2000).

INDEX

ABOUT THE EDITORS

Magda Salvesen is an art and garden historian. With Diane Cousineau, she edited *The Sound of Sleat: A Painter's Life*, by Jon Schueler. She lives in New York, where she is the curator of the Jon Schueler Estate.

Diane Cousineau is the author of *Letters and Labyrinths: Women Writing/Cultural Codes*. She has taught literature at both American and French universities, and is currently on the faculty of Washington College in Chestertown, Maryland.